SOCIALIST REALISM WITHOUT SHORES

Post-Contemporary Interventions

Series Editors: Stanley Fish & Fredric Jameson

SOCIALIST

REALISM

WITHOUT

SHORES

Edited by

Thomas Lahusen and

Evgeny Dobrenko

Duke University Press Durham and London

1997

The text of this book originally was published without the essays by Katerina Clark, Boris Groys, Hans Günther, and Régine Robin as volume 94, number 3 of the South Atlantic Quarterly.

"Paradoxes of Unified Culture: From Stalin's Fairy Tale to Molotov's Lacquer Box" adapted from *Common Places: Mythologies of Everyday Life in Russia* by Svetlana Boym, was first published by Harvard University Press. Copyright 1994 the President and Fellows of Harvard College. "Arctic Mirrors: Russia and the Small Peoples of the North" by Yuri Slezkine, was first published by Cornell University Press. Copyright 1994 by Cornell University.

CONTENTS

Contents

Thomas Lahusen and Evgeny Dobrenko

INTRODUCTION

As David Joravsky argues in his recent essay on "Communism in Historical Perspective," "The continuing public taste for the history of Communism as moralistic melodrama and the scholarly aversion to serving that taste are opposite responses to a huge question that embarrasses everyone: why are constitutional democracy and capitalist prosperity persistently frustrated in the East and the South?" [1] They are persistently frustrated indeed, for our post-Soviet expectations have not been fulfilled: Russia remains backward, "primordial and gelatinous" (Gramsci); China continues to be unpredictable and its inhabitants are still perceived as "a sheet of loose sand" (Sun Yat-sen), despite—or because of—their recent achievements.

The present collection of essays is an enlarged version of a special issue of the *South Atlantic Quarterly* (volume 94, number 3, summer 1995), with four new contributions by Katerina Clark, Boris Groys, Hans Günther, and Régine Robin. The title of the collection (as of the *SAQ* issue) refers to Roger Garaudy's *D'un réalisme sans rivages,* one of the best-sellers of Western revisionism a little less than thirty years ago. The various responses that it provoked within the "Soviet bloc" testify to the various attempts to Westernize what was perceived as a very "Asiatic mode of (cultural) production." But the endeavor to open up the method of socialist realism to a kind of parliamentary democracy of style and genre did not bring the expected results: socialist realism was replaced by its parodic inversion, and democracy was frustrated once again. The discourse of Slavic studies followed this evolution closely. Here too, "the classroom crusader, mobilizing domestic virtue by denouncing fiends abroad, had become an embarrassing anachronism," and criticism turned to a more sympathetic and "anthropological" reading of the Soviet past, including this most "impossible" of all aesthetics, socialist realism. Critical discourse finally mimicked the techniques of *sots art* (the Soviet version of postmodernism), as shown in some of the essays collected here. The reader will have to judge to what extent they fulfill Joravsky's hope for "some constructive dialectic of tragic irony." [2]

While most of these essays still focus on "central" (i.e., Russian) themes, an attempt has been made by some to reach the shores of the "periphery": China (Xudong Zhang and Antoine Baudin), East Germany (Julia

Hell), Hungary (Régine Robin), France and Poland (Antoine Baudin), the "small peoples" of the Far North of the former USSR (Yuri Slezkine) and of other peoples and nations of the former Soviet Union (Greg Castillo), and even the United States (Lily Wiatrowski Phillips). Because of the literary-centric character of socialist realism itself, literature is likewise privileged here, although several other domains of culture are represented (the arts, architecture, and film) and new aspects have been added: Evgeny Dobrenko's data on the socialist realist readership contribute to those rare studies in the field by attempting to find out "how Russia learned to read," while Svetlana Boym's study on Soviet "folklore" and kitsch felici-tously completes the impressive "wheel" of (pseudo?) aesthetic categories that Leonid Heller has extracted from the entropic but, as it happens, not so amorphous discourse of late Stalinist criticism. By investigating the aesthetic strategies of Western modernism and the "style and a half" of socialist realism, Boris Groys shows how the differences between these two affected the discrepancies between the subsequent strategies of Western postmodernism and Russian post-Sovietism.

Three essays resort to psychoanalytic tools: while Sergei Zimovets's irreverent reading of a socialist realist "classic" can be considered a sots-artistic exercise in itself (raising a question about what is being parodied — Valentin Kataev's *Syn polka* (Son of the Regiment), "Oedipal triangula-tion," or both), it tells the story — narrated in Deuleuzian terms — of a Russian Mowgli, rising from nature to Soviet imperial culture. Julia Hell's search for sublime "post-fascist bodies" in the East German "novel of ar-rival" opens the "Great Family" — one of the paradigmatic features of the "master plot" of socialist realist literature — to a new and much needed type of interpretation, one that moves away from taxonomy and other re-ductionist forms of ideology critique to the disclosure of the social uncon-scious and a redefinition of the genre. Hans Günther proposes a "Jungian" reading of the mythopoetic transformations at work in the deep structure of Soviet culture through the cinema of the 1930s and 1940s, which brings us back to the Great Family via a pattern of binary features: two periods, two film directors, two archetypes (the Magna Mater and the Wise Old Man), sons and daughters, and their various — always binary — actualiza-tions, such as blood and fertility, steel and flowers, machinery and earth. Xudong Zhang's "criticism of criticism" of the Chinese socialist realist tra-dition from the point of view of present-day Chinese intellectual discourse and the "search for alternatives" adds an indispensable dimension to the

discussion of our "method": after all, China was—still is?—a crucial ingredient of "world communism." Thomas Lahusen's contribution deals with a similar topic, the theoretical discussion of socialist realism within late Soviet culture and its "outside" responses, from Sovietology to its commodification on the global market.

Greg Castillo's article on exhibition architecture from prerevolutionary Russia to the post-Stalin era of the Soviet Union is a timely demonstration of how ethnographic imagery was used to display the axioms of the Soviet nationalities policy. Showing how "built socialist realism" exemplified the maxim "national in form, socialist in content," Castillo contributes to a redefinition of the method in its internationalist and Orientalist implications. Antoine Baudin's institutional exploration of the international dimension and fallout of Soviet art during the Zhdanov era poses the crucial problem of the status of the visual arts within Soviet culture, its mutations and foreign "contamination," and questions the exportability of socialist realism. Mikhail Iampolski's insights on the "carnival" of censorship in the Soviet film industry of the "heroic" period (late 1920s to mid-1950s) will correct some well-established "received wisdom" concerning the very function of socialist realism. Lily Wiatrowski Phillips writes about the late fiction of W. E. B. Du Bois, whose trilogy *The Black Flame,* traditionally excluded from the canon for ideological and aesthetic reasons, addresses such issues as class and race, the relation between U.S. mainstream and marginal culture, and Soviet literature. Yuri Slezkine takes us on the "Long Journey" that the "primitive" peoples of the former Soviet Union—Eskimos, Chukchi, Nanai, and other "Russian Indians"—embarked upon in their quest for Russianness and socialist civilization, and "the other way around"—the Soviet quest for authenticity in the Far North; with Slezkine, we retrace the debate between nature and culture in the global context of Sovietness.

In an enlarged and reworked version of a "left out" chapter from her *Soviet Novel* focusing on the conventions for the positive hero in Alexander Fadeev's *Molodaia gvardiia* (The Young Guard) and other paradigmatic novels, Katerina Clark forcefully states again that "socialist realism is not to any marked degree performing an aesthetic function," that it is a parabolic structure "which has its ends," despite a certain amount of imperfection and hybridity of form. Not to recognize this most defining and recurring feature is to fail to perceive its historical function. Régine Robin's meditation in the "Statue Park" of the twenty-second district in southwest-

ern Budapest, a place of banishment for socialist realist and other monu-mental leftovers of the previous regime(s), argues for the "necessity of the work of mourning" and the urgency of a "critical, nonhysterical reread-ing of the past." Both articles summarize and exemplify a debate which permeates this collection and which is definitely not over: *with* or *without* shores—representing closure or open-endedness, aesthetics or "pure" poli-tics, ritual or promise—the method and its "specter" still haunt Europe, and beyond.

The order in which the articles appear does not follow their presenta-tion above, and indeed, who cares? We have no obligation to satisfy the taste of the "mass reader," for whom—as one of us shows in his article—"the plot should develop sequentially." After all, there is no final plot line (and no final shoreline) for what remains, despite its failure, the ultimate artistic experiment: namely, the "truthful, historically concrete depiction of reality in its revolutionary development."

The editors are sure that all the contributors join them in expressing their gratitude to Candice Ward, who helped us in our attempts to re-spond to the aesthetic challenge of the method.

Notes

Eds.' note: With respect to Russian, "popular" transliteration has been followed in the text except with titles of books and journals, in which the simplified Library of Congress transliteration system is used. Library of Congress style has also been followed in endnote citations. "Hard" and "soft" signs have been retained in end-note citations but not in text except with titles of books and journals.

1 David Joravsky "Communism in Historical Perspective," *American Historical Review* 99 (1994): 852.
2 Ibid., 852, 857.

Thomas Lahusen

SOCIALIST REALISM IN SEARCH OF ITS SHORES

Some Historical Remarks on the "Historically
Open Aesthetic System of the Truthful
Representation of Life"

> We proceed from the logic of the real
> forward movement of history.
> —Dmitry Markov

In a paradoxical way, socialist realism has reached the level of one of
its latest definitions, namely, a "historically open aesthetic system of the
truthful representation of life": with the disappearance of the Soviet State,
the socialist realist heritage truthfully represents the Soviet past. Beyond
an ironic reading of Soviet official art, however, it is worth reassessing (if
possible) the problem of the "openness" versus the "closure" of a liter-
ary practice that produced the overwhelming majority of Soviet literature,
minus, of course, the well-known "dissident" exceptions and the "returned"
masterpieces.

One of the last theoretical debates, exemplified by Dmitry Markov's
1978 definition of the "historically open system," occurred at a time when
socialist realist theory was responding to Western revisionism, above all to
Roger Garaudy's *D'un réalisme sans rivages* (1966), and when socialist real-
ist literary practice was already fighting a rearguard battle, challenged by
increasing cultural pluralism, "rural (nationalist) prose," "magic realism,"
samizdat, tamizdat, and so on.

The internal debate regarding the "openness" or "closure" of the social-
ist realist method was followed by a series of appraisals from "outside":
some Western readings (by Jochen-Ulrich Peters, Katerina Clark, Hans
Günther, and others) and an "already-outside-but-still-inside" exchange of
points of view during the late 1980s (by Evgeny Dobrenko, Galina Belaya,
and Yury Andreev, among others). Some of these readings reproduced the
internal debate, albeit with inversions and deviations. The "method," for
its supporters and opponents alike, was often part of the "logic of the real
forward movement of history," a logic which suddenly crumbled in 1991.

Various meanings can be attributed to "openness" and "closure" in the context of socialist realist writing of the "mature" period. In reexamining some structural and institutional aspects of Soviet writing from the 1920s through the late 1940s—in other words, from the "protocanon" to the phase of its "full functioning" (in Günther's terms)—and in evaluating the theoretical presuppositions posed by such a reexamination, we can challenge the idea of Soviet literature as "monolithic" during the Stalin era. On both the structural and the institutional level the method disintegrated much earlier than is commonly assumed, and the very moment of the canon's crystallization coincided with its *opening* to dislocation and decay, well before socialist realism was defined as a "historically open system."

From the very outset of his *Problemy teorii sotsialisticheskogo realizma* (Problems of the Theory of Socialist Realism), Dmitry Markov dissociates himself from "left" and "right": from attempts to identify the method with proletarian-revolutionary currents, on the one hand, and from the idea of bourgeois aesthetic theory (according to which modernist currents represent the highest stage of artistic development), on the other.[1] This double dissociation, by which Markov attempts to stand aloof from both the "dogmatic" heritage and foreign contamination, organizes the book's whole argument, developed under the overarching principle of the "logic of the real forward movement of history." Markov's famous formulation of the "historically open aesthetic system of the truthful representation of life," which became the last official definition of socialist realism in Soviet history,[2] is motivated by a series of legitimizing genealogies, considered "critically": the nineteenth-century proletarian-revolutionary tradition, for example, should not be confused, as Lenin correctly showed, with later postrevolutionary developments, such as the "vulgarizing" theories of the Proletkult. This heritage should also be viewed with some balance, that is, with a reasonable degree of openness: if the limitations that the socialist realist method placed on the modernist tendencies of the 1920s should remain an "organizing principle," this does not imply that all modernist writing has to be dismissed. Symbolism was in some cases, after all, "the expression of social rebellion and protest." Maxim Gorky—"for whom any narrow treatment of artistic consciousness was alien"—knew how to distinguish the "good" (Bryusov, Blok) from the "bad" (Sologub, Merezhkovsky).[3]

Concerning "revolutionary romanticism," Markov believes that its role during the period of formation of socialist realism has to be reevaluated.

His argument is based on the "late" opinions of Leonid Timofeev, as expressed in *Osnovy teorii literatury* (Principles of the Theory of Literature), according to which romanticism and realism are "functional concepts, relative to art in its entirety."[4] Again, criticism and openness are two aspects of the same dialectical "logic" as Markov distinguishes two tendencies of "romanticism" in the literature of the late nineteenth and early twentieth centuries: the reactionary and the progressive, that is, (reactionary) symbolism and Gorky's (progressive) "revolutionary romanticism." The "diversity" of forms that characterized the development of the new literature has still not been satisfactorily explained, argues Markov. On one hand, the vulgarizing interpretation of Marx's letter to Ferdinand Lassalle by "RAPPian nihilism" (to "Shakespearize" more and "Schillerize" less) must, of course, be dismissed;[5] on the other hand, at the dawn of the proletarian movement the socialist ideal had not yet unfolded within realist forms and could therefore only be expressed by revolutionary romanticism.

Markov's chapter on "The Socialist Literatures of the 1920s and 1930s in the Context of the Worldwide Process of Literary Development" shows that the "diversity of forms and styles" was affirmed not only over time, but also in other places: that is, the overall process was not limited to the Russian/Soviet experience. The fact that the development of socialist literature had its "limits" becomes clear, however, with Markov's use in a subsequent chapter of "humanism" as a cornerstone of the "method": "The humanist concept of man [*cheloveka*], in which the spiritual appearance and the attitude of the artist find their reflection, is undoubtedly linked to the global question of the relation between art and reality." But this cornerstone also marks a boundary insofar as the humanist conception of man determines the limits of the artistic cognition of the world, that is, its "relation with the progressive ideals of the time." Socialist realism — continues Markov — "inherited the humanist traditions of the past in elevating them to a new quality," namely "socialist humanism," and thereby "expressing the social and spiritual-ethical freedom of mankind."[6] It goes without saying that this development had nothing to do with bourgeois artistic ideologies, such as existentialism, structuralism, or the "literature of the absurd." Socialist realism, understood as a "historically open system of aesthetic possibilities," is consequently perceived as having an increasing and massive power of attraction in world literature. If its "internationalist character" is mainly related to the literature of socialist countries (Bulgaria, Czechoslovakia, Hungary, Yugoslavia, and, to a cer-

tain extent, the G D R and Poland), many writers in the capitalist countries who represent modernist tendencies also practice critical realism and have been creatively influenced by the art of socialist realism, with its concept of the new man. Concerning the socialist countries, Markov admits that they are not free of modernist tendencies and regrets that part of the creative intelligentsia in some of these countries, still identifying socialist realism with narrowness, schematism, normativity, has no faith in it, or even rejects it. Some remnants of dogmatism inside the Soviet Union (Gennady Pospelov, for example) can be held responsible for this attitude. The category of "truthfulness" (*pravdivost*) finally sets limits to the "openness" of the system. Therefore, revisionist views—Garaudy's concept of a "realism without shores," for example—are unacceptable because they "open the door to alien ideological phenomena." [7]

Among the polemics against the theory of the "open system" one can cite Yury Andreev's *Dvizhenie realizma* (The Movement of Realism).[8] For Andreev, Markov's views (with which he associates the formula of "realism without shores") show a fundamental lack of faith in the realist method. Realism has not been exhausted by nineteenth-century critical realism: its development, including its socialist realist one, is a dynamic concept in continual evolution. How could it have reached the point of critical realism and then dried up, reaching the stage of socialist realism only on the crutches of symbolism, avant-gardism, and romanticism? Realism distinguishes itself from other creative methods in avoiding the single labels applied by other literary schools, and this is its specificity. Stylistic diversity is defined by two antonymous processes: nonrealistic literature included a multitude of canons, each focusing on one or another obligatory, self-sufficient aspect, such as the image (imagism), the impression (impressionism), the renewal of device and form (avant-gardism), the individual's subjective opinions and dreams (romanticism), and so on. The liberation from any given canon, on the contrary, is achieved by realistic literature because, in tending only toward the cognition of objective reality, it changes with every change of focus.

A second point of contention for Andreev is the fact that many theoreticians and critics refuse to distinguish between socialist art and socialist realism. Ideological unity (*ideinoe edinstvo*) does not imply ideological-artistic unity (*ideino-khudozhestvennoe edinstvo*), even if socialist realism represents the vanguard of the latter. One should beware of misapplying the label of socialist realism because doing so will only compromise the

"method." Andreev cites the example of "those Polish colleagues on the literary front" who justly criticize such "headlong politics of overzealous activists," which gave only bad results. He invites the "talented and leading masters of culture who think in socialist terms [*sotsialisticheski mysliashchie*] to create according to their national artistic traditions instead of dealing with the destruction of art. . . . Time will then show that their artistic method, imprisoned in one or the other narrow canon, will give people much less than realism, with its manifold possibilities and its diversity of individual manifestations." [9]

The foreign observer who has probably given the best account of the Soviet response to Western revisionism is Jochen-Ulrich Peters. His 1974 article "Réalisme sans rivages?" does not address Markov's subsequently published concept of the "open system," but it has the double value of contextualizing the discussion in the post–Twentieth Congress period and relating it to the crucial Brecht-Lukács debate, which is scarcely mentioned, if at all, in Soviet criticism relative to the "open system." [10] Peters exposes the various stages of the discussion held within the Soviet Union since the criticism of the rigid literary politics of Stalin's time was launched in 1952 with Pomerantsev's famous article "Ob iskrennosti v literature" (On Sincerity in Literature). [11] This development is considered on the institutional level, as well as the "theoretical," through the evidence of official documents, articles, books, and conferences.

Here are some highlights: The explicitly "educational" formulation of socialist realism ("the ideological remolding and education of the workers in the spirit of socialism") was abandoned in 1956. [12] Theory as such was the product of liberalization, beginning in December 1956 with Alexei Metchenko's *Novyi mir* article on "Historicism and Dogma." [13] Metchenko's article was followed in April 1957 by the discussion on realism at the Gorky Institute of World Literature, published in *Voprosy literatury* during 1957 and 1958, and by the publication of *Problemy realizma v mirovoi literature* (Problems of Realism in World Literature) in 1959. [14] Viktor Vinogradov's views, according to which the literary development of realism could not be considered independently from the relevant literary language, did not get a positive response. [15] The majority of theoreticians and literary historians continued to understand realism as a determined "artistic form of thought" (*khudozhestvennoe myshlenie*). Although the principal task of the "science of literature" was to consider "the artistic development in the

light of Lenin's theory of reflection, as a continually developing truthful perception of reality,"[16] a consensus was reached to abandon the non-differentiated opposition between realism and antirealism and to consider the former as only one, very fruitful artistic method that was not necessarily identifiable with a determined weltanschauung. At the same time, explicit and openly "polemic" positions against "revisionist" literature and literary criticism in Hungary, Poland, Yugoslavia, and the Soviet Union (against Lukács's *Wider den mißverstandenen Realismus,* for example) were voiced in the 1959 volume *V bor'be za sotsialisticheskii realizm* (The Struggle for Socialist Realism).[17] Elsewhere, one can see attempts to integrate "non-realistic" works in the canon. In *Realizm i ego sootnosheniia s drugimi tvorcheskimi metodami* (Realism and Its Relations with Other Creative Methods), for instance, N. S. Pavlova blames Lukács for having abandoned "left expressionism" too hastily in the "expressionism debate" and maintains that the abstract character of left expressionism and its immediacy had allowed Brecht to translate the task of theater into direct artistic practice.[18] This did not prevent Mikhail Kuznetsov from expelling, in the same volume, modernism, naturalism, and the neorealism of the new Italian cinema from the socialist realist canon.[19]

A special place was reserved for romanticism, the reevaluation of which became, according to Peters, the most important element of the antidogmatic movement in Soviet criticism after the Twenty-Second Party Congress. The discussion took a new turn with the publication of Alexander Solzhenitsyn's "One Day in the Life of Ivan Denisovich" in 1962 and Vladimir Lakshin's controversial 1964 and 1965 *Novyi mir* articles in response to the story.[20] While not abandoning such traditional concepts as "popular spirit" (*narodnost*), "truthfulness" (*pravdivost*), and "Party-mindedness" (*partiinost*), Lakshin attempted to relate these directly to narrative: literature could succeed in fulfilling its educational mission by depicting truly *what is.* As the discussion developed over time, according to Peters, the constraints on form were somewhat relaxed, whereas the ideological "shores" remained stable. Only the realist author could mediate between abstraction and naturalism, socialist realism being the only method capable of rendering at once a subjective and an objective appreciation of social evolution. Specific problems arose in regard to poetry within socialist realism, while such concepts as Brecht's "epic theater" or that of the experimental novel (Thomas Mann's *Doktor Faustus* or Maxim Gorky's *Klim Samgin,* for example) produced works that were understood as "exceptional,"

as the expression of a revolutionary era. The disruption of causal relations in individual scenes or other such devices often encountered in this literature were counterbalanced by the "fundamental theme," that is, the relation between the people, the hero, and history. This theoretical operation allowed Gorky, Tolstoy, and Dostoevsky to be seen in continuity, with all of them representing a "closed period" of Russian history within the overall literary development. What remained was the other forbidden shore: Joyce, Beckett, and the *nouveau roman*. The well-known formula of "unity of method, diversity of styles" allowed different "methods" to compete within Soviet literature. As for Garaudy's notion of a "universal humanism" which corresponded to the given sociohistorical situation but could not be derived from it, his concept of a socialist-committed art and literature, his desire to replace "Party-mindedness" with subjective (although socialist-oriented) partisanship, and, above all, his departure from the Leninist theory of reflection, all of this remained unacceptable to Soviet critics.

Peters concludes with the repercussions in the USSR of the Brecht-Lukács debate. Even if Brecht's concept of realism gained ground not only in the GDR, but also in the Soviet Union, the anti-Lukács critique in the latter was not only less radical, but motivated by different concerns than, for instance, West German attacks against Lukács's aesthetic theory. The reasons for the attack on Lukács's objectivistic theory of realism within Soviet criticism (and by Werner Mittenzwei in the GDR[21]) were twofold: first, such a concept would no longer allow a distinction to be drawn between critical realism and socialist realism; second, and more importantly perhaps, it would hamper attempts to overcome the internal dogmatic thinking oriented toward nineteenth-century "great realism."

Peters's "descriptive" manner conveys an impression of his own "objectivity" toward these issues, as well as a feeling of "synchronicity" and paradoxical timelessness. His message seems to be: Soviet literary theory has changed and become more liberal, but *plus ça change, plus c'est la même chose*. Indeed, Soviet resistance to revisionism seems to have been well-entrenched during the "period of stagnation," and Peters's article, written in the midst of this period, reflects a certain mimetic relationship to this state of affairs.

The same can be said about a very different piece of literary criticism, namely, Katerina Clark's foreword to the 1983 English translation of Chingiz Aitmatov's novel *The Day Lasts More than a Hundred Years*. "Readers

[of Aitmatov's work] might well wonder how this novel ever managed to get published in the Soviet Union"—these are the introductory words with which Clark presents what would eventually come to be considered one of the harbingers of perestroika and glasnost.[22] A novel which "created a sensation among the Soviet intelligentsia" after its publication in the November 1980 issue of *Novyi mir,* for us the novel can function as a welcome concretization of the theories discussed above because it is in itself a "historically open system." As Clark observes, *The Day Lasts More than a Hundred Years* did not "slip past the censor," given its politically loaded themes, such as the revival of national traditions in Central Asia, the theme of the "wall" (i.e., the Iron Curtain and the Berlin Wall), and a possible allusion to the invasion of Afghanistan, among others. For Clark, however, Aitmatov's novel had nothing to do with "dissidence," since it accommodated the tastes of both the power structure and the intelligentsia, as well as those of Western commentators. It even became a favorite of the Soviet literary establishment and was elevated to the status of a canonical exemplar of socialist realism, satisfying, by the same token, certain contemporary trends and needs. Among these, Clark mentions the reaction against the "nostalgia" and ideological backwardness of "village prose" in favor of technological modernity and "global scope"; the inclusion of a "multinational" ingredient, in a shift away from Russocentrism and closer to strategically important Central Asia (Kazakhstan-Kirghizia); and the theme of mind control being shifted toward a more "politically correct" (i.e., anti-Chinese) orientation. For Clark, Aitmatov's novel also succeeds in combining "contradictory" literary models, such as García Márquez's *One Hundred Years of Solitude* and Solzhenitsyn's "One Day in the Life of Ivan Denisovich."[23] But it was only in an article published a year later that Clark fully developed her analysis of Aitmatov's novel as a "case study of the way the socialist realist canon can generate new paradigms out of itself."[24] In "The Mutability of the Canon," Clark attempted to show that the conventions of socialist realism were still alive in 1980 and that Aitmatov's novel revealed them "to a greater extent than has been seen in the major Soviet writing of the past fifteen years." According to Clark, *The Day Lasts More than a Hundred Years* basically follows the Stalinist "master plot" (described in her 1981 bestseller, *The Soviet Novel: History as Ritual*[25]), with the difference that the plot functions (in the Proppian sense) have been reversed or modified. "Completing a task in the public sphere" becomes a personal and religious duty to bury a friend according to the old rituals

of Central Asia. The novel's overall structure is also Stalinist, with a main formulaic plot, various subplots tied to the central themes, a climactic moment toward the end when the protagonist's ability to complete his task is threatened, and a denouement in which the old conventions reemerge as "phantoms" (the funeral ceremony marking the "completion of the task," political progress, and the renewal of generations). At the same time, the novel has enough ambiguity to "cover both bases," Stalinist and post-Stalinist (i.e., "village prose"). For Clark, Aitmatov is a "superb bricoleur" who "has assembled here a structure that is made from bits and pieces of the socialist realist tradition but is nevertheless shaped by his own singular intentions." [26] This "Janus-like quality" integrates old patterns (such as the "machine" and the "garden," the father-and-son theme, the mentor and the simple worker, etc.) with the "revisionist trends of recent prose." But what allows Aitmatov to maintain the basic structural feature of classic socialist realism in *The Day Lasts More than a Hundred Years* is, for the author of *The Soviet Novel,* its organization in binary patterns of space and time: the ordinary and the extraordinary, the "day" and the timelessness of legend (the hundred years), the "village" and the larger "scale." If Clark is right about Aitmatov's novel, then whatever conflicting interpretations its ambiguity may have provoked, it nevertheless shows the vitality of the "method" and the maturity of the genre, demonstrating "its ability to produce new variations of the generic constant that defines it as a genre or subgenre." [27] We are strikingly close to the definition of "late" socialist realism—"unity of method, diversity of styles"—a diversity which, if we remember what Dmitry Markov had to say about it, was affirmed not only over time, but also across space. On the level of explanation, West meets East.

It seems that the limitations of Clark's interpretation of this particularly open-yet-still-closed work by Aitmatov lie in the immutability of the model itself. Models prove to be "true" when they resist the pressure of time. And time, in this case, seems to have stopped: Clark's structural model was built, after all, upon an underlying belief in the fundamental unchangeability of the Soviet system. This belief has recently been defined as the "subjective experience of hegemony" in late Socialist consciousness.[28] If "hegemony" is the "symbolic order which is experienced in the form of (Soviet) institutions, discourses and practices, including both state ritualized activities and minute elements of structured every-day practice," then its late Socialist version can be seen as the social order, based on the recognition of the fact that the given reality is "unchangeable" and is going

to stay in its present form "forever." [29] In other words, late Soviet consciousness corresponded to the consciousness of "late Sovietology," both of which were imprisoned in the same "hegemonic" principle of the "logic of the real forward movement of history."

The historical acceleration that we witnessed after 1985 had an undeniable impact on "consciousness," including the consciousness of Sovietology. This impact can be discerned in a 1987 article on the "life stages of a canon," with socialist realism taken as an example, by the (West) German scholar Hans Günther, and in a 1990 anthology edited by Evgeny Dobrenko and published in Moscow. The latter is of exceptional interest, having been the last public debate on the "method" that appeared in print before the disintegration of the Soviet Union.

Günther's article presents itself from the outset as a theoretical contribution.[30] The problematic of canon formation is seen in the larger framework of systems theory:

Canonical formations are among the strongest cultural mechanisms of stabilization and selection that we know. If we take as a point of departure the evolutionary flow of change as a rule . . . canons represent more or less comprehensive systems of regulation. On one hand, they form barriers and dams against the ever-changing flow of time (function of stabilization). On the other, they select, steer, and channel the various currents of the tradition (function of selection).[31]

Günther refuses to see the dynamic of an artistic canon in the constant flow of automatization and disautomatization undergone by dominant genres or currents, a concept which was given its classic formulation by Yury Tynyanov.[32] To the "weak canon" of the Russian Formalists, Günther opposes the concept of a "strong canon" predominantly determined by other, external factors, such as ideological monopoly, institutional conservatism, or mechanisms of exclusion. The action of a canon consists precisely in weakening or impairing the mechanisms founded on innovation and change; contrary to Formalist beliefs, canonical art can continue to function even when it appears to be aesthetically "automatized." Consequently, the global analysis of a canon must take into account the interdependent mechanisms of several levels of discourse: the general discourse of the given period (in our case, Stalinist "Leninism"); the discourse of literary politics, including the slogan of socialist realism and its ideological postulates; the meta-discourse of literary criticism, which concretizes the

"artistic method" and applies it to literary texts; and the literary discourse per se, the rules of which are formulated by the stylistic conventions of socialist realism. This theoretical construct allows Günther to avoid—to a certain extent—the teleology or "immanence" we saw at work in Markov's "logic of the real forward movement of history" and Clark's "generic constant" and seems to "open" the analysis to time and context.

According to Günther's "life stages" model, the socialist realist canon was preceded by a "protocanon," preparatory to and functioning as a "textual reservoir" for the canon proper. During the subsequent, inaugural phase of canonization, the canon was formulated, in opposition to other traditions, as a more or less systematic construct; then a phase of "practice" followed, during which its mechanisms were fully implemented. The two following phases marked the decline of the "method": a period of decanonization, when the canon lost its hegemony and was being deconstructed (the early 1950s through the 1960s), and a phase of "postcanonicity," elaborated during the canon's period of decadence (the 1970s). On one hand, Günther's model reproduces the standard periodization of Soviet literary history: the first two decades of the twentieth century, the early 1920s, the 1930s and 1940s, and post-Stalinist or post–Twentieth Congress literature. On the other hand, his discussion of the last two stages, which draws upon Peters's analysis and contemporary literature, undeniably benefits from his being able to foresee "the end" and therefore seems less inspired by the historical "logic." What about the phases of "real" socialist realism, from protocanon and canonization to practice or full functioning? Despite Günther's apparently "objective" account of the processes at work, his argumentation appears to rely quite heavily on his "discursive" model. It also follows the well-known "seasonal," or "meteorological," scheme: a development that proceeds from "narrowing" and "freeze" to "opening" and "thaw." The chaotic "thaw" that we are witnessing today makes a revision of these schemes imperative.

It is true, of course, that some of the novels assigned to Günther's "protocanon," such as Maxim Gorky's *The Mother* or Fyodor Gladkov's "classic" of the 1920s, *Cement,* were bound to reveal "some deficiencies" during the 1930s. But it is not true that these deficiencies were simply "overlooked" during the later phase of canonization, when, according to Günther, only the "global schemes" of such novels were considered.[33] The "later canonization" did not "close its eyes" to the "symbolic-ornamental" style of *Cement!* It *corrected* the "deficiencies" to make the novel "teleo-

logical" and continued to make such adjustments well into the canon's "practice" phase and even beyond. As has been shown elsewhere, Gladkov's rewriting of *Cement,* a revision that covered several decades (and was still in force after the author's death), was not limited to purging certain stylistic or thematic "deficiencies"; its purpose, or its outcome (which, in this case, amounts to the same thing), was to disrupt literary discourse as it was practiced during the 1920s in order to replace it with another "teleology."[34] Moreover, Günther's discursive model cannot explain why some novels, such as *Cement* (and many other "classics" of the 1920s), were indeed corrected, while others, like Gorky's *The Mother,* resisted the "pressure of time" despite their "deficiencies." I would risk an interpretation here: During the canonization phase, *The Mother* already belonged to History (i.e., to the history of the Founding Fathers) and was therefore not touched by the process of correction, but this did not prevent its author (Gorky) from participating in this process *by proxy,* notably, in the rewriting of Gladkov's *Cement.* In a letter of 1926, for example, Gorky encouraged Gladkov to work on the style of his novel, and this included its ornamental ingredients, regionalisms, and "vulgarisms": "Your language [of the first—1924— version] will be difficult for the citizen of Pskov, of Viatka, for the inhabitants of the higher and middle Volga, to understand. Here too, like many other contemporary authors, you reduce in an artificial way the scope of influence of your book, of your creation."[35]

With regard to the "canonization" and "practice" phases of the socialist realist canon during the 1930s and 1940s, this period was, according to Günther, the canon's most "extreme" phase of "contraction." It is interesting to observe how the metaphors Günther uses here are responding to those of the times: if, for Stalin "life [had] become better, happier," for Günther the "instrumentalization of literature and the uncontrolled monopoly of the state on communication" were "degenerative."[36] But what is at stake here is not only a matter of the "metaphors we live by,"[37] but the very interpretation of history and culture. Despite this period's high degree of "canonicity" and "degeneration," such novels as Nikolai Ostrovsky's *Kak zakalialas' stal'* (How the Steel Was Tempered) or Mikhail Sholokhov's *Podniataia tselina* (Virgin Soil Upturned) (cited by Günther as exemplifying the "phase of canonization") reveal contradictory, and therefore dynamic, processes related to both "content" and "form." In many aspects, these novels are closely related to the 1920s and to the very times of their own production, that is, the *early* 1930s. A careful analysis of their poetics and

themes "in their revolutionary development" shows that these novels are far from representing a monolith, despite their stylistic and narratological linearization and their "lies."[38] Günther explicitly addresses the problem of rewriting in his 1984 book on the "nationalization of literature," but seems not to draw the obvious conclusions. It is clear that during the period of socialist realism institutionalized control over the function of the canon was not maintained exclusively by censorship and terror: "Literary texts were considered unstable variables, open to 'correction' according to present needs, that is, to manipulation, [and] comparable to palimpsests that could be scratched off and then inscribed anew."[39] As it happens, palimpsests are an excellent source for "archaeology," always revealing a present that includes its past or its future, a previous or a later stage of writing. But Günther, like many others, privileges the "present," that is, the unification and standardization of the "classic" socialist realist text, and neglects its inherent variability. This "instability" cannot be emphasized enough: it explains the paradox of the openness and closure of socialist realist culture at its peak in the late 1940s. Just at the moment when the socialist realist canon reached its highest degree of unification and standardization, during the period of "conflictlessness" and the "varnishing of reality," it became maximally fragmented and "open-ended."

The paradox of "high Stalinism's" openness and closure is well illustrated by Leonid Heller and Antoine Baudin's recent article on "socialist realism as the organization of the cultural field" and other publications of the "Lausanne project" on socialist realism of the Zhdanov period.[40] Through a detailed analysis of the various levels of the "chain of cultural practices" (production per se, circulation, and reception), including a large-scale survey of Soviet cultural institutions, Heller and Baudin arrive at the conclusion that Soviet culture during the late 1940s was characterized by ideological, aesthetic, and organizational integration and compartmentalization, a process that resulted in the hierarchization of cultural production, in its concentration and even rarefaction, which paralleled, to an unknown degree, its "massification" and ritualization on the level of usage. This process was realized through a heterogeneous and complex institutional mechanism, whereby centralization and hierarchization ("closure") increased, on the one hand, while institutionalized organs, the competencies and authority of which remained unspecified ("openness"), multiplied, on the other. This multiplication appears to have occurred in response to a double strategic objective: First, to control the field (often via

duplication of functions), thereby neutralizing the respective artistic institutions, which were always suspected of striving for "autonomy." (Such a politics of neutralization conformed to a Party line that dated back to Lenin's attacks on the autonomist tendencies of Bogdanov and the Proletkults). Second, this institutional complexity, which kept growing with every new reorganization, seems to have perpetuated, at least on the symbolic level, a number of remnants of revolutionary utopianism. To a certain extent, it also obeyed more universal laws of bureaucratic life, according to which bureaucratic organisms tend toward gigantism and increased functional complexity. Ultimately, Heller and Baudin conclude that the cultural field of high Stalinism was far from rigid. It possessed a dynamics of its own, driven by internal tensions and, above all, by the power structure—the political machine and its levers, such as criticism, self-criticism, and the eradication or implementation of its organs. Soviet culture, like Soviet society, as these authors observe, always had to be "moldable" to allow for improvement. Therefore, the most immediate and the most enduring consequence of the Party's interference was not the stability of the system, but its destabilization.

An analogous idea of the system's "open-endedness" in its very "closure" is to be found in a 1990 article by Evgeny Dobrenko, albeit in a context of generalizations about the "static phenomenon" of high Stalinist literature and other "functional" aspects of "totalitarian culture."[41] Here, the open-endedness is specifically related to the "epicization" of the socialist realist "panoramic" novel, its "atomization of biography," in the late 1940s through the sheer *size* of such works. The postwar epic novels by Nikolai Zadornov, Sergei Zlobin, and L. Nikulin, among others, are literally "endless." By the late 1930s, Pyotr Pavlenko had already defended the poetics of his novel *Na vostoke* (In the East) against those critics who attacked him for the fuzziness and "porousness" of his composition:

The construction corresponds to the difficulties of the task. I don't share the point of view of those critics, to whom this construction seems porous, fuzzy. I can only agree with one point, that it is difficult. Yes, the construction of the novel is difficult, somehow complex. . . . I wanted to write a stream, the gigantic and terrible movement of human waves. We have ceased to grow in solitary confinement; we grow in masses, in waves. I wanted to express the character of the mass production of our growth, its continuity, the storm of our growth and development, and if in

this movement some biographies of individual characters have been lost, it doesn't matter: others are left.[42]

I wonder whether Pavlenko's characterization of his own work is not valid for socialist realism in its entirety (at least in its "mature period"), especially in terms of the specific "transition from quantity to quality" worked out by the "method." In its *form,* socialist realism had a tendency toward "length" by virtue of the very fact that it privileged the "longer form" (e.g., the novel over the "novella" or *povest,* and other "minor" genres) in the hierarchy of genres. While the "master plot" was oriented toward a teleological "completion of the task," the "master closure" of all socialist realist novels showed that this task was always *open* to the future. "Tragedy" was thus inherently "optimistic."[43] The unfinished nature of their plots was literally inscribed in the novels, in the *practice* of socialist realism: censorship and, above all, *redaktura,* that is, the corrections, additions, and deletions by which the editorial staff contributed to a given work (with or without the participation of the author), as well as the general activity of criticism, were all perceived as modes of participation in the collective creative act. Socialist realist practice thus extended the literary process and transformed its products into an "open work" well before Markov defined socialist realism as a "historically open system." Examples are too numerous and well-known to need to be cited. Some other aspects of "collective creation," however, have been studied less, and not only for lack of sources. Günther's discursive scheme, for example, seems to ignore reader-response theory. If we "open" our own interpretation of the method to such "shores," we see that "life itself" is continuing the story.

After the publication of Vasily Azhaev's Stalin Prize winner and bestseller, *Far from Moscow* (1948), two readers out of three wrote to the author and urged him to tell them "what happened later."[44] A glance at readers' letters published in the journal *Novyi mir* during the early 1930s shows that such works of the "phase of canonization" as *How the Steel Was Tempered* or *Virgin Soil Upturned* received the same kind of "open" interest from the reading public as works of the later stage of "practice" did.[45] Finally, the return to outmoded critical practices, such as raising questions about the author's "biography" or—what is worse—about his or her "intentions" (what the writer "really meant"), or—still worse—focusing on the sociohistorical "relevance" of a given work, can yield important insights and open up our analysis to an even greater revision of our "totalitarian" approach to

the "total art of Stalinism," a revision that does not necessarily have to entail applying postmodern techniques of criticism. A good example of such revisionism is Vera Dunham's rarely cited attempt to understand socialist realist postwar writing in the context of social change.[46] Whether one does or does not perceive "middle-class values" in the Soviet literature she analyzed, her attempt to address the social sphere anticipated "antitotalitarian" approaches that have been taken only recently, following the disintegration of the Soviet state.

Turning now to the other essays published in Dobrenko's 1990 anthology,[47] most of them continue the "byzantine" discussion, and most continue to affirm the "unity of the method," although a few contributors reject it wholesale. At the same time, the collection attests to a "multiplicity of forms" that is definitively "offshore" by employing the old (but modernist) technique of montage, thereby establishing the volume formally in the context of the "returned literature" of the 1920s. This montage effect is conveyed (albeit modestly) with different typography for the essays, the intermingled readers' comments (!), the 1988 colloquium on socialist realism (entitled "Method or Myth") that was held at the Institute of Philosophy in Moscow, and the "roundtable" ("Should We Give Up Socialist Realism?") reprinted from a 1988 issue of *Literaturnaia gazeta*.

Among the thirteen essays (not counting those from the colloquium and the roundtable), only one is directly related to our "open system" discussion. Its author is the same Yury Andreev who defended realism, "as such," against the revisionist gravediggers (my formulation). The essay's title, which translates as "The Echo of the Earth and the Sky: Theses on Socialist Realism and the Eternal Evolution of Art," is faithful to its "epic" and "cosmic" resonance. Attacking the "conformity of [today's] anti-conformists," who attempt to rewrite literary history by resorting exclusively to examples of bad socialist realist works, the Andreev of 1988 situates socialist realism in the great tradition of literature that reflected the process of humanization and democracy by representing the "little, unfortunate brother" and thus elevating "the suffering object of history to its representation as subject." (The quotation is from Engels.) Andreev also refers to and draws examples from Dostoevsky, Lenin, Gorky, Sholokhov (compared to Márquez), Abramov, Rasputin, Trifonov, and Vysotsky. The priorities of art have shifted from "class" to the "overall human," to peaceful coexistence and the environment. Andreev concludes by warning against those "reformers" who see the future in the American economic

model and forget that, "to reach the stars" (and stripes?), one has to follow a "path made of thorns."[48]

Apart from an excerpted "classic" (Sinyavsky-Terts's *What Is Socialist Realism?*) and an article, also by Sinyavsky, on *The Mother* as an "early example of socialist realism," the essays represent, as the title of the collection indicates, "different points of view." Among the stronger of these are certainly Galina Belaya's "Threatening Reality" and Valery Tiupa's "Alternative Realism." The first gives a historical account of the method's first formulation in the late 1920s. For Belaya, the foundation stone of socialist realism is the version of "dialectic materialism" promulgated by RAPP, including its notions of the "social determination" and "social mandate" of art. These are the concepts and the practice that will be implemented later, despite their temporary condemnation as "vulgar sociologism" during the early 1930s. Belaya's article also explores some less well-known concepts and instances, such as Naum Berkovsky's "class semantics" and his polemics with Bakhtin after the publication of *Problems of Dostoevsky's Poetics* in 1929.[49]

Valery Tiupa's essay offers a sweeping historical reexamination of the paradigm of literariness (*khudozhestvennost*) from which emerge two types of twentieth-century "realisms": socialist realism and "alternative realism." Despite its conservatism, socialist realism from the 1930s to the 1950s is seen by Tiupa as the direct descendant of avant-gardist and "left" art, with a central function of "impact" that overshadowed other functions of literariness (e.g., the Romantic emphasis on the author, the classical emphasis on the "chosen" educated reader, etc.). "Alternative realism," however, is grounded on a specific "ideological" (not to be confused with "political") "poetics of the addressee" and "aesthetics of actualization," both of which unite writers as different as Brecht, Thomas Mann, Fadeev, and Sholokhov, or such different works as *The Mother* (regarded by Tiupa as one of the first examples of "alternative realism" in its "internally journalistic" version), Mayakovsky's "agitational art" and Vysotsky's lyrics, Sholokhov's *Virgin Soil Upturned,* Platonov's *Foundation Pit,* or Márquez's *Autumn of the Patriarch.* Is this another "realism without shores"? Certainly not for Tiupa: when the "self-selecting" hero is devoid of any character, if he is situated beyond the chain of the cause-and-effect system of motives, we leave the territory of realism for existentialism, another "sector" of non-classic twentieth-century culture (Sartre, Camus, Murdoch). "Alternative realism" is a wide-ranging phenomenon in contemporary literature, *but it is not*

without shores. Existentialism, classic realism, "epigonic" realism, natural-ism, the "avant-gardism of the author's own will," and the "illustrativity of extreme politicization" all mark the outer shores of this phenomenon.[50]

After reading this whole anthology (the colloquium and roundtable included), the reader's head spins from what I would call its frenzy of (re)classification. Here are some of the definitions of the method ad-vanced in Dobrenko's collection: a "school of historical optimism" (Dmitry Urnov); a "path into the barracks" (Vyacheslav Vozdvizhensky); a "reli-gion in disguise" (Alexander Gangnus); a "realism which penetrated the essence of life during socialism" (Shamil Umerov); "real socialist realism" in the "artistic reflection of the truthfulness of life of the socialist era" (Viktor Vanslov); a "Stalinist myth" (Arseny Gulyga); a "purely ideologi-cal and political concept" (Vladimir Gusev); a "scientific concept . . . that one should not attempt to get rid of" (I. Volkov); the "history of a disease" (Yury Borev); the "epics of the victorious Revolution" and a "socialist ideal, free of deformations" (Svetlana Selivanova); and, as applied to the special case of Andrei Platonov, "planetarian humanism" (Vsevolod Surganov).

In concluding with some brief remarks from the "postfuture," I turn now to Boris Groys's *Total Art of Stalinism: Avant-Garde, Aesthetic Dictatorship, and Beyond.* Having been much discussed, Groys's ideas are well-known, if not really new, boiling down to the fact that Stalinist culture in general (and socialist realism in particular) satisfied the fundamental demands of the Russian avant-garde. What might interest us more here is what Groys has to say about the meaning of (Russian) "postutopian art," which brings us back to the problem of history, and to the question of its openness, or closure:

The meaning of postutopian art is to show that history is nothing other than the history of attempts to escape history, that utopia is inherent in history and cannot be overcome in it, that the postmodernist attempt to consummate history merely continues it, as does the opposite aspiration to prove that historical progress is infinite. Postutopian art incorporates the Stalin myth into world mythology and demonstrates its family likeness with supposedly opposite myths. Beyond the his-torical, this art discovers not a single myth but an entire mythology, a pagan polymorphy; that is, it reveals the nonhistoricity of history itself. If Stalinist artists and writers functioned as icon painters and hagiographers, the authors of the new Russian literature and art are frivolous mytho*graphs,* chroniclers of utopian myth, but not mytholo*gists,* that is, not critical commentators attempting to "reveal the

true content" of myth and "enlighten" the public as to its nature by scientifically demythologizing it.[51]

Groys is himself—at least in *The Total Art of Stalinism*—just such a "frivolous mytho*graph*." Indeed, who could take "seriously" the idea that "we may safely assume that [millions of Soviet workers and peasants] would not have protested or been greatly surprised if they had in addition [to studying such laws of Marxist dialectics as the 'transition from quantity to quality' or the 'negation of the negation'] been called upon to study suprematism or the *Black Square*"?[52] Groys's purpose is not to "reveal the true content" or to "enlighten" us about what the "total art of Stalinism . . . really was" because there is no such thing if you are a mythograph. Groys teaches the same "lesson" that modern Russian "postutopian" art has learned and makes the defeat of Stalinist culture seem "obvious and final," a matter of "overcoming the Stalin period by remythologizing and aestheticizing it."[53] If we agree with Fredric Jameson that "aesthetic production today has become integrated into commodity production generally," an integration that is explicitly claimed as "emancipating" by Groys himself, who sees the only value of contemporary art as its having a *price* within an artistic market, then socialist realism in its contemporary guise is finally becoming what it has always wished to be: "planetarian," or simply "global."[54] But in reaching the distant shores of commodification, our method, like other "futures," must compete against other products. On the New York Stock Exchange of culture, *sots art,* for example, "did well"—and, for that matter, so did *The Total Art of Stalinism*. What are the method's chances of enduring into the future? The "logic of the real forward movement of history" will show us, if there is any such thing.

Notes

1 D. Markov, *Problemy teorii sotsialisticheskogo realizma* (Moscow, 1978). All translations from the Russian are my own unless otherwise indicated.

2 See Markov and Leonid Timofeev's definition in *Literaturnyi Entsiklopedicheskii Slovar'* (Literary Encyclopedic Dictionary) (Moscow, 1987), 416.

3 Markov, *Problemy teorii,* 118–22.

4 Ibid., 146. See L. I. Timofeev, *Osnovy teorii literatury* (Moscow, 1971), 107–8.

5 Markov, *Problemy teorii,* 154. RAPP, or the Russian Association of Proletarian Writers, was active during the second half of the 1920s.

6 Ibid., 244–48.

7 Ibid., 296–306.

8 Iu. A. Andreev, *Dvizhenie realizma* (Leningrad, 1978).

9 Ibid., 122–79.

10 Jochen-Ulrich Peters, "Réalisme sans rivages? Zur Diskussion über den sozialistischen Realismus in der Sowjetunion seit 1956," *Zeitschrift für Slavische Philologie* 37 (1974): 291–324.

11 V. Pomerantsev, "Ob iskrennosti v literature," *Novyi mir,* No. 12 (1953): 218–45.

12 Peters, "Réalisme sans rivages?" 295.

13 A. Metchenko, "Istorizm i dogma," *Novyi mir,* No. 12 (1956): 223–39.

14 *Problemy realizma v mirovoi literature* (Moscow, 1959).

15 V. V. Vinogradov, "Realizm i razvitie russkogo literaturnogo iazyka" (Realism and the Development of Russian Literary Language), *Voprosy literatury,* No. 9 (1957): 16–63. Vinogradov's views were subsequently developed in *O iazyke khudozhestvennoi literatury* (On the Language of Artistic Literature) (Moscow, 1959).

16 Ia. El'sberg, "Problemy realizma i zadachi literaturnoi nauki" (Problems of Realism and the Tasks of Literary Scholarship), *Voprosy literatury,* No. 5 (1959): 178.

17 Georg Lukács, *Wider den mißverstandenen Realismus* (Hamburg, 1956); *V bor'be za sotsialisticheskii realizm* (Moscow, 1959).

18 *Realizm i ego sootnosheniia s drugimi tvorcheskimi metodami* (Moscow, 1962), 297.

19 Ibid., 329–31.

20 V. I. Lakshin, "Ivan Denisovich i ego druz'ia i niedrugi" (Ivan Denisovich and His Friends and Enemies), *Novyi mir,* No. 1 (1964): 223–45; and "Pisatel', chitatel', kritik" (The Writer, the Reader, and the Critic), *Novyi mir,* No. 4 (1965): 222–40; No. 8 (1965): 216–56.

21 Werner Mittenzwei, "Die Brecht-Lukács-Debatte," *Sinn und Form: Beiträge zur Literatur* 19 (1967): 235–71.

22 Katerina Clark, Foreword to *The Day Lasts More than a Hundred Years* by Chingiz Aitmatov, trans. John French (Bloomington, 1983), v.

23 Ibid., v–xv.

24 Katerina Clark, "The Mutability of the Canon: Socialist Realism and Chingiz Aitmatov's *I dol'she veka dlitsia den',*" *Slavic Review* 43 (1984): 573–87.

25 Katerina Clark, *The Soviet Novel: History as Ritual* (Chicago, 1981).

26 Clark, "Mutability of the Canon," 582.

27 Ibid., 582–87.

28 See Alexei Iourtchak, "Cynical Reason of Late Socialism" (paper presented at the 26th national convention of the American Association for the Advancement of Slavic Studies, Philadelphia, November 1994), 1.

29 Ibid.

30 Hans Günther, "Die Lebensphasen eines Kanons—am Beispiel des sozialistischen Realismus," in *Kanon und Zensur: Beiträge zur Archäologie der literarischen*

Kommunikation II, ed. Aleida Assmann and Jan Assmann (Munich, 1987), 138–48.

31 Ibid., 138.

32 See Iurii Tynianov, "Literaturnyi fakt," in *Arkhaisty i novatory. Nachdruck der Leningrader Ausgabe von 1929: Mit einer Vorbemerkung von Dmitrij Tschizewskij* (Munich, 1967), 5–29.

33 Günther, "Lebensphasen eines Kanons," 141.

34 See Leonid Heller and Thomas Lahusen, "Palimpsexes. Les Métamorphoses de la thématique sexuelle dans le roman de F. Gladkov *Le Ciment:* Notes pour une approche analytico-interprétative de la littérature soviétique," *Wiener Slawistischer Almanach* 15 (1985): 211–54; Thomas Lahusen, "Socialist Realism Revisited: Or, the Reader's Searching Melancholy," *SAQ* 90 (Winter 1991): 87–109.

35 Quoted in I. P. Ukhanov, *Tvorcheskii put' F. Gladkova: Posobie dlia uchitelei srednei shkoly* (The Creative Path of F. Gladkov: A Manual for High School Teachers) (Moscow, 1953), 47.

36 Günther, "Lebensphasen eines Kanons," 144.

37 George Lakoff and Mark Johnson, *Metaphors We Live By* (Chicago, 1980).

38 See Lahusen, "Socialist Realism Revisited."

39 Hans Günther, *Die Verstaatlichung der Literatur: Entstehung und Funktionsweise des sozialistisch-realistischen Kanons in der sowjetischen Literatur der 30er Jahre* (Stuttgart, 1984), 66–67.

40 Leonid Heller and Antoine Baudin, "Le Réalisme socialiste comme organisation du champ culturel," *Cahiers du Monde russe et soviétique* 34 (1993): 307–44; see also the contributions of both authors to this volume; as well as Antoine Baudin, "'Socrealizm.' Le Réalisme socialiste soviétique et les arts plastiques vers 1950: Quelques données du problème," *Ligeia* (Paris) 1 (1988): 65–110. For a programmatic presentation of the project, see Antoine Baudin, Leonid Heller, and Thomas Lahusen, "Le Réalisme socialiste soviétique de l'ère Jdanov: Compte rendu d'une enquête en cours," *Etudes de lettres* (Lausanne) 10 (1988): 69–103.

41 Evgeny Dobrenko, "Ne po slovam, no po delam ego" (Not by His Words, but by His Deeds), in *Izbavlenie ot mirazhei—Sotsrealizm segodnia* (Ridding Ourselves of Mirages—Socialist Realism Today), ed. E. A. Dobrenko (Moscow, 1990), 330. (The volume appeared in the series "From Different Points of View.")

42 P. Pavlenko, *Sobranie sochinenii v 6 tomakh* (Collected Works in Six Volumes), (Moscow, 1953), 1: 546–47; quoted in Dobrenko, "Ne po slovam, no po delam ego," 330.

43 As in Vsevolod Vishnevskii's 1933 play *Optimisticheskaia tragediia* (Optimistic Tragedy).

44 These letters were found by me in the personal archives of Vasilii Azhaev and will be presented in a forthcoming publication. For preliminary notes, see Thomas Lahusen, "The Mystery of the River Adun: Reconstruction of a Story," in *Late Soviet Culture: From Perestroika to Novostroika*, ed. Thomas Lahusen, with Gene

Kuperman (Durham, 1993), 139–54; and *"Loin de Moscou, ou les trois utopies de Vasili Ajaïev,"* *Le Gré des langues* (Paris) 5 (1993): 116–40.

45 See, for example, the reader responses to *Virgin Soil Upturned* in "Knizhnoe obozrenie," *Novyi mir,* No. 9 (1934): 197.

46 Vera S. Dunham, *In Stalin's Time: Middleclass Values in Soviet Fiction.* Enlarged and updated ed. (Durham, 1990) [1976]).

47 Dobrenko, ed., *Izbavlenie ot mirazhei.*

48 Iurii Andreev, "Rezonans zemli i neba: Tezisy o sotsrealizme i vechnoi evoliutsii iskusstva," in Dobrenko, ed., *Izbavlenie ot mirazhei,* 381–401.

49 Galina Belaia, "Ugrozhaiushchaia real'nost'," in Dobrenko, ed., *Izbavlenie ot mirazhei,* 28–48.

50 Valerii Tiupa, "Al'ternativnyi realizm," in Dobrenko, ed., *Izbavlenie ot mirazhei,* 345–72.

51 Boris Groys, *The Total Art of Stalinism: Avant-Garde, Aesthetic Dictatorship, and Beyond,* trans. Charles Rougle (Princeton, 1992), 115; his emphases.

52 Ibid., 8–9.

53 Ibid., 114–15.

54 Fredric Jameson, *Postmodernism, or, The Cultural Logic of Late Capitalism* (Durham, 1991), 4; Boris Grois, *Utopiia i obmen* (Utopia and Exchange) (Moscow, 1993), 328.

Katerina Clark

SOCIALIST REALISM *WITH* SHORES

The Conventions for the Positive Hero

One of the problems in the study of socialist realism has been that, since it was the received literary tradition of the Soviet Union during its heroic period, it has been compared with modern highbrow literature. Such comparisons miss the point that socialist realism is not to any marked degree performing an aesthetic function.

In order to understand the function of socialist realism we have to go back to Hegel's insight (in *The Phenomenology of the Spirit* and elsewhere) that particular stages of cultural development produce particular cultural forms. Most of us are familiar with this position from its most sophisticated articulation in Erich Auerbach's *Mimesis,* where Greek agricultural, preliterate society produces the Homeric epic and then growing degrees of complexity in the society itself that result in the Greek novel. Actually, the case of socialist realism demonstrates that any stadial development of culture is not necessarily uni-directional or teleological. Although the "novel" was the backbone of the socialist realist tradition (almost all the canonical examples are novels or novellas), it was not really a novel in the modern sense or even in the ways that Auerbach foregrounded in his discussion of the Greek novel.

After the term "socialist realism" was coined in 1932 and declared *the* "method" for Soviet literature, the tradition that quickly emerged used forms that are only apparently literary in the same sense as other received forms of modern-day literature. Rather, socialist realism represents something of a return (with differences, of course) to an earlier stage in literary evolution, the age of parable. Essentially, the socialist realist "novel" is grounded in something comparable to the medieval worldview. In the case of much medieval literature, this entailed a horizontal dimension in which a Manichaean struggle between the forces of good and of evil was closely tied to a vertical, scripturally inspired dimension, producing a constant interaction between supernatural and natural forces, with events unfolding in historical time presented as instantiations of those greater events described in Scripture. In socialist realist literature, the corresponding text

guiding the vertical dimension is the Marxist–Leninist (and, during the Stalin period, -Stalinist) account of history—what will be represented here as History.

The essential structure of the socialist realist novel is parabolic (a form far from exhausted, of course, by its medieval Christian examples). The point is that it *is* a structure, something difficult to fully credit in an age of poststructuralism; not to do so, however, is to fail to perceive the historical function of this structure, the function of the Soviet novel within its society. A parable requires a recurring structure that can be read off for different historical meanings. This constant interplay between the synchronic and the diachronic was an important feature of socialist realism because, in that highly ritualized, intensely citational Stalinist society, changes in meaning were reflected in the slightest changes in the ritual forms, so not to know the forms is to run the risk of riding roughshod over meanings. At the same time, however, socialist realist novels were *imperfectly* realized parables; Hegel and Auerbach were right in the sense that in the novelistic age a return to earlier genres could never be achieved absolutely. The socialist realist novel was a hybrid form, but its most defining feature was nevertheless its overall parabolic structure.

One aspect of parable that is particularly significant in understanding the socialist realist variant is its rhetorical component. The socialist realist novel is rhetorical in two senses: first, in its advocative function, but second, and perhaps more importantly for our purposes, in its tropological dimension. The enormous complexity of universal history is distilled in socialist realism as a normative progression from dark to light. The fact that the structure of the socialist realist novel tropes this movement of the whole in the progress of an individual character—*the* "positive hero"— makes it structurally analogous to medieval hagiography.

One of the problems common to studies of the positive hero is their assumption that he or she is a character with a relatively static identity in the novel. In fact, however, the positive hero should be viewed more dynamically, not as a character type but as a characteristic progression. Socialist realist fiction entails a completely different sense of the subject from that which obtains in most modern novels, not to mention a high degree of depersonalization in its characters. As a consequence, it appears simple, even crude and naive. Yet in some senses socialist realist characterization is actually more sophisticated and complex in that these novelists were not working with a naive model of the absolute subject; character

depiction was thus relational and entailed negotiation rather than a stable identity.

In *The Soviet Novel: History as Ritual*, I analyzed the parabolic plot structure of the socialist realist novel. Here, I am concentrating, rather, on the most formalistic, technical aspect of this synechdochal form, the relation of the small elements, the clichés used for depicting the positive hero (epithets, gestures, and other conventions) which stitch the horizontal dimension of a novel to the vertical.

The Soviet socialist realist novel was, de facto, expected to provide a parable showing how the forces of "spontaneity" and "consciousness" work themselves out in history. This was the fundamental dialectic in the Leninist appropriation of Marxism, with spontaneity standing for those forces, groups, or individuals which as yet are not sufficiently enlightened politically and might act in an undisciplined or uncoordinated way, be willful or self-centered, and with consciousness standing for those who act from complete political awareness, in a disciplined manner and, in all probability, following Party policy or directives.

The political parable of the socialist realist novel was also patterned by the basic myth of Stalinist political culture, in which the working out of this dialectic accorded with the myth of the "Great Family." This myth described Soviet society and history in terms of an ongoing hierarchy of "fathers," or highly "conscious" members of the vanguard, and "sons," or highly "spontaneous" positive figures who were nurtured to political consciousness by the "fathers." The myth confirmed symbolically both the purity of the line of succession from Lenin, the original "father," and the assured progress toward Communism, or universal "consciousness."

In this way, history's vast, transpersonal forces were personalized. Although the Marxist–Leninist categories of *spontaneity* and *consciousness* are political, in the Soviet novel's working out of the myth of the Great Family, their dialectic is resolved largely at the level of character. Earlier revolutionary fiction had often shown familial-like relationships between individual revolutionaries or had even made them members of the same biological family. Also, its heroes had generally progressed as revolutionaries under the guidance of some mentor figure. But Stalinist political culture had systematized and (generally) depersonalized such patterns, with all positive heroes represented as either sons or their more "conscious" fathers (their moral/political mentors). Who was assigned which role in a

given novel generally bore no relation to his/her biological ties, but was determined by her—or most often, his—position within that Great Family which was the Soviet state or the Bolshevik Party.

The Great Family, the central, organizing myth of Stalinist political culture, gives the socialist realist novel its backbone, or overarching structure. At the center of all conventional Stalinist novels will be found the saga of an individual's struggle for self-mastery, a struggle which stands in for society's own reaching out toward self-realization in a state of consciousness. As in much traditional myth, the individual (or son) is assisted in his struggle by a father figure who helps him win through in his quest, to combat the "spontaneous" forces (e.g., passions, enemies, or self-centered bureaucrats) that assail him from within and without. However, the dialectic of passion and reason that in earlier Russian revolutionary novels was played out in terms of divided selves has in socialist realism (per se, as it were) been transformed into an impersonal dialectic (between spontaneity and consciousness) in which "characters" are merely symbolic media.

Thus the positive hero, or son figure, is the most burdened character of a Stalinist novel. In the account of his life, past, present, and future must be illumined, the forward movement of History proclaimed, and the legitimacy of the status quo endorsed. His mentor figure is also important, since he functions as a role model for the son. This is no doubt why these positive heroes have been the focus of so much criticism on the Soviet novel. Many critics confined their reviews to a discussion of whether such heroes showed the correct attributes and acted correctly; in effect, they would compare the particular positive heroes of the book they were reviewing with the conventions for the myth of fathers and sons.

The situation that came to characterize full-blown socialist realism did not arise overnight. There was a progressive evolution from the more depictive and symbolic modes of characterization in Russian revolutionary fiction of the late nineteenth and early twentieth centuries to the highly conventionalized and even ritualized patterns of socialist realism itself.

During the 1930s, the language of Soviet rhetoric became more sloganistic and no longer sought to convey real information; the language of fiction became correspondingly less "realistic" and more symbolic. This development in fiction happily coincided with the dictum of Gorky and others who, in the early 1930s, devised official formulations of what the

term "socialist realism" might mean, namely, that literature should become "simpler."[1] The later, purer versions of the socialist realist novel were to their antecedents as, within the history of writing, alphabetic symbols were to hieroglyphs. More specifically, the conventions for characterization which evolved during the 1930s were more abstract, standardized, and economical than the "hieroglyphs" of earlier revolutionary fiction — like an alphabet, they comprised a standard register of cryptic, encoded signs.

Characterization in most early Bolshevik novels was mimetic and relatively individualized, like a hieroglyph. Even that symbol-ridden 1925 classic, Fyodor Gladkov's *Cement,* had its own idiosyncratic set of symbols, with a different cluster for each character and each cluster complemented by prolix passages of description and commentary. Once the term "socialist realism" was coined in 1932 and proclaimed *the* official method of Soviet literature, however, authoritative figures began to identify particular novels and particular positive heroes from existing novels as models for the kind of writing they considered socialist realist and to urge writers to follow them. As a consequence, writers began copying key features from this small pool, and socialist realism became so intensely citational that, by the mid-1930s, a single, conventionalized system of signs was already evident in virtually all novelistic depictions of positive heroes.

The main function of the alphabet-like symbols of socialist realist fiction was to indicate the moral/political identity of the characters. As a consequence, the characters were not *differentiated* by means of these signs. For such signs were not iconic motifs, as they were classically deployed in Tolstoy's prose (e.g., in *War and Peace* Elene's marble breasts, Bolkonsky's pregnant wife's quivering upper lip, and so on). On the contrary, the signs themselves suggested similarities among characters who might otherwise seem disparate. No attempt was made to capture their specificity in these signs, but rather to indicate how individual characters represented some broad, general ideological category; each symbol used to describe them had encoded within it some meaning derived from the Marxist–Leninist–Stalinist account of history, patterned in terms of the spontaneity/consciousness dialectic, while linking History's inexorable onward march (symbolically) to the Soviet status quo personified in the Lenin–Stalin succession. Hence the binary pattern of fathers and sons simultaneously served the regime's legitimizing aims and the socialist realist imperative to create parables of dialectical materialism.

A milestone in the evolution from earlier revolutionary fiction to the

socialist realist novel was Maxim Gorky's 1906 work *The Mother,* the only prerevolutionary novel to be included in the standard list of exemplars of socialist realism. The clichés of the positive hero in *The Mother* have their origins in nineteenth-century revolutionary fiction, but are more abstract, laconic, and recurrent than the conventional symbols and epithets used to depict the hero in other pre-Stalinist exemplars. They are not merely clichés, but actual elements constitutive of an "alphabet."

This "alphabet," or system of terse signs with standardized meanings, was not the only means by which Stalinist fiction indicated the moral/political qualities and symbolic roles of its heroes. But it was the most definitive. Consequently, *The Mother* provides the best reference point for looking at how earlier symbols were modified under the impact of High Stalinist culture. Gorky's novel chronicles the progress toward consciousness of a working-class lad, Pavel Vlasov, and the subsequent progress (particularly evident after Pavel's arrest) of his widowed mother. *The Mother* employs a roster of recurrent epithets to depict Pavel, as in the following representative sample of quotations that come on virtually successive pages:

[He has become] simpler [*proshche*] and gentler [*miagche*].
[His mother thinks to herself:] My, he's stern [*strog*].
[Pavel explains his beliefs to her] He started talking sternly [*strogo*]; for some reason . . . he looked at her and answered softly and calmly [*spokoino*]. . . . His eyes glowed with determination [*upryamo*].
Her son's eyes shone attractively and brightly [or "radiantly": *svetlo*].
[His] swarthy, determined [*upryamoe*], and stern [*strogoe*] face.
His calmness [*spokoistvie*], his gentle [*myagkii*] voice and simplicity [or "openness": *prostota*] gladdened the mother's heart.
He said seriously [*serëzno*].[2]

These epithets are used recurrently in *The Mother* to indicate Pavel's positivity and consciousness: "determined" (*upryamyi*), "serious" (*serëznyi*), "stern" (*strogii*), "calm" (*spokoinyi*), "simple" (*prostoi*), "gentle" (*myagkii*), and "radiant" (*svetlyi*). Tending to cluster in two groups, one set of epithets suggests a "stern" guise ("determined," "serious," "stern"), the other a "loving" one, such as that of a loving father ("simple," "gentle," "loving"). "Calm," the primary sign of transcendence, belongs to both clusters, for, in theory, in a state of true consciousness a character's spontaneous, human aspects do not conflict with the interests of consciousness, although consciousness presupposes an extrapersonal perspective (hence "serious," etc.).

Most of these stock epithets from *The Mother* became clichés of positive heroes in Stalinist novels. This situation was fostered no doubt, by the fact that Gorky, as First Secretary of the Writers Union (founded in 1932, when socialist realism was also instituted), was an extremely powerful figure in the 1930s, although whether the precise list used by Gorky was deliberately co-opted for socialist realism is difficult to ascertain since these epithets were also widely used in other revolutionary fiction. The interest here, however, is not so much in the *same* as in the *different:* If Stalinist scribes imitated the prescribed models, what changed?

One of the important differences was that in socialist realism the quasi-familial roles assumed by the positive hero and his mentor (i.e., of a son and his father) were more systematized and differentiated. All of the characters, to the degree that they were positive, would impend toward one role or the other (i.e., they would be characterized in terms of the respective conventions for them). Each of these roles has two crucial aspects, one related to moral/political identity and the other to the corresponding symbolic role in the Great Family. These two aspects are not entirely separate, of course, but tend to be fused in the presentation of any given character. In other words, "son-ness" involves positive spontaneity; hence, paradoxically, a character may be depicted as somewhat childish or childlike, with this very quality operating as a sign that he has the potential to develop into an emblem of consciousness. (Generally, however, this can happen only if he has the right credentials—minimally, a proletarian background—for otherwise his spontaneity is probably of the negative type.)

In Stalinist fiction, the father's role of a "father" is not (as was the case, for instance, with the mentor figure, Pavel, in *The Mother*) given to a character who merely *happens,* due to circumstances, to be more conscious than his "son" (in the case of *The Mother,* a role assumed by Pavel's own mother in an inversion of biological seniority). The role of the father in a Stalinist novel was normally given to a member of the "vanguard," which by then generally meant some Soviet official who was also a Party member.

Thus the differences between "father" and "son" progressively came to consist of qualities other than their different degrees of consciousness. In Stalinist fiction, the father figure, as an official, must wear the austere cloak of responsibility which requires very circumspect behavior. He is also rarely shown to be subject to sexual desire; as Freud established in *Group Psychology and the Analysis of the Ego,* the pattern with charismatic leaders is that while they generally are sexually attractive to their followers, they are themselves sexually aloof. Hence, although Stalinist "family values" gen-

erally required the leader figure to be married with children (especially in novels of the 1940s), to a marked degree this figure would be shown (tragically) separated from his family for the span of the novel or his family would be rarely visible, if at all.

Essentially, the father figure must exude transcendence and hence is rarely seen in action. As a consequence, certain epithets indicative of prowess in action, which marked all positive heroes in earlier fiction, such as "brave," "daring," "tenacious," and "determined" (*smelyi, derzkii, upornyi, upryamyi*)—the latter found, for example, in the characterization of Pavel in *The Mother*—were no longer as appropriate for a mentor or father figure. The son, however, must overcome obstacles in order to *progress* during the course of the novel and must, therefore, have precisely those virtues which indicate prowess in action. The previous standard catalogue of epithets for a positive hero was consequently more or less divided up, with those indicative of high spirits and bravery going to the son as signs of "son-ness," while the remainder were used to signify the father's consciousness. Indeed, the son qua son became more childlike and impulsive than his antecedent in pre-Stalinist fiction, the "disciple." Thus rather than "brave," the son was often positively hotheaded.

The means of portraying a father is likewise different from those by which a son is depicted. Since the father must symbolize consciousness incarnate—that state which would be attained at the end of the hero's quest —whereas the son must progress toward that state and therefore undergo a progressive change, the father figure would be portrayed in a much more iconlike, formulaic, and standardized way (somewhat like the positive heroes of *The Mother*), while the son would not be rendered as a static emblem of virtue, but rather as quintessentially exuding energy, exuberance, and dynamism (somewhat like Gleb, the protagonist of Gladkov's *Cement*, the most seminal novel from the 1920s in the socialist realism tradition). As a consequence, most of the "alphabet" signs to be found in the conventional socialist realist novel are used for father figures and are applied to the sons only in proportion to their progressive attainment of "consciousness." Most of the conventions associated with the son are essentially functions of the plot and related to action. There are, as I have indicated, some conventional epithet markers of son-ness, such as "daring" and "tenacious," but in general the signs for son-ness are less economically and rigidly codified. Thus, although the father figure appears less often in the text than does the son, the depiction of him is more highly conventionalized.

One can get a good sense of this by comparing the patterns Gorky used in depicting positive heroes in *The Mother* with those used for positive authority heroes in two classics of socialist realism, Nikolai Ostrovsky's *How the Steel Was Tempered* of 1932–34, and Alexander Fadeev's *The Young Guard* of the 1940s. (We will be looking at the revised 1951 version here.)

How the Steel Was Tempered chronicles the political maturation of that most famous of all Soviet positive heroes, Pavel Korchagin. It covers a broad time span, beginning just before the 1905 Revolution, when Pavel is in his early teens, and closing in the late 1920s, when illness threatens to end Pavel's career as an established Party functionary. The intervening sections take the reader through Pavel's revolutionary conversion, the 1917 Revolution, his joining the Party, and the Civil War, in which he fights with the Red Army.

In the course of Pavel's somewhat peripatetic career as a professional revolutionary, he encounters a whole series of mentor figures. The first of these is the Bolshevik sailor Zhukhrai, whom he initially encounters in childhood (when Zhukhrai, a political outlaw, is fleeing the police) and then much later, during the Civil War, when Pavel is a military and Party administrator and Zhukhrai works for the Cheka (secret police). The following selection of quotations are from successive meetings between Pavel and Zhukhrai (with the original Russian versions of the "alphabet" of signs again in brackets).

Initial encounter:
Pavka encountered grey, calm [*spokoinye*] eyes which studied him intently [*vnimatelno*]. Their firm [*tverdyi*], unflinching gaze he found somewhat unsettling.
Sometime later:
Zhukhrai spoke vividly, concisely, and in a language which was simple [*prostym*] and readily understood. He knew his own path in life exactly, and Pavel began to understand.
Later, during the Civil War:
Zhukhrai had a body of iron [*zheleznaia*], cold and calm [*spokoinaia*], and a voice that was taut and brooked no objections.
Later in the Civil War, when Zhukhrai supervises a voluntary mass-labor project:
Zhukhrai's eyes looked at the trench diggers with exhilaration and stern love [*surovaia-liubovnaia*].[3]

As is typical of socialist realist character depiction, Ostrovsky here not only uses conventionally coded epithets to convey Zhukhrai's moral/political

identity, but also occasionally describes a given quality fairly explicitly (as with "He knew his own path in life" for "conscious") or through a metaphoric use of physical traits (such as "a body of iron" for an iron will). Among the actual epithets employed by Ostrovsky in these passages, the reader will recognize some from *The Mother* ("calm" and "serious") plus synonyms for "stern" ("firm" [*tverdyi*] and "severe" [*surovyi*]). There are, however, some epithets and traits in the passages above which are not found in *The Mother*, but which are nevertheless typical of the father figure in Stalinist fiction. These reflect changing values and illustrate three important factors that contributed to the way in which the conventions for depicting the hero in Gorky's novel were modified in full-blown socialist realism.

The first of these is the de facto stipulation that any truly positive authority figure be pressed into the "Leninist" or "Stalinist" mold. In *How the Steel Was Tempered*, Ostrovsky made his father figure a leader in the Leninist tradition. The primary source for definitively Leninist traits was Stalin's 1924 obituary for Lenin, and Ostrovsky slotted into his account of Zhukhrai the two most commonly invoked Leninist traits from that obituary: Zhukhrai has contact with what Stalin called the "simple and ordinary masses" and can show his "paternal" care by "carrying on . . . a most ordinary conversation with the most ordinary [people]," listening "patiently to everyone's tales about their everyday life"; and Zhukhrai's utterances are marked by "the simplicity and clarity of the argument, the brief and easily understood sentences, the absence of affectation."[4] ("Zhukhrai spoke vividly, concisely, and in a language which was simple and readily understood.") These conventions did not of course originate with the Stalin obituary, but they became specifically Leninist from then on.

At the same time that the Stalinist version of the positive hero was becoming more avuncular (Leninist) than his predecessors in fiction, he was also being represented as *tougher*—an effect, perhaps, of the purge period when the conventions of High Stalinism were set. In the 1930s (and, to a lesser extent, the 1920s), the conventions for the positive hero were reinflected to suggest that extra degree of toughness and "vigilance" demanded by the new historical moment, a shift that is discernible in each of the passages from Ostrovsky's novel quoted above. For instance, whereas the gaze of Pavel Vlasov in *The Mother* is "determined" (*upryamyi*), Zhukhrai's is "unflinching." To some extent, new epithets (such as "vigilant" [*bditelnyi*]) were added, while among those from the original register some were now used more frequently and others less; even when the *same* epithet was used as in earlier fiction, it acquired a different coloration. This

can be sensed in the first quotation from Ostrovsky above, where the epithet "intently" (*vnimatelno*) is applied to Zhukhrai's gaze: "intent[ly]," a stock epithet of all Stalinist fiction, not only connotes the relatively innocent, Leninist meaning of listening attentively to others, but also implies the extreme wariness of the vigilant revolutionary.

The centrality of "vigilance" in High Stalinist culture caused a reordering of emphases in the "alphabet" of signs it had inherited from Bolshevik rhetoric. "Stern" became so crucial an epithet that a selection of conventional substitutes had to be found. This practice can be seen in the following quotation from *How the Steel Was Tempered*, in which another of Pavel's mentors, Lysitsin, the secretary of the Executive Committee (*Ispolkom*) of a border town, is depicted: "He was a big, strong man, severe [*surovyi*] and at times awsome [*groznyi*]. . . . He had a strong body, his huge head was set on big shoulders, and he had cold, penetrating [*s kholodkom pronitsatel-nye*] hazel eyes."[5] Here, not only are two near synonyms used to convey Lysitsin's "sternness," but an even "sterner" substitute has been added for the conventional rendering of the eyes of the truly "vigilant" leader (i.e., instead of an "intent" gaze, we have "cold, penetrating" eyes—actually a staple of Russian Romantic fiction for characterizing the man of exceptional "will"[6]).

It should be noted that Ostrovsky also gives Lysitsin (and Zhukhrai) great physical strength. This was not a convention for Stalinist positive heroes, but rather one of the variables. Although most of the earlier heroes of Russian revolutionary fiction had been fine physical specimens (e.g., Pavel of *The Mother*), that trait was not a convention of Stalinist hagiography. Stalin himself was, of course, on the short side. Moreover, in his obituary for Lenin he remarked on how amazingly "ordinary looking" Lenin was: "below average height, in no way, literally no way, distinguishable from ordinary mortals."[7] In Stalinist fiction, as in rhetoric about the Stakhanovites (production heroes), the formula "ordinary looking man/extraordinary deeds" was most often (but not invariably) used to depict the positive hero.

Thus, in general, the father figures of *How the Steel Was Tempered* seem to anticipate the patterns of High Stalinism, which is perhaps why Ostrovsky's novel was singled out for high honors in late 1935, more or less at the same time as the Stakhanovite movement was launched. It provided a ready-made exemplar for writers endeavoring to translate the new ideals into fiction.

The "alphabet" of signs is used even more heavily in Fadeev's novel

The Young Guard. This is partly because the main criticism leveled at the novel's first version, and the one which most impelled him to rewrite it, was that Fadeev had not shown the leading role of the Party in his story of a Komsomol resistance organization active during the German wartime occupation of Krasnodon, a coal-mining town in the Donbass. The canonical, 1951 novel has an unusually large number of positive characters— about sixty or so members of this Young Guard organization ("sons") and about ten senior Party, army, or partisan officers ("fathers"). Despite this potentially confusing profusion, the revised novel manages perfectly well to differentiate between the *exemplary* sons and fathers and the many more routine heroes. This is because, even though this revised version of *The Young Guard* is among the best-written and most readable of all the socialist realist exemplars, Fadeev has used the alphabet of conventions here for indicating positive heroes with almost monotonous regularity.

Consequently, this novel provides the best example of textbook variations on the positive hero conventions. It is a purer, sparer version of socialist realism than *How the Steel Was Tempered.* Although both novels modulate among fairly explicit descriptions of their heroes' moral/political qualities, "hieroglyph" (symbolic description), and "alphabet" (terse, formulaic signs), Fadeev's characterization is markedly more austere and abstract than Ostrovsky's, less tied to physical characteristics and more standardized. In *The Young Guard* one can see the tradition more or less fully evolved.

This greater symbolization is apparent, for example, in the eighth chapter of the novel, the first chapter in which several positive authority figures are present for the first time. Meeting in response to the German invasion to organize the underground, this group includes Ivan Fedorovich Protsenko (a partisan commander), Matvei Shulga, and Lyutikov (who will assume the role of principal father figure to the novel's exemplary son). The most striking feature of this chapter is the austerity of the narration. Lyutikov and Shulga are being introduced into the plot here, and yet very little material is provided on the participants other than sketchy summaries of their respective careers; this is particularly striking in the ensuing conversation where, other than the dialogue itself, the reader is given little more than what might be called minimal stage directions (such as "[X] said"). None of the devices of narration which Western authors usually use to interest readers (such as language with flair, a colorful or enigmatic character, or suspense) is used in this case. The following excerpts represent the only noteworthy examples of narration in three pages:

In the whole town of Krasnodon, there were none as calm [*spokoinye*] as these three. Lyutikov said without a smile.

His eyes, stern [*strogie*] and intent [*vnimatelnye*], with that expression of sagacity common to people who take nothing on trust but think of everything themselves, were fixed firmly on Protsenko.
Lyutikov looked at him sternly [*strogo*].
Lyutikov smiled for the first time since the conversation had begun [when referring to the peasant woman who is to hide him], and his heavy, drooping face was brightened by a smile.
Shulga replied slowly, and fixed his calm [*spokoinye*] eyes on Protsenko.[8]

One is struck by how much more august and severe Fadeev's father figures are by comparison with their counterparts in Gorky's novel. The grimness of Lyutikov is relieved somewhat, however, when he smiles, but this smile is no random gesture on Lyutikov's part. Fadeev has given him two masks, one of stern and unsmiling mien, and an alternative mask of a smiling — even laughing — figure. Lyutikov, as *the* father figure in the novel, must bear the "burden of paternity" and hence appear predominantly in the guise of the stern statesman and unflinching emblem of consciousness, but periodically, when his humanity, optimism, and love of life shine through, he suddenly breaks into a smile.[9]

For the exemplary sons in *The Young Guard*, the order of the masks (i.e., predominantly unsmiling, but occasionally smiling) is reversed. The sons, zesty, spirited creatures that they are, are forever laughing and smiling. However, they periodically grow serious and don the mask of severity.[10] Moreover, a marker of their gradual progress toward consciousness is their increasing assumption of a serious mien.

This smiling/unsmiling (or vice versa) alternation was a pattern commonly used in depicting positive heroes in Stalinist fiction. A canonical source for it was Gorky's 1924 tribute to Lenin, in which he emphasized Lenin's proclivity for oscillating between joviality and seriousness.[11] The function of this pattern went beyond mere affirmation of the father figure's "Leninist" bent, for it provided an efficient way of dramatizing those two alternative guises (stern/loving) of any icon of consciousness which have been a feature of Bolshevik fiction since at least *The Mother*. But the pattern's significance does not end here. In fact, the set image for the prince in medieval Russian chronicles involved a similar dichotomy (awesome [*groznyi/laskovyi*]). If we are to accept Michael Cherniavsky's argument in *Tsar and People*, this dualistic public image of the medieval prince evolved

until, by the modern period, there were two, contrary canonical images of the czar: one a caring, father figure (*tsar-batyushka*), the other an austere statesman (*gosudar-imperator*).[12]

The image of the positive authority figure in Stalinist fiction reflects this traditional dualism, as demonstrated quite dramatically by the last quotation above from *How the Steel Was Tempered*. Zhukhrai looks at the toiling earth diggers before him with *both* love *and* sternness, an expression that is rendered, alphabet-like, solely by the incongruous double adjective "severe-loving" (*surovaya-liubovnaya*). Thus, in terms of etiology and function, the conventionalized formulas for the father figure represent a conflation of those used for the medieval prince (or his successor, the czarist statesman and leader) and those that incarnate Bolshevik virtue. It was a cliché of Stalinist fiction that the hero be "loving." This quality was generally conveyed by *laskov*, an epithet which has stood over the ages for care and concern in, first, the medieval prince,[13] then the czar, later the revolutionary hero, and finally the Bolshevik leader. In some instances, however, the mentor's "loving care" is represented more explicitly: he is often said to love children and women, who are drawn to him instinctively, or to make people feel so relaxed in his company that they suddenly find themselves laughing.[14]

That the Stalinist heroes laugh or smile is in itself hardly remarkable, of course. What is significant is that laughing and smiling by positive heroes was emphasized in Stalinist novels to the point where these gestures became key conventions. Moreover, with this emphasis, the degree to which the father figure is "loving" and life-affirming has in effect been extended into gaiety, as it were, to counterbalance a corresponding extension of severity in the alternative mask of the father figure. "Laughter" counterbalanced the emphasis on "vigilance," *the* catch phrase of the 1930s purge period (but also prominent during the Civil War). "Laughter" also provided a convenient replacement for such earlier clichés indicating the hero's humanity as "gentle" which were now considered too effete for the hardened revolutionary. However, there was also a hierarchy in the two masks for the authority figure; he typically wore his "smiling" mask in less highly ritualized scenes,[15] and, when depicting him in this guise, the narrator was more likely to use straight description rather than the coded epithets more often employed for his august guise.

"Vigilance" was sometimes represented explicitly, as in the quotations above: "people who take nothing on trust but think of everything themselves." It also had its own "alphabet" term, "merciless" (*besposhchadnyi*),

one of the few additions (other than synonyms) which Stalinist fiction made to the very small register of epithets it adopted from *The Mother* and radical lore. "Merciless" was often presented very tersely and cryptically (e.g., by using the short form of the adjective), and thereby all the more emphatically. This can be seen in a later section of *The Young Guard* where the narrator waxes quite lyrical for several pages as he describes how popular Lyutikov is, establishing his "loving-caring" identity: the young love him, people like to confide in him, he is a good listener, gives good advice, and so on. Suddenly, the narration, in which long-form adjectives have been used almost exclusively, is drawn up short with the following portrait in contrasts that culminates with a string of short-form adjectives: "Despite all this he was in no way what might be called a kind [*dobrym*] man, much less a gentle [*miagkim*] person. He was unswervable [*nepodkupen*], stern [*strog*], and, if necessary, merciless [*besposhchaden*]." [16] The information in the last sentence is encoded, but is all the more powerful for that.

Thus in Stalinist novels the basic system of signs for representing iconic "consciousness" in an authority figure was a modified version of the one used by Gorky for revolutionaries in *The Mother.* The Stalinist system retained the pattern which was a convention of revolutionary lore for the spread of consciousness—through a "mentor" and a "disciple"—but extended the parameters of their traditional roles so that the figure corresponding to the traditional mentor (the father) became more august, while the counterpart of the disciple (the son) would often be more "hotheaded." Additionally, the Stalinist system retained the traditional Russian dualistic image of the leader (stern/loving), but likewise extended both of its poles to include those High Stalinist institutions of "vigilance" and "gaiety" ("Life Has Become Better," the slogan ran, "It Has Become Gayer"). In short, the Stalinist system took the earlier patterns of contrast to an extreme.

The Stalinist novel is so formulaic that it bears comparison with other kinds of formulaic writing (folktales, detective stories, romances) which have character "functions." For example, as Vladimir Propp said of the Russian folktale in his *Morphology of the Folktale,* the Stalinist novel has a small number of "functions" (or formulaic actions that have become generalized relative to its "extremely large" number of "personages." In the folktale, Propp maintained, the variety of personages is somewhat deceptive because it obscures the fact that many of them perform the same functions. "Functions of characters serve as stable, constant elements in a

tale, independent of how and by whom they are fulfilled." [17] As a corollary, "functions" are transferable, that is, different personages may perform the same actions or assume the same roles fairly interchangeably.

Since a large number of positive characters may perform more or less the same role in Stalinist novels (as we saw from *The Young Guard* quotations in the case of Shulga, Protsenko, and Lyutikov), the tradition bears comparison with that of the folktale, though the two have different ideological underpinnings. However, even without going into the dimension of meaning, there are important *formal* differences between the morphological systems of these two traditions. For example, in the Soviet socialist realist novel, characters (or "personages") are History's puppets, hence there is much less scope for arbitrary transfers of function. In fact the "color" of the personage who performs a particular function is often of great importance because it indicates his political orientation or sociological category. Furthermore, in terms of the positive characters at any rate, the number of available roles to be played by the assorted "personages" of any novel is much more radically limited than in the case of the folktale, for there are basically only two positive roles, father and son. Moreover, this difference is not merely quantitative but, as it were, qualitative: all positive characters qua positive characters must be caught up in History's *single* onward path, so what is sought in them is not variety or diversity but, on the contrary, likeness.

The Stalinist author does not strive to create a memorable character, an individual, but rather someone who largely fits preordained patterns. In this respect, his aims are unlike those of both writers of formulaic fiction and novelists writing in the mainstream tradition of the European novel in its heyday, the nineteenth century. The differences can be sensed even in the names: whereas nineteenth-century heroes often had striking names (e.g., Raskolnikov, Kostanzhonglo, etc.), the Soviet hero who plays a son is most often represented by a common first name (e.g., Pavel or Oleg, sometimes with a last name) or even a nickname, while his father–mentor is referred to by a common first name plus patronymic (e.g., Pavel Ivanovich) and/or by an ordinary last name (e.g., Voronov). In effect, the Soviet hero is not individually marked; only his relative seniority is indicated (because the most formal and deferential way of naming someone in Russian is by use of the first name and patronymic).

It seems, then, that by comparison with most other varieties of formulaic writing socialist realism is unspeakably duller. It is *more* formulaic, *less* colorful, and has an extremely small range of positive hero roles (two!).

Some variety is introduced into their depiction because the narrator can modulate among "alphabet" (cryptic, encoded sign), "hieroglyph" (physical symbols such as the gaze of the eyes) and explicit description of the protagonist's moral/political virtues. Clearly, this variety is limited, however, and thus the novelist runs the risk of endowing any novel in which he uses this system with a terrible sameness and monotony—especially since the same register of "signs" is used from page to page and from book to book. The reader will cry out for some of the color of Baba Jaga or James Bond.

For the faithful scribe in the socialist realist tradition the danger of monotony is not as great as it might seem, however. For a start, the positive protagonists can be presented as *both* character functions (i.e., personages whose identities and actions are predetermined by their roles) *and* characters. While for much of the novel they may don the mask(s) of their role (i.e., be depicted by the standard register of epithets), this is mandatory in only a few crucial scenes (especially encounters between a "father" and his "son"). Throughout the rest of the novel, there is always the possibility that a given character will lay his mask aside for a moment and assume more human, individualized dimensions. Indeed, the ratio of totally formulaic character description to individualized characterization is one of the variables of the socialist realist novel.

The socialist realist author could even introduce characters who have no ritual role whatsoever, positive or negative. Such characters can therefore be as colorful and even idiosyncratic as he can paint them. They can provide diversion from the ritual of maturation that structures the novel's plot, somewhat as Shakespeare and others used comic characters in their tragedies. A good example of this in socialist realist fiction would be the lovable old buffoon, Ded Shchukar, in Mikhail Sholokhov's *Virgin Soil Upturned* (1931–60).

Additionally, it is, in effect, the task of the positive hero (or main protagonist) to provide some variety and suspense that will counteract the sameness of his mentor. The main protagonist does not appear iconlike until the novel's end. Indeed, as a "son," he is virtually expected to be perverse, headstrong, or willful on occasion; his escapades and feats can provide the novel with color and excitement. However, they are ultimately not self-valuable but variants on standard representations of the struggle for self-mastery against willful, "spontaneous" forces.

In socialist realism, then, the kind of deindividuation that Propp identified with the folktale has been taken to an extreme. There is even a sense in which the positive hero, when depicted as a function of his ritual role,

has no intrinsic self at all. If he does have one, it is merely an embellishment which could be cut out without seriously affecting the overarching plot. Once stripped of his human self-boundaries, the positive hero appears to be nothing more than a node of motifs, epithets, and symbolic gestures—terse words and phrases, or what I call "particles"—which accrue to his self-boundary and are repeatedly invoked when he appears. All the rest—whatever has been stripped away—largely consists of inconsequential individualizing markers, such as blue eyes and blonde hair or dark eyes and black hair, height, build, and so forth. The "particles" (epithets, etc.) are themselves no more than words and gestures which stand for abstract qualities (e.g., to look intently at someone signals both that one is a leader in the Leninist tradition and that one exemplifies vigilance). Consequently, such "particles" need not adhere to any self-boundary (or particular character's "node" of attributes) exclusively but can be attributed to another character, either consecutively or simultaneously (as in the excerpts from *The Young Guard,* where three authority figures appearing together in one scene are marked with pretty much the same attributes). A given node (for a particular character) can be altered by the mere addition or subtraction of an epithet from the standard register or by changing a given epithet's prominence within the node itself (by repetition or emphasis). These slight alterations can change the moral/political identity of the node, and therefore of the character in question. In fact, a character's moral/political identity is more likely to be changed radically by altering the node (such as by omitting one epithet) than by any action that he or she may perform: the ritual role is paramount in the socialist realist novel and is indicated by these signs.

The entire node of epithets that makes up a particular character is not, of course, usually presented in toto on any one page. Rather, these epithets will be introduced selectively (on any one page) and gradually, with a node thus being subject to some very fine tuning. The epithets can be deployed to lend subtlety and gradation to comparable characters, who could not be compared on the basis of the "gross" character distinctions typical of formulaic writing. While socialist realism may lack any Baba Jagas or other colorful personages, even on its shoestring budget of positive personages (two, with variations) its characterization can still achieve variety.

The stock epithets for the Stalinist positive hero indicate not only his consciousness but also his role in the Great Family, as can be sensed in the

passages quoted from *The Young Guard.* While some of the standard signs for consciousness are used to mark all three leader figures in this scene, one of them, Lyutikov, has more of the epithets assigned to his node than either of the others do. This is surprising since Lyutikov is not the most senior of the three Party members here, nor is he marked as being exceptional in any other way. (The capsule biography of him given upon his entrance, for instance, seems very generic.) But later in the novel it becomes clear that Lyutikov is to play the role of father to the novel's positive hero (Oleg Koshevoy); thus his status *in the novel* (as distinct from the reality depicted) is ritually indicated well before any other sign is given to suggest that. Thereafter, this technique is maintained, and in any scene where Lyutikov is shown with a Party official senior to him he is always given the lion's share of the particles standardly used to indicate consciousness.

In effect, then, different nodes or clusters of epithets represent different equations of moral/political virtue, with each equation a quantitative or qualitative measure of either spontaneity or consciousness, plus a ritual role (father or son). The degree of consciousness indicated is, however, only relative to the scale which applies in a given novel. Thus, for instance, in a novel about children the older boy who plays father to his juniors may be given the same equation as, in a different novel using a different scale, is given to an experienced Party official who is as "conscious" vis-à-vis his "son" as that older boy is relative to *his* "son."

The nodes of epithets indicate not only the static category, "role," but also the more dynamic one, political progress. Such progress in these novels is, once again, only relative to the scale of political maturity of its positive characters, but, given the parabolic nature of the socialist realist novel, it stands in for that greater progress of History itself. According to Marxism–Leninism, the end of both society in general and its individual members in particular is to attain consciousness. In theory, everyone in society stands along a hypothetical continuum which stretches from the very beginnings of man (when, according to Lenin, he was in a state of spontaneity that nevertheless contained the embryonic possibility of consciousness[18] to that ultimate state of complete consciousness. In a novel, therefore, each node (or cluster of conventional signs given a particular character) is a marker of place, although only of place within that artificially limited time and setting of the novel's microcosm. Each node signifies where a given positive character stands on the continuum relative to others in that particular microcosm. There is a wide gap between posi-

tions along the continuum where the mix of signs in a given node indicates that spontaneity predominates and where consciousness prevails, but since these are locked in a dialectical relationship, each individual node will always reflect some proportion of both qualities. Even in the ultimate state of consciousness, after all, spontaneity is to be present, no longer in conflict with consciousness but in harmony with it. Consequently, the father figure is both "stern" and "caring" not only because Russian tradition features this dualism, but also because he represents transcendent consciousness (pro tem).

Thus in socialist realist fiction the two main character functions—consciousness incarnate and spontaneity incarnate, or father and son—are not, strictly speaking, character functions, but rather represent a broad division between the places occupied on the continuum by various characters. Since the system of signs marks places on this continuum, the roles assumed by different characters in the same novel may be transferred, but preferably only between characters from the same division on the continuum: structural fathers and sons can always be found to assume the role of an absent, weakened, or deceased member of the Great Family. In other words, either of Lyutikov's two interlocutors could have been co-opted for the role of the protagonist, Oleg (ipso facto the most positive representative of consciousness in the novel), merely by adding to his node more of the formulaic epithets and gestures indicating consciousness. But, of course, any new mentor would need to assume this role for only as long as the author might care to assign it to him and hence to endow his node with the biggest share of positive "particles." In the next scene the principal mentor figure may regain his stature (or simply return), and, in order to reassign him his old role, the author need only make a few quick adjustments to the respective nodes.

In *The Young Guard* we see such a transfer of ritual role not with the mentor but with his "disciple." For the first third of the novel, before the Young Guard organization is actually formed, the role of model son is assumed by Seryozhka, a young and incredibly daring Komsomol. The ultimate son figure and Young Guard leader, Oleg Koshevoy, is at this point temporarily absent from the town as he attempts to evacuate rather than fall into German hands. He is forced to return, however, and once he reenters the novel's microcosm he supersedes Seryozhka as *the* son. Thus, in effect, Seryozhka and Oleg share one role in turn. This role transfer is motivated in a scene in which Oleg is shown to be more conscious than Seryozhka.[19]

Such "quick changes" are not plausible with role reversals between father and son, however, and the conventions of the socialist realist novel have assured that this rarely occurs.[20] That is, *A* (a father) and *B* (a son) do not suddenly reverse roles—or at least not until the son has attained full consciousness, which usually occurs only at the novel's culmination. A son does sometimes assume the role of a father, but only vis-à-vis someone who is not *his* father—someone *less* conscious than himself. Similarly, a father figure may assume the role of a son vis-à-vis someone who is *more* conscious than himself. In effect, then, although the basic pattern for positive heroes is a binary one, inasmuch as all positive protagonists must be positioned at different points along the (hypothetical) continuum stretching from a state of pure spontaneity to one of pure consciousness, each positive hero can potentially play father to any less conscious character and son to any more conscious one.[21] In practice, however, most novels single out *one* exemplary authority figure as *the* father and one other figure to act as his son—*the* positive hero (or central character) of the novel. This hero should ideally represent the upper reaches of spontaneity as it approaches transcendent consciousness (transcendent, that is, relative to the scale of the given novel).

According to the general understanding of Marxism–Leninism, which assumes that there will be progress in humankind, especially in a post-revolutionary situation, an individual is not meant to occupy a static position on the continuum stretching from unchecked spontaneity to full consciousness, but to progress toward and through ever greater degrees of consciousness. Thus every positive character other than the mentor figure (who is an icon) will, in effect, advance along the continuum during the course of the novel, and his advance will be marked by the addition to his node of more "particles" indicating consciousness or of increasingly frequent appearances by one such particle. All characters who are positive will ipso facto have some measure of consciousness and the potential to acquire more. Thus the main difference among positive characters is, on the one hand, the various places on the continuum they occupy at the outset and, on the other, the distance they will cover along it during the course of the novel.

Since the socialist realist novel is a political parable and History is its underlying hero, plot takes priority over character. Consequently, even though the novel is about moral/political virtue, it is no less crucial that the protagonists assume their correct functions within the plot than that they appear to be emblematic of particular virtues. Thus, for instance,

fatherhood, which had previously been a symbolic quality, ultimately became a value in its own right.

Eventually, the roles of father and son became more mandatory features of socialist realist fiction than the signs of a hero's moral/political identity, which were then subsumed under these respective roles (i.e., the one who assumes the role of the father had to be conscious). Thus it was no longer necessary that a given positive hero's moral/political identity be made explicit as long as his ritual role was indicated.[22] In *The Young Guard,* for example, for all the most elevated scenes involving Oleg and Lyutikov, the narrator uses "the youth" and "the old man," respectively, to refer to them, rather than their actual names. In socialist realist fiction the "fiery youth" and the experienced old man became symbolic representations of spontaneity and consciousness, respectively. Over time, the positive heroes were more often contrasted as "old" and "young" not merely because the older one was more experienced or more senior in the hierarchy. By then, these roles derived not from actual age, experience, or status (although there was usually some correspondence), but from the Marxist–Leninist mythologizing of history which guided the plots of all socialist realist novels.

For most characters, the changes over the course of a novel in their nodes (as indices of their degree of spontaneity or of consciousness) are largely quantitative and consist in the gradual accretion of more and more "particles" indicating "consciousness." In general, however, spontaneous positive characters other than the chosen son do not attain such a degree of "consciousness" that they achieve the status of one who embodies it. The hero's progress, however, is ultimately *qualitative* rather than quantitative because it culminates in a great leap forward. This leap represents the climax in the ritual resolution of the spontaneity/consciousness dialectic. Since the leap cannot occur in "reality," however, it is not motivated logically but only ritually.

Thus the plot of the Soviet socialist realist novel is essentially a motivating structure which has as its end the kairotic moment of passage to consciousness. This represents an incredible condensation of the Marxist–Leninist account of history into a parable about an individual life which stands for broad movements over centuries. But just as the one (the positive hero) stands in for the many who exemplify spontaneity, so is consciousness normally represented by only one character function, the hero's father figure or mentor, who enables him to make that breathtaking leap.

Notes

This article represents an enlarged and reworked version of a chapter I left out of my book, *The Soviet Novel: History as Ritual* (Chicago 1985 [1981]), when required to shorten it.

1 See, for example, "Doklad A. M. Gor'kogo o sovetskoi literature" (Talk by A. M. Gorky on Soviet Literature), in *Pervyi s'ezd pisatelei. Stenograficheskii otchet* (First Writers Congress: Stenographic account) (Moscow, 1934), 14.

2 M. Gor'kii, *Mat'*, in *Sobranie sochinenii v tridtsati tomakh* (Collected Works in Thirty Volumes) (Moscow, 1950 [1906]), 7: 202–4, 206, 209.

3 Nikolai Ostrovskii, *Kak zakalialas' stal'*, 39th ed. (Moscow, 1936 [1932–34]), 32, 35, 83, 180, 230.

4 J. V. Stalin, "On the Death of Lenin" (speech delivered to the Second All-Union Congress of Soviets, 26 January 1924), in *Works* (Moscow, 1953), 6: 56–57.

5 Ostrovskii, *Kak zakalialas' stal'*, 289.

6 For example, Vulich in Mikhail Lermontov's *Geroi nashego vremeni* (A Hero For Our Time), in *Polnoe sobranie sochinenii* (Complete Works), (Moscow, 1948), 4: 143–45.

7 Stalin, "On the Death of Lenin," 56.

8 Aleksandr Fadeev, *Molodaia gvardiia*, enlarged and revised ed. (Moscow, 1951), 80–83, 235–36, 52–53, 82.

9 Ibid., 82.

10 Ibid., 58.

11 See Clark, *Soviet Novel*, 58–59.

12 See Michael Cherniavsky, *Tsar and People: Studies in Russian Myths* (New Haven, 1961), esp. 83.

13 See Clark, *Soviet Novel*, 58–66, where I point to the similarities between the roster of epithets used to characterize the positive hero from Russian revolutionary fiction to socialist realism and those conventionally used to characterize the medieval prince.

14 See Fadeev, *Molodaia gvardiia*, 237.

15 Cf. the representations of Lyutikov in his ritual encounter with his "son," Oleg, and as he sees other characters in an *adjoining* room (ibid., 252–55).

16 Ibid., 238.

17 Vladimir Propp, *Morphology of the Folktale*, 2d. ed., trans. Laurence Scott (Austin, 1968), 21.

18 See V. I. Lenin, "Gosudarstvo i revolutsiia" (State and Revolution), in *Polnoe sobranie sochinenii* (Moscow, 1962), 33: 226.

19 Fadeev, *Molodaia gvardiia*, 226.

20 An exception to this general rule can be found in Leonid Leonov's *Sot'* (1930), in which the original son figure, Potyomkin, comes to play father in a scene of

ritual "last testament" (*pouchenie*) and a more fatherlike figure, Uvad'ev, plays son to him. However, this novel comes from the period when the conventions of socialist realism had not yet been formed; see Leonid Leonov, "Sot'," *Novyi mir,* No. 4 (1930): 25–27.

21 See, for example, Valentin Kataev's socialist realist classic of 1936, *Beleet parus odinokii* (A Lonely White Sail Gleams), in which, schematically, *A* plays father to *B*, while *B* in turn plays father to *C*.

22 See, for example, the representation of Ledenev in *How the Steel Was Tempered* (Ostrovskii, *Kak zakalialas' stal',* 358).

Leonid Heller

A WORLD OF PRETTINESS
Socialist Realism and Its Aesthetic Categories

Many works on socialist realism endow this "artistic method" (to use the Soviet terminology) with the status of an "aesthetics"; indeed, the term itself appears in the titles of two books on this subject that were published around the same time in France a few years ago.[1] But when it comes to the actual analysis of socialist aesthetics, this term is often used in conjunction with the most disparate concepts, some of which are anything but aesthetic, at least in the literal sense of the word. Such works may be devoted to a discussion or a critique of the philosophical foundations of Stalinist, Soviet, or simply Marxist aesthetics (e.g., the theory of reflection).[2] Others have analyzed the theoretical discourse of socialist realism as systems of "mythologemes" or "ideologemes."[3] There are models of socialist realism based on abstract, historical, culturological, semiological, and psychological or psychoanalytic conceptualizations (e.g., closedness, openness, verticality, horizontality, schizophrenia, or masochism), which are not so much descriptions as interpretations of the phenomenon of Soviet aesthetics and, as a rule, of Soviet culture as a whole.[4]

Ultimately, the most frequent and self-evident approach is an analysis of the officially acknowledged "central concepts" of socialist realism, such as "ideological commitment" (*ideinost*), "Party-mindedness" (*partiinost*), "national/popular spirit" (*narodnost*), and so on. It goes without saying that these categories are in essence deeply ideological and not simply "aesthetic."

A dictionary published in Moscow recently conflates (or confuses) aesthetics with art theory, semiotics, epistemology, and sociology. Here, "aesthetics" is categorized according to eighteen rubrics, beginning with the "aesthetic" in general and ending with the apparatus of cultural politics, while "ideological commitment" and other basic concepts of socialist realism are defined as "categories of the sociology of art." The "categories of aesthetics" that I have in mind correspond to the traditional array of concepts that this dictionary (implicitly citing Chernyshevsky) defines as "the relations of art to reality."[5] These categories will be considered (following Blanché[6]) *predicates of aesthetic evaluations,* or, in Kantian terms, "predicates

of judgments of taste" (e.g., the beautiful, the sublime, the charming, the comic, etc.). These traditional concepts were occasionally examined in the context of Soviet culture, but either individually, as isolated notions, or—in dictionaries and textbooks—as part of some ahistorical, presumably universal, and inevitably arbitrary inventory. I am not familiar with any works in which they were treated together, united within a system recognized as such and as specific to Stalinist socialist realism.[7]

"Aesthetic" categories in socialist realism have a rather complicated history. From the very moment when the doctrine began to be formulated, two tendencies were at odds with each other. One of them was quite radical: all of the old world categories and rules had to disappear and be replaced by entirely new ones, spontaneously invented and creatively realized. In 1921, the constructivist Gan announced the end of art; ten years later, Iezuitov proclaimed: "An end to beauty!"[8]

The rejection of traditional aesthetic categories was crucial to Soviet criticism for both philosophical and ideological reasons: at stake was the rejection of metaphysics itself. The Proletkultists and representatives of the sociological school in literary and art criticism had already attempted to develop a new conceptual apparatus in accordance with their doctrine. In the discourse of the 1930s, and even more so in that of the Zhdanov era, the negation of metaphysics meant, in part, that the scientific disciplines lost their autonomy and their distinctiveness. Submitted without exception to "perestroika" (a truly Stalinist term), they were reexamined and revised from the perspective of the class history of mankind. In a speech he made during the famous philosophical debate of 1947, Zhdanov claimed that philosophy as such did not exist and that what mattered was the history of the struggle between idealism and materialism in philosophy. Correspondingly, Marxist-Leninist aesthetics no longer meant the study of various aesthetic views and concepts, but rather the history of "the struggle for a materialist aesthetics against idealist directions and theories."[9]

The concepts developed in the 1930s were used to form the theoretical base of Zhdanovite socialist realism. As mentioned earlier, the famous triad of "ideological commitment," "Party-mindedness," and "national/popular spirit" constituted the core of socialist realist aesthetics. In simplified terms, this meant, first, that in order to be perceived as "ideologically committed," an artwork's elements all had to contribute to the uncovering of a dominant "idea," which functioned as the structural focus of

and chief motivation for these elements. ("Ideological commitment" thus stood in opposition to "formalism," which ascribed a self-sufficient role to the formal level of an artwork.) Second, the artwork's dominant idea obviously had to be "communist." But while this was a *necessary* condition for an artwork's identification as "Soviet," it was far from *sufficient:* "Party-mindedness" meant not merely illustrative of some abstract (communist) idea, but also "militant," "aggressive," producing an active effect. An artwork was "Party-minded" insofar as it contributed to "the construction of communism" or, in other words, insofar as it commented on the burning problems which confronted socialist society. For example, the typical industrial novel of the early 1950s, in which the plot was based on the ups and downs of industrial production, would prove insufficiently "Party-minded." For that, the plot would have to include scenes of workers studying and sharpening their skills, transforming themselves into a technological intelligentsia. (According to the doctrine, this was precisely how the age-old gulf between physical and mental labor would be closed.) "Party-mindedness" was opposed to everything that was passive, to everything that harkened back and was "reactionary." Third and finally, the "national/popular spirit," opposed equally to "cosmopolitanism" and to "bourgeois nationalism," was an inevitable feature of the new art, an art that could not fail to express the expectations and the will of the whole people.

These three, tightly intertwined concepts necessarily entailed several others: "ideological commitment" presupposed a unity of content and form, but one in which content dominated; given that the mastering of Marxist-Leninist teachings was the only effective way to apprehend reality, "Party-mindedness" presupposed the social activism and optimism of art; and, as for the national/popular spirit, it could flourish only by feeding on universalism and humanism (Figure 1).

Certain formal consequences followed from these concepts. For example, the art of socialist realism had "to speak to the broad masses in the name of the Party." As one Zhdanovist theoretician, evoking "Gorky's commandments," put it, "The accessibility of the artwork is to the broadest masses; simplicity and clarity of form are among the most important criteria of the new aesthetics." [10] Thus did a hierarchy of interrelated aesthetic categories emerge, with the classical concepts strictly subordinated to the ideological ones. A striking feature of this aesthetics, one that has been neglected by historians, was its drastic reduction of components, that is, its willingness to make do with a limited number of concepts.

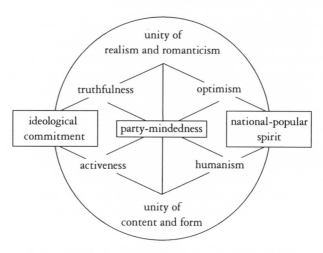

Figure 1. The basic conceptual schema of socialist realism.

In 1950, the philosopher and literary scholar A. Belik posited an even greater reductionism, defining socialist realism as a "Party method," with "Party-mindedness" constituting both its main motivating principle and its main aesthetic category, under which all others were subsumed.[11] But here an alarm was sounded. Shortly before this, Belik had participated in the hunt for "cosmopolitans"; now he was himself subjected to merciless criticism and for several years remained stigmatized for the terrible crime of "RAPP-ism." It became apparent that in this new stage of the development of socialist society, many non-Party citizens could attain almost the same level of consciousness as Party members, thus rendering their access to activist Soviet art undeniable. Socialist realism risked losing its popular spirit if "Party-mindedness" overwhelmed all other principles. Moreover, the "RAPP position" signified a breaking away from "the traditions of Russian culture which are dear to us" and the "neglect of the continuous connection between socialist literature and the treasured past attainments of Russian literature."[12]

For the struggle with "RAPP-ism," the second, less radical tendency of early socialist realist aesthetics was mobilized. During the debate stirred up by Belik's article, this tendency was interpreted as Leninist. According to its exponents, socialist culture, while remaining completely innovative, had not severed its ties to the heritage of the past; therefore, new aesthetic categories were nothing other than the reimagined categories of classical

aesthetics. A typical example of such a reevaluation (at an early stage of socialist realism) can be found in I. Vinogradov's 1935 article "O sotsialisti-cheskoi krasote" (On Socialist Beauty). "Does socialism acknowledge the beauty and delightfulness of a rose?" asked Vinogradov, sternly answering, "A rose, like any other thing, is a whole world . . . and it is important to find out what the object of our aesthetic admiration is in it." But instead of trying to clarify the complexities of the rose, Vinogradov proposed a far more obvious object for admiration: the new industrial and collective-farm landscapes in which "the new beauty of the socialist homeland" was incarnated.[13]

The problem of how to relate socialist art to the heritage of classical aesthetics was complicated by another problem: the need to produce art of high quality. Ever since the Revolution, Soviet writers and artists had been certain that the time had come for immortal masterpieces to be produced, works that would surpass all those earlier masterpieces rendered under the deforming pressure of an exploitative society. As early as the 1920s, critics were speaking of creating "Soviet classics." Georg Lukács reflected upon the question of a new classicism, sharing with many other Marxist theorists a reverence for antiquity; and an order for classic Soviet music was issued by Stalin in his famous talk with musicians in 1936. But the very idea of a classic depends on classification, on judgments of normativity, on cate-gorization—thus was the doctrine of socialist realism formulated through debates about norms and categories.

Initially, these were seen as living and dynamic. At the First Writers' Congress, I. Altman asked, "Isn't it time for us to talk seriously about the creation of a socialist aesthetics?" He then proceeded to sketch out a highly optimistic project:

We must create new laws, and not canons of art. [Socialist realism] is not a dogma legislating certain forms for all eternity. . . . It has brought to an end the old metaphysical debates about romanticism and realism in their relation to creative methods. . . . The joy of creation is the collective struggle, a joint creative search. That is what defines beauty, that is what defines the new aesthetics. Socialist aes-thetics will be not a dry science of long paragraphs, statutes, frozen canons, and rubrics, but rather a joyful science of the classical art of socialism.[14]

In precisely the same way, V. Asmus, flouting classical rules in a work of literary criticism from the same period, refused to "establish firm bound-aries between poetic genres," since their complex interrelation expressed

"the complexity and contradictoriness of social development."[15] At the same time, however, the need for a new aesthetics was perceived in precisely the opposite way—as a need for a new aesthetic codex—by proletarian theoreticians who defined the themes, genres, and devices of a new literature and called for a "red Boileau."[16]

The debate over normativity and the nature of socialist realist aesthetic norms would continue up to the very end of the Stalinist era, and beyond. Here are several representative quotations from articles published in the postwar years:

There are generally obligatory norms of Marxist-Leninist aesthetics.

Our aesthetics should not fear the reproaches of normativity.

The attempt to turn socialist realism into a collection of literary canons can only hinder the growth of Soviet art.

The concept of the "norm" cannot be conjoined with the declaration of certain means and devices of creation which have been established once and for all.[17]

One of the late Zhdanovite theorists, Boris Ryurikov, attempted to sum up the debate in 1952: "The aesthetics of socialist realism is not a bringing together of dead canons, but rather a militant theory of art full of active force, a generalization of experience, and leadership in struggle." But he went on to elaborate as follows:

Throwing aside the old, we can create nothing new in art. . . . It is bad that the problem of genre has not been posed in Soviet aesthetics. We need clarity, precision, and consistency of form. . . . A classic art is . . . an art of clear and transparent form, an incarnation of a rich content. . . . The art of socialist realism, . . . in negating the foundations of decadent and devastated [bourgeois] art, . . . stretches out its hand to the classical art of the past . . . for the sake of creating classical images of the present, classical images of the era of the great struggle for humanity's happiness.[18]

Altman's 1934 speech to the First Congress and Ryurikov's article were separated by almost twenty years, yet the similarities between them are striking. The Zhdanov era, when socialist realism crystallized, produced the same slogans that were heard in the early 1930s, a period which is often seen (by comparison with the Zhdanov one) as relatively liberal in the history of this evolving system. The discussion about classics and normativity, going on for years in cycles, was typical of socialist realism. If it has been

a trend or current in art, then it may be distinguished from other currents by its endless discussions, among other things. The same debate about romanticism and realism, or more precisely about romanticism *in* realism, erupted with the same frequency, as did the debates about literary criticism, about conflict versus "conflictlessness" and the "varnishing of reality," about beauty in life and the "Party-mindedness" of art, about satire and the critical principles of socialist realism, and about the object of aesthetics itself. It may seem as if such debates were senselessly scholastic, as if the whole system must have found itself in a state of utter immobility. It did and it didn't: the system was always at once static and constantly changing.

The discussions about aesthetics and art were carried on in a context of incessant local turbulence and stormy overturnings of the Party line. One need only list the annual Zhdanovite campaigns.

1946: the beginning, with the attacks against the journals *Zvezda* and *Leningrad,* and against Akhmatova and Zoshchenko; the decrees of the Central Committee on the repertories of Soviet theaters and on cinema;

1947: the philosophical discussion;

1948: the first peak, with the decree on music and with Lysenko's victory at the meeting of the Agricultural Academy;

1949: the second peak, with the campaign against cosmopolitanism, paralleled by mass participation in the international peace movement;

1950: the beginning of a discussion in all fields of culture, after the publication of Stalin's famous articles on linguistic questions;

1951: a brief period of calm, disturbed only by the campaign against nationalism (the pretext for which was Sosyura's poem "I Love Ukraine");

1952: a new shock — Stalin's work *On the Economic Problems of Socialism in the USSR,* and a campaign against the theory of conflictlessness, which began in April and continued through the Nineteenth Party Congress.

Despite what may appear to be their complete unexpectedness, the majority of these campaigns did not begin without a warning shot. Take the struggle against the theory of conflictlessness, for example, which is often associated with the end of the Zhdanov era and the beginning of a post-Stalinist "thaw." Actually, campaigns against the "varnishing of reality" were launched as early as 1948 and so were the arguments over sharp conflict as the true object of militant, aggressive Soviet art. The very term "conflictlessness" appeared as early as 1949, from the pen of Vladimir Ermilov.[19] These artillery exercises notwithstanding, the beginning of

every campaign came as a shock. Not stability and stasis, but shock therapy or chronic destabilization best describes the conditions for the optimal functioning of this system. It operated according to an "uncertainty principle" of sorts, analogous to what Heisenberg formulated for quantum physics: that is, the spin and the position of a particle cannot be simultaneously determined, nor its trajectory predicted, just as the ups and downs of the Party line, of the whole system, were always unpredictable, despite the codification of all its elements.[20]

Each shock stimulated feverish activity in the field of aesthetics. There would be talk of the backwardness of aesthetic science, which hindered the whole development of Soviet art. But this activity was largely unproductive. In 1948, Meilakh complained that not one book on specialized questions in aesthetics had been published recently.[21] Despite the fact that discussions of such questions were conducted in 1948, 1951, 1954, and 1956, no real change occurred until about 1960. During the Zhdanov era, texts on socialist realism appeared in print almost every day, but they only repeated the same formulaic "Party-minded" discourse, while works that attempted to overcome the backwardness of its aesthetics totaled one or two articles, one or two anthologies of articles (from those that had already been published in journals). The dearth of works on aesthetic categories was particularly problematic. Even though books and articles addressed the aesthetics of Chernyshevsky, the highest authority in the field, they touched only upon his concept of beauty and completely ignored all of the other categories, such as the sublime, the tragic, and the comic. (As one of the participants in the 1948 discussion about "the tasks of Soviet aesthetics" exclaimed, "Alongside the problem of the beautiful stand the problems of the sublime, the tragic, and the comic." [22]) But research on the comic and the tragic didn't even begin to appear in print until 1953, and the sublime had to wait for several more years.[23] It is curious that even Losev and Shestakov's 1965 book, which gave the Soviet reader the most comprehensive treatment of classical aesthetic categories, lacked a chapter on the sublime — proof of the formidable inertia of the system, especially in light of the fact that the famous treatise by "Longinus" had already been discussed in Soviet publications and was published in translation a year later.[24]

The Stalinist system not only subordinated traditional aesthetic categories to ideology, but also neglected to analyze them or even to consider them notions worthy of scientific or philosophical study (especially the sublime). This attitude is particularly noteworthy because of the con-

trasting situation in the West, where the so-called return to order of the 1930s, following the avant-garde explosion of the first quarter of the century, was accompanied by a renewed interest in classical aesthetics and its categories. In France, for example, a kind of "neoclassicism" developed, counterbalancing surrealism and stimulating a "neotraditionalist" school in aesthetics (e.g., Alain, Etienne Souriau). The new trend was even more spectacularly evinced in Italy, where most of the former Futurists turned to Renaissance ideals, and of course in Germany, where "degenerate" modernism gave way to "healthy and sound" Nazi art. In the Soviet Union, despite a somewhat similar evolution from avant-garde to socialist realism, Zhdanovite culture produced no analogue to Alfred Rosenberg's *Myth of the Twentieth Century,* which devoted a long discussion to the beautiful and the sublime. There was simply no standard, authoritative text on Party aesthetics and culture. Such works had been published in their time by Bogdanov, Trotsky, and Lunacharsky, but they had gone out of print even before the war, giving way to anthologized excerpts from Marxist-Leninist classics and works by Party leaders. These classics, like the sayings of the leaders, were open to various interpretations. For example, on one page we find M. I. Kalinin saying, "We must love our motherland along with all the new that is taking root now in the Soviet Union, and display it, the motherland, in all its beauty . . . in a bright, artistically attractive way," while on the following page he says, "Socialist realism should depict reality, the living reality, unadorned"; and then again, "But it should also use its works to advance the development of human thought." [25] These directives were not supplemented with instructions on what concrete methods to use in reconciling the need for a "beautiful" appearance with a stern rejection of adornment. This contradictoriness is telling: theoretical discourse was directed less by its own logic than by strategic considerations conditioned on the "uncertainty principle."

It is widely held that the Stalinist system generally, and its art in particular, aspired to create a utopia of total communication, the utopia of a language that would be monosemic, terminological, fully adequate to reality.[26] This goal, however unattainable, is said to explain the constant battles over terminology in Stalinist criticism, the striving for an impossible "clarity." To a great extent, this perception is accurate, for clarity, comprehensibility, and accessibility were the main criteria of an art that was called upon to serve the masses. "A language pure as water, through which the content of life is visible" — thus did Novikov-Priboi describe the

ideal of this sort of art.[27] Not only should the word be comprehensible, but the sound and the image as well. Zhdanovite culture entailed an ongoing process of verbalization, of "literarization" (*oliteraturivaniya*), of all artistic disciplines.[28]

But this is only one aspect of the whole picture. While theoretical discourse was struggling for clarity in terminology and thought, it was also actively *obscuring* that same thought, eroding its contours. In artworks a corresponding effect was attained through their incompleteness, their essential "openness," which derived from the readiness with which they could be manipulated; in written works, revising earlier editions was the paradigmatic act of Stalinist creativity.[29] This "openness" can be viewed as one of the main obstacles to the creation of a coherent system of aesthetic categories in the Zhdanov era. As has been repeatedly observed, socialist realism was normative, but only negatively so: it gave practical instructions on what could not be done, but its positive applications and its theorizing (as shown by Kalinin's comments above) remained highly nebulous.

In 1949, two renowned theoreticians of socialist realism attacked a colleague who had written that "the foundations of Marxist aesthetics are still poorly elaborated." But, of course,

if there are no longer any foundations, then there is no more aesthetics. It is blatant slander to assert that the foundations of Marxist-Leninist aesthetics are . . . "poorly elaborated." Actually, in the wonderful works of Marx, Engels, Lenin, and Stalin, the foundations of a new, socialist aesthetics were worked out with striking depth and consistency.[30]

Moreover, as another, equally well-known critic affirmed, "Marxist-Leninist aesthetics elaborated a well-composed system of aesthetic concepts."[31]

Meanwhile, complaints about the backwardness of Marxist-Leninist aesthetics continued to be heard. Some voices expressed despair: "The discussion which took place in the pages of the magazine *Oktiabr'* confused the clearly resolved issue of the correlations between romanticism and realism." Others were purportedly at a loss to explain how L. Timofeev's book on literary theory (the only such book available at that time) could reflect such "terminological confusion despite all of Comrade Stalin's clear and concise definitions."[32]

Similarly obscured, it seems, were even the most foundational concepts of Marxist-Leninist aesthetics. For example, M. Rozental, the chief reporter of the 1948 discussion, was quoted in *Voprosy filosofii* (Questions

of Philosophy) as having said, "The main principle of Marxist aesthetics is Bolshevik Party-mindedness." Yet another, slightly later published report of that same speech in the journal *Bol'shevik* quoted him as saying that "communist ideological commitment is the main and most valuable quality characterizing Soviet art."[33] If the very nature of information exchange in the Stalinist system excluded a direct link between what was said (the signifier) and what was meant (the signified), with the consequent need for decoding, then Rozental's "contradiction" presumably masked some ulterior strategy.[34] Indeed, the Institute of Philosophy was a site of struggle over the definition of socialist realist aesthetics; it was Institute philosophers, such as P. Trofimov and F. Konstantinov, who led the main attack on Belik and who would try in 1951–52 to shift that definition's center of gravity from "Party-mindedness" to communist ideological commitment, a pre-"Thaw" initiative which provoked many energetic protests.[35]

"Party-mindedness" and ideological commitment, although demonstrably distinct concepts whose inaccurate usage could lead to grievous consequences, as in Belik's case, were nevertheless always being exchanged, conflated, or placed on a continuum with one another. In this context of unceasing debate, the declared yearning for clarity was almost completely neutralized. Theory could not adequately and definitively "formulate" anything. But it didn't have to, since its conceptual and terminological confusion was immanent, structural. It reflected a dynamic of sorts, one that was proper to the system. At an early stage, Zhdanovite theoreticians (following the tradition of the 1930s) recognized that certain dramatic conflicts could not be avoided and should be laid bare to their depths; then, around 1950, the idea that any kind of conflict could exist in Soviet life was rejected and the doctrine of the rivalry between the good and the better was adopted fairly easily. Two years later, and almost as easily, this false "varnishing of reality" and the whole doctrine of "conflictlessness" were disavowed, yielding to the discovery of some negative and even monstrous facts in Soviet reality and to the acceptance (more in theory than in practice) of the deformed, the exaggerated, and the grotesque. None of these turnabouts weakened the monolithic coherence of the socialist realist doctrine—thanks to its indefiniteness, its "uncertainty," which injected just enough flexibility into the inflexible system to save it from collapsing at each sharp turn.

There was one other reason, more pragmatic but no less important, why Zhdanovite socialist realism turned its attention away from the specialized

questions of aesthetics: the principle of activism and the postulated erasure of the contradiction between physical and mental labor had led to science's being viewed as an immediately useful activity. The main task of all scholars was to advertise the achievements of the Soviet era, so studies in the history of literature were viewed by contrast as a flight from reality:

> It is an insupportable fact that our whole group of literary scholars has shut itself up inside the narrow circle of the problems of our classical heritage, not participating in any real way in the Soviet literary movement, . . . occupied with the problems of Russian literature from the eighteenth and nineteenth centuries, completely neglecting Soviet literature in their criticism and research. They do not participate in the evaluation of new works created by Soviet writers, or help them in their struggle for quality and mastery; moreover, they have in fact withdrawn from the task of propagandizing the attainments of Soviet literature.[36]

In such a situation, books about the "applied" aesthetics of socialist realism (e.g., film or theater direction) were still possible, but theoretical aesthetics was considered too pure and useless to warrant occupying oneself with.

In the discursive complex of socialist realism, Hans Günther has distinguished the following types and levels of discourse: first, a common political-ideological one, developing the ideology of Marxism-Leninism; second, a political-literary one, defining the concept and the ideological postulates of socialist realism; third, a metaliterary one, interpreting socialist realism as an "artistic method"; and fourth, a literary one, formulating the poetics of socialist realism.[37] Useful as it is, this model seems to need supplementation. Any hierarchy of discursive levels is related to the hierarchy of its instances of enunciation. In other words, it is crucial to take into account who is uttering the concepts, rules, and demands — whether it is a high-level political figure like Zhdanov, Kalinin, or Malenkov, a cultural bureaucrat like Fadeev, or, on the level of intra-institutional control, a literary scholar or critic, or, ultimately, even a text. (While the self-reflexive explorations of "modernist style" were virtually banished from socialist realism, in many Zhdanovite novels the "artist" would appear as a secondary character and defend some artistic position.) All these discursive levels revealed elements of aesthetic discourse, with corresponding differences in their specific weight, relevance, and importance, and this overlapping of competencies and instances enhanced the "uncertainty" of the Stalinist system without ensuring 100 percent conductivity of information. For example, in his 1948 speech to the Congress of Soviet Musicians,

Zhdanov repeated three times that the people were waiting for a "beautiful, refined music."[38] He spoke as well of music that was "not beautiful, unrefined." One could have expected that the aesthetic category of the "refined" (*izyashchnoe*) would have attracted attention and that the term itself would have acquired theoretical currency. But this did not occur: neither the term nor the concept were fully appropriated, but appeared mainly in quotations from Zhdanov's speech. Nevertheless, one could find the *idea* of a "refined" or "graceful" form in a whole series of literary works (even, it might be added, in works published well before Zhdanov's contribution): everyday Stalinist culture included many elements of bourgeois culture, including a concept of refinement that was close to kitsch.

From a corpus composed of issues of the four central "thick" journals from 1948 to 1952, supplemented by other relevant texts (from *Literaturnaia gazeta,* the journal *Teatr,* and anthologies of socialist realist theory), I have compiled a list of Stalinist predicates of aesthetic judgment and grouped them in such a way as to preserve their contextual semantics. Several groups appear to be homogeneous, with their members consisting of a dominant traditional category and several other closely related ones (e.g., the sublime, the lofty, and the elevated); other groups are more heterogeneous. In this regard, I have distinguished, for reasons of economy, between discourse that directly names and treats aesthetic categories and more "indirect" discourse whose vocabulary does not coincide with traditional aesthetic terminology, although it may correspond to it.

I am not concerned here with the question of the relation between these categories, as manifested in critical or theoretical discourse, and the phenomena that might correspond to them in literary works themselves, or between these predicates and the concepts posited by classical aesthetics. I am interested only in what *words* were used in the Stalin era to talk about literature and art, and in the content acquired by these words when they were put into practice and concretely functioning in a concrete discursive system. Such a leveling of aesthetic categories, with their conjunction on a single level, allows us to identify the fundamental systemic connections among them. All this can be visually represented by a "wheel" on which the significance and distribution of the categories corresponds to the discursive situation (Figure 2).[39]

These categories form pairs defined by polarity (e.g., beautiful/ugly, sublime/base) or by contrast (e.g., emphatic/melodramatic, grandiose/

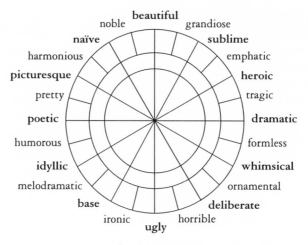

Figure 2. Predicates of aesthetic judgment in the Stalin era.

ironic). Quantitatively and qualitatively (in terms of frequency and of discursive attention or emphasis), the main categories turn out to be four pairs from "direct" discourse (beautiful/ugly, sublime/base, naive/deliberate, and picturesque/whimsical), and two pairs from "indirect" discourse (heroic/idyllic and poetic/dramatic). Moreover, according to my analysis, the critical/aesthetic ("direct") discourse contains a great many frequently used predicates—all twenty-four on the wheel as well as other traditional categories. This abundance virtually contradicts the above-mentioned view of socialist realist discourse as tending to reduce the number of operational concepts, but we are dealing here with another functional aspect of the discourse. Furthermore, it can be argued that the multiplicity of judgments and evaluations need not necessarily signify a richness in the aesthetic system itself, but rather may indicate its inertia (i.e., its overdependence on literary-critical clichés), which is corroborated by the huge number of repetitions and fixed phrases found in the critical and theoretical texts of my corpus.

Many categories were rather stable, but over the course of the five years studied there were also plenty of changes. For example, the frequency of the word "beautiful," although high throughout the period, rose significantly in its second half. Over time, the categories also formed different combinations: "labor," for instance, which (according to doctrine) was a source of aesthetic pleasure for the Soviet citizen, usually aligned itself

with the "poetic"; after 1949, however, the "poeticalness" of the labor depicted by literature and art began to steadily increase. The positive coding of the "dramatic" and of its opposite, the "idyllic," as deeply negative, from the perspective of a militant aesthetic, gradually became less frequent, and the pair had virtually lost this polarization before 1952 (the theory of "conflictlessness" having reduced the intensity of "drama"); after that date, the pair's importance began to increase again. At the same time (i.e., beginning in 1952), with the abandonment of the "varnishing of reality" and the adoption of the slogan "We need Gogols and Saltykov-Shchedrins," certain negative categories were propagated: while the "repulsive," the "satiric," and the "grotesque" didn't win a place on the wheel in their own right, they were subsumed by two negative categories that did—the "horrible" (*uzhasnoe*) and the "ugly" (*urodlivoe*).

Let us concentrate on positive categories, starting with the surprising significance of the "picturesque" (*zhivopisnoe*) and the "naive" (*naivnoe*). As is conventional, I identify these with the "indirect" discourse, especially since they spawn a great variety of epithets. The "picturesque" subsumes such predicates as "painterly" (*kartinnoe*), "colorful" (*krasochnoe*), "expressive" (*vyrazitelnoe*), and "plastic" (*plasticheskoe*), whereas the "naive" covers a vast field of epithets from "natural" and "unaffected" to "sincere" and "ingenuous" (*estestvennoe, bezyskusstvennoe, iskrennee,* and *beskhitrostnoe,* respectively). The specificity of socialist realist discursive practice resides partly in these categories, although, as it happens, they do not accord well at all with the usual understanding of "socialist realism." Their specific gravity is by no means paradoxical, however, and can be explained "functionally," or "interrelationally." The category of the "naive," for example, included "clarity," which was specifically conditioned on the demand for art's total accessibility and on the myth of a "clear classical form." In the texts, however, the "clear" is linked most closely with two semantic registers: (1) the "naive" series listed above and identified with the "natural," to which we may add the "simple" (*prostoe*) and the "fresh" (*svezhee*); and (2) the series composed of the "bright" (*svetloe*), the "joyful" (*radostnoe*), and the "living" (*zhivoe*). There can be no doubt, therefore, that a "naive" vision of the world signified one that was not sullied by excessive culturedness— a child's vision of sorts. It is no coincidence, then, that the "adult" criticism of 1949–50 included ecstatic reviews of Pavlenko's *Stepnoe solntse* (Sun of the Steppe), a story for and about children.[40] I have written elsewhere about the infantilization of the Stalin-era reader (as of society as a whole),

about the collapsing—despite assiduous attempts to keep them clear and precise—of age criteria with respect to literature.[41] Indeed, such works as Nikolai Ostrovsky's *Kak zakalialas' stal'* (How the Steel Was Tempered), Anton Makarenko's *Pedagogicheskaia poema* (A Pedagogic Poem), and Alexander Fadeev's *Molodaia gvardiia* (Young Guard) by rights belong to children's or young adult literature, but instead they have been persistently hailed as paradigms of socialist realism.

But there are other aspects to the category of the "naive." I am inclined to think that it somehow corresponds to the primitivism that has been characteristic of many Modernist currents. In the context of the fierce attack on mere "laboratory science" (*kabinetnuiu nauku*), however, not to mention the equally fierce protestations of workers' equal rights and claims for the advanced culture of the collective-farm village, we may glimpse a relapse into the Makhaevism that had been long-since stigmatized and then forgotten.[42]

The category of the "picturesque" is related to that of the "fresh" in terms of a childlike perception of the world. But it is important for other reasons as well. We must not forget that the Stalinist discourse fashioned according to a utopian model had a contingent relationship to its object, particularly with regard to aesthetic judgments. Here is how one critic, of the journal *Oktiabr',* wrote in 1948 about the first part of Mikhail Bubennov's novel *Belaia Berioza* (The White Birch): "[The building is not yet finished,] but one's gaze is drawn immediately to the perfect proportions; one is amazed by the abundance and brightness of its world, the richness of its harmonizing colors, and the depth of its scope. And amid all this endless diversity of the surroundings, there is not a single empty or boring spot!"[43] Practically the whole critical corpora of this period reflects the same operating principle of sleight of hand and juggling with the predicates of "aesthetic evaluations," made possible by an almost totally formulaic critical mode.

Talking about the "picturesque" in this situation serves as an exorcism: the duller the literature, the more one wants bright, juicy, rich, and harmonious colors. In the anthology *Voprosy literaturovedeniia v svete trudov I. V. Stalina po iazykoznaniiu* (Questions of Literary Scholarship in Light of Stalin's Work on Linguistics), we find a typical definition: "Literature is a reflection of reality, a reproduction of it in artistic images and living pictures, and a knowledge of life."[44] It is possible that these "living pictures" allude to a passage in which Chernyshevsky considered art as a means to

enliven recollections.[45] A magic enlivening of that which does not exist—
at least no longer, if at all: this is the function of the "picturesque," as it was
one of the main tasks of socialist realist art as a whole. (It is worth remark-
ing parenthetically that when the dramatic principle was weakened with
the advent of "conflictlessness," the combination of the "picturesque" with
the "naive" was manifested in works of an idyllic tone, and when—as often
happened—the emphatic or pathetic was added to the mix, the result
was pure Zhdanovite kitsch.) But from the orthodox point of view, a cer-
tain danger lurked in the "picturesque." In the mouths of critics, the term
sometimes acquired a negative connotation. It could express "a distrust of
the aesthetic content of our lives, which would seem to ask for embellish-
ment." Art criticism rejected pictures in which "a picturesque form [plays]
the role of a distinctive veil flung over a grey chunk of reality."[46] Such
superficiality of the "picturesque," the pretty, was opposed to the "beauti-
ful," the essence of reality itself—which brings us to the pivotal category
of Zhdanovite aesthetics.

The first substantive discussion on socialist realism after the shock of
Zhdanov's attack on the Leningrad journals was conducted in *Oktiabr'* and
lasted a year, from August 1947 through August 1948. Its main theme
was the place of romanticism in the new art. In an article programmati-
cally entitled "Nado mechtat!" (We Must Dream!), Boris Bialik defined
socialist realism as a synthesis of realism and romanticism (repeating al-
most verbatim Zhdanov's statement at the First Writers' Congress), and
he recommended that the heroes of the outstanding works of the new lit-
erature not be too clear and well-defined, that these works give birth—as
in the 1920s—to romantic and heroic characters who would be "elevated"
(*pripodniatye*) above reality.[47] Since Bialik's proposed synthesis represented
a critical lever that could overturn the whole world of socialist realist
aesthetics, everyone rushed to attack him. The notion of synthesis pre-
supposed, of course, the presence of opposed principles, but socialist real-
ism represented an organic unity of realism and romanticism; moreover,
romanticism was an integral part of true realism, since Soviet life itself
was romantic. (Here again we have the Stalinist dialectic: instead of syn-
thesis and the negation of negation, there was a unity of nonantagonistic
principles in which one component played the dominant role, namely, the
unity of content and form, of Party and people, and so on.) Bialik could
also be understood as saying that Soviet life was not bright enough, roman-
tic enough, heroic enough. That was a lie: "There is no need to introduce

a heroic principle into an artistic reflection of contemporary reality. That heroic principle already exists in life, in our actual reality."[48] The conclusive formula was cast in 1948: "Chernyshevsky's famous thesis that 'beauty is life' is deciphered by us in our time as a proposition that beauty is our Soviet reality, our victorious movement toward communism."[49]

Formulating the beauty/reality relation in these terms was not at all absurd; on the contrary, it made perfect sense given the fact that Zhdanovite realism presupposed the objective existence of everything it depicted. It thus created reality, much in the way the avant-garde had hoped to create it (and, for that matter, not unlike medieval literature, with its refusal to question the different ontological status of the "seen" and the "written"). No wonder the theorists of the Zhdanov era insisted time and time again that "socialist reality itself acquires an aesthetic character . . . becoming the bearer of beauty reproduced by means of art."[50]

The formula was applicable to subjective perception as well: "Of course, in actual reality there is not only beauty, but also ugliness—everything inimical to communism. But the struggle to overcome any and all monstrosities, the struggle with the enemies of communism, is itself beautiful!"[51] This is how the painting by the Kukrynyksy, *The End,* depicts the last hours of Hitler and his retinue in the Berlin bunker, that is, deprived of any human appearance, caricatured as animal-like. The picture is dominated by beauty nonetheless, since "the Soviet person experiences a feeling of aesthetic pleasure in viewing the spectacle of an inevitable and impending retribution."[52]

From 1950 to 1952, critics indulged in a veritable orgy of the "beautiful," accompanied by the "emphatic," the "grandiose," the "heroic," the "poetic," and the "sublime." These categories, according to the laws of Soviet discourse, had no definite boundaries, were seldom used separately, and were constantly being used in all sorts of combinations, acquiring equivalence and sometimes even synonymity with one another. Thus the "sublime" was often combined with the "heroic," as in the "heroic, sublime character of Soviet literature." There were references to the "sublime" images of such heroes as Zoya Kosmodemyanskaya, Liza Chaikina, and the Young Guard. In this context, the strength of will that conquers suffering, the spirit triumphing over matter, took on Schilleresque features. The military theme could accommodate even the "tragic." As a rule, death did not appear on the horizon of socialist realism, but in this case socialist realism drew on the tradition of the most elevated tragedy, positing

itself as the tradition's heir and opposing itself to the narrow ideals of the bourgeoisie: "Contrary to Hollywood, the Soviet masters don't elude the theme of death, even that of positive heroes. . . . They don't escape from the great human tragedies, because Soviet films reflect real life, [which is] filled not only with joys and victories."[53] But these tragedies of death and suffering did not "convey to the spectator a sense of doom": Nilovna (Gorky's *Mother*), Chapayev, or Zoya might die, but what they believed in continued to live. Unlike Schiller's hero, the Soviet hero never struggled in solitude; his strength was increased by the consciousness of his fusion with the collective, with the people; he was "penetrated by the high spirit in which the personal and the general merge and thanks to which the tragedy of death is surmounted in the fullest and the most optimistic way."[54]

Even more frequently, the "sublime" replicated the "beautiful." This is clearly evinced by certain pronouncements referring to the romanticism debate: "Our writers don't need to fall back on intentional romanticization in the sketching of their heroes, since the Soviet people themselves and all that is created by them are sublime and poetic!"[55] The artist should believe in the "sublimity of the human character." Sublime were the ideals of the Soviet person, as were his goals; sublime and magnificent the goals of Soviet literature, for "our literature communicates the power of the beautiful and sublime idea [of communism]."[56]

Remaining in beauty's gravitational sphere, the "sublime" functioned as a synonym for the "elevated" or the "lofty." The sublimity of life—the fond wish of Zhdanovite culture—was supposed to be conveyed by language as well, and this function became an object of interest as a result of the great Stalinist contribution to linguistic theory. As Viktor Shklovsky wrote, "Not the naturalistic reproduction of conversational speech, and not an antiquarian's love for linguistic rarities, but rather the transformation of lofty speech into everyday speech . . . that is the goal of any Soviet person writing about language."[57] It is interesting to observe how this remark establishes the functional tripartite division of classical rhetoric—trivial, embellished, and lofty speech—but then swiftly destroys (or "overcomes") that division by endowing "lofty speech" with the communicative function of "everyday speech."

Stalinist socialist realism would have been unthinkable without the lofty style that invoked the classical understanding of the "sublime." For example, here is what a Soviet citizen saw "when he examined, with a thoughtful gaze, his great motherland":

The beauty of this scene consists not only in its size, not only in its liveliness and diversity, but also and most of all in its unity. If every creative thought radiated its own hue of light, and every creation had its own sound, then our Motherland would stand before us like unspeakably beautiful music, in which all voices blend together in harmony, and which would be accompanied by the movement of invisible and fascinating forms where not one line would be accidental, and not one hue would offend the eye. That happens because the single beautiful design guiding us is that, in every Soviet person, there burns a concern for the general, a concern that inspires us to create." [58]

Although there are references here to the "unspeakable" and the "invisible," these are made manifest by virtue of being subordinated to a single plan. Shklovsky summed up the problem in his usual fashion with a single sentence about the lofty style. The "sublime" in socialist realism was subordinated to a "plan," given a utilitarian function or made to define a goal (the sublime goal of communism)—in other words, bound by strict limits.

It was precisely this elaboration of the "sublime" outside the realm of the limitless, the inexpressible, the double, the intense, the dynamic (and therefore the frightening) to which it belonged in the classical definitions of Burke, Kant, and Schiller and within the sphere of the limited, the static, the expressible "in contemporary form"—all this "planned cultivation" of the "sublime" under the guise of the "beautiful"—that typified Zhdanovite socialist realism. Equally important was the intense yearning of Zhdanov-era socialist realism to depict the phenomenon "in which the beautiful essence of socialist reality is most precisely uncovered . . . a fusion of the sublime and the everyday, the communally relevant and the private, the 'ideal' and the real." A model for such a fusion was within everyone's reach: "Amidst all the beautiful material of life, the first place should be occupied by images of our great leaders. . . . The sublime beauty of the leaders of all our united peoples . . . is the basis for the coinciding of the 'beautiful' and the 'true' in the art of socialist realism." [59] The only unconstrained sublimity permissible in socialist realism was to be found in the image of unlimited power, an image that did not inspire horror at all (as it did in the old theorists, such as Burke or Kant). It neither deprived the subject of freedom nor opened up before itself the abyss of chaos. On the contrary, the Soviet citizen had feelings of "simplicity and sincerity" toward the image of "the great Director, Teacher, and Friend." [60]

I will end with a quotation that is a model of accomplished Zhdanovite prose, as well as a perfect expression of the "sublime" in its functional relations with other aesthetic categories. Here, an art historian describes Shurpin's painting *Utro nashei Rodiny* (The Morning of Our Motherland):

Amid the vast expanses of the collective-farm fields, observing the feverish life of labor of our Soviet land, stands her leader, her wise navigator. . . . He has stepped out to take a look at how the spring field work is going. The figure of the leader is suffused with the golden light of the morning sun. Stalin's face is lit up with deep thought; it is severe and magnificent, filled with wisdom and sincere humanity. Inner meaning, calm, and simplicity [show themselves] in the whole appearance of the leader. The sharpness of his profile, the plastic completeness of the image, the soft palette, the compositional clarity of the picture—all this lends it that livingness, that monumentality, that deep poeticalness and realistic sublimation that correspond to the inner essence of the image.[61]

— Translated by John Henriksen

Notes

A modified version of this article in Russian was published in *Wiener Slawistischer Almanach* 34 (1994): 81–114.

1 Régine Robin, *Le Réalisme socialiste: Une esthétique impossible* (Paris, 1986); J. Pérus, *A la recherche d'une esthétique socialiste* (Paris, 1986).

2 See Theodor Adorno, *Théorie esthétique* (Paris, 1986); and *Théories esthétiques après Adorno,* ed. Rainer Richlitz (Paris, 1990).

3 See *The Culture of the Stalin Period,* ed. Hans Günther (London, 1990); and Evgenii Dobrenko, *Metafora vlasti: Literatura stalinskoi epokhi v istoricheskom osveshchenii* (Metaphors of Authority: The Literature of the Stalin Era in Historical Context) (Munich, 1993).

4 See V. Papernyi, *Kul'tura "Dva"* (The "Second" Culture) (Ann Arbor, 1985); I. Smirnov, "Scriptum sub specie sovietica," *Russian Language Journal* 41 (1987): 115–38; and Boris Groys, *Staline oeuvre d'art totale* (Paris, 1991).

5 "Kategoriia Estetiki" (The Category of Aesthetics), in *Estetika, Slovar'* (Aesthetics, a Dictionary) (Moscow, 1989), 141.

6 R. Blanché, *Des catégories esthétiques* (Paris, 1979), 7.

7 This article relies on my research in socialist realism for the last several years in Lausanne, the principal goal of which is to describe on the basis of statistical data the actual functioning of socialist realism during the Zhdanov era (1946–53) as a

multilevel "organization of the cultural field." In using the materials and methods of this research here, my intention is to verify the usefulness of the classic aesthetic categories to that sort of functional description. I take this opportunity to express my deep gratitude to my friend and sometime coauthor Antoine Baudin, thanks to whom the material for this study was collected. For a description of this material and the methodology informing it, see Antoine Baudin, Leonid Heller, and Thomas Lahusen, "Le Réalisme socialiste soviétique de l'ère Jdanov: Compte rendu d'une enquête en cours," *Etudes de lettres* 4 (1988): 69–103; see also A. Baudin and L. Heller, "Le Réalisme socialiste comme organisation totale du champ culturel," *Cahiers du monde russe et soviétique* 34 (1993): 307–44.

8 N. Iezuitov, "Konets krasote!" *Proletarskaia literatura*, No. 4 (1931): 122–59.

9 See Andrei Zhdanov, "Vystuplenie na filosofskoi diskusii" (Speech at the Philosophical Debate), *Voprosy filosofii*, No. 1 (1947); and B. Meilakh, "Filosofskaia diskussiia i nekotorye voprosy izucheniia estetiki" (The Philosophical Debate and Several Questions about the Study of Aesthetics), *Zvezda*, No. 1 (1948): 157.

10 V. Ozerov, "O sotsialisticheskom realizme" (On Socialist Realism), *Oktiabr'*, No. 9 (1948): 189.

11 A. Belik, "O nekotorykh oshibkakh v literaturovedenii" (On Some Mistakes in Literary Scholarship), *Oktiabr'*, No. 2 (1950): 150–64.

12 V. Novikov, "Za printsipial'nuiu i ob"iektivnuiu kritiku" (For a Principled and Objective Criticism), *Zvezda*, No. 5 (1950): 164.

13 I. Vinogradov, "O sotsialisticheskoi krasote," *Literaturnyi sovremennik*, No. 11 (1935): 171–89.

14 I. Al'tman, "Estetika sotsializma: Rech' na I–m s"ezde" (The Aesthetics of Socialism: Speech at the First Congress), in *Izbrannye stat'i* (Selected Essays) (Moscow, 1968), 54.

15 V. Asmus, "Epos" (The Epic [1933]), in *Voprosy teorii i istorii estetiki: Sbornik stat'ei* (Questions on the Theory and History of Aesthetics: Essays) (Moscow, 1968), 54.

16 See, for example, Iurii Libedinskii, "Temy, kotorye zhdut svoikh avtorov" (Themes Waiting for Their Authors), *Na postu*, No. 2/3 (1923).

Eds.' note: "red Boileau" is a reference to the French neoclassicist critic and poet Nicolas Boileau-Despréaux (1636–1711).

17 I. Al'tman, "Problemy dramaturgii i teatra" (Problems of Dramaturgy and Theater), *Znamia*, No. 11 (1946): 183; Meilakh, "Filosofskaia diskussiia," 157; A. Tarasenkov, "Sovetskaia literatura na puti sotsialisticheskogo realizma" (Soviet Literature on the Path to Socialist Realism), *Bol'shevik*, No. 9 (1948): 47; E. Koval'chik, "Cherty sovremennoi literatury" (The Features of Contemporary Literature), *Novyi mir*, No. 9 (1948): 236.

18 Boris Riurikov, "O nekotorykh voprosakh sotsialisticheskogo realizma" (Some Problems of Socialist Realism), *Novyi mir*, No. 4 (1952): 227, 257, 260.

19 V. Ermilov, "Prekrasnoe—eto nasha zhizn'" (Beauty Is Our Life), in *Voprosy teorii literatury* (Questions in Literary Theory) (Moscow, 1950), 5–29.

20 See L. Heller, "Printsip neopredelennosti i struktura gazetnoi informatsii stalinskoi epokhi" (The Principle of Indeterminacy and the Structure of Newspaper Information in the Stalinist Era), in his *Slovo mera mira* (The Word as Measure for the World) (Moscow, 1994), 157–74.

21 Meilakh, "Filosofskaia diskussiia," 154.

22 "Zadachi sovetskoi estetiki: Diskussiia v Akademii obshchestvennykh nauk pri TsK VKP (b)" (The Tasks of Soviet Aesthetics: The Debate in the Academy of Social Sciences [on G. Lukanov's speech]), *Voprosy filosofii*, No. 1 (1948): 288.

23 See, for example, Iurii Borev, "Oruzhiia liubimeishego rod (Zametki o komicheskom)" (The Weapon We Prefer [Notes on the Comic]), *Teatr*, No. 7 (1953): 51–64; and I. Kiselev, "Cherty sovetskoi tragedii" (The Features of Soviet Tragedy), *Teatr*, No. 7 (1953): 124–34.

On the sublime, see A. Abramovich, *N. G. Chernyshevskii o kategoriiakh iskusstva* (Chernyshevsky on the Categories of Art) (Irkutsk, 1956); V. Vanslov and P. Trofimov, "Prekrasnoe i vozvyshennoe" (The Beautiful and the Sublime), in *Voprosy marksistko-leninskoi estetiki* (Questions in Marxist-Leninist Aesthetics) (Moscow, 1956), 58–100; and V. Malygin, *O vozvyshennom: V mire estetiki* (On the Sublime: In the World of Aesthetics) (Leningrad, 1966). Some texts on the sublime in the European tradition (e.g., Longinus, Burke) can be found in the following two collections: *Iz istorii esteticheskoi mysli novogo vremeni* (From the History of the Aesthetic Thought of Modern Times) (Moscow, 1959); and *Iz istorii esteticheskoi mysli drevnosti i srednevekov'ia* (From the History of the Aesthetic Thought of Antiquity and the Middle Ages), ed. V. F. Brestnev (Moscow, 1961).

24 A. Losev and V. Shestakov, *Istoriia esteticheskikh kategorii* (The History of Aesthetic Categories) (Moscow, 1965). See also I. Nakhov, "Vydaiushchiisia pamiatnik antichnoi estetiki: Traktat *O vozvyshennom*" (An Outstanding Monument of Ancient Aesthetics: The Treatise *On the Sublime*), in Brestnev, ed., *Iz istorii esteticheskoi*, 139–82; and *O vozvyshennom*, trans. N. Chistiakova (Moscow and Leningrad, 1966).

25 M. I. Kalinin, "Ob ovladenii marksizma-leninizma rabotnikami iskusstv" (On Artistic Workers' Mastery of Marxism-Leninism), in *O literature* (Leningrad, 1949), 93–94.

26 See Robin, *Le Réalisme socialiste;* and Dobrenko, *Metafora vlasti*.

27 Quoted in N. Maslin, "Veniamin Kaverin," *Novyi mir*, No. 4 (1948): 282.

28 See Papernyi, *Kul'tura "Dva";* and Antoine Baudin and Leonid Heller, "L'Image prend la parole: Image, texte, et littérature durant la période jdanovienne," in *Russie-URSS, 1914–1991: Changements de regards*, ed. W. Berelowitch and L. Gervereau (Paris, 1991), 140–48.

29 See Leonid Heller and Thomas Lahusen, "Palimpsexes: Les métamorphoses

de la thématique sexuelle dans le roman de F. Gladkov *Le Ciment*," *Wiener Slawistischer Almanach* 15 (1985): 211–54.

30 A. Belik and N. Parsadanov, "Ob oshibkakh i izvrashcheniiakh v estetike i literaturovedenii" (On Mistakes and Perversions in Aesthetic and Literary Scholarship), *Oktiabr'*, No. 4 (1949): 167.

31 Riurikov, "O nekotorykh voprosakh," 229.

32 "Zadachi sovetskoi estetiki" (on T. Fedoseev's speech), 289; T. Trifonova, "Cherty neodolimogo dvizheniia" (The Features of a Movement That Cannot Be Stopped), *Zvezda*, No. 6 (1950): 168.

33 "Zadachi sovetskoi estetiki" (on M. Rozental's speech), 279; and "Voprosy sovetskoi esteticheskoi nauki" (Questions of Soviet Aesthetics), *Bol'shevik*, No. 13 (1948): 49.

34 See Heller, "Printsip neopredelennosti."

35 See, for example, V. Ermilov, "Nekotorye voprosy teorii sotsialisticheskogo realizma" (Some Questions about the Theory of Socialist Realism), *Znamia*, No. 7 (1951): 156.

36 A. Tarasenkov, "Zametki kritika" (Notes of a Critic), *Znamia*, No. 10 (1949): 175–76.

37 Hans Günther, *Die Verstaatlichung der Literatur: Entstehung u. Funktionsweise des sozialistisch-realistischen Kanons in der sowjetischen Literatur der 30er Jahre* (Stuttgart, 1984), 171.

38 Andrei Zhdanov, "Vystuplenie na soveshchanii deiatelei sovetskoi muzyki" (Speech to the Congress of Soviet Musicians), *Sovetskaia muzyka*, No. 1 (1948): 23.

39 Figure 2 is based on the wheel constructed by the French aesthetician Etienne Souriau; see his "Art et vérité," *Revue philosophique* 18 (1933): 186–89.

40 See, for example, B. Platonov, "Literaturnoe obozrenie. Zametki o russkoi proze 1949 goda: Stat'ia pervaia" (A Literary Survey. Notes on Russian Prose in 1949: Article One), *Zvezda*, No. 1 (1950): 156–78.

41 L. Heller, "Konstantin Paustovskij, écrivain-modèle: Notes pour une approche du réalisme socialiste," *Cahiers du monde russe et soviétique* 26 (1985): 311–52.

42 According to the theory of V. Makhaiskii-Vol'skii (1867–1926), the intelligentsia constitute the main instrument of the workers' oppression; the Revolution gave the proletariat only nominal power, and it continues to be exploited by the intelligentsia. The Bolsheviks always struggled against the Makhaiskii current—making the fierce anti-intellectualism of the Zhdanov epoch all the more curious.

43 M. Shkerin, "Kriticheskie zametki" (Critical Notes), *Oktiabr'*, No. 5 (1948): 33.

44 M. Dobrynin, "Literatura kak nadstroika," in *Voprosy literaturovedeniia v svete trudov I. V. Stalina po iazykoznaniiu* (Moscow, 1951), 65.

45 See, for example, Nikolai Chernyshevskii, "Esteticheskie otnosheniia iskusstva k deistvitel'nosti" (The Aesthetic Relations of Art to Reality), in *N. G. Chernyshevskii ob iskusstve* (Chernyshevsky on Art) (Moscow, 1950), 69.

46 G. Nedoshivin, "O probleme prekrasnogo v sovetskom iskusstve" (On the Problem of the Beautiful in Soviet Art), in *Voprosy teorii sovetskogo izobrazitel'nogo iskusstva* (Questions in the Theory of Soviet Visual Art) (Moscow, 1950), 89.

47 B. Bialik, "Nado mechtat'!" *Oktiabr'*, No. 11 (1947): 29–30.

48 G. Lukanov and A. Belik, "O tvorcheskom metode sotsialisticheskoi literatury" (On the Creative Method of Socialist Literature), *Oktiabr'*, No. 7 (1948): 180.

49 V. Ermilov, "Za boevuiu teoriiu literatury" (On the Militant Theory of Literature), *Literaturnaia gazeta*, 15 September 1948.

50 L. Timofeev, "O sotsialisticheskom realizme" (On Socialist Realism), *Oktiabr'*, No. 4 (1952): 166.

51 Ermilov, "Prekrasnoe—eto nasha zhizn'," 271.

52 Nedoshivin, "O probleme prekrasnogo," 81.

53 Vs. Pudovkin and E. Smirnova, "K voprosu o sotsialisticheskom realizme v kino: Massa i geroi v sovetskikh fil'makh" (On the Question of Socialist Realism in the Cinema: Masses and Hero in Soviet Films), *Oktiabr'*, No. 5 (1948): 190.

54 L. Subotskii, "Zametki o proze 1947 goda" (Notes on the Prose of 1947), *Novyi mir*, No. 2 (1948): 118.

55 F. Gladkov, "Sovetskaia literatura na pod"eme" (Soviet Literature on the Upswing), *Kul'tura i zhizn'*, 21 September 1949.

56 I. Grinberg, "Kritika i novaia proza" (Criticism and the New Prose), *Novyi mir*, No. 9 (1949): 271.

57 V. Shklovskii, "O literaturnom iazyke" (On Literary Language), *Literaturnaia gazeta*, 21 June 1951.

58 B. Agapov, "Sovetskii ocherk segodnia" (The Soviet Sketch Today), *Novyi mir*, No. 8 (1949): 216.

59 Nedoshivin, "O probleme prekrasnogo," 91–92.

60 L. Seifullina, "Obraz Stalina v sovetskoi khudozhestvennoi proze" (The Image of Stalin in Soviet Prose), *Oktiabr'*, No. 12 (1949): 172.

61 K. Sitnik, "Ob ideinosti i narodnosti sovetskogo iskusstva" (On Ideological Commitment and National Spirit in Soviet Art), in *Voprosy teorii sovetskogo*, 57.

Boris Groys

A STYLE AND A HALF

Socialist Realism between Modernism and Postmodernism

In Russian literary and art criticism of the post-Soviet era, it has become a commonplace to characterize the present period as "postmodern." Postmodernism, in this case, is most generally understood by Russian critics as a culturally acknowledged pluralism of styles: no single artistic method is henceforth to be regarded as predominant, and all styles are equally available to a writer or artist. In this sense one can claim that the term "postmodernism," Western in origin, is used in contemporary Russian criticism to articulate a very specific analogy: the liberation from the aesthetic dictatorship of modernism and the transition to a programmatic cultural pluralism (which occurred in the West during the 1960s and 1970s) is parallel to the gradual liberation from the norms of official socialist realism in Russia during the 1970s and 1980s. In both cases, however, this new cultural pluralism formulated itself, directly or indirectly, through its polemic reaction to a preceding period of "positive values" whose actuality was still preserved nonetheless—hence the prefix "post," signifying both the polemic "non" of negation and the logical and historical continuity connecting it with the cultural standard it has rejected.

The precision of this kind of cultural analogy—and, correspondingly, the use of "postmodernism" to describe the post-Soviet cultural situation—therefore depends, in the first place, on the extent to which socialist realism (and Soviet culture in general) can be considered part of the modernist paradigm of the twentieth century. I have previously tried to show that Stalinist socialist realism can at least be considered one particular version of the global modernist culture of its time.[1] From this perspective, the analogy above may be seen as justified to a certain degree. At the same time, it is obvious that socialist realism is a modernism of a very particular kind. Therefore, it is to be expected that post-Sovietism would be a rather idiosyncratic version of postmodernism.

The specificity of the Soviet situation lies primarily in the fact that from the outset the dictatorship of socialist realism under communism differed on the institutional level from the dictatorship of modernism over the institutions of art and criticism in the West. Here, my focus is, first

and foremost, the correlation between the aesthetic strategies of Western modernism and socialist realism but also, and more specifically, their differences and how these relate to the discrepancies between the respective strategies of Western postmodernism and Russian post-Sovietism.

Any cultural strategy may be best described from the vantage point of what it seeks to exclude. High modernism, as is well known, defined itself primarily by its exclusion of the entire domain of mass or commercial culture, which, given the framework of its ideology, constituted kitsch. But modernism also excluded any traditional art that had been absorbed and assimilated by mass consciousness.[2] The central opposition operative in modernism was therefore high culture versus mass (or "low") culture. High culture was understood as an autonomous artistic praxis, ideally precluding any dependence by the artist on such "external" factors as political regime or market forces, as well as generally any content that referred to external reality (i.e., reality as it might be perceived by mass consciousness). According to the ideology of modernism, it was only in liberating himself from everything external that the artist could reveal the inner truth of art and express it adequately. Ideological differences within the modernist paradigm itself converged, as a result, in a more and more consistent exclusion of everything that was external or commercial, everything that was conditioned politically or by mass taste, in order to achieve the maximum purity of artistic gesture. The artistic praxis of modernism thus involved the continual purification of the internal space of the artwork, cleansing it of everything external to it. Even though certain doubts as to the attainability of absolute artistic autonomy and inner purity might be raised from time to time in modernist criticism, the ideal itself was never placed in question.

While modernism was defined by the high/low opposition, the fundamental antinomy of socialist realism revolved around the opposition between Soviet and non-Soviet. To clarify the correlation of modernism and socialist realism, therefore, we must start by comparing and contrasting how these two sets of oppositions functioned. The notion of Sovietness, like the notion of high culture in modernism, was understood, first and foremost, in terms of autonomy, with communism defined as man's liberation from the forces of nature and the market economy (which was viewed as the effect of natural laws on society). By implication, then, communism represented the transition, in Marxian terms, from the description

of the world to its transformation by the "interior," authentic demands of man. This was why Soviet culture also focused primarily on its own purity and autonomy from all alien/external perspectives and influences. Only such self-purification (which occasionally took the form of political purges) could lead, from the point of view of Soviet culture, to the revelation of what communism truly was. (Andrei Platonov's *Chevengur* and *Kotlovan* [Foundation Pit] describe these processes of self-purification and self-authentification from the perspective of a skeptical "fellow traveler.") It is here that the closest link between classical Sovietism and classical modernism becomes apparent, for this desire to achieve purification from all external influences was also the decisive precondition for the authentic internal artistic vision of modernism, the most salient example being Malevich's *Black Square.*

The Soviet/non-Soviet opposition was nevertheless organized somewhat differently from the classic modernist high/low opposition. In all fields of art socialist realism made particular use of conventional forms of traditional representation as well as elements of mass culture, folklore, and so on. Thus it cannot be distinguished—at least at the level of those purely formal, aesthetic analyses on which the entire system of modern museums, art criticism, and art pedagogy was based—from what modernist criticism identified as kitsch. The distinction between socialist realist art and traditional academic, mass (or commercial) art was drawn in terms of its specific contextual use of available artistic devices and forms, which drastically altered their "normal" functioning: instead of just being "enjoyed" (i.e., instead of merely catering to the tastes of the masses), these devices and forms became a means of propaganda, deployed to achieve the very modernist ideal of a historically original society independent of any tradition or prototype. The specificity of socialist realism therefore lay not at a level susceptible to formal aesthetic analysis, but rather at the level of its contextual work with form. And it is here that its parallel with postmodernism becomes apparent, for postmodernism can be generally characterized as the appropriation of ready-made cultural forms deployed in contexts at odds with their normal functioning.

The ideological context for the artistic praxis of socialist realism was, of course, the dialectical materialism formulated during the Stalin era as the only legitimate mode of philosophical thought. Dialectical materialism, aimed first of all against formal logic, took as its constitutive principle the "unity and clash of opposites." Unlike Hegel's dialectics, the continua-

tion of which it claimed to be, dialectical materialism also maintained the impossibility of any "subjective" philosophical contemplation that might resolve the clash of contradictions at the end of the history of the Absolute spirit: the only agency deemed capable of regulating the synthesis of opposites was political praxis. When applied to art and culture in general, the principle of the "unity and clash of opposites" meant the possibility of using any artistic form in the context of Communist political praxis. Theorists of socialist realism repudiated the left wing of the Russian avant-garde precisely on account of its "formalism," understood to be based on a merely formal-logical definition of "proletarian art" which excluded the use of "nonproletarian" art forms. To the formalism of the avant-garde socialist realism counterposed its own dialectical materialism, which made possible the "struggle for the artistic heritage" and its use to advance the development of socialism and mass education.[3] This anti–avant-garde position therefore highlights the extent to which socialist realism separated itself from the avant-garde, despite having inherited its premises, here shifting the ideological emphasis of the avant-garde from form to its social use — a strategy characteristic of many philosophical and artistic movements of the 1930s from surrealism to the "second philosophy" of Wittgenstein.

Socialist realism was, if you will, a "style and a half": its proto-postmodernist strategy of appropriation continued to serve the modernist ideal of historical exclusiveness, internal purity, and autonomy from everything external. Modernism's formalist criticism, however, was incapable of differentiating among various usages of previously available art forms because it lacked the necessary theoretical apparatus. Since the specific work with form in socialist realism was primarily contextual and not explicitly expressed at the formal level, as in the case of surrealism, for example, it eluded the modernist perspective and seemed "formless," "invisible," "nonexisting." For Grinberg or Adorno, socialist realism was accordingly just another version of mass kitsch. (It may be noted parenthetically that postmodernist art is likewise nothing but kitsch to modernist-inspired criticism.) On the other hand, the style-and-a-half character of socialist realism naturally placed it — via its own self-consciousness, above all — in opposition to the entirety of Western culture: "high" modernist culture was too high (i.e., too elitist and individualistic), whereas "low," commercial, mass culture seemed too vulgar. (It is significant, moreover, that the Russian criticism which has taken up the traditions of socialist realism has inherited the modernist blindness and also confuses postmodernism with

mass culture.) Socialist realism was suspended, as it were, between the main categories of Western modernist culture and, finding no place there, defined itself as modernism's total opposite.

The definition of "Sovietness" was achieved by separating it from everything that questioned the fundamental project of the world's transformation by the autonomous will of man. "Bourgeois objectivism," which insisted on the insurmountability of natural and economic laws, was subject to the same ostracism as "bourgeois subjectivism," which, in making any collective project impossible, thereby "objectively" contributed to the stabilization of the status quo. While for classic modernism the realization of its project meant essentially the creation of a work of art that was autonomous from any existing social or natural context, this autonomy remained completely illusory for Soviet culture. What the absolute freedom of the artist meant to the modernist was absolute control over the context of the artist's work. But from the point of view of Soviet culture, the modernist artist merely served the market, unlike the Soviet artist, who participated in the collective project of reconstructing the world.

Naturally, this argument was immediately shredded by the theorists of modernism, who saw it as nothing but an ideological cover-up for the Soviet artist's dependence on the political regime. The ideological dispute between Sovietism and modernism was therefore an intermodernist dispute. Both parties saw the aim of art as autonomy and reproached each other for betraying it: modernism for the benefit of the market, Sovietism for the sake of politics. At the level of artistic strategy, however, the discrepancy was much more substantive, for it was precisely due to the style-and-a-half character of socialist realism that there was no internal schism between high and low Soviet art. Soviet culture perceived itself as an integral whole, with the same artistic ideal at every level and in opposition to all of Western art, which was likewise a whole. Of course, there could be "non-Soviet" elements and tendencies in Soviet art, just as the West could harbor "our" artists. But this division was horizontal, not vertical — eventually coinciding with the borders of the "socialist camp" as a hermetic entity, as a total and collective work of art. The high/low opposition was not coterminous with the Soviet/non-Soviet opposition: the former divided each national culture vertically, whereas the latter demarcated cultures which had achieved autonomy from those which were still "enslaved by capital." Therefore, if we define postmodernism as the surmounting of the modernist high/low opposition, and if we define post-Sovietism as the undoing of the Soviet/non-Soviet opposition, then we would expect that the

different structures of those oppositions would also lead to different strategies for overcoming them, as well as to different results.

The very notion of "postmodernism" is, to be sure, rather vague and has already been defined in a number of contradictory ways. It is nevertheless possible, as I have already noted, to outline the main strategy of postmodernism, namely, its shift of emphasis to the very mass-cultural context from which modernist ideology had tried to separate itself. Everything that modernism wished to get rid of in order to achieve autonomy became, in the framework of postmodernism, the main object of theorization and artistic practice.

Poststructuralist philosophy began to thematize the dependence of discourse on desire, on the market, on the rhetoric of the text, or, in general, on the "Other" in all of its guises (Deleuze, Baudrillard, Derrida). Art began to work with popular photography, commercial advertising, kitsch, the mass media, as well as with the institutional, generic, and semiotic conditions of its own functioning. The modernist aspiration toward autonomy gave way to an acknowledgment of art's dependence on external factors and on the "gaze of the other," which could be reflected but never evaded.

In the West, however, the new postmodern concern with cultural practices and institutions has continued to function within these very institutions. From a formal point of view, the central device of postmodernist culture is *appropriation,* that is, the transposition into high culture of elements belonging to its low or mass counterpart. On the one hand, therefore, those hidden elements of the field of "low" culture "edged out" by modernism have now become visible. On the other hand, this conflation of high and low is occurring within those same institutions of "high culture" that were formed in the era of modernism and thus have inherited the status of "high art" or "high philosophy." In addition, the "low" context of "high" culture is studied only insofar as this culture depends on it and seeks to somehow cope with this dependence. Therefore, Western postmodernism can be said to be merely another stage in the struggle of high culture for social dominance, a dominance now grounded not in autonomy but in the acknowledged power of communication. The postmodern "critique of institutions" serves, as does any other critique of this kind, only to fortify these institutions by rescuing them from their disregard of the "Other," an obliviousness which might threaten their stability.

The situation in post-Soviet culture is completely different, although post-Sovietism has also gradually grown aware of its dependence on the

Other (i.e., on the non-Soviet or Western world) and has proceeded to appropriate its signs—a tendency dating back to the late 1950s, hence coinciding with the first manifestations of Western postmodernism. Evtushenko, Voznesensky, or Aksyonov is, in this sense, the Soviet analogue of a Rauschenberg or a Ginsberg, above and beyond their well-known personal regard for each other.

Official censorship in Soviet Russia, which was grounded on the combined power of existing political institutions, can be seen as the only means by which Soviet culture could maintain itself as "high" culture. The struggle against this system of censorship involved an attempt to expand available "Soviet" space by appropriating the maximum number of signs betokening the "non-Soviet." This struggle, which went on during the entire period between Stalin's death and the collapse of the Soviet Union and which structured the internal drama of the entire culture of that time, can be compared to Western postmodernism's struggle against the aesthetic censorship of modernist cultural institutions. In both cases the struggle would succeed by stretching the constraints of censorship to the maximum without losing the status of a "serious" or a "Soviet" artist, respectively.

The failure of Soviet cultural institutions has therefore meant, among other things, the impossibility of any further cultural transgression against them. In the post-Soviet context, all Soviet culture has now been relegated to the status of "low," mass culture, since the former, privileged context of working both with and against it has been lost. As a result, contemporary Russian culture finds itself without any institutionalized tradition against which it might transgress—either in the modernist sense (by making its own autonomy more and more radical) or in the postmodernist sense (by appropriating the Other). This is why many post-Soviet works of art which Russian criticism tends to characterize as postmodern cannot be considered such. To play with quotations, "polystylistics," nostalgia, irony, or the "carnivalesque" is not, in and of itself, a postmodernist strategy because the very context of such a strategy remains undefined, precluding any appropriation of the Other. But to the extent that Russian culture remains Other to Western high culture (as theorists of classic modernism always claimed), the only remaining possibility for post-Soviet Russian art is to appropriate itself within the context of Western, modernist high art.

Such self-appropriation has indeed been the main device of the art which came to be known as Moscow Conceptualism, or *sots art,* and which

emerged within Moscow "unofficial art" circles in the early 1970s. "Unofficial artists" were socially isolated, and, far from seeking to overstep the boundaries of censorship, they never really took them into account in the first place. The system of unofficial art thus functioned as a kind of analogue to "high" art that could successfully—at least according to some of its representatives, such as Vitaly Komar and Alexander Melamid, Ilya Kabakov, Erik Bulatov, and Dmitry Prigov—appropriate official art as "low" art. But since this unofficial art had no institutional power whatsoever, its appropriative strategies were more of a fantasy than a reality. An apt term for the pseudo-institutional character of this postmodernist wing of unofficial Moscow culture in the 1970s and 1980s is *noma*—coined in the mid-1980s by the "Medical Hermeneutics" group—an allusion to the mythical, ancient Egyptian burial place of Osiris's mutilated body.[4]

This notion of "noma" rather aptly illustrates the major difference between post-Soviet Russian postmodernism and its Western counterparts. In the West, postmodernist appropriation occurred in the real context of real cultural institutions such as museums, universities, and publishing houses. In Russia, on the other hand, the context for this appropriation had to be first created by the artist or theorist himself. The creation of such contexts was complicated, above all, by the uniqueness of the Soviet/non-Soviet borderline, which, within this context, had to be at once drawn and transcended.

The strategies of ethnic self-representation in the context of Western high-cultural institutions are quite familiar, thanks to the discursive framework of "identity politics." One might well assume that Soviet cultural identity could be represented analogously, but the particularity of Soviet culture lay precisely in its lack of any specific national form recognizable or exotic enough to be classified and displayed by Western cultural institutions as yet another Other of European modernism. On the contrary, socialist realism defined itself as "national in form, socialist in content." The central issue involved in "Sovietness" therefore had nothing to do with national form (which could be anything), but rather concerned the unified, socialist, ideological work done with this form. Sovietness stood in opposition to modernism not as regional or exotic art is opposed to universal art; instead, here one claim to universality opposed another claim to it. Therefore, to thematize and transcend the binary Soviet/non-Soviet opposition (or, what amounted to the same thing, the Soviet/Western opposition), the Russian artist needed to create a context in which these two universali-

ties might be compared—a context that could not, of course, exist in real life, since those two competing claims to universality would cancel each other out.

In this respect, the situation of the contemporary Russian artist is hardly novel. Its history is a long one. Throughout the nineteenth century and the first half of the twentieth, Russian thought kept inventing various fictitious contextualizations for the opposition between Russia and the West, from the communal (*sobornoe*) Christianity of the Slavophiles, Vladimir Solovyov's *Sophia,* Nikolai Danilevsky's theory of historico-cultural types, Nikolai Fyodorov's "Common Task," Leo Tolstoy's *oproshchenie* (embracing the simple life), international communism, Velimir Khlebnikov's universal "transrational" language, Mikhail Bakhtin's Carnival, to Daniil Andreev's *Roza mira* (Rosa mundi). These fictitious comparative contexts compensated for the lack of any real cultural institutions linking Russia with the West. Their emergence and their privileged role in Russian culture were manifestations of a constant demand for institutions that could establish some yardstick for the relative measurement of the "high" Western and Russian cultures. It ought to be noted that various attempts to create such fictitious comparative contexts were also made in the West; they include, in particular, the Absolute Spirit of Hegel (for whom fictitious contexts eventually came to coincide with real cultural institutions), the Dionysian element in Nietzsche, theosophy and anthroposophy, or, if you will, Derridean textuality (which is, however, rather tolerant toward existing institutions). Characteristically, all such theories have always been enthusiastically received in Russia.

The pecularity of contemporary Russian authors' developing such comparative contexts nevertheless lies in the fact that their work is not grounded in any specific ideology suggesting a certain hidden context of comparison in reality itself which the theorist or artist might have to reveal in order to justify his practice. The very space of the text or work of art becomes its own comparative context; and it is precisely in this space that the contiguity and, by the same token, the mutual exclusiveness of the Western-modernist and Russian/Soviet claims to universality come to the fore.

Here are a few salient examples: Ilya Kabakov's installations, Vladimir Sorokin's texts, and the texts and installations of the Medical Hermeneutics group, all of which formally present themselves as analogous to museum collections or libraries of world literature, thus appropriating the

very form of contemporary art institutions for themselves. The space of comparison eventually comes to be constituted by the space of the text or installation itself. Thus constituted, the context is more artificial than fictitious, since it is not based on any collective myth. Fictitiousness entails an ideological reference to a concealed and altogether unattainable reality; therefore, one cannot speak of the fictitiousness of an artwork when it can itself be considered the given reality.

Let us now consider some examples of how such artificial contexts of comparison are created. Kabakov's installations, for instance, are collections of various objects, texts, pictures, drawings, commentaries, and so forth.[5] The various elements of these collections all refer to the Other—other fictional or real authors, impersonal, mass visual and textual productions, and quotations from everyday life. Kabakov's installations are therefore organized—implicitly or explicitly—just like museum exhibitions, that is, like institutional spaces of comparison in which objects from both "high" and (appropriated) "low" culture are displayed. However, within this pseudo-museological display, Kabakov always draws a borderline which separates the "correct" presentation of objects from the "incorrect," most often by means of light, with part of the exhibition poorly lit and almost invisible to the viewer. In other cases, Kabakov leaves part of an installation unfinished or heaped with rubbish, or deficient in some other way that renders it inaccessible to "normal" viewing. Such borderlines therefore mark the difference between what is "worth viewing" and what is "lost in the darkness," or, if you will, the difference between a museum exhibit and a heap of rubbish, or between historical memory and historical death (i.e., erasure of memory). In addition, the objects displayed on either side of Kabakov's borderline are essentially the same, which is also emphasized by a rather gradual transition from light to darkness that leaves the question of trespass open. As a result, the viewer's attention is focused not so much on the objects displayed as on the problematic boundary between light and darkness, between the visible and whatever recedes from vision.

Undoubtedly, if not predominantly, this boundary is also a borderline between Russia and the West—the latter understood as the space of high culture. We are talking here about the zone that remains "dark" to the system of museological representation and thus eludes institutional vision, the zone in which one can't see anything, namely, the "Russian" zone. For Kabakov, the borderline between the West and Russia is at once tran-

scendable and untranscendable. It is transcendable not only because what lies on either side of this border is essentially the same, but also because no distinct demarcation between the two sides is possible. By the same token, this borderline is untranscendable because the realm of light of art institutions automatically presupposes a domain of darkness that lies beyond their own boundaries. As a matter of fact, Russia and the West constantly switch places across this borderline: if *Russia* is invisible, then it is so precisely from the vantage point of *the West*. At the same time, it is the darkest or most "rubbishy" parts of an installation that, precisely because of their "invisibility," become the focus of the viewer's attention.

Kabakov himself defines his works as "total installations." Indeed, they seek to establish a broader context of comparison than that provided by institutions or museums—one in which museum objects could be compared to non-museum ones. The borderline between Russia and the West here acquires a much deeper quality, becoming a border between the historical and the ahistorical, which corresponds to the Russian cultural tradition of self-reflection from Pyotr Chaadaev on. At the same time, the correlation of these two borders makes Kabakov's works universal in terms of their opening up further possibilities for the play of substitutions and associations leading away from Russia proper.

The tension of the borderline between the Soviet (or Russian) and the non-Soviet (or Western) is also instrumental to Sorokin's prose: like Kabakov, Sorokin opens up possibilities for interpretative play and boundary-switching. His texts operate with "alien," appropriated forms of *écriture* organized such that they are posited on both sides of the conventional border, which can also be characterized as the boundary between the conscious and the unconscious. The "non-Soviet" here represents the hidden zone of the body, the zone of desire, of a dangerously attractive Other. Fragments of "Soviet" texts, especially in Sorokin's early work, therefore mark the zone of consciousness, that is, the zone of writing allowed by official censorship. The domain of unconsciousness, in contrast, is marked by "forbidden" writing, notably, descriptions of enigmatic erotic rites with a heavy sadomasochistic flavor. In addition, both the official and the unofficial texts take the form of rather banal and impersonal citations, so that no Bakhtinian "carnivalesque" relationship between them can be established. The reader's attention is completely focused on the moment of transition from one type of discourse to the other—from the language of the Soviet "practice of industrial production" to that of the body and desire. The

reader becomes necessarily even more alert to this transition from the rites of industrial production to the erotic ones because it is so gradual, as is the transition from light to darkness in Kabakov's installations: it is impossible to pinpoint where one ends and another begins.

Sorokin's works thus display different modes of writing within the space of a single text, organizing them according to an economy of "readability" similar to the economy of "visibility" operating in Kabakov's installations. Moreover, the sphere of the unconscious, submerged (or rather, produced) by Soviet censorship, is endowed with maximum readability, for the "Soviet" blocks of text are read primarily as a prelude to "what is going to happen." All of Sorokin's works may be seen as generally exploiting the devices of suspended (mis)recognition (Freud's *Aufschub,* Derrida's *différance*) and of defamiliarization, as analyzed by Viktor Shklovsky on the example of erotic puzzles.[6] In other words, the priority of the conscious over the unconscious is inverted: the erotic rituals of the Other, their programmatic literariness notwithstanding, are read more closely than the seemingly trite and banal "Soviet" texts.[7] As a result, it is precisely the Soviet/Russian which turns out to be the unconscious of the text itself, since it is "overlooked" by the reader in the process of reading—hence the potential for inversion when the Soviet rites-of-industrial-production discourse is charged with an even stronger energy of desire and infused by an even greater fascination with the Other than the conventional and long-since literarily codified erotic practices. This inversion had already been explicitly developed by Sorokin in his early novel *Tridtsataia liubov' Mariny* (Marina's Thirtieth Love), whose heroine turns to the most intense Socialist labor as the most ecstatic manifestation of her erotic unconscious. Later, Sorokin began to gravitate more and more toward German National Socialism, treating it as an extremely eroticized form of Soviet totalitarism and thereby using the zone of the unconscious and desire to locate, as it were, the East in the West.[8]

In the framework of modernist aesthetics, literary writing was considered pure, autonomous text. Postmodern aesthetics, by contrast, tends to read literary texts as manifestations of desire that appropriate everything this desire might wish for. There is a certain blockage, some repression or frustration, of the totality of desire in Sorokin's texts, but one which has nothing to do with the classic frustration caused by the repressive effect of the "reality principle." Repression emerges, rather, at the level of the text per se, although it may be a real trauma caused by the Soviet boundary (i.e,

the impossibility of its transgression) that is reproduced by literary means. The peculiarity of the boundary (and its transgression) in Sorokin's prose is determined by the fact that this boundary is not between desire and its object but always between desire and lack of desire, although it is impossible to tell on which side of the boundary each is located. The "Soviet" text either looks like "just a text," that is, neutral vis-à-vis any desire, or manifests desire in an extreme form. The same ambiguity defines the status of the "non-Soviet" text, subject to the same economy of desire. Sorokin's works therefore function as a space of continuous comparison between desire and non-desire while at the same time problematizing the boundary between them—the space of the text itself being construed as neutral vis-à-vis both possibilities. In this way Sorokin's texts resemble Kabakov's installations, which thematize the relation of the visible to the invisible.

While the very space of Kabakov's installations or Sorokin's texts is programmatically de-ideologized, the Medical Hermeneutics group (e.g., Sergey Anufriev, Pavel Peppershteyn) plays with possibilities of "artificial ideologies." These do not claim to describe extratextual reality, but rather are a means by which texts or installations can be placed in a Russian literary or broader cultural tradition of fictitious contexts of comparison where anything can potentially be compared to anything else. Medical Hermeneutics texts and installations often explicitly work with the "myth of Russia," as their emblematic installation "To Beat with an Icon against a Mirror." It represents, rather aggressively, the opposition (formulated earlier by Pavel Florensky in *Iconostasis*) between the "materiality" of the Byzantine-Russian icon and an "illusory" or "mirrorlike" Western reflection.[9] In the installation, the icon is positioned with its blunt end toward the mirror ("the West") so that "the Russian" cannot be imaged in the mirror of Western reflection. At the same time, however, the icon is suspended from the ceiling in such a way as to constantly threaten to break the mirror: the clash of the West with Russia is made possible only as the death of reflection, an act of pure destruction. In their novel *Mifologicheskaia liubov' kast* (The Mythological Love of the Castes), Anufriev and Peppershteyn thematize Russia's mythic war with the West, which becomes, at least on Russia's part, a continuous, unreflective delirium.[10]

In works by the Medical Hermeneutics group, the boundary between the West and Russia, the conscious and the unconscious, the visible and the invisible, acquires the frontline quality of an ongoing military action. At first glance, the theme of the border appears to be especially pronounced

and radical. But that boundary is actually being erased, given that war is inevitably a form of communication. Even more importantly, for Medical Hermeneutics, Russia and the West differ in their natures, so from the very outset the boundary between them links rather than separates them. The presence of the border in these works is most acutely felt where it is not motivated in any way—just as it is in Kabakov's installations, where the same things lie on either side of the border. This is why Medical Hermeneutics works, referring as they do to the long history of the "myth of Russia" vis-à-vis the West, are in the end (and despite their seemingly aggressive character) a therapeutic experience of the boundary between the Soviet and the non-Soviet, or the Russian and the Western.

The strategies of post-Soviet Russian postmodernism, then, are primarily characterized by the constitution of a borderline between the Soviet-Russian and non-Soviet Western; indeed, it is against this boundary that these strategies invariably measure themselves. Their fate will thus depend, first and foremost, on the fate of Western cultural institutions. Should these institutions prove stable enough, Russian postmodern art may well be incorporated by them as a particular version of "high" international postmodernism which has appropriated socialist mass culture, with the style-and-a-half character of socialist realism thereby ignored. *Sots art* could then act as a conduit for the museification of the "formless" and consequently "invisible" Soviet-Russian culture, in that it would be endowed with an aesthetic form assimilable by contemporary or postmodern museums. In that case, the aspiration of Russian art to create autonomous, artificial, noninstitutional contexts of comparison would be consigned to oblivion, as were the works of the Russian avant-garde, which in their time were read not as life-affirming, constructive, utopian projects but merely as examples of radical formalism.

On the other hand, if the institutions of "high culture," unable to withstand the pressures of the contemporary mass media, collapse in turn (which is not unimaginable), the strategies of noninstitutional "high art" may well be brought to the fore. Actually, as is usually the case, both things are more likely to happen at once.

—Translated by Julia Trubikhina

Notes

1 Boris Groys, *The Total Art of Stalinism: Avant-Garde, Aesthetic Dictatorship, and Beyond* (Princeton, 1992).

2 For examples of this strategy, see Clement Greenberg, "Avant-Garde and Kitsch" (1939), in *The Collected Essays and Criticism* (Chicago, 1986), 1: 5–22; see also Theodor W. Adorno, *Ästhetische Theorie* (Frankfurt a.M., 1970).

3 For a discussion of artistic heritage, see Boris Groys, "The Struggle against the Museum; Or, The Display of Art in Totalitarian Space," in *Museum Culture: Histories, Discourses, Spectacles,* ed. Daniel J. Sherman and Irit Rogoff (Minneapolis, 1994), 144–62.

4 See the catalogue *I. Kabakov "Noma": Kunsthalle Hamburg* (Stuttgart, 1993).

5 See, for example, Ilya Kabakov's installation "Das Leben der Fliegen" in *Katalog einer Ausstellung im Kunstverein Köln* (Stuttgart, 1991).

6 See V. Shklovskii, *Gamburskii schet* (The Hamburg Score) (Moscow, 1994).

7 See V. Sorokin, *Norma* and *Roman* (Moscow, 1994).

8 See V. Sorokin, *Monat in Dachau* (Zurich, 1991).

9 See "Inspektion Medhermeneutik 'Die Ikone gegen den Spiegel schlagen,' " in *Fluchtpunkt Moskau: Katalog einer Ausstellung im Forum Ludwig, Aachen,* ed. Boris Groys (Stuttgart, 1994), 134–35; and Pavel Florenskii, *Stat'i po iskusstvu* (Essays on Art) (Paris, 1985), 193–316.

10 S. Anufriev and P. Pepperstejn, "Die mythogene Liebe der Kasten," *Schreibheft* (Essen) 41 (1994): 3–18.

Greg Castillo

PEOPLES AT AN EXHIBITION

Soviet Architecture and the National Question

A highly decorated Soviet *belletrist* of the 1970s tucked this apparent non sequitur into his salute to the traditional folk arts of Kazakhstan: "Socialism has long . . . proved that the more intense is the growth of each national republic, the more apparent becomes the process of internationalization."[1] The passage is from the memoirs of the chief administrator and, in a late literary career, official chronicler of the Virgin Lands campaign: Leonid Brezhnev. Embedded in his cultural observation is the Soviet paradox of national identity as the driving force of an emerging multinationalism. In the Kazakhstan Brezhnev knew in the 1950s, this dialectical logic was more than just a paper exercise. New architectural ensembles at any number of administrative centers provided tangible evidence of the concurrent flourishing and merging of national cultures. It could be seen in Alma Ata's Academy of Sciences, designed by the creator of Lenin's tomb, Alexei Shchusev, and finished in 1953, or at the 1951 apartment block designed by A. Leppik for the Kazakh Council of Ministers. Both of these buildings merged an exotic vocabulary of details adapted from local folk art and archaeology with the Stalinist lingua franca of monumental neoclassicism. The resulting design dialect was indisputably Soviet yet recognizably regional.

The cultivation of an All-Union architecture sprouting with national variants is customarily attributed to the aesthetic mandates of "high" Stalinism, and with good reason. Under Stalin's rule the maxim "national in form, socialist in content" came to embody all that was considered progressive in art. But while that well-known equation marked the high tide of the Soviet preoccupation with national form, it does not explain the focus on national styles that distinguished architectural practice outside the Russian republic in the early 1920s or why that stylistic discourse remained important to Soviet architects long after de-Stalinization.[2]

A Stalinist cultural doctrine of prerevolutionary ancestry was pivotal to the development of socialist realism, providing continuities between its practices and those that preceded and followed it. Stalin's nationalities

policy—the focus of his first test as a scholar and of his first administrative position at the helm of Narkomnats (the People's Commissariat of Nationality Affairs)—was that doctrine. In the arena of national expression, Stalin's formative influence on Soviet architecture thus predated by decades his socialist realist debut as "the First Architect and Builder of our Socialist Fatherland," the honorific bestowed upon him at the 1934 Congress of Soviet Architects.[3]

The construction of Soviet national identities was, in a literal sense, an exhibitionistic pursuit. World exhibitions served late nineteenth-century Europe as laboratories for experiments in style, as sites where nationalism was fashioned into architectural spectacle. Soviet exhibitions, overlooked in the scholarly literature on the culture of world's fairs, also displayed peoples and nations side by side for popular comparison.[4] Three Moscow expositions, of 1923, 1939, and 1954, were culture-hearths for architectural innovation. They constitute a time line tracing Soviet national expression from its NEP-era birth, through a socialist realist adolescence, to its postwar apotheosis. Soviet exhibitions used ethnographic imagery to display the axioms of the nationalities policy, unintentionally revealing its internal tensions as well. Fairground architecture was expected to link each member of the family of socialist nations with an identifying style and weave the results into a harmonious ensemble of pavilions: a project that simultaneously acknowledged and disarmed nationalist sentiments in a multinational state.

Stalin's first pronouncements on nationalism were forged in the heat of a bitter prerevolutionary conflict. His 1913 treatise, *Marxism and the National Question,* was commissioned by Lenin as a rebuttal to Austro-Hungarian and Polish Marxists who had broken ranks with the Bolsheviks over this issue. Stalin asserted that nationalism came in two basic models. "Dominant-nation chauvinism," which the Bolsheviks ascribed to Imperial Russia, bolstered colonialism and was historically retrograde; in contrast, the "oppressed-nation" variety was characterized by a struggle for independence that could be enlisted in the larger project of dismantling capitalism. Such a distinction between Russian and non-Russian nationalism shaped the course of Soviet architecture. One consequence was a taboo on recycling the imagery of medieval Muscovy, the standard point of departure for the Russian Revival style of the previous century.[5] This tacit ban was upheld by the Soviet architectural profession with few exceptions until the 1940s.[6] No such prohibition applied to non-Russian architectural

motifs, however, many of which were showcased at Moscow's Agricultural and Cottage Industries Exhibition in 1923, the year after the Union of Soviet Socialist Republics was formally chartered. Less than a mile from the Kremlin, on the site of a former municipal rubbish dump at the edge of the River Moskva, this exhibition amounted to the new federation's first architectural portrayal.

A feeble economy and the consequent need to promote cash exports help explain why the Soviet state, innocent of postwar reconstruction, would choose to underwrite a village of temporary pavilions as its first large-scale architectural project. The 1923 exhibition was one facet of a foreign policy designed to pitch Soviet products to ideological foes. With Western capitalists ranking high among the fair's intended audience, guidebooks were printed in English, French, and German; multilingual signage was the norm; and plenty of interpreters were available to assist the visiting businessmen.[7]

An old guard of Muscovite architects was responsible for design co-ordination. Ivan Zholtovsky's site plan, much indebted to the tradition of late nineteenth-century world expositions, was adopted almost unchanged from a competition sketch done in 1922.[8] It featured clusters of pavilions separated by landscaped buffer zones, conventionally explained as a precaution against the spread of fire among the wood and stucco constructions. This spatial organization was part of a long-standing exhibitionary tradition, not just a fire-safety precaution. The fair's pavilions were divided into ten thematic groups organized around agricultural production and various categories of manufacture, with a separate category for faraway republics. Here Zholtovsky's layout rehearsed the site-planning formula pioneered in the Paris Exposition of 1889, which became a standard for imperial fairground celebrations. In its segregation of displays of modernity from those of "primitivism" and the exotic, the socialist world's first fair conformed to the practices of Western colonial exhibitions.

In the fairground zone known as the "foreign section," Russian architects blended ethnography and fantasy to represent non-Russian republics (Figure 1). Asiatic shrines, palaces, and even a medieval mausoleum were conjured up for sightseers. Azerbaijan's pavilion and one designed for Turkmenia by the ancien régime architect Fyodor Shektel both featured a multistory *iwan* entryway reminiscent of a mosque's main portal. As in colonial expositions, Islamic imagery here was stripped of religious content and exploited for its mystery. Parallels with colonial exhibitions were also underscored by the rhetorical gestures of the fair's guidebook:

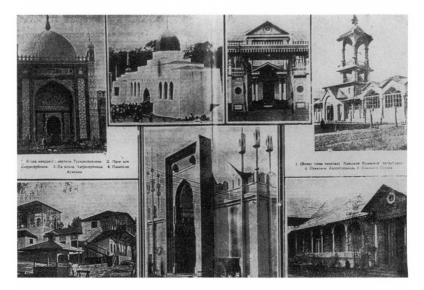

Figure 1. Pavilions of the Foreign Section, Agricultural and Cottage Industries Exhibition, Moscow, 1923. Above (left to right): Turkmenia (F. Shektel), Kirgizia, Tataria, Armenia; below (left to right): Crimea, Azerbaijan, and Georgia. Reproduced from S. Khan-Magomedov, *Pioneers of Soviet Architecture* (New York: Rizzoli, 1987).

The majestic ancient mosques of Samarkand . . . ; the white minarets of Azerbaijan; a colorful Armenian tower; a strikingly Oriental building from Kirgizia; a solid Tatar house covered with grillwork; some picturesque chinoiserie from the Far East; and further on the yurts and *chums* from Bashkiria, Mongol-Buriatia, Kalmykia, Oiratia, Yakutia, the Khakass, the Ostiak, and the Samoyed; all of it surrounded by the artificially created mountains and villages of Dagestan, the Caucasian Highland Republic, and Chechnia.[9]

Whereas Russia's traditional village life was illustrated in an exhibit showing its transition to modern labor in the new agricultural cooperatives, agrarian life in the foreign section was presented as an anthropological *tableau vivant,* or played for entertainment value. These built expressions of the discourse now called Orientalism provided contrasting experiences of culture at the core and at the periphery of the realm. As exegetes of colonialist practices have noted, this exhibitionary trope also guided visitors at nineteenth-century world's fairs to a standard set of conclusions about the nature of progress and the right to rule.[10]

The Russian republic itself was not represented by a dedicated pavilion at the Agricultural and Cottage Industries Exposition, an absence that would become something of a Soviet exhibitionary tradition. This is not to say that Russia went unrepresented, architecturally speaking. As the hearth of socialism, Russia's cultural signature was indistinguishable from the Soviet project of defining and heralding the future. In contrast to the stucco exoticism representing non-Russian cultures, the remainder of the exhibition featured architectural icons of modernization. The fair's main entrance was through a triumphal arch, rendered in skeletal form, bracketed by a banking tower and neoclassical temple fronts. Beyond were pavilions dedicated to such themes as transportation, culture and education, and science and enlightenment. The kiosk designed by architect Boris Gladkov and sculptor Vera Mukhina for the newspapers *Izvestiia* and *Krasnaia niva* was spun from the forms and materials of modern industry (Figure 2). Exhibition galleries were decorated with murals executed by some of the brightest stars of the Soviet avant-garde, including Alexander Rodchenko, Lyubov Popova, and Alexandra Exter. These accomplishments would be described by the Constructivist theoretician Moisei Ginzberg in his influential *Style and Epoch* as "reflections of the new style in the works of Russian architects." [11]

The Soviet nationalities policy of *korenizatsiya* (literally, "taking root") was instituted in the summer of 1923, shortly before the Agriculture and Cottage Industries Exhibition opened. Promoted as the antidote for "Great-Russian chauvinism," it nurtured the development of native Communist elites in the non-Russian republics and was geared toward replacing reactionary traditions with conceptions of local culture consistent with Soviet multinationalism. The representations of non-Russian culture displayed at the 1923 exhibition, with their colonialist undertones and Orientalist veneer, may seem inconsistent with the progressive goals of that nationalities policy, but in fact they underscored two axioms of korenizatsiya. The first was an overt acceptance of Russia's superiority, as measured developmentally, while the second concerned making amends for that condition by means of the classic colonialist rationale of a *mission civilatrice* — in this case, freighted with socialist content — to disseminate the dominant nation's vision of progress. Both axioms are evident in a remark made by Stalin in 1921, speaking in his capacity as the head of Narkomnats: "The essence of the nationality question in the USSR consists of the need to eliminate the backwardness (economic, political, and cultural) that the nationalities have inherited from the past, to allow the backward

Greg Castillo

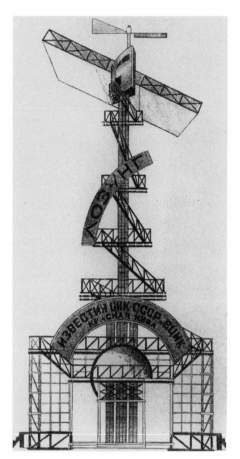

Figure 2. Pavilion of the newspapers *Izvestiia* and *Krasnaia niva;* designers: B. Gladkov and V. Mukhina, Agricultural and Cottage Industries Exhibition, Moscow, 1923. Reproduced from S. Khan-Magomedov, *Pioneers of Soviet Architecture* (New York: Rizzoli, 1987).

peoples to catch up with central Russia."[12] Narkomnats pursued its objectives through the dialectical process outlined by Stalin in 1912: that is, the nationalities would be readied for their eventual rapprochement (*sblizhenie*) and merger (*sliyanie*) with Soviet society by encouraging their socialist specificities.

The policy's distinction between the different cultural tasks facing Russia and its less-developed neighbors was paralleled in a bifurcated architectural practice during the NEP era. While modernism brewed at Moscow's Vkhutemas (a state-subsidized avant-garde studio—sort of a Soviet Bauhaus), designers at the periphery continued to devise national architectures based on regional traditions, much as they had before the Revolution.[13] The indigenous styles of Transcaucasia and Soviet Central Asia were heavily indebted to forms associated with Islam. An Azerbaijani Revival

96

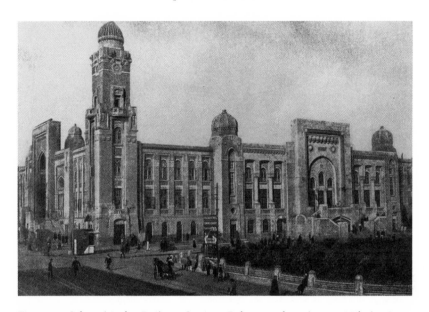

Figure 3. Sabunchinsky Railway Station, Baku, 1926; architect: Nikolai Baev. Reproduced from S. A. Dadashev and M. A. Useinov, *Arkhitektura Sovetskogo Azerbaidzhana* (Moscow: Gosudarstvennoe Izdatel'stvo Arkhitektury i Gradostroi-tel'stva, 1950).

style that incorporated elements of the fifteenth-century Shirivan style was tested in the work of Nikolai Baev, whose 1926 design for Baku's Sabun-chinsky Railway Station included lanceolate arches, pointed domes, and the framed portals known as *peshtaks* (Figure 3).[14] Ornament associated with early Christian architecture was utilized by Alexander Tamanian to concoct an Armenian style. His interpretation of architectural koreniza-tsiya merged this locally derived decoration with the compositional rules of Russian neoclassicism, a synthesis that he developed in his commissions for the Erevan Opera House (1926) and the regional headquarters of the People's Commissariat for Agriculture (1927–28). Both exemplars proved uncannily predictive of the formula for national architectures codified a decade later under the rubric of socialist realism.[15] A national style based on the Baroque was popularized in the Ukraine by a group led by Dmitry Diachenko. Ornamental stucco brackets, volutes, and cornices decorated his Forestry Institute (1925–27) and Agrochemical Institute (1927–30) at Kiev's Agricultural Academy.

The First Five-Year Plan brought Soviet architecture's festival of native

ornamentation to an abrupt close.[16] Plan visionaries called for "the actual-ization into practice (of) all that, until recently, was fantasy and utopia."[17] Assisting in that project were a host of international design luminaries: the French Modernists André Lurçat and Le Corbusier, Frankfurt's social housing director, Ernst May, and Bauhaus pedagogue Hannes Meyer.[18] Their colleagues back in the capitalist world, where architectural practice remained stalled by the building downturn of a global depression, were kept abreast of developments in this Modernist proving ground through the international press. The Great Transformation redefined the USSR as the site where the future would be determined and thus stripped exhibi-tions of their proprietary hold on architectural innovation. In effect, the entire country was becoming an international exhibition — or so it seemed from the state's promotional imagery.

The new era's enthusiasts called for the elimination of all forms of back-wardness: economic, technological, social, and cultural.[19] The past and all of its emblems were to dissolve in the span of a decade. Slated for extinc-tion was the fawning traditionalism reflected in the foreign pavilions of the 1923 exhibition as well as a host of retrospective, republic-specific design modes.

The architectural language of Stalin's Great Transformation was Mod-ernist and, more often than not, Constructivist. These modes were dissemi-nated in the republics through newly established schools of architecture modeled on the lines of Moscow's Vkhutemas, through well-publicized competitions, and the efforts of a radicalized student body. The nationali-ties question, with its insinuation of fracture along ethnic and geographic lines, was being overshadowed by a discourse of class and generational conflict. National styles and their proponents were seen as the suspect products of a prerevolutionary design establishment, an attitude reflected in the comments of a disgruntled architecture student at Kharkov's Artis-tic Polytechnic: "Our problem is that Narkompros (the Commissariat of Enlightenment) decided to 'Ukrainianize' the polytechnic and therefore designing has to be done in Ukrainian style, which comes in two versions: Ukrainian Baroque and Ukrainian Art Nouveau. . . . it is useless to seek help from the school council since they are old-style people of another per-suasion."[20]

Exponents of the new line included the Armenians Karo Alabian and Samvel Safarian, the Azerbaijani team of Sadyk Dadashev and Mikael Useinov, and Stepan Polupanov (see Figure 4) of Uzbekistan: designers

Figure 4. Project for a housing commune, Tashkent, 1931; architect: Stepan Polupanov. Reproduced from S. Khan-Magomedov, *Pioneers of Soviet Architecture* (New York: Rizzoli, 1987).

whose reputations would later be made in Moscow. Their studies explored the new building types called "social condensers"—the worker's clubs, mass kitchens, and housing communes intended to speed the transition to a fully socialist society—which they rendered in a crisp, planar vocabulary equally at home in Moscow or Samarkand. Here the rejection of national ornament was uncontaminated by Great-Russian chauvinism: at issue was the unseemliness of architectural symbols that recalled a rank past of religious and "class-alien" exploitation. But this Modernist mission civilatrice carried a conflicting message. The stylistic rapprochement and merger of Soviet architectures struck some critics as a purge of regional sensibilities. In Armenia and the Ukraine, the rejection of national styles by cadres of young Moscow-trained architects touched off fierce debates within the profession.[21]

Soviet modernism was short-lived, with the cultural revolution's backlash, socialist realism, ensconced by 1932 as the keystone of Soviet art. Rapprochement and merger now acquired a new meaning for architects. Quarreling design factions were dissolved by mandate and combined into

a monolithic "All-Union" institution in 1932, a reorganization consonant with the goals of rationalizing production under a system of centralized management. The creation of "socialism in one country" now demanded a certifiably Soviet mode of expression, something that the international language of Modernist forms could not provide. The resources of world culture would supply the raw material for a Soviet summation of all that was progressive in architecture. In the West, where an international Modernist movement was still in a delicate stage of incubation, influential architects and critics recoiled in horror at the ensuing banquet of recycled classicism.[22]

Socialist realism called on artists to develop an idiom that would be "national in form, socialist in content." How this aphorism was to be translated into *built* form was by no means obvious. Ideological ambiguity exerted a mutagenic influence on style, collapsing Soviet architecture's past, present, and future tenses. Modernism's floating planes and ramps were surfaced to resemble cut-stone construction at Evgeny Levinson's Lensovet residences of 1931–34, yielding a surreal and weightless monumentality. Ivan Fomin labored to invent a "Red Doric order" for his stripped and spartan "proletarian classicism," while others opted for historical revivals. Egypt, Pompeii, and Renaissance Florence began to leave their mark on Moscow's reconstructed boulevards. In Baku, Lev Rudvinev's 1934 essay into socialist realist regionalism for the local House of Soviets combined Palladian loggias from the Italian Renaissance with lanceolate arches and hexagonal windows of exotic pedigree (Figure 5). The confusion about what constituted a national heritage was well-founded. While Azerbaijani designers were being exhorted to learn from the treasure-house of native tradition, the millennial shrine of Bibi Eyat, just outside Baku, was dynamited and backfilled as part of a road construction project.[23]

Socialist realism's call for national form was answered persuasively in the late 1930s at a site near the village of Ostankino, north of Moscow. There, at the All-Union Agricultural Exhibition, or VSKhV (*Vsesoyuznaya Selskokhozyaistvennaya Vystavka*), Stalinist architecture emerged from its state of flux and settled on formulas that, for the first time, established reproducible norms for practice. This is not to say that the architectural aesthetic of high Stalinism now emerged full-blown. It was culled from a diverse field of entries, each of which was evaluated for its suitability as an expression of the Stalin era.

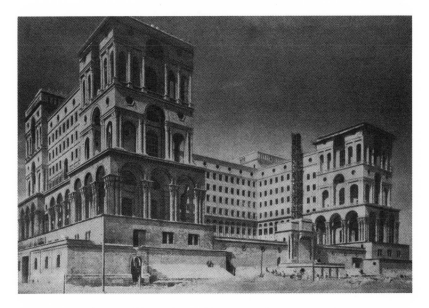

Figure 5. Azerbaijan SSSR House of Soviets, Baku, 1934; architect: Lev Ru-dvinev. Reproduced from S. A. Dadashev and M. A. Useinov, *Arkhitektura Sovetskogo Azerbaidzhana* (Moscow: Gosudarstvennoe Izdatel'stvo Arkhitektury i Gradostroitel'stva, 1950).

According to the official genesis myth, the vskhv owed its existence to the Second All-Union Congress of Collective Farm Shock Workers. Delegates were said to have lobbied for a showplace for collective agriculture, which was duly approved by Stalin in February 1935. Initially conceived as a pilgrimage site where collective farmers and champions of socialist labor could absorb the latest developments in agriculture,[24] a second programmatic mission soon eclipsed the park's function as a model farm and training grounds. Agricultural attractions were pushed to the rear of the exposition site, occupying a position comparable to that of the foreign section at the 1923 fair, and visitors arriving through the main gates were led to a *cour d'honneur* surrounded by regional and national pavilions. The exhibition became known and celebrated as a shrine to the cultural commonwealth.

Exhibition architecture was again called upon to play its familiar role as a medium for portraits of national culture. Of the fifty-two main pavilions, twenty-two were dedicated to individual Soviet republics and autonomous territories. Successful designs were said to embody the true spirit

of a people, their joy and the trajectory of their progress. Failure to express this was framed as a form of deviance, even betrayal. In the culture of high Stalinism, beauty, patriotism, and correct class consciousness were inextricably entwined. The facile connoisseurship that insists upon lumping together all Stalinist buildings as identical exercises in "coercive and boring symbolism" must be disregarded if we are to reconstruct the politically freighted discourse of Stalinist aesthetics.[25] Only then can we make sense of the cycle of design, censure, demolition, and reconstruction that produced the vskhv and that designated individuals as either major talents or saboteurs.

The exhibition was slated to open in 1937, the year that would be remembered as the climax of the Great Purge. Its terror also swept the site of the vskhv. A special government committee appointed to look into construction delays found the exposition riddled with defects in planning, design, and decoration. One of those accused of being a "wrecker" and subsequently arrested was the chief architect, Vyacheslav Oltarzhevsky. A former New York City resident and a champion of the American skyscraper, Oltarzhevsky was a high-profile architect with a high-risk past. His Pavilion of Mechanization, crowned by a slender tower of geometric setbacks that recalled the high-rises he had penned in Manhattan, was denounced for blocking views and distorting impressions of scale.[26] Just as the pavilion was nearing completion, its demolition was ordered, and it was replaced with a hangar-like vault, open at both ends to allow unimpeded sight lines along an axial vista.

Another scandal involved the national pavilions arrayed around the vast central space of "Kolkhoz Square." Most of these were "filled with grave architectural errors," and all were judged too small for the site. A fifty-percent increase in height was achieved through extensive remodeling of the façades.[27] The streamlined USSR theme building, rendered in an Art Deco idiom by the celebrated design team of Vladimir Gelfreich and Vladimir Shchuko, was one of many declared "primitive and schematic." Rehabilitation efforts entailed the reconstruction of its tower to serve as a pedestal for heroic statuary and the liberal application of frescoes and bas-reliefs.[28]

The vskhv's main entrance, also found wanting, was demolished and rebuilt to a more acceptable standard of beauty. The new version featured the monumental sculpture *Worker and Collective Farm Woman* by Vera Mukhina and Boris Iofan, which had crowned the Soviet pavilion at the

Paris Exposition of 1937.[29] Reconstruction of the main entrance was still in progress as the exhibition gates opened to the public in August 1939, two years behind schedule.

Despite the debacle of disruption and reconstruction, the All-Union Agricultural Exhibition was hailed by the press as one of the great works of the Stalin era, along with Moscow's Metro and the Volga–White Sea canal. Georgy Golts, a leading neoclassicist, cited these monuments as proof positive that Soviet designers finally possessed "a good and true architecture of our own."[30]

As in 1923, Russia again lacked its own national pavilion at the VSKhV and was represented as a dismembered collection of parts. Separate structures were dedicated to Leningrad and the Northwest, Siberia, the Soviet Arctic, the Central Region, the Volga Region, and to a combined Moscow, Tula, and Ryazan. None of these pavilions received more than lukewarm praise from the architectural press, and all of them—as well as Shchuko and Gelfreich's USSR theme pavilion—were demolished or remodeled beyond recognition after the war. Taking that fate into account, the Russian pavilions can be construed as comprising a sampler of design approaches that were ultimately jettisoned from socialist realist practice. A checklist of rejected attributes would include exterior trusses and exposed metal structural members, stripped or abstracted neoclassicist features, Art Deco compositions and detailing, and Modernist asymmetry. Although enthusiasts wrote that the "miracle city" of 1939 disproved the vulgar notion that socialism resulted in a loss of national culture, in the case of Russian national architecture that culture had yet to be found.

On the other hand, stunning design successes were boasted by some of the non-Russian republics. Uzbekistan's pavilion, by Stepan Polupanov, was praised in several design journals as the best of its class (Figure 6). Georgia's, by the design team of A. Kurdiani and G. Lesava, netted its principal designer the 1941 Stalin Prize for Architecture. Also top-rated were Azerbaijan's pavilion, by Sadyk Dadashev and Mikael Useinov, and Armenia's, by Karo Alabian and Samvel Safarian. These pavilions were spared the radical postwar remodeling to which most exhibition structures were subjected. Considered genuine contributions to the development of their respective national cultures, they were reconstructed with their original design for the most part preserved.[31]

The compliment marked a complete volte-face in five architectural careers. Polupanov, Dadashev, Useinov, Alabian, and Safarian had first

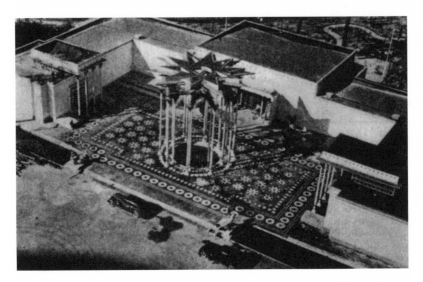

Figure 6. Uzbekistan Pavilion at the VSKhV, Moscow, 1939; architect: Stepan Polupanov. Aerial view reproduced from Arthur Voyce, *Russian Architecture* (New York: Philosophical Library, 1948), plate CLXXVIII.

made their mark during the Great Transformation with a Modernist idiom intolerant of the regional motifs that now spelled success. The architecture of the late 1930s was, of course, anti-Modernist by decree. But the specific regionalist modes developed by these converts to socialist realism were only partially motivated by Party proclamations. Regionalism was also the by-product of an institutional power struggle in which nationalism was mobilized as a weapon in the contest for state commissions.

Moscow's host of independent architectural factions had been consolidated into a single Union of Soviet Architects in July 1932, but this new-found unity existed only on paper. The organization was riven by disagreements about officers and administrative policies.[32] At a meeting held in the autumn of 1934, a circle of ambitious Transcaucasians led by Karo Alabian denounced Russian members of the Soviet design establishment as Great Russian chauvinists. Arguing for a conception of Soviet architecture that would ensure a niche for non-Russians in a field still dominated by Russian talent, Alabian claimed that national audiences were the only legitimate arbiters of socialist art and that national styles were the only possible medium through which to reach them.[33] Through "equal opportunity"

provisions bequeathed by korenizatsiya, non-Russians came to outnumber their Russian colleagues on the presidium of architecture's first All-Union Congress in 1937. Alabian's new position at the helm of the Union of Architects was of great portent in the struggle to define architectural practices consistent with the motto "national in form, socialist in content."

A specific recipe for such an architecture emerged at the highly acclaimed exhibit "Soviet Folk Art" held in the spring of 1937 at Moscow's Tretyakov Gallery. There, the gallery was the canvas. Craftsmen painted directly onto walls and doorframes in a purposeful experiment. Miniaturists from Palekh tried their hand at frescoes, and for the first time woodcarvers from Kudrin worked at the inflated scale of architectural features. Critics predicted that this creative adaptation of regional ornament would yield a new Soviet style that, properly tailored to monumentality, would someday adorn the interiors of the skyscraping Palace of the Soviets.[34] The press instructed architects to take note.

The designers of the most highly praised buildings at the VSKhV did exactly that. Two thousand master craftsmen were brought to the fairgrounds from their native lands to work alongside architects on the national pavilions. While both the professional and the traditional designers quoted vernacular forms, they did so creatively rather than slavishly, according to glowing contemporary accounts. Design elements were simplified, and religious symbols avoided, while new socialist content was injected into folk motifs. At the Uzbek pavilion, a ten-pointed star motif alluded to a traditional eight-pointed design, but with its two superimposed and slightly rotated five-pointed stars, it now echoed the famous symbol of Soviet power. The abstract foliage patterns of traditional ornament were rendered here as cotton plants and grapevines, reflecting the transformation of agriculture.[35]

Vernacular building types were charged with new symbolic meaning as well. The point of departure for the Uzbek pavilion was a traditional courtyard dwelling arranged around a central water basin. Polupanov's design glorified this inner yard, surrounding its pool of water with a carpet-patterned mosaic terrace and crowning it with a polygonal trellis supported by delicate columns. "Antiquated and reactionary" aspects of Islamic life—the segregation of women from men and from the public realm—were expunged from the original building form by peeling away one of its sides so that the courtyard now opened directly onto the street.[36] Within the pavilion's richly decorated interior, a panoramic landscape

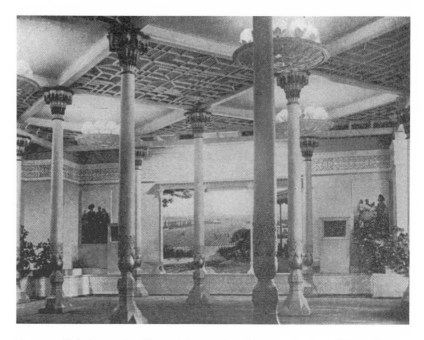

Figure 7. Uzbekistan Pavilion at the VSkhV, Moscow, 1939; architect: Stepan Polupanov. Photograph of interior reproduced from Arthur Voyce, *Russian Architecture* (New York: Philosophical Library, 1948), plate CLXXI.

mural framed a view of the Central Asian countryside (Figure 7). An architectural journal described the experience as that of being inside "a house where the hostess invites guests to see the beauty of the sunny country, its fields full of tractors, (and) precious cotton."[37]

The calculated revision of vernacular form to create an image of a progressive, socialist Uzbekistan inverted the tropes of Islamic exoticism deployed at nineteenth-century colonial expositions. There, the visitor was allegedly exposed to native culture in its unadulterated form; at the VSkhV, however, pride was taken in the overt manipulation of tradition. Where colonialist representation had fetishized the mystery of unintelligible calligraphy and "curious" practices, socialist realist representation domesticated the exotic — by superimposing upon it the conventions of an idealized collective farm and household, in the case of the Uzbek pavilion. And while colonial expositions had frozen native cultures "in an ambiguous and distant past," demonstrating their incapacity for "change and

advancement," the VSKHV depicted exotic national cultures converging at full speed upon a predetermined Communist destiny.[38]

Not all artifacts of vernacular culture, however, were suitable as raw material for socialist realism's construction of a progressive national culture. The toughest challenge faced designers commissioned to create pavilions for republics "without any national traditions in architecture." Bashkiria was often mentioned as one such case of cultural impoverishment.[39] As a seminomadic people, the Bashkir had, in fact, a well-developed tradition of transportable housing that included the "yurts and chums" celebrated in the 1923 fair's ethnographic diorama. But unlike the state-sponsored culture of the 1920s, that of high Stalinism strove "to tie people to their spaces, to settle them down," as Vladimir Papernyi has pointed out.[40] Monumental building traditions were thus the most suitable for recycling as socialist realist architecture. Where these were lacking, the decorative forms of fixed and stable vernacular dwellings—the "true examples of folk art" found in the elaborate window-frame ornament of Karelian cottages, for example—could be applied to classical forms as a regionalizing motif.[41] The shelters of a nomadic life, on the other hand, were too retrograde, both economically and culturally, to constitute the basis for a national architecture. At the VSKHV, the quandary of a national pavilion for Bashkiria produced a mixture of ethnographic, industrial, and agricultural metaphors. Above the crenellated walls and domed chambers of something resembling a desert caravansary rose a conical cupola which suggested an oil derrick to one architectural reviewer. The tower was embellished with slender columns and a mural depicting the Bashkir harvest festival.[42] The architects responsible for the Bashkiria pavilion, along with those of Kirghizia and Kazhakstan, were congratulated on their skillful detection of the "faint national features" found in embroideries and carvings and their application to built form: the first step in establishing new cultural traditions.[43] All three of these pavilions were rebuilt in strikingly different interpretations of national culture for the postwar reopening of the exhibition.

Soviet histories of the 1930s condemned Russian capitalism for burying local craft in an avalanche of cheap manufactured goods. That process "drew the Transcaucasus into world commodity circulation, wiping away its local characteristics, ruining its ancient handicraft industries, turning it into a market for manufactures." [44] By contrast, the socialist realist resuscitation of regional culture did indeed perpetuate folk art, but commodi-

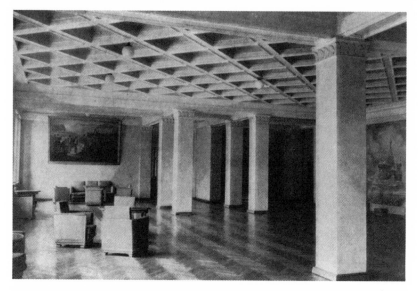

Figure 8. Interior, Marx–Lenin–Engels Institute, Tbilisi, 1933–38; architect: Alexei Shchusev. Reproduced from Akademia Nauk SSSR, *Proizvedeniia Akademika A. V. Shchuseva Udostoennye Stalinskoi Premii* (Moscow: Izdatel'stvo Akademii Nauk SSSR, 1954).

fication operated here, too, in a colonial model of exchange applied to cultural production. Local traditions, in the persons of regional craftsmen, were shipped from the colonial periphery to Moscow, where the raw material of vernacular form was processed. Extraneous content was removed, leaving a picturesque residue that could be blended with Soviet symbols. Architects would then apply this synthetic cultural compound in regulated amounts to an organizing matrix of neoclassical form. The colonial cycle of exchange was completed when the new product was shipped back to its peripheral point of origin as a new national architecture.

That the vskhv formula for national style found immediate application in the non-Russian republics can be demonstrated by a comparison of two important public buildings, one in Georgia and the other in Uzbekistan. Both commissions were awarded to the Russian architect Alexei Shchusev. Tbilisi's Marx–Lenin–Engels Institute (Figure 8), the result of a 1933 competition, was completed in 1938, a year before the vskhv opened; Tashkent's Opera House was commissioned in 1940 and com-

Figure 9. Craftsman Tashpulat Aslankulov posed with chisel in the Tashkent Opera House. Reproduced from Akademia Nauk SSSR, *Proizvedeniia Akademika A. V. Shchuseva Udostoennye Stalinskoi Premii* (Moscow: Izdatel'stvo Akademii Nauk SSSR, 1954).

pleted in 1947. Although both were celebrated as cutting-edge expressions of national style at their debuts, the period between the two projects was critical in the development of this new working method. That gestation period is not readily apparent on the outside, where both façades recapitulate neoclassicism and judiciously accent it with local detail. But while the interiors of the Marx–Lenin–Engels Institute are typical of early socialist realism's all-purpose neoclassicism, whether found in Moscow or in Merv, those of the Tashkent Opera House seem to be from some other culture — which was precisely the point. In the latter, carved tracery of Persian inspiration scrolls across wall and ceiling surfaces and on hanging light fixtures; ceiling beams are elaborated with honeycomb *muqarnas*. A publicity shot, showing master craftsman Tashpulat Aslankulov posed with chisel beside his commission, reveals how thoroughly the lessons of the 1939 Exposition were learned (Figure 9).

The socialist realist synthesis of all progressive strands of design, proclaimed a Soviet triumph, was received in the West with little more than a shrug. The snub was of little consequence to Soviet architects, however, for their accomplishments now occurred in a bell jar. By the unveiling of

the VSKhV, the policy of cultural autarky established in the early 1930s had come to fruition. The USSR was now an autonomous world composed of many nations and peoples, one that even possessed its own internal passport system. Beyond the edge of the known lay a dangerous terra incognita, and, as in the legends of medieval navigators, any attempt to cross that threshold flirted with death. Policing the boundary was a distinguished duty that gave a special identity to those nations performing the service. Their mission was celebrated in the statues of sentries and guard'dogs that greeted visitors to the VSKhV's Byelorussian and Far East pavilions. Of the latter's façade, a blind rampart topped by swallow-tailed merlons like those of the Kremlin wall, an architectural reviewer wrote: "It is composed of original forms revealing the importance of the Far East Region as the outpost fortress of Soviet defense."[45]

Geopolitical isolation was legitimated in socialist realism's celebration of the USSR as a world unto itself, with its own rich complement of national cultures and identities. That trope was elaborated for *Pravda* by the Danish communist Martin Andersen Neksø, one of the handful of Westerners who visited the 1939 exhibition. He embraced the VSKhV as the cultural pulse of both a people and a planet:

Before us lies an exhibition that, with its 52 pavilions, is reminiscent of a fairy-tale town from *1001 Nights*. . . . Each people of the USSR gets its proper place at the exhibition. Despite the fact that only Soviet peoples are represented there, we get a much wider idea of the whole of mankind than at any international exhibition I have ever been to.[46]

With the outbreak of hostilities in 1941, the Soviet world's fair closed to the public. Wartime deprivations forced it to take up its original agricultural mission. Its gardens were converted to farmland, and, without maintenance, the lathe-and-plaster tributes to national culture deteriorated.[47] After the war, the Central Committee agreed to revamp and enlarge the exposition, which made its debut in 1954. The new, improved VSKhV, built of permanent materials, was to be a lasting monument to the survival and expansion of the multicultural dominion that Neksø had saluted more than a decade earlier.

As the ultimate artifact of Stalinist environmental design, the 1954 fair reprised earlier exhibition themes, refining and amplifying them. The depiction of the USSR as socialist kin gathered in fancy dress was the premise

Figure 10. USSR theme pavilion at the VSKhV, Moscow, 1954; architects: Y. Shchuko et al. The Friendship of Nations fountain is in the foreground. Reproduced from Alexei Tarkhanov and Sergei Kavtaradze, *Stalinist Architecture* (London: Laurence King, 1992), 159, fig. 185.

of a new attraction: the "Friendship of Nations" fountain (Figure 10). Featuring sixteen larger-than-life maidens of gilded bronze—one per republic—arrayed in national costume around a broad red granite basin sprayed by 800 water jets, the fountain represented a family that had grown through annexation by the war's end—so an annex to the fair's Court of Nations had been built to accommodate these new members. An octagonal plaza on the former site of Gelfreich and Shchuko's 1939 USSR theme building, the annex served as the setting for the centerpiece fountain.

All three Baltic states found neighboring homes in the new precinct, where site planning sometimes echoed geography. The Baltic pavilions varied in form and finish, with individual decorative motifs derived from the usual folk sources. Of the trio, only the middle structure, Latvia's pavilion, employed the bilaterally symmetrical façade typical of late socialist realist practice. Estonia's monumental portico was offset to the left, Lithuania's to the right. Viewed from afar, the three idiosyncratic pavilions assembled themselves into a unified and symmetrical composition, a visual

device applauded for its bravura expression of national specificity and collective harmony.

Kazakhstan's new pavilion occupied its 1939 site, but otherwise differed radically from its predecessor. Said to reflect a renaissance of national culture, it revealed as much about the fortunes of Soviet ethnography. The architects who created the original VSKHV had been left largely to their own devices in coming up with progressive interpretations of regional form. Ethnographic scholars were shell-shocked and in hiding in the mid-1930s. Just a few years earlier, the Cultural Revolution's militant academics had attempted to eliminate ethnography as part of the war on archaic survivals. But by the 1940s, the discipline had found a new raison d'être in socialist realism. In the manner of an applied science, ethnography now identified and catalogued phenomena for inclusion in the panoply of progressive socialist culture. It was a job description best suited to the nationals who were its primary beneficiaries, according to some authorities.[48] Thus Kazhakstan could thank its own Academy of Science for the new national style of its pavilion, which was based on archaeological finds that conclusively disproved the notion of the Kazhaks as a people without a monumental past. Between recent discoveries of ancient mausolea and untapped traditions of carpet-weaving and metal-working, experts had recovered enough national form to permit a design team, led by N. Kupriyanov, to create an imposing pavilion reminiscent of a Safavid emperor's tomb. Partially sheathed in majolica, it was crowned by a steel-framed skylight that approximated the shape of the more traditional blue-tiled dome.[49]

Archaisms of Russian extraction were revived in the 1954 exposition as well. Taboos on the icons of Great Russian chauvinism had dissolved during the Great Patriotic War. Recollections of Muscovy resurfaced as early as 1942 in a round of unbuilt designs for memorials to Russian sacrifice.[50] Stalin's 1945 toast "to the great Russian people" made the rehabilitation official. By the decade's end, the pre-Bolshevik history of Russia was being ennobled in text and verse, with a neo-Muscovite architecture following suit. Pre-Petrine architectural motifs were hoisted above Moscow atop a ring of high-rises, their spires copies of the late fifteenth-century towers of the Kremlin wall. The new VSKHV boasted miniatures of both. A white Kremlin-like tower appended to confectionery battlements represented the Central Regions. A more streamlined affair that paraphrased the capital's new crop of high-rises distinguished Moscow's pavilion.

Mainstream socialist realist praxis, however, remained devoted to the

project of reclaiming the global heritage of classicism. That legacy, it was now safe to say, had been parceled out unequally. The richest allotment lay in Russian neoclassicism of the late eighteenth and early nineteenth centuries, a bequest exploited by the team of R. Vegunts and S. Nikulin in a separate pavilion dedicated to the Russian Federation — itself a novelty in the history of Soviet exhibitions. Reviewers found the building's neoclassicism modest and tasteful, but abstained from the "mirror of national character" rhetoric used to praise the fair's more exotic styles. Unlike those national dialects, Russian neoclassicism served a double duty as the lingua franca of late-Stalinist architecture. Its applications could be seen throughout the 1954 exhibition, lending monumental stature to the USSR's theme tower, the pavilions of Leningrad and Byelorussia, and even to the fair's celebrations of collective farming, rabbit breeding, and grain and sugar beet production. From the perspective of national expression, Russian neoclassicism suffered from multiple personality disorder. The blurred and shifting identities incurred through overuse voided any equation of this stylistic Russian Revivalism with Stalin's Great Russian renaissance.

Russia's unresolved national style was the outstanding failure of the symbolic language forged at VSKhV, the one name its *architecture parlante* was never able to associate with a façade. Otherwise, the design method that premiered in 1939, and was recalibrated in 1954, enjoyed a successful (if brief) postwar career at home and abroad. As Moscow's exhibition was being revamped in the early 1950s, other Soviet republics were in the process of creating their own. The Ukraine's permanent exposition, designed by a team headed by Vladimir Orekhov and under construction from 1952 to 1958, is a fairly straightforward transposition of the VSKhV to the Goloseev forest just outside Kiev. Individual pavilions seen at the Moscow fair are quoted fairly precisely, but with one consistent deviation: the substitution of Ukrainian motifs for whatever national ornament graced the originals.

The VSKhV's more consequential legacy can be seen a few kilometers away, in the very heart of the Ukraine capital. At the end of the war, Kiev's main thoroughfare, Kreshchatik, existed only as a paved track through a field of rubble. With German troops still in retreat, Moscow architects Alexei Shchusev and Alexander Vlasov arrived in Kiev to begin reconstruction planning. A three-round competition for the design of Kreschatik was announced in the summer of 1944. The twenty-two proposals submitted by local designers and their colleagues in Moscow and Leningrad demonstrated renewed enthusiasm for Kiev's eighteenth-century "Cossak

Baroque," as well as for Ukrainian folk art. Vlasov's winning plan, on which construction began in 1948, followed those norms as well. For his recreation of the boulevard, ceramic modules embossed with progressive renditions of folk ornament were assembled into the pilasters, friezes, and pediments of a monumental urban ensemble.[51]

The fair's applications went wider still. As advisors on reconstruction projects scattered across a hemisphere, Soviet architects carried the lessons of the VSKHV to Eastern Europe and China, where its formulas became standards for the articulation of the local heritage. The sticky question of East Germany's socialist national identity was resolved with the help of Moscow architects late in 1951. The arrival in East Berlin of Sergei Chernyshev, the city architect of Moscow, and Alexander Vlasov, from the design team responsible for Kiev's Kreshchatik Boulevard, coincided with the climax of a pitched "battle for a new German architecture."[52] The importance of understanding the German national tradition was underscored by the Russian visitors, who chided local architects for adhering too closely to Moscow precedent in their preliminary designs for East Berlin's Stalinallee.[53] German tradition, it was becoming clear, meant the spare neoclassicism of Schinkel and not Bauhaus modernism, as some designers had mistakenly assumed in the late 1940s.[54] Kurt Liebknecht, an architect whose résumé included seventeen years of practice in exile in the Soviet Union, informed his audience at the November 1951 conference of the German-Soviet Friendship Union that the Bauhaus style in fact represented "the height of imperialist cosmopolitanism."[55] From Soviet architectural authority G. Alexandrov, whose comments appeared in East Germany's new architectural journal *Deutsche Architektur,* architects learned that "cosmopolitanism" was a strategy "to disassociate people from their homeland, language, and culture in order to replace it with the 'American lifestyle' so that they would adopt the slavery of American imperialism."[56] The lesson, if not the logic, was clear: Prussian neoclassicism was native and progressive; Weimar modernism was foreign and colonialist.

The built discourse of national style and socialist progress that had been polished through reiterations at Soviet exhibitions served one more postwar mission. Socialist realism was now billed as an architecture of opposition, a counterforce to the imperialist advance of Western modernism—especially the branch that had been cultivated since the 1930s as "the International Style."[57] This battle of styles constituted the Cold War's architectural front. In a group of postwar journals disseminated across Eastern Europe in the early 1950s, socialist realism was promoted as the

savior of regional differentiation, especially of those aspects of local tradition that the International Style had resolved to throw away.[58]

The legacy of the VSKhV was writ large across East Berlin's Stalinallee, Warsaw's Marszałkowska Street, Sofia's Largo, and a host of other Eastern bloc projects. They comprised a matched set of architectures, each composed of regionally inspired details mounted on a standard urban chassis of Soviet specification. But what was national in inflection was also unmistakably international in gestalt. The elaboration of socialist realism into the "other" International Style constituted the ultimate twist of the Revivalist, reformist, and Orientalist strands of the Soviet exhibitionary tradition. That genealogy can best be traced in the journals that transmitted the socialist realist method to a far-flung audience of architects. In the pages of these journals the new national architectures of Poland, Germany, Romania, Bulgaria, the Soviet Republics, and China could be compared. When so juxtaposed, these projects of diverse geographical origins and cultural contexts fell into ranks, each revealing its place in a harmonious architectural ensemble—albeit one constructed in the imaginary space of the printed page. The dialectic of socialist development proposed by Stalin, with its differentiation of national cultures as well as its expression of their merging trajectories, was rendered as a statement of architectural fact in these periodical exhibits of built socialist realism.

Notes

Despite a good faith effort to identify rights holders of all the photographs reproduced here, I was unable to do so either because the sources were older, Soviet publications or because they were reprints of works whose original publishers have gone out of business. Credits in figure captions are accurate to the best of my knowledge; corrections will be made upon request in any future reprints of this article.

1 Leonid I. Brezhnev, *Virgin Lands: Two Years in Kazakhstan, 1954-55* (Oxford, 1979 [Moscow, 1978]), 70.

2 For perestroika-era opinions on national expression in Soviet architecture, see "An Exchange of Opinions," *Architectural Design*, No. 7/8 (1987): 27-36.

3 Hugh Hudson, *Blueprints and Blood: The Stalinization of Soviet Architecture, 1917–1937* (Princeton, 1994), 172.

4 Most authors of the literature on world exhibitions, while concerning themselves with the colonial and imperialist content of these events, nevertheless ignore Soviet exhibitionary practice. For the most extreme example of this tendency, see

Paul Greenhalgh, *Ephemeral Vistas: The Expositions Universelles, Great Exhibitions and World's Fairs* (New York, 1988), who states that the tradition of exhibitions "had little opportunity or need to evolve" in Russia. "The flavor of imperial displays was non-European, that is, in the 19th and 20th centuries empire usually suggested overseas conquests. Imperialism referred to the colonization of the non-Western world through trade and technology, which tended to exclude the old European-based empires, epitomized by the type of control Austria and Russia exercised over their territories" (74). Only two recent studies address the cultural implications of Soviet exhibition architecture: Vladimir Papernyi, *Kul'tura "Dva"* (Ann Arbor, 1985); and Christian Borngräber, "Nationale und regionale Bauformen in der sowjetischen Architektur," *Archithese* 3 (1981): 44–47.

5 Medieval architectural styles were a common medium for nineteenth-century nationalism across Europe. For a discussion of its Russian praxis, see William Brumfield, *The Origins of Modernism in Russian Architecture* (Berkeley, 1991).

6 The most notable exception was the ongoing construction of Alexei Shchusev's Kazan Railway Station in Moscow. Designed in 1911 and begun in 1914, it was not completed until 1940.

7 See S. Frederick Starr, *Melnikov: Solo Architect in a Mass Society* (Princeton, 1978), 56.

8 See M. Astafeva-Dlugach, "Pervaia sel'skokhoziastvennaia," *Arkhitektura SSSR,* No. 1 (1974): 28.

9 A. Skachko, "Vostochnye respubliki na S.-Kh. Vystavke SSSR v 1923 godu," *Novyi vostok,* No. 4 (1923): 482–84; quoted in Yuri Slezkine, "The USSR as a Communal Apartment, or How a Socialist State Promoted Ethnic Particularism," *Slavic Review* 2 (1994): 433–34.

The fairground convention of presenting exotic cultures as elements in an ethnographic diorama is illustrated by a passage from a guidebook to the colonial area of the Paris Exposition Universelle of 1900 quoted in Philippe Julian, *The Triumph of Art Nouveau: Paris Exposition 1900* (New York, 1974): "To the left, recalling the Byzantium of the empresses and the Moscow of Ivan the Terrible, rise the gilded ridges of the Siberian pavilion. . . . Lower down, the sculptured structures of the Dutch Indies display their red and blue masses. . . . Nearby, to the right, rises the graceful spire of the pavilion of the Transvaal and in the background, beyond masses of greenery, the inextricable entanglement of the Chinese roofs bear witness to the active presence of the children of the Celestial Empire" (158).

10 The ways in which colonial and world expositions have manifested the discourse so labeled by Edward Said in *Orientalism* (New York, 1978) are traced in a substantial literature. See Zeynep Çelik, *Displaying the Orient: Architecture of Islam at Nineteenth-Century World's Fairs* (Berkeley, 1992); Robert W. Rydell, *All the World's a Fair: Visions of Empire at American International Expositions, 1878–1916* (Chicago, 1984); Jean-Claude Vigato, "The Architecture of the Colonial Expositions in France," *Daidalos* 19 (1986): 24–37; and Greenhalgh, *Ephemeral Vistas.*

11 Moisei Ginzberg, *Style and Epoch,* trans. Anatole Senkevitch, Jr. (Cambridge, MA, 1982 [Moscow, 1924]): 120–21.

12 Quoted in Slezkine, "USSR as a Communal Apartment," 423.

13 The period from 1923 to 1928, according to Soviet architectural historian Selim Khan-Magomedov, "witnessed an intensive search for national styles based on local architectural traditions" in the non-Russian republics; for a review of these efforts, see his *Pioneers of Soviet Architecture* (New York, 1987), 239–58.

14 Ibid., 240.

15 Although the style was scorned by a younger cadre of Moscow-trained Modernists like Karo Alabian and was shelved as an anachronism during the course of the First Five-Year Plan (1928–32), it was duly revived during Stalin's Great Retreat of the mid-1930s. Tamanyan was honored with the commission of Erevan's new master plan, and his built exemplar of the neo-Armenian style was again celebrated in the architectural press as a model of progressive Soviet Socialist architecture.

16 The "internationalization" of non-Russian modes of architectural expression during the First Five-Year Plan ran somewhat counter to corresponding linguistic developments. The Great Transformation included a push to "nativize" language use at high levels of administrative bureaucracy in many of the non-Russian republics; see Slezkine, "USSR as a Communal Apartment," 438–39.

17 Quoted by Milka Bliznakov, "Soviet Housing during the Experimental Years, 1918–1933," in *Russian Housing in the Modern Age: Design and Social History,* ed. William Brumfield and Blair Ruble (New York, 1993), 136.

18 See Anatole Kopp, "Foreign Architects in the Soviet Union during the First Two Five-Year Plans," in *Reshaping Russian Architecture: Western Technology, Utopian Dreams,* ed. William Brumfield (New York, 1990), 176–214.

19 See Slezkine, "USSR as a Communal Apartment," 440.

20 "Zhizn Vuzov," *SA (Sovremenaia Arkhitektura),* No. 1 (1926): 23–24, quoted in Catherine Cooke, *Russian Avant-Garde Theories of Art, Architecture, and the City* (London, 1995).

21 See Khan-Magomedov, *Pioneers,* 240–59.

22 For a review of how the premiation of Boris Iofan's entry for the Palace of the Soviets competition triggered the contempt of designers and architectural organizations in America and Western Europe, see Jean-Louis Cohen, *Le Corbusier and the Mystique of the USSR* (Princeton, 1992), 193–200. The depiction forged at this time of a Modernist egalitarian utopia annulled by a reign of totalitarian kitsch leads—and misleads—architectural historiography to this day. For a dissenting view, see my "Classicism for the Masses: Books on Stalinist Architecture," *Design Book Review* 34/35 (1995): 78–88.

23 See Tamara Dragadze, "Azerbaijanis," in *The Nationalities Question in the Soviet Union,* ed. Graham Smith (London, 1990), 166.

24 See Borngräber, "Nationale und regionale Bauformen," 44.

25 See Charles Jencks, *The Language of Post-Modern Architecture* (New York, 1977), 91.

26 See R. Khiger, "Arkhitektura pavil'onov," *Arkhitektura SSSR,* No. 2 (1939): 5.

27 See D. Aranovich, "Novaia planirovka vystavki," *Arkhitektura SSSR,* No. 10 (1939): 17–24.

28 See Khiger, "Arkhitektura pavil'onov," 6.

29 The sculptural group is attributed in Western histories to Mukhina alone, a notion contested by many Soviet historians; see *Skulptura i vremia,* ed. Ol'ga Kostina (Moscow, 1987).

30 Golts's judgment, delivered at a 1940 conference of Leningrad and Moscow architects, is quoted in Alexei Tarkhanov and Sergei Kavtaradze, *Stalinist Architecture* (London, 1992), 68.

31 See A. Ershov, "Dva pavil'ona," *Arkhitektura SSSR,* No. 2 (1939): 12–16.

32 Disagreements within the Union of Soviet Architects ultimately delayed the staging of its first congress for nearly five years; originally slated for the fall of 1932, it opened on 16 June 1937. For an account of these institutional tensions, see Tarkhanov and Kavtaradze, *Stalinist Architecture,* 49–50; and Hudson, *Blueprints and Blood,* 166–84.

33 K. S. Alabian, "Protiv formalizma, uproshchenchestva eklektiki," *Arkhitektura SSSR,* No. 3 (1936): 1–6; cited in Starr, *Melnikov,* 219.

34 See, for example, V. Vasilenko, "Narodny ornament v arkhitekture," *Arkhitektura SSSR,* No. 6 (1939): 44–47.

35 See I. Rabinovich, "Arkhitekturnye motivy natsional'nykh pavil'onov," *Arkhitektura SSSR,* No. 1 (1939): 12–13.

36 Jury Jaralow, "Nationale Züge in der Architektur der Unions-Landwirtschaftsausstellung in Moskau," *Deutsche Architektur,* No. 6 (1954): 255–56.

37 Ia. Kornfeld, "Arkhitektura vystavki," *Arkhitektura SSSR,* No. 7 (1939): 16.

38 Çelik, *Displaying the Orient,* 56.

39 Kornfeld, "Arkhitektura vystavki," 19.

40 Vladimir Papernyi, "Men, Women, and the Living Space," in Brumfield and Ruble, eds., *Russian Housing in the Modern Age,* 154.

41 Nicholas Mikhailov, *Land of the Soviets* (New York, 1939), 111.

42 See Rabinovich, "Arkhitekturnye motivy," 10–12.

43 I. Gainutdinov, "Pavil'ony soiuznykh i avtonomnykh respublik," *Arkhitektura SSSR,* No. 1 (1939): 6. It is interesting to note here yet another parallel to architectural practices associated with colonial exhibitions in Western Europe. Compare the design process used to create the Bashkir pavilion with this description of the Palais du Congo at the Antwerp Exposition of 1930 published in the fair's *Rapport Général* and quoted in Greenhalgh, *Ephemeral Vistas:* "One could not find in Congolese art the inspiration for the great architectural forms of this palace, [so] the artist has used very advantageously the ornament, engravings [that] certain

populations indigenous to the Belgian Congo use on their weapons and utensils, and characteristic drawings [that] one can find on the mats of certain tribes in our colony" (72). The important difference between the Antwerp exhibition of 1930 and the Moscow exhibition of 1939 is, of course, that in Belgium the new stylistic synthesis of cultural artifacts was attributed to the colonizer, not to the colonized.

44 Mikhailov, *Land of the Soviets,* 241.

45 Ershov, "Dva pavil'ona," 14; my translation.

46 Quoted in Jaralow, "Nationale Züge," 257.

47 See Jamey Gambrell, "The Wonder of the Soviet World," *The New York Review of Books* 21 (1994): 32.

48 For a discussion of the changing fortunes of Soviet ethnography during this period, see Yuri Slezkine, *Arctic Mirrors: Russia and the Small Peoples of the North* (Ithaca, 1994), 246–63 and 308–17.

49 See Jaralow, "Nationale Züge," 254.

50 See Andrew Day, "Stalin's Museum Cities: Early Post-War Soviet Urban Reconstruction Projects" (paper presented at the national meetings of the American Association for the Advancement of Slavic Studies, Philadelphia, 1994).

51 See Boris Schumatsky, "Kosakenbarok und Stalinistische Postmoderne," *Bauwelt* 48 (1992): 2766–71.

52 Bruno Flierl, "Stalinallee in Berlin," *Zodiac* 5 (1991): 85.

53 See Alexander Vlasov and Sergei Chernyshev, *Neues Deutschland,* 23 December 1951; cited in Anders Åman, *Architecture and Ideology in Eastern Europe during the Stalin Era* (Cambridge, MA, 1992), 61, 122.

54 The first reconstruction project of the Soviet sector, Ludmilla Herzenstein's Freidrichshain housing of 1949–50, was built in a postwar Bauhaus style. Hermann Henselmann, an up-and-coming architect in the Soviet sector, had also looked to the Bauhaus legacy for a German postwar architecture that would steer clear of both Soviet socialist realism and American praxis. Herzenstein's project was publicly denounced by Walter Ulbricht, while Henselmann was forced to publish a letter of self-criticism for his ideological deviance. For a summary of the Sovietization of the East German architectural profession, see Andreas Schätzke, *Zwischen Bauhaus und Stalinallee: Architekturdiskussion im östlichen Deutschland 1945–1955* (Braunschweig, 1991).

55 Åman, *Architecture and Ideology,* ix.

56 Alexandrov's comments are quoted in Edmund Collein, "Die Amerikanisierung des Stadtbildes von Frankfurt am Main," *Deutsche Architektur,* No. 4 (1954): 151; my translation.

57 The seminal text is Henry Russell Hitchcock and Philip Johnson, *The International Style: Architecture since 1922,* the catalogue of an exhibition of Modernist works shown at the Metropolitan Museum of Art in 1932.

58 See Åman, *Architecture and Ideology,* 60–62.

Svetlana Boym

PARADOXES OF UNIFIED CULTURE

From Stalin's Fairy Tale to Molotov's Lacquer Box

In the last years of the Soviet Union a Moscow journalist observed: "The unique Russian character is shaped by Russian bread lines, Russian inefficiency, as well as Russian culture . . . a powerful word, which has replaced everything—democracy, law, education, food."[1] In Russia, "Culture"— defined in the singular and with a capital "C"—has survived as an emblem of national identity for nearly 150 years. It has become a kind of civic religion that has led to many contradictory phenomena, to the flourishing of both literature and censorship, to the cult of the poet as a national hero and to poets' physical extermination. In the nineteenth century, "culture" was often synonymous with literature, and Russians were defined less by blood or class than by being a unique community of readers of Russian literature.[2] According to Vissarion Belinsky, who masterminded the cult of literature in Russian society, "Our literature has created the morals of our society, has already educated several generations . . . has produced a sort of special class in society that differs from the 'middle estate' in that it consists not of the merchantry and commoners [*meshchanstvo*] alone but of people of all estates who have been drawn together through education, which, with us, centered exclusively in a love of literature."[3] These words and those of the perestroika journalist encompass the birth and twilight of the literature-centric and culture-centric Russian universe, from the intelligentsia's quasi-religious cult of culture to the avant-garde dreams of an aesthetic transformation of the world, from the Soviet policy of mass culturization to the dissent of underground art. The Russian intelligentsia creatively reinterpreted the German Romantic idea of "culture," defined in opposition to the French and English Enlightenment idea of "civilization." This unique spiritual culture, the foundation of Russian national identity, was opposed to transnational "Western" individualism and its "civilizing process," often perceived as "artificial," false and inauthentic.[4] Socialist realism represents the last organized attempt at creating an "all-people's culture," translating into life the old dream of the Russian intelligentsia, with an ironic or tragic twist.

In Stalin's time the word "culture" acquired an important suffix, and

the slogan of the 1920s, "cultural revolution," turned into an advocacy of *kulturnost* (culturalization). This term included not only the new Soviet artistic canon, but also manners, ways of behavior, and discerning taste in food and consumer goods. Culturalization was one way of translating ideology into the everyday; it was a kind of Stalinist "civilizing process" that taught Marxist-Leninist ideology together with table manners, mixing Stalin with Pushkin. Material possessions, crêpe-de-chine dresses, old-fashioned dinnerware, and household decorations were no longer regarded as petit bourgeois; rather, they were presented as legitimate awards for the heroes and heroines of labor, for the marching enthusiasts of the new Stalinist order. Moscow was proclaimed the premier communist city of the future, the most "cultured city in the world." Moscow citizens were encouraged to discover new pleasures in Metro rides or walks in the Parks of Culture and Leisure, where they could taste delicious, newly imported ice cream. Culturalization offered a way of legitimating the formerly despised bourgeois concerns about status and possession; it both justified and disguised the new social hierarchies and privileges of the Stalinist elite.[5]

The aim of socialist realist mass culturalization was to synthesize — in a peculiar Hegelian-Marxist-Stalinist manner — the old opposition between culture and civilization, high and low art, public and private genres. Yet unified socialist realist culture hardly presented a unity of grand style. It was rather a kind of monstrous hybrid of various inconsistent elements from right and left: aristocratic and proletarian culture; radical avant-garde rhetoric and the chaste Victorian morals of nineteenth-century realism; happy endings and nature descriptions from popular fiction of the turn of the century; and "positive heroes" from the Russian classics and Slavic hagiographies.[6] The only thing that was consistent and unified about it was its dependence on Soviet power.

To understand the paradoxes of unified culture we might look at two, newly revived genres of Stalinist art that could be easily incorporated into everyday life: the "mass song" (*massovaya pesnya*) and the lacquer box. The song reflected the futuristic aspirations and technological dreams of the recently defeated avant-garde, while the box embodied the desire to preserve and rewrite Russian national traditions and the "peasant art" that avant-gardists opposed. The song flirted with the future, while the box recreated the allure of the past; the song affirmed that "fairy tales would come true," while the box made fairy tales look realistic. Furthermore, in the last years of Stalin's power, the lacquer box became a kind of Pandora's

box for Stalinist criticism, reflecting the debates over mimesis in socialist realism and the "lacquering (or "varnishing") of reality" (*lakirovka deistvitelnosti*), and testing the limits of socialist realist doctrine.

"March of the Aviators": Singing the Unreadable.

> The song helps us build and live,
> It is like a friend who leads us ahead.
> The one who marches through life with a song
> Will never be stranded again!

This popular song from one of the most celebrated musicals of the 1930s celebrates itself: it is self-referential, a "mass song" about the importance of mass singing. Indeed, singing was an important part of the Stalinist *Bildung*. Stalinism was not merely a political system, but also a mentality, a way of life and a grand totalitarian spectacle that needed to be continually reenacted. The favored genres were no longer poetry or even the novel, but rather the arts of mass spectacle—film, ballet, and organized popular festivities. The move was toward a collectivization of the utopian vision, as in the words of the popular song entitled "The March of the Aviators":

> We were born to make fairy tales come true
> To conquer distances and space
> Reason gave us steel wings for arms
> And a flaming motor for a heart.
>
> And higher, and higher, and higher
> We aim the flight of our wings,
> And the hum of our propellers
> Spreads peace across our borders.
>
> Our sharp gaze pierces every atom
> Our every nerve is bold and resolute
> And trust us: to any ultimatum
> An answer will give our Air Fleet!

Here the romantic metaphor of the flaming heart is wedded to love for the machine; these cheerful humanoids with wings and motors in their chests are the product of Futurist and Constructivist imaginations. One is reminded of avant-garde ballets in which the dancers impersonated machine parts and made mechanical gestures instead of the undulating, organic movements of classical dance. The protagonist of the song is not a

Whitmanesque poet or a modern Icarus. It is rather a collective, patriotic "we," projected onto the millions of people who were supposed to fall in love with the song—and they did. The song has an amazing history that reveals a continuity between the art of the 1920s and the 1930s and kinship with other totalitarian cultures.[7] Written in 1920 by the little-known team of poet B. German and composer D. Hait, the song became popular in the 1930s and in 1933 was adopted as the official march of aviators. It was translated into German and sung by the German communists; later, its catchy melody captured the imagination of the Nazis, who took the song for their own. After the words "and higher and higher and higher," they sang "Heil Hitler and dethrone the Jews," which was particularly ironic since the song's composers were Jewish. What it shows is how easily the words of a catchy patriotic tune can circulate from one totalitarian culture to another. The phrase "we were born to make fairy tales come true" became one of the central slogans of the time; it functioned like an advertising logo and was frequently recycled as a caption for paintings and for newspaper articles. These words were sung during the years of collectivization and hunger, of purges and war. The march was frequently played on the radio to cheer up the Soviet youth as they performed heroic feats of labor. (My father, a Soviet émigré whose mother spent five years in a Stalinist labor camp, still occasionally hums his own version of the "March of the Aviators" as he washes dishes in his well-equipped American kitchen, with the TV on.)

According to the most popular songwriter of the 1930s, Lebedev Kumach, what people needed during those years was a song "with distinct patriotic character," a song-slogan, a "song-poster" (*pesnya-plakat, pesnya-lozung*). The march, like the songs he composed for the "Stalinist musicals" of the 1930s, was "from the musical point of view, . . . a cheerful [*bodryi*] march with robust rhythm; from the verbal point of view, . . . lines not connected by inner plot, lines patriotic in content . . . with lyrical tonality."[8] The new Soviet song was not supposed to present a coherent narrative but to offer a series of life-affirming punch lines and slogans.

A close reading of the song points out its elements of absurdity and incongruity. Among other things, the "flaming motor for a heart" makes us apprehensive about the general success of this flight. But a mass song was not created to be read closely. The art of mass spectacle was not made for interpretation; indeed, it was extremely suspicious of interpretation and of any attempt at individual comprehension instead of shared experience. And one of those shared experiences was fear. The incantatory power of

the song could only be enhanced by the fear of interpretation internalized by the participants in the optimistic march. The song was made not to be read, but only to be memorized and repeated as an incantation of fairy-tale magic. The commonplaces of socialist realist art, the slogans and punch lines, functioned collectively as a magic force that programmatically aroused a certain predictable emotional, even behavioral, quasi-Pavlovian response. To understand the "March of the Aviators" it is necessary, first of all, to sing it in a crowd.

Boris Groys claims that Stalinist art is not merely a return to academism and conservatism, but an even more radical continuation of the avant-garde project.[9] Avant-garde theorists and Russian Formalists regarded every new period in art in terms of how it managed to lay bare its modes of operation and devices, seeing art in terms of undoing, defamiliarizing, and critical negativity. Socialist realist art did not simply, unselfconsciously, believe in the transparency of language, as did some of the realists of the nineteenth century. Rather, it self-consciously promoted the manipulation of consciousness, using the techniques that automatically secure specific emotional responses. Moreover, there was an ideological and theoretical justification for that radical self-conscious "automatization of consciousness," turning it into a collective unconscious not in a Freudian or Jungian sense, but in a Pavlovian sense. According to Groys, "Stalinist culture [was] very interested in different models of the formation of the unconscious, without exposing its mechanisms, as in the theories of Pavlov, or in Stanislavsky's method, which required the actor to enter the role so completely as to forget his identity."[10]

To read socialist realist texts as texts, revealing their strategies of manipulation, can yield important insights into the Stalinist cover-up. But this approach, in turn, covers up the central blindness of such analysis — its failure to theorize or to incorporate into the framework of critical inquiry *emotion,* that "demon" of Russian literature and culture. In fact, Vladimir Propp, in his pioneering study of fairy tales, analyzed them merely as *tales,* as narratives, failing to confront the element of the marvelous which explains how they could have operated in society. The Stalinist fairy tale cannot be read merely on a textual level. Otherwise, one would be confronted with its sheer absurdity and fail to comprehend how it could have come true, even if only in the imagination. Stalinist magical commonplaces only became commonplaces when they were enacted in popular spectacular rituals; they were hypothetical commonplaces that existed nowhere; they were omnipotent because circumscribed and guarded by fear. And there

was no child who would have innocently disclosed them as the emperor's new clothes. This happy dénouement belongs in a foreign fairy tale.

Saul Friedländer has proposed a distinction between the kitsch of death characteristic of Nazi Germany and the more innocuous and "life-affirming" kitsch of Stalinist Russia.[11] Indeed, in the socialist realist universe of the 1930s the emphasis on death was not crucial. Early socialist realist novels written before World War II were motivated neither by love nor by death—*pace* Freud—but rather by the drama of labor, of overcoming the petit-bourgeois self and partaking of the heroic collective spirit.[12] After the war, however, many war heroes entered the Soviet pantheon, and the scene of the death of a hero became crucial for postwar iconography—be it Alexander Matrosov, the pilot Gastello, or the partisan Zoya Kosmedemyanskaya. Not death as such, but a heroic feat, an ultimate victory, and the official resurrection of the tortured hero were brought to the fore. In spite of this difference in emphasis, victory over death in the communist socialist realist universe and the glorification of death in Nazi art manipulated the same emotional and behavioral structures. Milan Kundera has described a socialist realist revolutionary festivity in which the French communist and surrealist poet Paul Eluard joins the Czech people in a dance around the scene of a public execution of another poet, the Czech surrealist Zavis Kalandra.[13] So the dancing ring of a new generation of youthful enthusiasts hid the scene of execution from view. After all, it is hard to say whether there was much difference between being killed with Wagner's "Death of Isolde" blaring in the background or with the sounds of a life-affirming collective march. (This is metaphorically speaking, of course, because most of the victims of Hitler and Stalin were killed in much less theatrical settings.)

It was not by chance that so many songs celebrated the utopian, life-affirming spaces of the new Stalinist culture—as did, for example, a well-known song from another Alexandrov musical, *The Circus:*

> Our country is the land of beauty,
> Our country is the land of glee,
> I don't know any other country
> Where a man is so gloriously free.[14]

In Stalin's time, geography was perhaps the most political of all sciences: in the song, the multinational Soviet Union is completely remapped and deterritorialized; the spaces of terror, the camps, are hidden from view and absent from the maps. Instead, another utopian ideological map of the

motherland is created, that of a "land of beauty and a land of glee." The utopian iconography of the "greatest country in the world" was reflected on both micro and macro levels—in the monumental mosaic *panneaux* of the Stalinist subway and on the black lacquer miniatures that Maxim Gorky called "the little miracles of the Revolution."

"Lacquering Reality": Molotov's Lacquer Box. At a Moscow flea market I recently came across a unique gadget, a perfect fetish of Stalinist culturalization, which illustrates many paradoxes of the idea of unified culture. It is a traditional *Palekh* box representing Molotov and Stalin as folk-heroes (*bogatyrs*) on a black lacquered background. The Palekh box is an example of the official reinvention of Russian national culture that began in the 1930s, as well as a sample of the everyday rituals of the Stalin era. Inside the box is a little visiting card that reads: "Mrs. Molotov has the honor of inviting you for an afternoon tea on September 13 at 5 o'clock."[15] The writing is in the old-fashioned script—elegant, ceremonious, and refined. Afternoon tea chez Madame Molotov, wife of the general and hero of the Civil War and the "Great Patriotic War" (World War II) perfectly exemplifies the rituals of the Stalinist haut monde, the last aristocratic revival by the grand-style Soviet nouveaux riches. The box provides a rich insight into the everyday life of the Stalinist elite and embodies some quite old-fashioned ideals of "culture" and "culturalization."

It might come as a surprise that the "traditional Russian lacquer box" was in fact a very recent invention. After the Revolution the craftsmen and icon painters organized themselves into the *Artel* (Workshop) of Proletarian Art and began to use Russian icon-painting techniques to depict revolutionary fairy tales on traditional Japanese lacquer boxes. Gorky called it "a little miracle of the Revolution" and praised the transformation of the "craft into true artistic mastery."[16] Palekh box makers, in turn, followed the example of nineteenth-century *kustars,* who had organized an industrialized production of Russian crafts primarily for the new middle class, nostalgic for premodern Russian ways and eager to consume them in prefabricated (modern) packaging. This contributed to the creation of pseudo-Russian style and to a national revival. Much of the "folk art" was intended for international exhibitions abroad and was consumed by foreigners as Russian premodern picturesque objects. Hence there was a continuity between the consumer culture at the turn of the nineteenth century and that of the Stalin era.

When Walter Benjamin visited Moscow in 1926, he was fascinated not

by the future-oriented technology and pace of progress, but by the old-fashioned Russian toys and the black lacquer boxes from the Museum of Popular Crafts. Here is how Benjamin described it:

There are the heavy little boxes with scarlet interiors; on the outside on a gleaming-black background, a picture. . . . A *troika* with its three horses races through the night, or a girl in a sea-blue dress stands at night beside green flaring bushes, waiting for her lover. No night of terror is as dark as this durable lacquer myth in whose womb all that appears in it is enfolded. I saw a box with a picture of a seated woman selling cigarettes. Beside her stands a child who wants to take one. Pitch-black night here too. . . . On the woman's apron is the word "Mosselprom." She is the Soviet Madonna with cigarettes.[17]

This exemplary Soviet allegorical artifact, with its dark background and red interior, had a contemporary surface: the Mosselprom Madonna with cigarettes was the perfect salesgirl for Soviet ideology.

For socialist realist critics, blind to the black terror of the night, these were examples of life-affirming, colorful popular art, at once useful and decorative. Yet in the last years of Stalinism the lacquer box turned into a controversial object of ideology that represented the terror of Stalinist criticism. One of the key terms in socialist realist criticism, "the varnishing of reality," came from the critical discussion of ideologically incorrect lacquer boxes, which we can dub "the critique of the pure lacquer box." The lacquer box was a unique product of Stalinist arts and crafts, exactly the kind of object that was burned during avant-garde "campaigns against domestic trash" in the 1920s and 1960s, yet one that would become a decorative objet d'art in the 1970s—the ideal gift for foreign guests, a beautiful, well-packaged box of Russian exotica.

In the early 1950s the boxes became a focus of the discussion of "people's culture," as well as of the critique of "conflictlessness" (*bezkonfliktnost*). Ideological correctness was at that time a complex balancing act. The boxes were supposed to reflect the Soviet "people's spirit" (*narodnost*) but not the "common people's spirit" (*prostonarodnost*); to give examples of "refined artistic quality" (*tonkii artistizm*) but not of mannerism (*mannerizm*); to reflect taste (*vkus*) but not "pseudo-tastefulness" (*vkusovshchina*). All the ambiguities of Stalinist mimesis found their reflection on these lacquered surfaces:

The overcoming of some mistakes by certain Palekh painters consists not in the escape into naturalism, into mere copying [*kopirovka*] into a "light" stylization

"à la Palekh." What is required is further study of reality, a development of the progressive tradition of Palekh arts, which consists of ideological wholeness [*ideinaya nasyshchennost*] of the works, their life-affirming spirit, festive brightness of coloring, and subtle artistry, along with great artistic taste, wise mastery of composition, expressive laconic drawing, and finally, attention to different kinds of decorative art.[18]

Everything that appeared in quotation marks in the criticism of the Stalin era was meant to be an insult; it parodied the words of the invisible enemy that was everywhere. In this case, the enemies were "naturalism," on the one hand, and "stylization," on the other. The words "craft," "artifact," and "copy" tended to be negatively valorized in Stalinist criticism. While copying and reproduction were central to socialist realist practice (as to most artistic practices in general), they were vehemently criticized in theory. "Stylization" posed a great threat to socialist realist aesthetics by explicitly deploying the evil scare quotes of irony and aesthetic distance and thus putting "ideological wholeness" in doubt. The ritual nature of the work, its reenactment of ideological and aesthetic formulas, was carefully "varnished" by the critics. Hence the explicitly stated intentionality of the miniature painter, his or her creative revolutionary impetus, was of central ideological importance. While in the capitalist world craftsmen were "poor beggars deprived of rights," in Soviet Russia the "people's painters [affirmed] their creative personality." [19] The artist was a "genius of the people," and despite the traditional nature of the work, artists were called "original treasures" (*samorodki*). They received praise for being both decorative and useful, but their utility was defined quite vaguely as "certain everyday meaning" (*nekii bytovoi smysl*). For instance, one of the lacquer boxes representing the traditional troika was described as "a useful traveler's item" (*dorozhnyi predmet*). Yet it is somehow difficult to imagine that a cultured Soviet citizen would have used the lacquer box painted with a troika for travel on the crowded Soviet train (unless, of course, he or she never had to take the crowded train and instead traveled in a black car with the black lacquer box).

The Palekh craftsmen were frequently criticized for trying to embody a "new revolutionary content in the old form." The conflict of form and content haunted the miniature-painters for thirty years. The debates around lacquer boxes reveal certain important hierarchies among artistic genres of Stalinist culture. Since literature was the arche-art, the model for both

the nineteenth-century idea of an "all-people's culture" and the socialist realist culture, the Palekh painters worked on many illustrations of Russian and Soviet classics. Pushkin was a common favorite; the hundredth anniversary of his death was celebrated in 1937 by the production of hundreds of lacquer boxes depicting scenes from his fairy tales. Other Soviet classics that were illustrated were Blok's long poem *Twelve* and Gorky's romantic tales. The lacquer boxes, miniatures, and small objects in general presented a great problem for the unified epic style of socialist realism. Its creative geniuses were urged to tackle new, ambitious subjects such as "The Battle of Stalingrad" or "Comrade Stalin giving a speech on the meeting of Batumi workers in 1902," all in the space of a small lacquer box. Critics instructed the miniature-painters to learn from the epic styles of urban sculpture (*uchitsia u Vucheticha*) and to think further about the boxes' "architechtonics." (The boxes' "plumpness" was criticized, perhaps for being incompatible with the modern age of physical culture.) However, some modern genres like photography were rejected. One critic denounced the use of photographs for portraiture on the lacquer boxes and appealed to the Palekh artists to make their lacquer miniature "in *plein air* and from the original [*pisat s natury!*]"[20] Here we encounter one reductio ad absurdum of Stalinist criticism: to paint lacquer boxes in "plein air" is equivalent to flying with a "flaming motor." The key here is that Stalinist criticism functioned quite similarly to the "March of the Aviators": not to be read for meaning, but rather reenacted, an obligatory ritual of invoking familiar formulas with mild variations that are understandable to the initiated few and feared by the uninitiated many. Even the clichés themselves were borrowed from different discourses and layers of culture—from right and left, radical and conservative idioms—including the writings of the nineteenth-century intelligentsia, the conventions of academia, Bolshevik slogans, and, occasionally, the campaign slogans of the avant-garde. Behind the eclecticism of Stalinist culture, one can see similar rules of the game and mechanisms of collective performance.

Socialist realist critics insisted on their crucial educational role in the life of the artists; they presented themselves as responsible for the artists' ideological Bildung:

One should not think that the Palekh artists arrived at their perfect mastery, their great life-affirming art, without individual creative failures, without a struggle of opinions around their wonderful work. In those periods Palekh artists experienced

doubts over whether their chosen route was the right one; they experienced bit-
terness at the just charges of mannerism, of narrowness (at first) in their themes,
in their unjustified attempts to reveal new content in the old canonical form (also,
only at first). With the help of well-wishing critics [*dobrozhelatelnye kritiki*], the
Palekh artists successfully overcame their mistakes and grew to be excellent mas-
ters in their field.[21]

The cautious tendentiousness of this critical self-praise requires no com-
ment. The adjective "well-wishing" was frequently used as a euphemism
for informers, whom the KGB referred to as "well-wishers." Yet in this case,
"well-wishing" criticism might also appear to be a kind of self-defense and
self-justification. "Art criticism" in Stalin's time was a peculiar balancing
act, more about the art of survival than about art; criticism could cost the
artist his life, and a lack of criticism could cost the critic his job. Thus he
usually had more training in ideology and the propaganda of culturaliza-
tion than in art history. The high seriousness of socialist realist criticism
bordered on absurdity because it did not acknowledge the distinction be-
tween literal and metaphorical levels; art could become life, and vice versa;
metaphors had to be practiced—often in the most "naturalistic" fashion.
While some painters of the lacquer miniature might have been forced to
work in plein air, it was not the consistency of vision that mattered, but
the gusts of power and its whims. At the end, the "varnishing of reality"
was not a critique of representation, but rather a polishing up of that cri-
tique; it was an internal critique within the system. Evgeny Dobrenko sees
"lacquered reality" as "a mechanism of literary politics": "Everything that
was later called 'the theory of conflictlessness' [*bezkonfliktnost*] was a part
of an apology for the system, characteristic of totalitarian culture. On the
other hand, the system itself was based on the mentality of conflict and
confrontation, the cult of struggle and the search for the enemy."[22] In
the 1960s, when totalitarian culture began to lose its magic spell and its
clearly delineated boundaries of power, the slogan "varnishing of reality"
was used again, but with a different signification. In the era of Khruschev's
thaw, the slogan was still taken literally and its reflective aesthetic surface
was not questioned. The intelligentsia of the 1960s proposed to substitute
one kind of "impossible aesthetic" of life for another, which would be more
"sincere." In 1980s art, the critique of varnished reality went through a
more radical perestroika, and the songs, boxes, and metaphors of socialist
criticism seemed to acquire the necessary estranging quotation marks.[23]

Having survived all the balancing acts of moribund Stalinist criticism, the Molotov Palekh box has now become a perfect totalitarian antique, a Stalinist objet de *folk* art, sold at the flea market together with the more expensive czarist eggs. The addressee of this refined invitation for tea and the history of this Stalinist family souvenir remain unknown. Yet one doesn't have to throw out the idea of culture with the Molotov lacquer box. The end of the culture-centric epoch does not have to lead to the decline of the arts at the turn of the next century, but only to the decline of their central educational and ideological role in society. In a sense, there are more ways now of dreaming "world culture"—or, to paraphrase Osip Mandelshtam, of "longing for the world culture"—than there ever were before, although this longing itself is becoming outmoded. It remains to be seen whether it will be possible to reinvent a Russian identity that will not depend on a unified Russian culture: an identity that would acknowledge differences and paradoxes beyond polished-up picturesque reflections in pseudo-Russian style.

Notes

1 A. Bossart, "A ia ostaiusia s toboiu," *Ogonek,* No. 44 (1989): 31; quoted in Irina Corten, *Vocabulary of Soviet Society and Culture* (Durham, 1992), 73. Corten offers many wonderful examples of the Soviet usage of the word "culture." Apparently the word entered post-perestroika slang, and "kul'turno" is now synonymous with "cool."

2 This explains why the word "culture" does not get much attention in Dal's *Dictionary,* where the first meaning given is "cultivation" (*obrabotka i ukhod, vozdelyvanie, vozdelka*), and the second is moral and intellectual "education" (*obrazovanie umstvennoe i nravstvennoe*); see Vol. 2, p. 217.

3 Vissarion Belinsky, "Thoughts and Notes on Russian Literature" (1846).

4 Here is how Norbert Elias described this opposition, in *The History of Manners,* trans. Edmund Jephcott (New York, 1982), 5:

The French and English concept of civilization can refer to political or economic, religious or technical, moral or social facts. The German concept of *Kultur* refers essentially to intellectual, artistic and religious facts. . . . "Civilization" describes a process or at least the result of the process. . . . The German concept of *Kultur* has a different relation to motion. The concept of *Kultur* delimits. To a certain extent, the concept of civilization plays down the national differences between peoples; it emphasizes what is common to all human beings

or—in the view of its bearers—should be. In contrast, the German concept of *Kultur* places special stress on national differences and particular identity of the group.

See also Jean Starobinski, "The Word Civilization," in *Blessings in Disguise; or The Morality of Evil,* trans. Arthur Goldhammer (Cambridge, MA, 1993), 1–36.

From Ivan Kireevsky to Nikolai Berdiaev, Russian culture was viewed in opposition to "civilization," which was described as "mercantile" and individualistic. This polarization is problematic, however, in that the histories of both words themselves internalize this opposition. In other words, the history of "civilization" in French exposes the battle between true and false civilization, and the same applies to the idea of culture. Thus no good or evil attaches to either "culture" or "civilization" as such; it depends entirely on the context. Starobinski writes that in mapping civilizations and cultures, "what matters is the shifting patterns of boundaries and distinctive systems of value, not the qualitative judgement we might make." In his view, "civilization"—and I will add "culture" as well—has to be seen both as "threatening and threatened, persecutor and persecuted. It is no longer a safe haven for those who shelter beneath its roof." Culture in the Russian context is this kind of a double-edged sword; it can be seen as a way of survival and of domination, of creating a community and of delimiting it, a way of dreaming of aesthetic emancipation and of taming those dreams. For more detailed discussion, see Svetlana Boym, *Common Places: Mythologies of Everyday Life in Russia* (Cambridge, MA, 1994).

5 On the concept of *kul'turnost',* see Vera Dunham, *In Stalin's Time* (Cambridge, 1976); and Sheila Fitzpatrick, "Becoming Cultured: Socialist Realism and the Representation of Privilege and Taste," in *The Cultural Front: Power and Culture in Revolutionary Russia* (Ithaca, 1992), 216–17. I am grateful to Golfo Alexo for bringing Sheila Fitzpatrick's new project to my attention.

6 Evgeny Dobrenko offers an insightful history of the "sources of Socialist Realism," which he finds not only in classical Russian literature or in high avant-garde art, but also in less canonical cultural stratas and subcultures, especially in the works of poet-proletarians and peasants of the early twentieth century; see "Levoi, levoi, levoi! Metamorfozy revoliutsionnoj kul'tury," *Novyi mir,* No. 3 (March 1992).

7 I am grateful to Felix Rosiner for sharing with me the information about this song. See Vladimir Frumkin, "Ran'she my byli marksisty: Pesennye sviazi dvukh sotsializmov," in *Obozrenie,* No. 17, to *Russkaia Mysl'* (Paris), November 1985.

8 Grigory Alexandrov, *Epokha i Kino* (Moscow, 1976), 286.

9 Boris Groys, *The Total Art of Stalinism,* trans. Charles Rougle (Princeton, 1992). The relationship between the avant-garde and socialist realism is one of the central issues in the contemporary debate about Soviet postmodernism. Indeed, what did occupy the space between the prefix "post" and the root of the word "modern-

ism"? What is the place of socialist realism, which comes directly after modernism in Soviet culture? In the 1960s and 1970s many writers and critics emphasized the break between the two, the war of languages and tastes between the avant-garde's nomadism and the socialist realist establishment. In the 1980s it was more fashionable to emphasize the continuity between the two, while insisting on the radical discontinuity between "Russian" and "Soviet." This led some Russian post-modern theorists to claim that Russians invented postmodernism and the practice of simulation, as described by Jean Baudrillard. Socialist realism is postmodern in one sense only: historically, it comes after modernism; ideologically, it discards its heritage.

At first glance, avant-garde art seems to be about reflection on language and defamiliarization, while socialist realism seems to be about precisely the opposite: a cover-up of rhetoric and an attempt at a new familiarization. This familiarization is even more uncanny than the avant-garde's defamiliarization because it seeks to make the most impossible and the fantastic into the familiar. The "realism" part of socialist realism has virtually nothing to do with the everyday existence of Soviet citizens; it does not even attempt to mimic or imitate it. The point is to enact the mythical and utopian world and thus bring it into existence. On the other hand, what socialist realism shares with the avant-garde is its total—and potentially totalizing—vision and the rejection of art as an autonomous domain of the beautiful in favor of the idea of art as a "road to life," to use the title of a popular film of the 1930s. Of course, the avant-garde has never achieved, and perhaps never could have achieved, its project of bringing art into the praxis of life; it is too caught up in the creative search for a new language and a new, antisubjective subjectivity. See Peter Burger, *The Theory of the Avant-Garde* (Minneapolis, 1984).

10 Groys, *Total Art of Stalinism,* 67.

11 Saul Friedländer, "Kitsch and Apocalyptic Imagination," *Salmagundi* 85/86 (1990): 201–6.

12 This is discussed in Katerina Clark, *The Soviet Novel: History as Ritual* (Chicago, 1981).

13 Milan Kundera, *The Book of Laughter and Forgetting* (London, 1983).

14 I am using a Soviet translation of the song from the time of stagnation, which was learned by heart in Soviet English schools of the 1970s to be performed for foreign visitors. The English translation is somewhat unfaithful to the Russian original, but it rhymes!

15 I do not exclude the possibility that the box was an artful fake made for the foreign market. Yet many similar boxes were produced in Stalin's time and many old-fashioned parties were held in the Kremlin for Party members.

16 Quoted in G. Zhidkov, "Laki," *Iskusstvo,* No. 2 (1947): 33.

17 Walter Benjamin, "Moscow," in *Reflections,* ed. Peter Demetz, trans. Edmund Jephcott (New York, 1978), 114.

18 N. Sobolevskii, "Iskusstvo Palekha," *Iskusstvo,* No. 6 (1955): 28.

19 Ibid., 26.

20 Ibid., 30.

21 Ibid., 28.

22 Evgenii Dobrenko, " 'Pravda zhizni' kak formula real'nosti," *Voprosy literatury,* No. 1 (1992): 23.

23 In the 1990s, the new, self-proclaimed "elite" of the Russian cinema has created nostalgic visions of the festive and macabre life of Stalinist elites. This retro art reflects a peculiar kind of nostalgia—not for Stalinism, but for the last grand style of Russian culture. Once it became stylized—an operation that Stalinist critics decried—the socialist realist world looked much more aesthetically unified in those films than it actually was. For further discussion, see my "Stalin's Cinematic Charisma: Between History and Nostalgia," *Slavic Review* 51 (1992): 536–43.

Evgeny Dobrenko

THE DISASTER OF MIDDLEBROW TASTE, OR, WHO "INVENTED" SOCIALIST REALISM?

We have enough of that sort of book,
Signed with other people's names,
This will be ours, and about us.
But what is "ours"? What will it be about?
— Anna Akhmatova

Not everything that is accessible is great,
but everything that is authentically great is accessible, and
the greater it is, the more accessible for the masses.
— Andrei Zhdanov

Who invented socialist realism? Two traditional, unsatisfactory answers to that question are (1) the powers-that-be, and (2) the masses. Such explanations can be called "conspiracy theories." They treat the phenomenon of socialist realism as the imposition on the whole Soviet Union of either the personal tastes of certain retrograde artists or, more often, of Stalin and his closest associates, who "invented" socialist realism out of their nostalgia for the feelings of youth (or a variant: out of their need for a showcase literature). With respect to the second "inventor," those in power are said to have pandered to the tastes of the masses—which is simply the flip side of the same idea. Such an interpretation, while not groundless, seems woefully inadequate.

The culture of socialist realism originated in neither state power nor the masses, but was the product of a hybrid, the "power-masses," functioning as a *single creator*. Their joint creative surge gave birth to the new art. The socialist realist aesthetic was equally motivated by the aesthetic horizon and the demands of the masses; by the logic of immanence inherent to revolutionary culture; and by the state's interest in preserving mass tastes and reinforcing the "organizational-political policy-making" power structures deployed in both formulating a new art and refashioning its market, or potential consumers.

A new reception strategy had to be formulated in revolutionary culture as a consequence of the collapse that occurred when the "old culture"

got a new consumer. This was an exceptionally complex and painful process, in the course of which a sharp break occurred in the masses' mode of aesthetic experience. That experience underwent an acute crisis in all traditional forms of cultural reception and led to the utter negativism of the masses toward culture generally—both "old culture" and the new avantgarde culture whose birth had caused such paroxysms of agony. The result of this negativism was a refusal to consume art and a corresponding determination to create one's own things—a rejection of the *artist's* creations in favor of *one's own* that produced the *consumer-as-artist/author*. We read in a book of the period, the 1926 anthology *Rabochie o literature, teatre i muzyke* (Workers on Literature, Theater, and Music), for example:

The class which has just been born into cultural life must construct its art virtually with its bare hands, must satisfy its artistic hunger through primitive means. At the same time, the treasures of artistic culture concentrated in our theaters, museums, academies, and so on are starting to decompose, since they have no workers or peasants using them. The jaded, anemic, tired brain of the petit-bourgeois intellectual is in no condition to absorb these riches and make them useful for society under the guidance of the proletariat advancing toward communism. . . . The more art comes into immediate contact with the proletariat, and the peasantry as well, the more [readily] will it be reborn, restructured, made into Communist art.[1]

Meanwhile, the new reader/viewer was likewise making it clear that the "old culture" was not for him: "I don't know who this performance was for," wrote one "worker-correspondent" after seeing a play at the Vakhtangov studio,

but, judging by the fact that I got my tickets through a workers' organization, I expected to see representatives of factories and plants there. But how surprised I was when I saw only three or four workers lost in the general masses. The other spectators looked like "cavaliers," dolled-up ladies, and mademoiselles painted and powdered, with rings and bracelets. I felt completely out of my element. I would remind you that this performance was free of charge. If there are no working-class viewers at a *free* performance, then what will happen when the performances cost money?[2]

It turned out, incidentally, that not only did the central and academic theaters go unvisited by workers, but so did the local ones: "Why are there so few people in the theater?" asked the same worker-correspondent, per-

plexed. "Half of the theater (and this theater isn't big) is completely empty. It's horribly annoying that even a theater located in a working-class district has no workers in the audience. Whose fault is this?"[3] There were no answers to these questions, but the problem seemed less one of workers' not rushing to "consume the old art" put at their disposal than of art's somehow not "being reborn, restructured, made into Communist art." Dissatisfaction was the result.

If we take the working-class perspective, then we see that all the plays offer nothing but decayed old-fashioned things. In all of them we see only lovers, dances, legs kicking, and little skirts blowing.

A Chekhov play was performed. Things went on that offered nothing to the worker—not to his head, not to his heart.

We saw *Dyadyushka's Dream* [*Diadiushkin son*] in the Dostoevskian style. . . . I wonder whether it's really necessary to put on stage a grandee lounging around, the quite repulsive type of prince who has already faded from memory. The worker doesn't need that sort of theme.

I recently saw the premiere of a play about Roman life (Shakespeare's *Antony and Cleopatra*), and I thought: Why does the worker, busy the whole day with hard work, need to see this musty historical trash?[4]

Responding to this "old trash" as such, the working-class viewer refused to recognize even the right to existence of some types of theater. This was especially the case with musical theater. Opera and ballet, for example, were categorically rejected. The new mass consumer's reaction to these musical arts was distinguished by a particularly aggressive anti-aestheticism. It is clear that the general, long-standing disinclination toward aesthetic consumption was supplemented by a disinclination toward "reading" a musical text, that is, one whose "language" demanded special preparation.

The worker-correspondents' reviews of opera and ballet certainly represented the extreme expression of the cultural impasse reached by the mass consumers' efforts to "master the cultural heritage." Here there could not even be any question of "reworking the old culture," for it was here that the cultural abyss yawned: "Why do they show us workers things that are dead and gone, and don't *teach* us anything?" asked one worker-correspondent after a performance of a Tchaikovsky opera. "All those gentlefolk (Onegin, Lensky, Tatiana) lived off the peasants; they didn't do

anything, and because of their inactivity they didn't know what to do with themselves!"⁵ Other workers voiced similar complaints:

It seems to us that *The Queen of Spades* [*Pikovaia dama*] has gotten completely outmoded in its content, and that it's time to take it out of the repertory. I want to call special attention to the end of the third act, where Catherine the Great appears and they all sing to her: "Be praised, be praised, Catherine!"... Nothing more exasperating could be imagined than singing the praises of a Russian empress from the stage of the state academic theaters.

The opera *The Demon* is terribly boring. All the characters whine and beg. Tamara whines and begs, her groom Sinodal (a sickly little fellow) whines and begs, Tamara's friends whine and beg, and even... the Demon himself whines and begs.⁶

"Here all the needs of bourgeois aesthetics are satisfied. But what is there for the workers? What use can they get out of it? Where are the ones who built the towers, the Pyramids, the Sphinxes?" asked one worker-correspondent after a performance of *Aida*. "*Those* heroes were not acknowledged by bourgeois art. It's time to depict living people from the present day, with their new worldview." Another correspondent, describing his impressions of *Swan Lake,* wrote: "The viewer watches a story of a prince's love for a princess, and, as a result of his betrayal, the dance of a dying swan. That's how this most boring of all boring stories takes place in four acts, a story of the love of a 'prince' for a 'swan princess' which nobody needs." The reactions of other working-class viewers were consistent with these sentiments: "Out of seven people [watching the performance], three kept falling asleep, and people had to pester them and say, 'Hey, guys, just don't snore!' The rest of them—what can you say?—they were suffering." And, in a similar vein: "Many workers do not understand whom our Russian theaters are supposed to serve, and for whom the honored peoples' actors of the republic are performing."⁷

Such a reaction was understandable, given the availability of an alternative "musical life" for the masses: "On one square you find six pubs, and in each of them after eight o'clock a cabaret is performed by 'the best and most talented' (even 'foreign') actors. It is clear that the 'programs' of these pubs consist of the most select smut and filth. . . . And the worker, after a hard day of work, goes . . . to the pub." About this pub scene, another worker wrote: "With the approach of evening, the guys start bawling out songs and whistling. The young men from the country, like the workers, go to the pubs."⁸ Clearly, the "guys" weren't interested in opera.

The traditional model for describing Soviet culture, one which was current in both the West and the USSR in the 1960s, was based on the premise that the negation of past art began either with the avant-garde or with the Proletkult and (later) the RAPP—in other words, with the "left" and the "right" within the culture.[9] But what was never taken into account was the fact that the negation of the cultural tradition, founded on the corresponding aesthetic threshold of the masses' perception of art, *proceeded from the broad masses,* both urban and rural, who were actively drawn by their new power into "cultural construction." There was no recognition of this factor in the leftist paradigm, neither the Western antitotalitarian one nor the Soviet "sixties" one, both of which tended, in populist fashion, to blame everything on ideologues and other betrayers of the people's interests, not on the masses. On the other hand, this factor could not be acknowledged by the national-traditionalist consciousness either, nor did it square with the revalorizing and mythologizing notion of "popular harmony." Thus the sources of socialist realist culture were partly sought in the logic of immanence of the cultural process itself, while the social and aesthetic presuppositions of socialist realism were significantly more multilevel and profound.

With respect to the reception not of "trash," but rather of the avant-garde productions of Meyerhold or Vakhtangov, for example, similar difficulties arose: "I intently followed all the episodes, but even so I couldn't link them together at all"; "I just didn't get it"; "The thing seemed very difficult and very confusing to me"; "In my view, this thing wasn't written for workers. It's hard to understand and it makes the spectator tired"; "After the first part there's chaos in your head, after the second part chaos, and after the third part there's still chaos"; "There's a lot of absurdity in the new productions. It doesn't produce any general impression." One worker compared a production of an avant-garde play to an equally confusing type of photomontage:

There are some photomontages which you can call "A Leap into the Unknown," or "The Bloody Nose," or "A Negro on the Gallows," or whatever you want. In montages like this there's a bottle of home-brewed vodka, a revolver, people in various costumes and poses, and cars, and steamships, and ripped-off arms, legs, and heads. . . . They're fine for everybody, but . . . you just can't make any sense of them. You can look at them from top to bottom, and from bottom to top, it doesn't matter: you won't understand a damn thing! It's like that in this pro-

duction. You've got everything in it. The Roman [Catholic] pope, and books, and libertines, a god and angels, riots, dancing girls, a fox-trot, meetings, even a worker is mixed up in it for some reason. All this is shown so that you can't even tell where the end and the beginning are. A worker who winds up at a play like this will come out of it completely crazed and senseless.[10]

The factory theater attracted incomparably greater interest from the mass viewer; in this theater, created "with our own forces," the viewer was able to participate in "the production of art" through his own authorship and a "familiar subject." Here is what several worker-correspondents wrote about these productions:

The central theaters for the time being serve only the downtown area, in other words the bourgeoisie and the Soviet intelligentsia. Masses of workers never show up in these "real" theaters. They see only the productions of the workers' drama clubs, which take upon themselves the whole responsibility for providing theater for the working masses. There, *that's* ours, the workers say.

The club produced dramatizations written by the guys themselves, with the guidance of the club director. The workers are entertained by dramatizations. They were especially satisfied by a dramatization that represented pictures of daily life in the 1914–1916 period, for example, "Transporting the Recruits." Many working men and women came up to thank the director for the production.

On International Youth Day, the club put on, through its own efforts, the play "Working Youth in Defense of the Revolutionaries." The play wasn't short—ten acts—but it conveyed very well the underground work of the youth and the workers in 1905. The play was performed twice, and the hall was full. All in all, 3,000 people attended.

We are collectively writing plays for every revolutionary holiday. For example, for Airforce Day we wrote the play "The Magic Carpet," for International Working Women's Day we wrote "Working Woman," then a five-act industrial play called "The Lamp." We recently produced a play dedicated to Dobrokhim, called "Their Card Will Be Covered," in 26 episodes. For the 28th of September we're preparing our factory committee's live report, called "Our Daily Life." We're writing a play dedicated to the MOPR.[11]

As for the subject matter of plays like these, which enjoyed such great popularity among the workers, the following account of one of them by a worker-correspondent is vividly informative:

I will tell you about the dramatization which I saw at one of the Moscow leather tanneries. On the stage there is a sofa. The plant director is lying on it, and he has a dream. Cowhides creep out from all the corners: finished hides and skins that had just been torn off, that is, hides from the departments of the plant, from the drying department to the finished-product warehouse. The hides start a conversation among themselves. And then everybody gets into it: they drag the director around, and the foremen and the workers, pointing out all the faults in production and explaining who's responsible for them. Then the "director" (a worker made up to look like the director) wakes up, grabs his head, and promises to correct all the mistakes that were pointed out. The production enjoyed a huge success among the workers.[12]

As one can see, it was this sort of openly agitational industrial play, produced on the workers' own initiative, that enjoyed the greatest popularity. To appreciate this, one need only glance at the repertory of such plays, which can easily be divided into the following "hot" themes:

— The international situation of the USSR and the workers' struggle in the West: "Recognizing the USSR," "America on Fire," "China and the USSR," "A Thousand Liebknechts," "Their Card Will Be Covered," "About Good Khim and Bad Jim," "Hands Off China," "The Rumanian Executioner and Moaning Bessarabia," and "Down with Amsterdam!"

— The history of the Party, the Revolution, and the workers' movement: "Ten Days That Shook the World," "Stenka Razin," "Working-Class Youth in Defense of the Revolutionaries," "1905," "Lena," "The Paris Commune," "The Origin of October," "The First Year of the October Revolution," "At the Gates of October," "Spartacus," "Uprising," "Lenin in October," "October in Moscow," "The Seventh Anniversary," "The Decennial of World War I," "The Mysterious Cabin," "May First," and "Guards of the Revolution."

— Current economic-political tasks: "Without Matches There's No Union," "The Union of City and Country," "The Thirteenth Party Congress," and "Industrialization Must Be Increased."

— Culture and everyday life: "Vera the Communist," "Judgment for a Syphilitic," "Devilry," "Our Everyday Life," "First You Study, Then You Marry," "How Terrible To Be Illiterate," and "A Komsomol Easter."[13]

It is obvious that the "mass viewer" wasn't ready to embrace traditional aesthetic forms. And what is important here is not only the forms themselves, but precisely their unwelcome reception. In almost every worker-

correspondent's report one reads some such statement as "we wrote plays collectively"; "we composed our own dramatization"; "we have an initiative group on writing plays and dramatizations for the drama club"; "we are working in league with a literary club and with worker-correspondents who give us material." The masses' desire to create things *for themselves,* which was a constant theme of Proletkult and then of RAPP rhetoric, indicated the gulf separating the mass consumer from the cultural repertoire of the age. And it was precisely the elimination of this gulf that became the double cultural task of socialist realism: on the one hand, "tightening up" the masses; on the other hand, bringing art closer to them, adjusting the one to fit the other, which was what generated the specific character of Stalinist culture.

Meanwhile, the builders of the new culture in the 1920s (the most radical of whom was the Proletkult), having taken their populist or rearward ("tailist") positions (*khvostitskie pozitsiy*)—as they would be later termed in the Soviet idiom—suggested that it was possible to continually pull "art closer to the masses," that

the working class needs professional theater, that in the future a "prof-theater" will be able to satisfy the needs of the masses. But for this it must be reborn, become more worker-oriented, tear out the rotten and decadent roots within it, become healthy. To get there, it has to assimilate many achievements, many distinctive characteristics of the factory- and plant-theaters: the first of which is their connection to the masses and to the Party. . . . The factory/plant-theater is creating new theatrical forms and a new content. . . . Its achievements should be used, reinforced, developed, and elaborated by the prof-theater, whose future constituency of workers will be almost entirely drawn from the present factory/plant-theater.[14]

As is well known, the same recipes were proposed for literature by the Proletkultists and the RAPPists. Accusing the contemporary theater of "decadence and neurasthenia," urging it to "become worker-oriented," the radical partisans of the masses proposed bringing "the working-class viewer onto the film-directing and theater-repertory councils," creating "new playwrights and actors," who would "listen and adapt to workers' criticism," orienting themselves, "in both the organizational and economic senses of the term, to the working-class viewer."[15] All such advice was openly demagogic: it was clear that the working-class viewer, for whom the whole theatrical repertory was either "old trash" or "avant-garde nonsense," had no business joining the film directors' or repertory councils; it

was clear that for the same reason it would be impossible to adapt the theater to the worker-correspondents' criticisms; and it was clear, moreover, that the call for working-class playwrights was simply a theatrical variant of the challenge posed in literature—that of "creating red Tolstoys"—and that this task could not be entirely accomplished by revolutionary or Soviet culture.

Accomplishing this task "fundamentally" would require giving up some of the radical goals and methods of which revolutionary culture was organically incapable. This "historical mission" was taken on by socialist realism. Having completed its avant-garde project, Soviet culture shifted "toward the masses" more thoroughly than its revolutionary predecessors had done; having resolved the masses' traditional inferiority complex toward "highbrow art," "working-classification" was considered a stage that had already been passed through, since "the directors and actors, with their jaded, perverse, intelligentsia tastes," whom the "fiery revolutionaries" had wanted to replace with "better members of the drama clubs, with bench workers, who deserve to be given the chance to master all the wisdom of theatrical art," [16] turned out to be nonrepresentative of Soviet culture: "jadedness and perversion," as well as "decadence and neurasthenia," became for many years the most persistent characteristics attributed to Western art in the demonology of Soviet aesthetics. An averaging-out occurred, according to the classic Soviet model: drama club members became, it was agreed, "Soviet viewers"; "decadence" moved to the West, the avant-garde theater died out, and the "people's art" of socialist realism arose to replace it.

This was why, in examining the new consumer of culture, his or her traditional characteristics had to be rejected. Adrian Toporov, who carried out the only cultural research done on the peasant reader of the 1920s, was right· "The so-called vulgarity of the artistic tastes of the peasants and workers is actually a malicious invention of people who have perverted reality." [17] As a matter of fact, neither vulgarity nor savagery characterized the new reader, but rather a *special system of aesthetic demands*. The expression of this set of demands was encouraged in various ways by the state: "It is the duty of every Komsomol reader to give a review of a book he or she has read. . . . The Komsomol reader cannot just be indifferent to this or that book. The Komsomol reader has a duty to request that the Komsomol writer and the Komsomol publisher take his or her opinion into account." [18]

The masses responded quickly to this appeal to "present their de-

mands." Throughout the 1920s they formulated, often clumsily, what they were demanding from the new culture, and in fact they *constructed its framework*. In 1928 the journal *Pechat' i Revoliutsiia* (Print and Revolution) published a translation of Karl Kosov's article, "What Is the German Worker Reading?" In his foreword to it, V. Goffensheffer referred to the "international character of the literary needs and artistic tastes of the working-class reader." [19] Did the librarian from Stettin come to the same conclusions? Kosov wrote about the "limited individual self-realization that characterizes the majority of the proletariat" and about the fact that the "workers instinctively reject anything that doesn't correspond to their milieu"; that "the majority of them take up a book in a confused romantic striving to find in the fantastic a way out of their own life, into a more attractive world"; that awakening self-recognition "forces the worker to take up a social novel, the story of sufferings that they themselves have lived through"; that "the striving to get out of one's narrow milieu through a widening of the intellectual horizon" is the least frequent motivation for reading; that the worker "reveals the liveliest need to take in all that has been thought out in the name of 'truth,' " and, "unable to perceive the literary work as an artistic form," he is always preoccupied with "questions of verisimilitude"; and that, "looking for rest and satisfaction in a book, the worker is often amused by what theory is struggling with" (most popular in working-class circles were the "idealizing writers"). From all his observations, Kosov concluded that

the worker does not perceive refined tastes in the field of aesthetics and intellectual life; he needs descriptions of what happens, spiritual experiences, events; he needs the art work to possess what he sees in his own life, familiar in its distinct objectivity. The worker is not at all attracted to delicacy of mind, but rather to quickness of heart and an understanding of how need creates guilt and crime. . . . The interest in pure politics is really not so large.[20]

Now let us turn to the Soviet mass readers of the 1920s. What did they like in literature? What did they expect from it? What was the horizon of their aesthetic expectations? What aesthetic needs and artistic preferences did they have? Mass readers of the 1920s and early 1930s responded to contemporary prose literature on a number of fronts, as the following sections show.

The book should be recognizably useful; it should instruct. "A helpful book. It taught me how peasants lived in earlier times" (man, age 22, referring to

Alexander Altaev's *Sten'kina vol'nitsa* [Stenka's Outlaws]). "It gave useful information about peasant uprisings" (woman, age 20). "Useful. It taught me how peasants in the old days struggled for their freedom" (woman, age 17, referring to Altaev's *Pod znamenem bashmaka* [Under the Banner of the Shoe]). "Useful. It teaches that you have to believe in what the Revolution started" (woman, age 17). "A useful understanding of the February Revolution was given" (man, age 21). "It teaches you how to fight with weapons and with your hands, and not to ask the czar for bread and shelter" (man, age 17, about Vladimir Bakhmetev's *Voskresen'e* [Resurrection]). "Useful. It contained an explanation of unfamiliar words, and the Morse-code alphabet" (man, age 20, about Vladimirsky's *Shakhta Izumrud* [The Emerald Mine]). "Useful. It teaches a woman how to live properly" (woman, age 18, about Maxim Gorky's *Mat'* [The Mother]). "Useful. It teaches where vodka will take you" (woman, age 22, about Alexander Neverov's *Avdot'ina zhizn'* [Avdotya's Life]). "Useful. It shows that the countryside suffers from its darkness" (woman, age 22, about Neverov's *Andron Neputevyi* [Andron the Good-for-Nothing]). "The book was interesting when it was instructive" (working woman, about Boris Pilnyak's *Golyi god* [Naked Year]). "This book is interesting, it grabs you with its instructiveness. I recommend this book to be read by the peasant, who can learn, when he sees all the arrogance of the White Guardsmen and the kulaks, not to get involved with that gang in a difficult moment" (worker, about Yury Libedinsky's *Nedelia* [Week]).[21] "They ought to write more interesting books of fiction that discuss the various policies followed by our Party and our government, and discuss how these policies were carried out in life. How it would help us in our work, and keep us from making mistakes!" (tractor driver, after Soviet Party School).[22]

The book should be accessible to, even cultivate, the reader. "Most of all I dislike books where you read and read, and the point still isn't made. The writer doesn't speak his mind; in other words it's not pure, he says everything askew. In my view, if you write, then write without tricks and cleverness, explain everything to the last detail so that what your thoughts are about can be understood; otherwise it's best not to write at all, so you don't take up people's time for no reason" (female collective-farmworker, age 28). "The writer is for us readers a guide who directs our thoughts, from the point of view of the working class, toward a definite ideology." "It seems to me that our literature should be something that cultivates the masses."[23] "We should have everyone look to Gladkov to learn how to write novels

like *Tsement* [Cement]; we must represent positive types so that the proletariat can strive toward perfection."[24]

Literature should be realistic, yet optimistic and heroic. "I'll say one thing about books: I want them to show me directly how people are moving the economy forward, and what our collective-farm life will be like in three or four years" (collective-farm brigadier). "I'd like to read a little about our collective-farm life; it'd be interesting to find out what's ahead" (collective-farm brigadier).[25] "If you look ahead a little, you'll make us happy. When great orators come to visit us, describing future socialism, our spirits can't help being raised" (worker).[26]

"The new literature is full of sadness and depression, but in life there's a lot of joy. In the factories you don't find those decadent moods that you have in our recent books. Writers reflect the moods that predominate in the taverns, but they don't know at all, they don't feel, the moods of the factories, plants, and workers' clubs."[27] "We don't need the past, so humdrum and gray, we need literature to dictate a healthy and beautiful, morally beautiful life" (working-class woman, age 23, about Gladkov's *Tsement*).[28]

"All the heroic triumphs of our life should be represented in books" (Komsomol member and collective-farmworker). "Recently I read Hugo's *L'Homme qui rit*. So many bright and noble adventures in it, my heart was bursting with pity. If only they could write about our life as movingly as Victor Hugo."[29] "I read this book with pleasure, I liked it—and you know why, it's because it described simply and clearly the heroes of the Revolution. Reading this book, I wanted to be a hero myself—Comrades Gorin, Aron, Fyodor, and even Fenya and the informant Kolya performed their roles so splendidly" (worker, about Alexeev's *Bol'sheviki*).[30]

Literature should realistically show the guiding role of the collective and the Party as well as their impact on working-class life. "I'd like to point out one flaw that's typical not only of this book, but of most works about working-class life: the factory committee and the Party collective aren't present. These organizations, of course, have great significance at the factory, and it's perplexing why their influence isn't visible anywhere." "In regard to the plant, the most important thing isn't there: the masses. . . . You don't see the Komsomol." "We consider it a flaw that the roles of the factory committee, the Party collective, and the Komsomol are absent from depictions of the life of the plant, as well as the influence of them all on the

working masses." "Among the flaws of the book, one would have to mention the absence of the factory committee and the collective at the plant." "There's nothing on the foundations of the Revolution, its core—the collective energy of the masses, their readiness to fight, their enthusiasm and unbendable will to triumph in the building of the economy, their social and political activity" (worker, about Georgy Nikiforov's novel *U fonaria* [By the Lantern]).[31]

"I read Balzac's *Père Goriot*. I hated Rastignac the whole time for his greediness and his groveling. Our writers should depict our contrary elements in the same way, so that we can not only imagine them in our minds but see them with our own eyes, as if it were living. . . . Ostrovnov is depicted in a very lifelike way, you really hate him as if he's alive; you can say the same thing about the bureaucrat as well, the secretary of the local committee—his behavior is appalling. . . . It was Kondrat Maidannikov who seemed nearest and most understandable of all" (Komsomol member and collective-farmworker).[32] "Everything is realistically described; I myself, being from the country, can't say that everything's told accurately, as it actually happens." "Who could have listened so well, and written it down just right, like in life!" "When they read it in the countryside, they'll say, here's a cock-and-bull story staring us in the face." "What area did this take place in?" "We'd believe it if it said where, in what province, in what district it took place, but as it is it's not a fact, it's some Communist idea" (peasants, about Alexander Serafimovich's *Bab'ia derevnia* [Women's Village]). "You absolutely have to indicate the province, the district, the area and even the village, or nobody will believe it. They'll say it's old wives' tales." "You don't have to think up a title like that, but a real one; you'd get the countryside, everyone would say—that's exactly what happened! Whoever feels like it can learn something" (peasants, about Stepan Shilov's *Nechistaia sila* [For Impure Force]).[33]

I didn't like it. Everything's really unplanned. The worker in it doesn't talk, he howls like a trumpet. At a book fair in a city garden I saw a wooden proletarian with a hammer, a giant kid three or four meters tall, you could hang a bull on his shoulders, you could shoe a horse on his chest, his mouth could gobble up a sheep in one gulp. That's the kind of kid who howls: "We are growing out of iron." And the poet also says "out of iron." Sometimes here every vein in you is aching, and still they're saying "out of i-r-o-n" . . . they really drum it into our heads![34]

"I liked Trishin's book *Traktornaia byl'* [A True Tractor Story] because the bin-workers didn't give up when the mill was ruined." "Stalsky's book

Obshchestvennyi stanok [The Social Machine] isn't interesting because it describes how the bad members of the governing board just knock around; we got tired of . . . it." "I liked *Traktornaia byl'* very much because of the good job done by those bin-workers." [35]

Novels should be big, thick books with realistic, well-developed plots. "In contemporary books there's no 'system': they just show a small bit of a person's life. You don't know where the hero came from, and they often don't tell you where he's going. That's not enough. A book should show the whole fundamental life of a person, without gaps." [36] "The book goes along with its fragmented themes, so that you can't tell where the beginning is and where the end is" (man, age 20, about Dmitry Furmanov's *Pozhar* [Fire]). "You can't understand any of it, it's garbage. Everything's mixed up" (man, age 17, about Pilnyak's *Golyi god*).[37] "There's nothing whole and definite, I didn't get it: it's all jumbled up."

Everything described in this book happens in fragments, with more and more characters appearing all the time, and frequent repetitions of what was already said, with certain absurd chapter divisions. . . . The whole content of this book is a sort of chaos of ideas. . . . I don't understand why the book ends with the description of a country wedding, and I'll also say that it's hard to understand where the beginning and the end are. In general, I'll say one thing: reading the book is heavy going, and hard to understand (workers, about Pilnyak's *Golyi god*).[38]

"My review of Babel's *Konarmiia* [Red Cavalry]: This book in itself is okay, but the bad thing is that certain stories in it are completely incomprehensible, and, based on what I read and understood, almost all the chapters are all mixed up. I mean they're not in order, and because of this the reader can't understand the essential fact of the words. That's how I'd finish up my review" (a spinner). "Artyom Vesyoly's book is called *Strana rodnaia* [Native Land] but basically it's all a lot of nonsense, more than anything it's just a long confused story. . . . He writes in some language that's impossible to understand, and he tosses out words unartistically. . . . In his works there's no ending" (a student in a factory school).[39] "Shubin's *Stepnaia byl'* [A True Story of the Steppe] is written sort of awkwardly. Everything kind of happens in jolts, first forward, then backward" (a village correspondent).[40] "How can you explain that with contemporary writers you can be in Moscow, Leningrad, and Odessa all on the same page? There are very quick transitions from one subject to another. In the old days, with Tur-

genev, Gogol, and Goncharov, the same thing would take many pages to be described." [41] "There's no biography, and because there's none you can't understand it" (worker, age 27, about Gladkov's *Tsement*).[42] "There are too many people floating around. For some reason you just can't remember them. . . . There's a kind of chaos throughout the whole novel! There's nothing dramatic in it" (peasants, about Fyodor Panfyorov's novel *Bruski* [Bruski: A Story of Peasant Life in Soviet Russia]).[43]

"The reader is most attracted by thick, everyday books. He wants the hero to take his time, not to speak sentences in fragments all the time. He wants a realistic novel realistically written, solving the problems of life that he's interested in" (a librarian).[44] "I don't like short little books. You don't have enough time to even get your chair warm, you haven't experienced anything, and you're already at the end" (female worker).[45] "I didn't like the book. It was very short" (male, age 16, about Volkov's *Raiskoe zhit'e* [Heavenly Home]). "I didn't like it. It's a thin little book" (male, age 19, about Ilyinaya's *Sama doshla* [I Got There Myself]). "It was well written, but I didn't like it because it was too short" (male, age 16, about Semyon Podyachev's *Sluchai s portiankami* [The Foot-Binding Incident]). "A good book. I like it because it's big" (male, age 16, about Dmitry Furmanov's novel *Chapaev*).[46] "The most important thing is that it be a thick book which describes the life of a person from cradle to grave."[47]

A novel's plot should be absorbing and full of adventures, simply narrated in language that's artistic but comprehensible. "It goes on monotonously, there aren't any outstanding bits" (female worker, age 21, about Gladkov's *Tsement*).[48] "In [Alexander Serafimovich's] *Zheleznyi potok* [Iron Stream], all the marches and battles and uprisings of the Kuban peasants are described. . . . All the suffering and courage of those farm laborers." "This book didn't make any impression on me because it only tells you about the torments of the people left behind after their countrymen had been killed in war. And the whole book is like that. Everything's monotonous. Nothing else happens. And that's why this author doesn't interest me" (worker, about Leonard Frank's *Chelovek dobr* [The Man Is Good]).[49]

"Reading this book, I didn't understand anything at all, and then I just put it down" (worker, about a Pilnyak novel). "He has a lot of incomprehensible stories which you have to analyze. . . . I couldn't understand anything." "The stories are too symbolic; they just won't be comprehensible to the broad masses" (worker, about Efim Zozulia's stories). "The author

composed this story in a painfully complicated way. There's nothing really good in it" (worker, about an Alexander Arosev novel).[50]

"A big, artistically vivid picture. . . . Only Gorky can write like this. With a simple and at the same time imagistically vivid language, so natural and understandable" (worker, age 48). "A nice, lively language, vivid. . . . You can't put it down" (worker). "A juicy, strong, vivid language" (worker, about Gorky).[51] "You can't teach young people anything with newspapers, and you can't do it with books written in 1918 either. . . . You have to present a real language, a beautiful, juicy, language that we could use at meetings, at lectures, in debates, in daily life, and in mass gatherings. . . . Writers should forge a language."[52] "The book is good in that it is laid out in simple language that isn't too literary" (worker, about Upton Sinclair's *100%*).[53] "The language is heavy, but the book is interesting and lively" (peasant, age 19, about Babel's *Konarmiia*). "You won't even be able to finish it—the language doesn't work" (peasant, age 18, about Sergei Esenin's *Radunitsa*). "It's not a good book. It's got kind of a funny language. You can't figure it out" (peasant woman, age 17, about Vsevolod Ivanov's *Bronepoezd 14-69* [Armored Train No. 14-69]). "It's written incomprehensibly, it's boring. The title is too racy, it could be a double-entendre" (peasant woman, age 21, about Ilya Erenburg's *Khulio-Khurenito* [Julio Jurenito; "khui" is an obscenity]).[54] "Writers who rewrite the rules of grammar should be hit."[55]

I read I. Kasatkin's book *Starinushka* [A Little Old Tale]. It was hard to understand, since after almost every word there are periods, commas, and question marks. It was hard to say the words. There are a lot of them with little embellishments and cute endings. It's hard to read through and pronounce out loud. . . . On the first pages you have to try to write entertainingly, so the reader can't tear himself away when he starts to read.[56]

"You have to write in an easy language, comprehensible and popular, so that the reader can understand what the writer is saying." "When I read through our poets, I won't understand anything, it's very very rare when I understand something, but with Pushkin and Lermontov it's a completely different thing."[57]

Poetry should be free of "futurism." "They write in a completely, completely new way, and it sometimes happens that we don't understand anything because we're used to speaking and reading in Russian, but some poet speaks

Mayakovskian, and we can't get it at all." [58] "I'd like to see big, strong, classical poems, with a clear subject and a deep plan, and a style that's not too sophisticated. . . . If you have to analyze poems, like a formula, then they lose their reality" (worker).[59]

The following remarks are from a transcript of a discussion by Adrian Toporov's communards about Boris Pasternak's 1930 poem *Spektorsky* (the communards could only manage to read the first eight lines):

— It's neither here nor there.

— This writer has made a mess of verse.

— Something crept somehow into a guelder rose.

— I couldn't make any sense of this poem. Guelder rose, raspberry, chicken shit, and nothing else is said.

— There's nothing comprehensible in it. Nothing is made for being understood. The whole poem is like a plucked chicken—it's terrible. He shouldn't write things like this.

— It would've been better if he had written some song!

— After the guelder rose everything just fell apart!

— What's written here is just trash and garbage. Pasternak has robbed the public purse.

— They ruined the book with this poem. What the author wanted to say I just didn't understand.

— I don't want to criticize him. I was so repulsed by the poem that I get nauseated just talking about it. Separately the words make sense, but not together.

— The words are Russian, understandable, but there's no substance behind them.

— The words aren't connected at all. A good man will say one word, then tie it up, then say another one, and tie up that one. The first bits, the middle bits, and the end bits—he'll tie them all together into one thing. But in this poem the words are scattered as if they passed through a strainer, all separated from each other.

— The words fly around your ears like flies: Bzz-bzz-bzz! But not a single word sticks to your soul.

— A lot has been thrown together. Kind of a crazy storm. Is the man who wrote this poem a fool? A simple person wouldn't come up with things like this!

— Everything that he had heard was blown out of his head by the wind.

— Oh, you don't even need a brain to put together nonsense like this!

— You don't need a brain to write poems like these. He just tangled up some threads together, and that's all!

- "It inoculates the coming life." . . . For this we should put a pitchfork in the writer's hands and let him dig manure.
- The peasants pay taxes, and the state uses them to pay for trash like this. Who and what are these verses for? It's a mockery of the people!
- It made me furious. I got so worked up about it, so upset, that right now I'd strangle the author with my own hands. Our brother works all summer just for bread, while this poet gives a little chirp and gets hundreds of rubles! These verses are a robbery of state funds. That's what they mean!
- The poem doesn't fit any purpose.
- Find out from the author, for the good of the state, how much he made from these verses.
- Confiscate his whole property! But how? The pig destroys the flower bed, and the neighbors complain, but here . . . what sums will be squandered! [60]

The general opinion of the communards was that Pasternak's poem "on the theme of Spektorsky" was a remarkable misappropriation of government funds, which should be immediately cut off. ("It's nonsense!")

Literature should not be "obscene." "When I was reading the book *Zheleznyi potok* there was the most shameless, most unrestrained foul language from beginning to end, foul language in its most outrageous forms. In my view, this is the negative side of the book, since young people who read it will learn that it's all right to use that form of conversation in their ordinary lives, the kind demonstrated in *Zheleznyi potok,* as if it were completely normal and accepted." "This gross flaw I've observed in all our contemporary writers, or almost all of them." [61] "In *Podniataia tselina* [Virgin Soil Upturned] everything is accurately described. . . . But in places it has very bad expressions. Shouldn't it be forbidden to express yourself like that, so that everything can be happy and not obscene? Maybe there are men like that, sure, but we women really don't like words like that, and the main reason is that all those words have something to do with women." [62] "All around us there's a struggle against hooliganism going on, and yet books give us all sorts of curses and obscenities." [63] "Lavrenyov is too distracted by the pornographic aspect and lets the reader follow the sailor all the way to Annushka's featherbed; and plus, since he wants to describe the sailor more fully, he's always using sailor expressions, including foul language, which seems to me unnecessary for the new literature; you can describe a sailor very well without using foul language." "There should be no place

given to foul language. Foul language should be thrown out."[64] "I don't like it. Girls like Maruska don't do anything but hang around with men — as if that's doing something" (peasant woman, age 19, about Vorobyov's *Marus'ka-komitetchitsa* [Maruska the Committee Girl]). "Why is it that Gorky describes so many rapists? It'd be better without them" (peasant, age 18, about Gorky's story "Dvadtsat' shest' i odna" [Twenty-Six Men and a Woman]). "There's a lot of pornography in it. I didn't like it" (peasant woman, age 22). "I didn't like it; it describes fornication" (peasant, age 18). "It's embarrassing to read books like this, to print them, and to buy them in the bookstore" (peasant, age 18). "I didn't like it. The second part is even nastier than the first. It gives harmful advice" (peasant, age 18, about Kalinnikov's *Moshchi* [Relics]). "It's an indecent book. Shameful. I didn't like it" (peasant woman, age 21). "It's no good, I didn't like it. Making love like dogs may be fine, but when that's all you get it's not enough" (peasant, age 18, about Pantaleymon Romanov's *Bez Cheremukhi* [Without a Bird Cherry]). "A woman who has a lot of good times. I don't like the book" (peasant woman, age 17). "I didn't like it. The woman's a whore. I don't know why they smeared her all over the book" (peasant, age 17). "It's a very good book. I like women like that. Only you shouldn't show them having sex. It doesn't do anything" (peasant woman, age 18, about Lidiya Seifullina's *Virineia*).[65] "There's cursing all over the plant; the worker comes home, wants to rest, picks up a book, but it just has more cursing; wherever you turn there's cursing everywhere. You just feel like having a rest from cursing." "The incidence of cursing in contemporary literature is a vestige of the old world. . . . But we have to strike out against this sort of vulgarity so that morals can be raised."

It seems to me that in our Mother Russia everybody's referring to mothers in their curses. How shameful it is, comrades, that in the eleventh year of the Revolution we have to admit that we're still up to our ears in swearwords. That's why I think that if you read a book, you should want to feel purer afterwards. In everyday life you get curse after curse, and then you get still more in books. That's why it would be good to avoid that sort of pornography.

"Comrade writers, you criticize the old writers, but in them you won't find the kind of obscenity that you read in your own works. Thanks to your books you have corrupted the whole youth." "Comrades, at times you write such questionable stuff that it's shameful to read it when children are present." "Many writers are occupied with harmful work: namely, they

collect perversities from people's sex lives and present them to the contemporary reader in the most tempting way. . . . It's their fault that after reading you get more heated up, you feel a greater relish for sex, and not the other way around—you don't feel disgust." "I've read a lot of the old Russian writers and I'll say one thing right away—our proletarian writers still have a long, long way to go to reach their level, with the exception of some idea-oriented ones, and the main shortcoming is that there's none of the beauty and artistry of the classics; there you get some pornography too, but it's so well depicted that you read it without blushing." [66]

Love stories should be "elevated," science fiction is "nonsense," and proletarian humor has great merit.

My favorite book is *Ovod* [The Gadfly] . . . it speaks about love so well: what a high, heroic love! Love should be written about only like that. But when the writer starts going into detail describing who the heroes kiss, embrace, tempt each other, get perverse, that only leads to bad thoughts. I know comrades who read too much of that sort of thing and start acting wild. . . . But it's good to read about the kind of love you get in a book like *Ovod*. Love like that elevates you. I think that the writer ought to write about love; it gives the book variety and it not only doesn't spoil the revolutionary idea, but strengthens it. [67]

"This is a utopian book. Some crazy fellow sent a manuscript from Mars and it's all about the lives of the Martians. Complete nonsense" (worker, about Alexander Bogdanov's utopian novel *Inzhener Menni* [Engineer Menni]). "People fly through the air without any machines . . . lots of unreal stuff. It doesn't prove any facts" (worker, about Alexander Grin's *Blistiaiushchii mir* [Shining World]). [68]

"The reader goes to the library and wants to find an easy book with a happy theme, with healthy proletarian humor" (worker). [69] "Very absorbing and funny. I read it to the kids. We laughed until our sides ached" (man, age 19, about Podyachev's *Sluchai s portiankami*). "We need more [books] that make you laugh" (man, age 19, about Podyachev's *Son Kalistrata Stepanycha* [Kalistrat Stepanych's Dream]). [70]

The Soviet reader of this period was hardly inclined to assume the role of someone asking for the "literary production" that he or she needed and lacked. On the contrary, the reader felt sure about received literature, sure that it belonged to him or her. But no matter how many reviews we

read, one way or another everything that these readers demanded from art fell into one of two distinct categories, which together comprised an elegant aesthetic system. It was a fully "possible aesthetic," to recall Régine Robin's well-known book *Socialist Realism: An Impossible Aesthetic*. As history has shown, this aesthetic was not only possible, but had much potential and many possibilities, and this was so precisely because it was constructed in *clear correlation* with the "social commandments" of the masses.

The adepts of the new culture fully recognized the necessity of taking these demands into account. Take, for example, the brochure entitled *Kakaia kniga nuzhna krestianinu?* (What Kind of Book Does the Peasant Need?), published by the Library Division of *Glavpolitprosvet*[71] in 1927, after the performance of over 300 readings in the peasants' auditorium. It contained clear prescriptions of how things should be written for the peasants, and on what themes (even insisting that writers use simple prepositions, avoid passive forms and gerunds, put commas only between enumerated items, and use parentheses only for explanations). Most interesting of all, of course, are the instructions pertaining to literature. Since peasants want to "extract something useful" out of prose fiction and, optimally, to find some "teaching" in it, a turn toward peasant themes was recommended; since the main thing in a book for peasants was "verisimilitude," avoiding plots that from the everyday point of view were unlikely was suggested: "The plot should be clearly constructed. Sidetracks, confusing the main story, often impede comprehension," explained the brochure's authors, using a participial construction.

Peasants like a well-developed plot. They want sequence and logic in the development of the action, and they want every moment to be justified by the preceding one. . . . Fragments, stories without a definite ending, aren't favorably received by the peasant reader. In cases like that, he always demands some sort of supplement, to find out [how] it all ended. . . . It's not good to abuse vulgar expressions. It often repels the reader. In particular, the woman reader doesn't like expressions that are too "loose." . . . The peasant reader isn't satisfied by a book that from beginning to end gives you a heavy, oppressed feeling. . . . The peasant reader who willingly listens to something "funny" doesn't always understand humor writing. For this you have to find out very carefully what sorts of humor he understands."[72]

Was socialist realism invented by Stalin, Gorky, Lunacharsky? Was it the result of an inner crisis of the avant-garde, or was it linked to the masses as an aesthetic rather than a confluence of canonical demands, as a

"guide for action" rather than mere doctrine? One can say definitively that what we have been examining here constituted *one of the most powerful sources of socialist realism.* One cannot seriously suggest, as traditional Sovietology maintained, that official Soviet criticism, guided only by political motivations, could have demanded literary *verisimilitude:*

The demand for truth in literary works . . . is one of the important characteristics that make the contemporary Soviet reader distinctive. The demand for truth in art is consistent with the whole moral aspect of the Soviet citizen, his whole world-view and world perception. This demand harmonizes with that same healthy feeling of historical optimism which to a high degree is peculiar to the Soviet person, and which allows him to overcome all difficulties and obstacles in his way. . . . The juxtaposition of literature and life, or, more accurately, the understanding of literature as a reflection and interpretation of the life lived by the readers themselves —this stands out like a red thread running through almost all the opinions given by readers, through the overwhelming majority of readers' letters to writers."

Or *total realism:*

Readers demand that fine literature have imagery, picturesque representation, rather than abstract discussions; they expect it to reveal for them life in living, concrete images. Any rhetoric, any fancy mannerisms, any formalist inventions go against the aesthetic tastes of our readers and make them sick.

Or *sequential logic:*

Readers demand—and rightly so—that writers give them consistency in the development of human characters, unconditional trustworthiness, rigorous justification for all the actions and intentions of the characters. If they can't get that sort of logic and trustworthiness in at least some of the episodes in the book, then they start to protest.

Or *"thick books":*

Readers like thick books, solid works. . . . Literary characters from the best books by Soviet writers are viewed by the mass reader as if they were living people, in whose fates they are passionately interested. For this reason the reader feels dissatisfied when, by the end of the book, he is forced to say good-bye to the heroes, who are so full of force and energy, standing on the threshold of new labors and new triumphs. For this same reason readers' letters are full of pleas for writers to let everyone know what happened to the heroes after the end of the book, and, if possible, to extend the book.

Or *"living people," "fullness," "completeness"*: "The reader demands fullness from a work of art. . . . The motive behind this demand is a desire for clarity and completeness in the representation of the characters and their fates." So, did the reader then demand *socialist realism?* Precisely: "Our readers have fully defined tastes in art—they want *realism* in art, *socialist* realism, representations of the living person, acting and thinking, without any naturalistic digging around in physiological details, and without avant-garde effects or formalist magic tricks." [73]

Soviet criticism resounded with the demands of the mass reader, and those demands coincided almost completely with the demands of state power. The political conditions of this or that campaign could never exceed the determined aesthetic norm that had been dictated by the masses and recognized by the state. "Popular spirit" (*narodnost*) was in truth the fundamental principle of socialist realism. Its *aesthetic correspondence* with "Party-consciousness" (or "Party-mindedness") constituted the true aesthetic kernel, the main aesthetic event, of socialist realism. The socialist realist canon in many ways was produced by the reader's "social commandment" and merely officially formulated by the state. The art of socialist realism was a self-tuning mechanism, or, in Eduard Nadtochy's concise definition, a "machine for encoding the masses' fluid desires." [74]

We must ask once again: From which social milieu (with its specific aesthetic experience and tastes, with its specific horizon of expectations) did history make its selection? And we return to the same set of possible answers:

— Soviet culture returned to the undeveloped taste of the masses;
— Soviet culture relied on the tastes of the leaders;
— Soviet culture realized the avant-garde's political and aesthetic project, as the product of avant-garde crisis.

These widely divergent answers do not, in fact, contradict each other at all. None of them, of course, is absolute. And none of them functions as an absolute. Contrary to Boris Groys, who suggests that socialist realism was alien to the "actual tastes of the masses" and was imposed by Stalin, that, instead of socialist realist doctrine, the phonetic trans-sense poetry of Khlebnikov and Kruchonykh or Malevich's painting *Black Square* could have been accepted with the same success, inculcated into the public with the same enthusiasm, obviously, Soviet culture could not—precisely because of its crucial reliance on mass tastes—have taken *Black Square* or trans-sense poetry as its point of departure.[75] Between egalitarian tastes

and elite tastes there was no gulf. What was definitive was not the direct reliance on a certain level of taste, but rather precisely the opposite—the reliance on a constantly shifting threshold of taste. The "undeveloped" tastes of the masses were not simply complex, but, much more importantly, *dynamic*. Social turbulence was the main obstacle to any attempt at social equalization among works of art, a social elite, and the masses.

Soviet culture actually did realize the political and ideological project of the avant-garde, a project which was exclusively elite in nature. But in realizing this project, it relied on mass culture. And what is at issue is not the "traditional means," as Boris Groys suggests, or—in this case—any "means" whatsoever; what is at issue rather is the satisfying of a certain horizon of aesthetic expectations, the reliance on a certain aesthetic experience. Socialist realist aesthetics never recognized the thesis of the "ontological elitism" of art, but rather fought against it throughout its history. Here, what must be kept in mind is that the Leninist theory of "two cultures within each national culture," on which Soviet aesthetics rested, was without a doubt an elitist theory that would be better called a theory of "two *elitist* cultures within each national culture." "Reactionary culture" was no less elitist than the "revolutionary culture of Chernyshevsky, Dobrolyubov, Pisarev." It was one and the same cultural paradigm. Yet the mass-culture paradigm was not generally taken into account by the revolutionaries: the Revolution gave birth to a super-elite avant-garde art and in many ways fought against *lubok,* or picture-book literature, eliminating the "vulgar" (*meshchanskuyu*) picture-book literature with the same resolve as it eliminated antirevolutionary literature. Mass tastes were equally alien to both cultures. But even so, this bipartite culture was rejected by mass tastes: the old was "trash," while the new was "incomprehensible drivel."

There is another issue here as well: Soviet culture's appearing to be the expression of state power. Soviet power was exclusively pragmatic, not to say anti-ideological. It was a pragmatic of *pure power,* its strategy dictated simply by the logic of self-preservation, the logic of keeping power. All the ideological attributes of Soviet power were wholly facultative. It rested with ease on ideological doctrines that were completely divergent, often diametrically opposed to each other. It was founded, for example, simultaneously on "proletarian internationalism" and on "Soviet patriotism"; it supported the "national liberationist movement" and fought "nationalism"; it "subdued nature," yet fought for "ecology"; it confessed to an overt expansionism and a "struggle for peace"; it espoused a "withering

away of the state," yet in various ways it strengthened the state. Nevertheless, it would be a gross oversimplification to say that it said one thing and did another: the "Stalinist plan for forest-preservation zones," for example, was as much a reality of Soviet history as "the redirecting of rivers." This was exactly the way that the culture itself was constructed in accordance with the contemporary needs of power. (One of the fundamental principles of socialist realism, the principle of "Party-consciousness," demanded just this sort of "hypersensitivity" from art.) As the tasks changed, the themes changed too, but one thing remained the same: the *nature* of culture, power, and the masses. Any government power's socially significant intentions had to be "authorized" by the masses, accepted by their collective consciousness, supported in the deepest mental structures typical of a given society at a given time. In this "oneness of Party and people" lay the real foundation of Soviet culture. The unity of state power and the masses forced the culture of power to be egalitarian, although totalitarian power is always created in the name of an elite.

The product of Soviet history and the transformations of power, the egalitarianism of Soviet culture was a complex phenomenon, one that was far from unacknowledged, reconciling within itself opposing cultural strata—from the academic opera theaters, with their "people's performers," to the conventions of court portraiture in painting and of the Empire style in architecture, to the demands for "simplicity," "comprehensibility," "accessibility," and "the representation of life in the forms of life itself." (Incidentally, the attendance at officially sanctioned opera theaters was similar in magnitude to the mass interest in officially sanctioned literature: Anatoly Ivanov and Konstantin Simonov were among the most read authors of the 1970s, just as *Chapaev* was the most popular film of the 1930s.)

Soviet society was, of course, never a "monolith," as official Soviet doctrine and Western Sovietology maintained. In the course of Soviet history, it encompassed complex, often latent sociocultural, national, political, and demographic processes and stratifications. As with any society, Soviet society was, above all, mosaiclike—which is not to say that there was no "organic Soviet culture." Such a culture existed, beyond all doubt, although it became vaguer and dimmer the farther from the center one got—just as the social segment on which this culture relied became vaguer and dimmer at its limits. Neither the Soviet person nor the Soviet culture was a theoretical abstraction, but neither were they monolithic giants. The

real social substrate on which Soviet culture relied accumulated a mass experience that was social, historical, and, ultimately, aesthetic as well. The phenomenon produced by this mutual influence can be called the *disaster of middlebrow taste*. The egalitarianism of Soviet culture consisted not so much in its primitive reliance on the "undeveloped tastes of the masses" as in its *total strategy of averaging* and its elimination of all enclaves of autonomy. Insofar as the taste of the masses was a giant looming over everything, it kept this position through its maintenance of the "average." The principle of symbolic interactionism, stimulated by state power through the automatizing and stereotyping of the individual's social reactions, enhanced this effect even more.

Literature (and art in general) as a social institution realized its control over society, since it was an integral element in the system of social control, and society was in the midst of a transformation—that is, it was undergoing systemic change as a result of emerging new relations among its constitutive elements, or of the disappearance of relations that had existed until then. The model of society under a totalitarian regime was in conflict with this natural tendency; the mechanisms of self-adjustment had no effect here. The contradiction was eliminated by state power as the single truly acting subject in that sort of society. Power, constantly renewing its "ideological arsenal," could, on one hand, change its forms of control and normalization and, on the other, "coordinate" those forms with social transformations. The regime could avoid performing those functions without risking the loss of its control, its power, over society.

Socialist realism got through the strait between the Scylla of "mass literature" and the Charybdis of "elite literature." Its artistic production never congealed into either of those two traditional forms, and its stylistic neutrality (the notorious "stylelessness" and "grayness" of socialist realism) was the result of this "third way." Some consider it the product of a complete massism, while others see it as the result of mutations within cultural institutions (most often the avant-garde). In our case the real source of socialist realist aesthetics is not to be found in the traditional "middle" of the two opposed positions. Its source lies not *between* those two positions, but in their *synthesis*. Socialist realism was a contact point and a cultural compromise between two currents, the masses and state power.

Thus Soviet criticism turns out to have been correct in asserting in 1934, after the First Congress of the Soviet Writers' Union and the announcement of socialist realism, that "the reviews and opinions of the

working-class reader are the best confirmation of the dictates of the Party and of its leader, Comrade Stalin, concerning the paths of development to be followed by Soviet literature, and concerning the struggle for the creative method of socialist realism."[76]

Precisely: *the best confirmation.*

— Translated by John Henriksen

Notes

1 S. Krylova and L. Lebedinskii et al., *Rabochie o literature, teatre i muzyke* (Leningrad, 1926), 32–33.

2 Ibid., 34–35.

3 Ibid., 35.

4 M. Alatyrtsev, "Pochva pod nogami" (The Ground under One's Feet), *Literaturnyi ezhenedel'nik* (Petrograd), No. 8 (1923): 12.

5 Krylova and Lebedinskii et al., *Rabochie,* 73.

6 Ibid., 74.

7 Ibid., 73–76.

8 Ibid., 82–83.

9 *Proletkult:* Proletarian cultural-educational organizations (1917–32). See Lynn Mally, *Culture of the Future: The Proletkult Movement in Revolutionary Russia* (Berkeley, Los Angeles, and Oxford, 1990).

RAPP: Russian Association of Proletarian Writers, organized in 1925 and disbanded in 1932. See Edward Brown, *The Proletarian Episode in Russian Literature 1928–32* (New York, 1953).

10 Krylova and Lebedinskii et al., *Rabochie,* 45–47.

11 Ibid., 54–55.

12 Ibid., 55–56. (The atmosphere of similar performances is evoked well by Vyacheslav Shishkov in his story "A Performance in the Hamlet of Ogryzovo.")

13 Ibid., 56.

14 Ibid., 60–61.

15 Ibid., 65.

16 Ibid., 66.

17 A. Toporov, *Krest'iane o pisateliakh* (Peasants on Writers) (Moscow and Leningrad, 1930), 24.

18 Mikhail Bekker, "Khudozhestvennaia literatura i zadachi kommunisticheskogo vospitaniia molodezhi" (Literature and the Tasks of the Communist Education of Youth), *Molodaia gvardiia,* No. 9 (1933): 135.

19 V. Goffensheffer, "O stat'e Karla Kosova i o rabochem chitatele" (On Karl

Kosov's Article and the Working-Class Reader), *Pechat' i Revoliutsiia,* No. 3 (1928): 110.

20 Karl Kosov, "Chto chitaet nemetskii rabochii?" (What Is the German Worker Reading?), *Pechat' i Revoliutsiia,* No. 3 (1928): 112.

21 Quoted in B. Bank and A. Vilenkin, *Krest'ianskaia molodezh' i kniga* (Peasant Youth and the Book) (Moscow and Leningrad, 1929), 71–72.

22 Quoted in Vezhe, "Chto chitaiut: Litso rabochego chitatelia" (What They're Reading: The Face of the Working-Class Reader), *Na literaturnom postu,* No. 9 (1927): 63.

23 Quoted in B. Brainina, "Kolkhoznyi chitatel' o knige" (The Kolkhoz Reader on Books), *Novyi mir,* No. 8 (1935): 263, 262.

24 Quoted in *Pisatel' pered sudom rabochego chitatelia: Vechera rabochei kritiki* (The Writer Judged by the Working-Class Reader: Evenings of Workers' Criticism) (Leningrad, 1928), 9.

25 Quoted in L. Poliak, "K voprosu o metodike obrabotki chitatel'skikh otzy-vov: Rabochii chitatel' o 'Tsemente'" (Toward the Question about Methods of Incorporating Readers' Opinions: A Worker on *Cement*), *Krasnyi bibliotekar',* No. 9 (1928): 56.

26 Quoted in Brainina, "Kolkhoznyi chitatel'," 262.

27 Quoted in *Pisatel' pered sudom rabochego chitatelia,* 69.

28 Quoted in Shipov, "Rabochii chitatel' o novoi literature" (The Working-Class Reader on the New Literature), *Zhurnalist,* No. 2 (1927): 49.

29 Quoted in Poliak, "K voprosu o metodike obrabotki chitatel'skikh otzy-vov," 56.

30 Quoted in Brainina, "Kolkhoznyi chitatel'," 264.

31 Quoted in Vezhe, "Chto chitaiut," 63.

32 Quoted in *Golos rabochego chitatelia: Sovremennaia sovetskaia khudozhestven-naia literatura v svete massovoi rabochei kritiki* (The Voice of the Working-Class Reader: Contemporary Soviet Literature and Mass Working-Class Criticism), ed. G. Brylov, N. Lebedev, B. Maiberg, and V. Sakharov (Leningrad, 1929), 139–40.

33 Quoted in Brainina, "Kolkhoznyi chitatel'," 263.

34 Quoted in *Kakaia kniga nuzhna krest'ianinu?* (What Kind of Book Does the Peasant Need?) (Moscow, 1927), 21–23.

35 Quoted in Mikhail Bekker, "Molodoi chitatel' v roli kritika" (The Young Reader in the Role of the Critic), *Molodaia gvardiia,* No. 11 (1933): 138.

36 Quoted in A. Meromskii, "Kriticheskoe chut'e derevni" (The Critical Percep-tions of the Countryside), *Na literaturnom postu,* No. 3 (1928): 36.

37 Quoted in Shipov, "Rabochii chitatel'," 48.

38 Quoted in Bank and Vilenkin, *Krest'ianskaia molodezh',* 76.

39 Quoted in Brylov et al., eds., *Golos rabochego chitatelia,* 10–11.

40 Quoted in Vezhe, "Chto chitaiut," 61–62.

41 Quoted in Meromskii, "Kriticheskoe," 40.

42 Quoted in *Pisatel' pered sudom rabochego chitatelia*, 80.

43 Quoted in Poliak, "K voprosu o metodike obrabotki chitatel'skikh otzy-vov," 49.

44 Quoted in Toporov, *Krest'iane o pisateliakh*, 189.

45 Quoted in A. Isbakh, "Chto chitaiut: O roste rabochego chitatelia" (What They're Reading: On the Growth of the Working-Class Reader), *Na literaturnom postu*, No. 2 (1928): 37–38.

46 Quoted in Shipov, "Rabochii chitatel'," 48.

47 Quoted in Bank and Vilenkin, *Krest'ianskaia molodezh'*, 81.

48 Quoted in A. Levitskaia, "Chitatel'skaia tribuna: Chitatel' v roli kritika" (The Readers' Tribune: The Reader in the Role of Critic), *Na literaturnom postu*, No. 6 (1929): 68.

49 Quoted in Poliak, "K voprosu o metodike obrabotki chitatel'skikh otzy-vov," 50.

50 Krylova and Lebedinskii et al., *Rabochie*, 19–20.

51 Ibid., 26.

52 Quoted in E. Korobka and L. Poliak, "Rabochii o iazyke sovremennoi prozy (K postanovke voprosa)" (The Working-Class Reader on the Language of Contemporary Prose [Toward a Formulation of the Question]), *Na literaturnom postu*, No. 14 (1929): 14.

53 Quoted in *Pisatel' pered sudom rabochego chitatelia*, 14.

54 Quoted in Vezhe, "Chto chitaiut," 64.

55 Quoted in Bank and Vilenkin, *Krest'ianskaia molodezh'*, 75–76.

56 Quoted in Shipov, "Rabochii chitatel'," 48.

57 Quoted in Meromskii, "Kriticheskoe," 38.

58 Quoted in *Pisatel' pered sudom rabochego chitatelia*, 12, 76.

59 Quoted in N. Konstantinov, "Govorit chitatel'" (The Reader Speaks), *Literaturnyi sovremennik*, No. 6 (1934): 185.

60 Quoted in Toporov, *Krest'iane o pisateliakh*, 267–69.

61 Quoted in Korobka and Poliak, "Rabochii o iazyke sovremennoi prozy," 61–62.

62 Quoted in Brainina, "Kolkhoznyi chitatel'," 265.

63 Quoted in Shipov, "Rabochii chitatel'," 48.

64 Quoted in Brylov et al., eds., *Golos rabochego chitatelia*, 91, 112.

65 Quoted in Bank and Vilenkin, *Krest'ianskaia molodezh'*, 77–78.

66 Quoted in *Pisatel' pered sudom rabochego chitatelia*, 13, 14, 70, 72, 74, 75, 79–82.

67 Quoted in Brainina, "Kolkhoznyi chitatel'," 265.

68 Krylova and Lebedinskii et al., *Rabochie*, 24.

69 Quoted in Vezhe, "Chto chitaiut," 65.

70 Quoted in Bank and Vilenkin, *Krest'ianskaia molodezh'*, 80.

71 The "Chief Administration of Political Enlightenment" (*Glav*noe upravlenie *polit*isheskogo *pros*veshcheniia), a state organ of the People's Commissariat of Enlightenment of Soviet Russia (1920–30), oversaw all propaganda activity in the country.

72 *Kakaia kniga nuzhna krest'ianinu?,* 22–24. In 1928, the Baku journal *Trud* (Labor) even announced a competition among its readers to write the best ending to S. Semenov's novel *Natal'ia Tarpova,* informing them that the best responses would be given an award, published, and sent to the author. See "Stranichka rabochei kritiki" (A Page of Workers' Criticism), *Trud,* No. 3 (1928): 7.

73 "Trebovaniia kritiki" (The Demands of Criticism); quoted in G. Lenobl', "Sovetskii chitatel' i khudozhestvennaia literatura" (The Soviet Reader and Literature), *Novyi mir,* No. 6 (1950): 209, 218, 220, 223, 224.

74 Eduard Nadtochii, "Druk, tovarishch i Bart (Neskol'ko predvaritel'nykh zamechanii k voprosheniiu o meste sotsialisticheskogo realizma v iskusstve XX veka)" (Druk, Comrade, and Barthes [Some Remarks Preliminary to an Investigation about the Place of Socialist Realism in Twentieth-Century Art]), *Daugava* (Riga), No. 8 (1989): 115.

75 See Boris Groys, *The Total Art of Stalinism: Avant-Garde, Aesthetic Dictatorship, and Beyond,* trans. Charles Rougle (Princeton, 1992), 6–9.

76 A. Ivanov and L. Chernets, "Sovetskii chitatel' o oboronnoi khudozhestvennoi literature" (The Soviet Reader on War Literature), *Zalp* (Leningrad), No. 11 (1934): 34.

Mikhail Iampolski

CENSORSHIP AS THE TRIUMPH OF LIFE

In the ethics of Soviet censorship in its "heroic" period (from the late 1920s to the mid-1950s), there was something that strikingly distinguished it from the "normal" functioning of ordinary censorship. Normally, what we call "censorship" does not exhibit itself before society so much as hide in its shadowy depths, producing its effects without attracting general attention. But in the USSR, prohibitions instituted against films, books, and live performances were ordinarily accompanied by an astounding song and dance. Public judgments, analyses, artistic advice, declarations, and resolutions generated such deafening cannonades that they inevitably attracted much attention to the prohibited work. The forbidden film often garnered many more critical analyses than the accepted film could ever hope for. Prohibition became vociferous public action, amounting almost to a *triumph* of censorship.

To some degree this uproar was elicited as a way of masking the activity of the censorship machine, of shifting responsibility onto an "indignant" public. But there was more to it than that. It can be argued that the carnival of censorship was performed as a ritual of self-torture for the artist, an inquisitorial procedure which had great symbolic meaning, a self-flagellation construed as the culmination of a sinister process of social therapy. The more furiously the artist publicly tortured himself, the fuller his recovery from his grave "illness." Any attempts to avoid this self-flagellation were read as signs of the incurability of that illness. In 1931, the director of the Association of Workers for Revolutionary Cinematography (*Assotsiyatsiya Rabotnikov Revolyutsionnoi Kinematografii* [ARRK]), Konstantin Yukov, harshly criticized Ivan Pravov and Olga Preobrazhenskaya's film *Tikhii Don* (The Quiet Don), lingering especially on Pravov's unacceptable behavior:

You all remember that we proposed to Pravov that he write an announcement evaluating his mistakes. The admission of his errors made by him here is a clearly unsatisfactory one, referring to a whole array of "objective circumstances." Two months have gone by, and we still have no announcement from Comrade Pravov. The secretariat of ARRK, summing up the effects of the Purge and discussing the report of the Commission for the Examination of Appeals against the Purge, has

affirmed the commission's decision regarding the exclusion of Preobrazhenskaya and Pravov from the organization. It has done so as a result of witnessing the unmistakable departure of fellow travelers for the reactionary wing.[1]

The joyful reception of such criticism, bordering on insult, was often considered a sign of the film director's good health. When Kozintsev and Trauberg (directors made suspect by their unremitting formalism) began production of *Iunost' Maksima* (Maxim's Youth), their screenplay was subjected to exceedingly crude and stupid censorship on the part of the old Bolsheviks. In a letter to ARRK head of cinematography Boris Shumyatsky, Kozintsev deemed it necessary to say what joy he had felt at that pogrom: "The reviews of the old Bolsheviks, despite their abundant abuse, made us surprisingly happy. . . . I was so touched, I even sent a letter to Shapovalov." [2]

The collectives would follow the phases of an artist's degradation with a doctor's attention, fixating on every last detail until the disgraced director's tone testified to his complete rehabilitation. This sadistic case study would include the most trivial information and would become common property. The creative section of "Mosfilm," for example, published an account of Eisenstein's behavior during the attack on his *Bezhin Lug* (Bezhin Meadow):

The most active members of this section consider it their duty to tell Comrade Eisenstein that his self-critique did not always display the deep and sincere understanding that is the unique pledge of the artist's genuine, deeply rooted reorientation. Moreover, in one of his statements (before showing material), Eisenstein said certain things that could be construed as expressing his offense at and noncomprehension of the Party's decision regarding *Bezhin Lug*. His wording unambiguously condemned the creative section of the studio. And only with Comrade Eisenstein's final appearance did any emotion become perceptible, only then were the clear and simple words spoken that inspired a hope that Eisenstein, going further down this path, after a deep and judicious reflection upon his creative life, would be able to create works of great, Party-conscious art.[3]

This sort of therapeutic ritual hid a certain ideology, even a theory. The increasing censorship persecutions in the late 1920s were mainly conducted under the banner of the so-called struggle against formalism. Why was formalism scapegoated in this way? The main charge leveled against the formalists (and almost all the great artists of the 1920s were classified

as such) was that they subjected the highly diverse reality around them to certain formal imperatives; form thus began to emerge as a dominant limiting factor relative to both the fullness of life and the production of art. Everyone was talking about "overcoming form." The theme of life overcoming form that marked the canonical "masterpieces" of socialist realism in the 1930s virtually grew out of the active censorship of the late 1920s and early 1930s, that is, out of censorship's battle against formalism. It is indicative that the "model" film, the socialist realist prototype of the 1930s, *Chapaev,* was continually praised for striking a blow against formalism. Vladimir Kirshon, one of the leading members of VAPP (*Vsesoyuznaya Assotsiyatsiya Proletarskikh Pisatelei* [All-Union Association of Proletarian Writers]), called *Chapaev* "the greatest victory for all those who struggle against formalism." The writer Fyodor Gladkov declared, "*Chapaev* is life itself, incarnated in deeply truthful images of our epoch. . . . With this picture we deliver a shattering blow to formalism." And Maxim Gorky noted that "the tricks of the formalists and the 'experimenters' did not tempt" the makers of *Chapaev.*[4] It is significant that even the directors of this film, the Vasiliev brothers, described their work as the overcoming of a formalist legacy, a claim that became a cliché in writing by directors and cinematographers on their own work.

This theme followed the same basic pattern: Undertaking to reflect life in art, the artist encounters in the first stages of his work certain rules and norms which hold him back. Then he heroically wages war against these norms, overcoming them with the help of an almost mystical union with the vital forces of life in all its diversity. Censorship thus emerged as a defender of those vital forces, itself a heroic warrior battling the withering oppression of artistic norms. Censorship surprisingly assumed a vital and life-affirming function; hence the noisy "carnivals" of censorship, hence the whole intricate system of "therapy" for the artist, which was designed to restore him, as it were, to life. Eisenstein, driven to repentance by Stalin's prohibition of *Bezhin Lug,* acknowledged such mistakes as abstraction, "hypertrophy of generalization," and a loss of "full-blooded comprehensiveness." To those who might wonder where exactly this director found grounds for alleging the noncomprehensiveness of his film, he had this to say:

I will explain this clearly and directly. In recent years I have been withdrawing into myself. I have been retreating into my own shell. The country has been ful-

filling its five-year plans. Industrialization has been advancing by gigantic strides. And I have been sitting in my shell. . . . I made this film not out of the flesh and blood of socialist activity, but rather out of a web of associations, a theoretical representation of that activity. The results are here before you.[5]

Formalism would seep into the artist's pores as soon as he retreated within the walls of his study—or within those of the film studio, where an artistic tradition and the continuity of an artistic language prevailed. Eisenstein's allusions to withdrawing into his "shell" can clearly be taken as a code for formalism. Dmitry Maryan, who participated in the intense denunciation of *Bezhin Lug,* leaves no room for doubt on this point: "And when you, Sergei Mikhailovich, made your sincere appearance and tried to establish the reasons for your failures, you found those reasons in the fact that you were a loner, that you worked separately from life." The point, however, was not such isolation per se, but, as Maryan remarks, the fact that it always went hand in hand with formalism:

Formalism accompanies the loner, the person with a deeply pessimistic worldview, the person at odds with his entire epoch. . . . I must say that with all the forces of my being I detest formalism, I hate its role in the production of art.[6]

It is obvious that this frank hatred went far beyond aesthetics, that it had to do with some social disease infecting *life*. Maryan's injunction to Eisenstein is telling: "Rip out the last remnants of formalism . . . represent the remarkable people of our era, love them all with a joyful love, and then you will have a firm path before you, then the lost banner of the Revolution will once again appear in your hands."[7] Since formalism could be overcome by this furious love for life, censorship had to be cast as a fierce proponent of that love, which partly explains its noisy collective rituals. The artist was drawn out of his formalist solitude by such rituals, publicly joining the ranks of reality. Public torture thus began to claim the status of supportive therapy or, in more extreme cases, the status of a salvational dynamic, a movement from death to life. For example, Eisenstein confessed that in his "overrefined" pursuit of generalized abstraction he had left the living person behind, donning a mask which in its stasis was an "extreme generalization of the private, dead face."[8] Here, however, the ruling powers' criticism came to his aid, helping him overcome this tendency to morbidity, leading him (back) to life.

The mission of censorship consisted not only in the destruction of formalism, but also in the complete annihilation of the conditions under which

formalism was generated — in other words, the razing of those places where production of formalist art traditionally occurred, those places haunted by the ghost of form as norm. The writer had to be driven out of his study, the director expelled from his studio. Thus was born a notion that would long endure: the idea that the artist must be violently forced into the midst of seething life (such seething, in the imagination of the 1930s, was closely associated with production). Thus was envisioned a utopia in which some new anthropological species of cinematographer would evolve, one who, having thrown himself into production, would turn into some sort of supersensory apparatus, capable of perceiving the world in all its vital totality and multifacetedness, going beyond mere artistic form. Ivan Popov, developing this utopian vision, wrote:

The cinematographer's participation in production and in the very creation of life should generate in him a deep and intimate perception that *human creativity in all its manifestations and applications is united in its inner nature, in its primary and basic methods, and in its goals of attracting interest.* This perception is perhaps initially born as something unruly and elemental, and is caught by the most sensitive antennae of the perceptual apparatus, grasped from the elusive air of the workers' social atmosphere. . . . Art will have to come closer to a sort of synthetic creation . . . uniting . . . a knowledge of immeasurably huge things and causal relationships with a creation of whole, living, organic, coherent images.[9]

As we can see, the plunge into life leads to a total transfiguration of the nature of creation itself. In place of form there arises a synthetic mode of creating something living, an organic whole, impossible to dissect.

During the 1930s, the old Symbolist notion of synthetic art was un-expectedly reborn and applied in a radical way to the filmmaker. The model film in this view would be one that synthesized all languages, all techniques, into a "total" work of art. The Vasiliev brothers declared that in order to create *Chapaev,* they had had to "find a synthesis of artistic techniques and production skills which generalized all the attainments of Soviet filmmaking and the best works of the related arts."[10] Eisenstein agreed:

The appearance of *Chapaev* heralds the beginning of the fourth five-year plan for Soviet film — the beginning of a five-year period of great synthesizing activity, a time when all the attainments of the whole preceding era of Soviet film will be-come, in [all their] uncompromisingly high quality, the property of the masses, of millions, charging them with new energy for heroism, struggle, and creation.[11]

In these pronouncements, Eisenstein emphasized the idea of production ("the five-year plan for Soviet film"), but industrial production throughout the 1920s was conceptualized in accordance with certain technical norms and in terms of a distinct engineering discourse, its own type of industrial "language." Such norms were attacked by the Stakhanovite movement and its ideology, as elaborated by Stalin. In a speech to *Pervoe Vsesoyuznoe Soveshchanie Rabochikh i Robotnits-Stakhanovtsev* (First All-Union Congress of Stakhanovites [14–17 November 1935]), Stalin described the history of the movement as follows:

The Stakhanovite movement grew not gradually but explosively, like a river bursting through a dam. It is clear that it needed to overcome certain obstacles. Some held it back, others tried to strangle it, and yet, having stored up strength, the Stakhanovite movement ripped through all these impediments and poured through the country.

But what was going on? Who was impeding its growth?

It was hindered by the old technical norms, and by the people embodying those norms.[12]

Stalin was essentially calling for the abolition of the technologically based norms of production that prevailed in the 1920s, an abolition that would lead to a liberation of elemental vital energies. The similarity between this argument and the ideology of the struggle against formalism is striking. In both industrial production and filmmaking, the professionals—the specialists, or *spetsy* (as they were called then)—were pounced upon, and a whole movement arose to oppose them, advocating instead the training of new cadres unburdened by any knowledge of "the old technical norms."

Films *about* production featured a new popular hero: the Stakhanovite who casts aside all the old norms of production. The historically minded filmmaker had to capture this heroic drama. In describing the hero of Vladimir Petrov's film *Petr Velikii* (Peter the Great), for example, film critic Yury Khanyutin referred to this reform-minded czar as "a Chapaev in Wellington boots with a scepter," thus turning the personification of Stalin's thesis into its antithesis: "A foreign general, seeing that Peter is putting a double load of gunpowder into the barrel of a cannon, shouts in fear, 'Your majesty, the cannon could explode,' whereupon Peter replies, 'To hell with it! It'll be a bomb then!'"[13] The eschewing of rudimentary norms became a sign of vitality as life in general was increasingly understood to be something over and against norms, something that could not

be subjected to the laws of physics. But that all-shattering vital energy had become a force only in present-day reality; the past had been deprived of it. Thus, as a method of enlivening historical films, the head of the Soviet film industry, Shumyatsky, advocated projecting present-day vitality onto the historical past. Both history and art had to be directed at the factory of today, at Stakhanovite teaching (a doctrine which had much in common with Peter the Great's own views of history), according to Shumyatsky:

It seems to me that in order to represent thoroughly, satisfactorily, and artistically the phenomena of past historical stages in film, along with the vain beliefs of those past stages, it is no less necessary — indeed, it is more necessary than ever — to be well grounded in an understanding of your own day. I say this with regard to the fact that, as it seems to me, screenwriters and directors have been studying past material rather than imbibing all the richness of colors, images, nuances, and typical features of our own reality.[14]

Contemporary reality thus had a distinctive full-bloodedness and "richness," while the past could only be defined — formalistically — by its characteristics.

The cult of reality as an elemental and vital source of creativity occasionally yielded some wholly unexpected results. It cast a shadow of suspicion, for instance, on the project of bringing literary works to the screen. According to the conventional logic, this suspicion made sense. The novelist could have been fully engaged with reality as he was writing his novel, but the filmmaker, in adapting that novel for the screen, must feed on the mere shadow of reality — the novel, that is — thus inclining him to formalism and bourgeois values. Konstantin Yukov (of ARRK) espoused this sort of thinking, but he also saw certain advantages in the position of the novel-adapting filmmaker, notably, that his literary source had already been subjected to the hygienic treatment of criticism and censorship: "Once the basic erroneous positions taken by the writer in his literary work have been uncovered, one can assess the interest of a certain socially defined readership in that work. These are positive conditions which the writer himself never enjoyed when he was working on his book." [15] A preliminary censorship thus essentially compensated for the absence of an immediate connection with reality, with censorship placing its life-affirming stamp on the text. This vitality was connected to the active position of the critic in the very process of the censor's meddling with the text, as the active critic was positioned against the passive screen adapter:

Authors of films [i.e., directors] *passively perceived* their heroes' actions, praising only what was understandable, harmonious, attainable by the *passive* consciousness of the *passive* reader [i.e., viewer]. And the position of the filmed novel is immediately susceptible to this sort of creative process, this relation to the literary work. Such positions are clear expressions of bourgeois thinking.[16]

All this rhetoric of life-centeredness and elemental vitality, emphatically opposed to norms, actually evolved into a canon in its own right, one which was extraordinarily rigorous and difficult to uphold; it sternly decreed a normative standard for representations of the very vitality that was supposedly the antithesis of norms. Stalin himself demonstrated one clever way to establish such norms in the same speech to the Stakhanovites examined earlier. If the old norms tied down the more advanced workers yet norms could not be dispensed with altogether, he reasoned, new ones "which would find a happy medium between today's technological norms and the norms attained by the Stakhanovites" must be created.[17] If 130 units per hectare were produced in the Ukraine on average, and some shock worker produced 500, then, Stalin recommended, a new norm of 200 or 250 units should be established. As we now know, the abolition of limiting factors led to the creation of unattainable, exhausting, backbreaking norms; it produced a monstrous increase in exploitation.

In film, something similar occurred. The new canon was complicated by the fact that it entailed two, mutually exclusive demands. On one hand, it fostered the attitude that life was to be maximally reflected in all its manifestations. But, on the other hand, emphasizing any element was perceived as elevating a part to the detriment of the whole, hence as a sign of formalism. The result was a constant demand for perfect averageness, for some "apothecaries' weight" of all components. At the end of the 1920s the struggle with formalism was being conducted according to the RAPP (Russian Association of Proletarian Writers) slogan "the living person." As elaborated by RAPP critic Vladimir Ermilov, the idea was that the "living person" had to be represented in the work of art, along with all of his vital elements and, most importantly, his psychology. The "living person" was conceived of as an antidote to the toxic limitations of form. Soon, however, the absolutization of life in all its manifestations began to provoke strong resistance on the part of the censors, for in order to get beyond the "formalist schema," beyond generalization, artists took to endowing their heroes with negative attributes, and their villains with positive traits. Alex-

ander Macheret recalled that when he started to make his 1932 film *Dela i liudi* (Things and People) in conformity with the RAPP recipe, and was thus intent upon enlivening the central character, the worker Zakharov, who wins a contest against the American specialist Mr. Kleins, he provided Zakharov with a whole array of negative characteristics: "I saw him as dull-witted, uncultured, expressing his thoughts with difficulty, out of control when angry. I was interested in showing that even this sort of person could have the upper hand in a competition against some highly qualified, restrained, proper, polished, educated, and cultured American specialist."[18] Beyond the already familiar theme of the triumph of unabashed culturelessness over professionalism, what is interesting here is the method of conveying the living person—a method which was soon rebuked by one of the most important ideologues of Soviet culture, Alexander Fadeev: "If we do not test life itself, but rather, as heirs of the Revolution, simply give some pauper a red beard ('to enliven him'), or take away the rich peasant's fat belly and endow him with love for his children, we will be creating not a real, life-based work, but rather a counterfeit of life."[19]

Life in all its manifestations in no way accorded with the principle of averaging. The "living person" was soon persecuted, and works which placed him at the center were criticized for naturalism or biologism, with their own vicious excesses in the war against formalist abstraction and generalization thus exposed. Gradually, the "living person" gave way to the "image," an amorphous construct that combined aspects of typification and averageness with those of life's elementary vitality. (The image eludes language, so in this sense it belongs to life, but at the same time it is not an unmediated incarnation of reality; rather, it encapsulates what is universal or typical of life. The concept of the "image," which dates back to the Byzantine tradition, has always been obscure, suggestive—something to be grasped not so much by understanding as by an intuitive illumination.) In 1930, the RAPP film critic Nikolai Iezuitov inveighed against "Pereverzevism" (the school of literary criticism identified with Valeryan Pereverzev) for its idea of the "image," which led, in Iezuitov's view, to "bourgeois ideology" and to "subjectivism and theology."[20] (And all for the sake of the "living person.") Seven years later, Yukov attacked one of the most active RAPP members, the cinematographer Vladimir Sutyrin, for having propagandized "a theory of the 'living person,'" while disregarding "the image, as the basic and decisive characteristic of art."[21] The image, an extralinguistic abstraction of life, realizable beyond form, enabled one to jettison

those elements which would contradict the triumph of vitality, that is, anything in life that undermined its triumph. Everything associated with the idea of suffering, for example, was subject to reproof. One of the reasons for the banning of Abram Room's *Strogii iunosha* (A Stern Young Man) was its view of unrelieved suffering as a part of life in all its richness. The new "ideology," with its abstracting of life in "images," promised relief from suffering and affirmed vitality unequivocally: "Maxim Gorky dreamed of 'writing a book about the annihilation of suffering.' He demanded the 'ridiculing of professional sufferers,' such as those people in the film *Strogii iunosha* who idolize suffering as an eternal leitmotif of life, a constant for all times and all epochs." [22] This obsession with the triumph of life became so intense that the head of the film industry, Sergei Dukelsky, even demanded the excision from Mikhail Romm's film *Lenin in 1918* of all shots related to the scene in which the attempted assassination of Lenin was portrayed: "First of all, he announced that the leader should not be depicted lying on the damp ground, then stated that [showing] the crowd parting after the shot evoked too great a feeling of drama." [23]

The theory of the image as a pure vital principle thus created a double bind: on the one hand, the hero had to incarnate all the best aspects of life, while on the other hand, everything in the film had to remain within the bounds of the average, with all extremes blandly balanced. And that is precisely how a reviewer of the Maxim trilogy described its oxymoronic protagonist: "The point is least of all to show Maxim as some exceptional hero," declared the critic, who then noted that the director presented Maxim "as a person of inexhaustible optimism, unending resilience, and warlike thoughts." [24] All these qualities would henceforth be depicted as attributes of the supposedly average, thoroughly unremarkable person. As a result, popular art was valorized, particularly the epic and other monumentalist genres which were the only ones that could accommodate standardization and averageness together with "unending resilience and warlike thoughts."

The impulse toward monumentalism dated back to the immediate post-Revolutionary period, with its reliance on monumentalist propaganda. As early as 1924, Alexei Tolstoy theorized:

To aestheticism I oppose the literature of monumental realism. . . . Its driving emotion, human happiness, rests on perfection. Its faith is in the greatness of humanity. Its path runs straight to the highest goal: to create, with passion and

grandiose intensity, the type of a great human being. . . . We need not be afraid of unwieldy descriptions, or lengthiness, or exhausting characterizations: monumental realism![25]

This standardized monumentalism, as evoked by Tolstoy, generated a purist rhetoric that essentially disdained form and thought. And this formless trivialization of the "great human being" marked the point at which national culture would no longer be thought of in the terms of European culture, with its intellectualism and its concern with form. "From this point on, the paths of Russian and European literature part," declared Tolstoy.[26] Against the backdrop of Russia's all-devouring rhetorical grandiosity, European culture began to be characterized as narrow, formal, deprived of life-affirming vitality. In a typical manifesto of monumentalist complacency, Naum Berkovsky's *O mirovom znachenii russkoi literatury* (On the Global Meaning of Russian Literature), the cult of epic vitalism was projected onto the whole history of Russian culture:

The Russian people, possessing enough inner resources to assimilate a new civilization, absorbed Europe; but, more importantly, in that very assimilation [Russia] manifested such a life [force] that borders and limits seemed weak before it; the individuality of the [Russian] people seemed broader than that of present-day Europeans, broader than bourgeois civilization. Not knowing this, not remembering this, one cannot hope to gain access to our art.[27]

National culture as a whole began to be understood in the terms of Stalinist aesthetics: that is, its distinctiveness was viewed as deriving from its violation of norms (Berkovsky's "borders and limits") under the pressure of its unprecedentedly active life force. The monumentalist emotion of the 1930s and 1940s thus developed into a frank cultural chauvinism that was especially dramatic against the backdrop of the complete break made by national art with the Western tradition and its extreme impoverishment. This smug affirmation of chauvinist completeness, synthesis, monumentalism, popularism, and rhetorical mastery was the culmination of a complex process of delineating the aesthetics of socialist realism, an aesthetics born out of a collaboration between the forces of censorship and a medievally pedantic set of theorizations.

When the censors pounced on Mikhail Shveitser's film *Tugoi uzel* (A Tight Knot) in 1956, a public denunciation of the picture was, as usual, organized. One of the participants in the discussion, Ivan Pyrev, analyzed

the director's errors and rebuked him for not shooting a scene with the hero Sasha that had appeared in the screenplay. According to Pyrev, Sasha's face in this scene would have shown

an expression of happiness. Filled with sunlight, a radiant mist envelops him. . . . "It is good to live like this, good!" says the author. . . .

And these were the episodes you took out . . . which is why there is a certain gloom-and-doom feeling. All the light, the youth, the poetry, the love, and so on, you either failed to shoot or you took out. Because of this your film is unbalanced, it leans to the left! [28]

This was typical of pronouncements by well-meaning censors. Only life's happiness in its most idealized forms could balance the text (and leaning to the left was leaning toward formalism). Life, youth, and love appeared to operate as replacements for any formal work, especially where these were free of deep individualization, remaining simply abstract life, abstract love, and so on.

The many years of activity enjoyed by our life-affirming censorship has left a deep impression on contemporary cinematic consciousness, as witness its tendency to produce epics and its judgments about "imagery" and "synthesis," not to mention its fear of formalism and consequent search for "living," "full-blooded" heroes, its disdain for professionalism, and its undying faith in a necessary balance of good and evil.

— Translated by John Henriksen

Notes

An earlier version of this article (in Russian) was published in *Iskusstvo kino* 7 (1990): 97–104.

1 Konstantin Iukov, "K proletarskomu kino" (Toward a Proletarian Cinema), *Proletarskoe kino* (Proletarian Cinema) 8 (1931): 37.

2 Grigorii Kozintsev, *Trilogiia o Maksime* (Maxim's Trilogy) (Moscow, 1981), 48. (Alexander Shapovalov [1871–1942] was an old Bolshevik who at this time worked for the Workers' and Peasants' Inspection.)

3 "Oshibki 'Bezhina Luga' " (The Mistakes of *Bezhin Meadow*), *Kino,* 22 April 1937.

4 Dmitrii Furmanov, *Chapaev* (Moscow, 1966), 174, 173–74, 172.

5 S. M. Eizenshtein, "Oshibki 'Bezhina Luga' " (The Mistakes of *Bezhin Meadow*), in *Izbrannye Stat'i* (Selected Essays) (Moscow, 1956), 3: 387.

6 D. Mar'ian, "V otryve ot deistvitel'nosti" (Apart from Life), *Kino,* 24 April 1937.

7 Ibid.

8 Eizenshtein, "Oshibki 'Bezhina Luga,' " 385.

9 I. Popov, "O tipe kinematografista" (On the Cinematographer as a Type), *Proletarskoe kino* 1 (1931): 36–37; his emphases.

10 Furmanov, *Chapaev,* 190.

11 S. M. Eizenshtein, *Izbrannye stat'i* (Selected Essays) (Moscow, 1968), 5: 52.

12 I. Stalin, *Voprosy leninizma* (Questions of Leninism) (Moscow, 1941), 501.

13 Iu. Khaniutin, *Istoriia sovetskogo kino* (The History of Soviet Cinema) (Moscow, 1973), 2: 234.

14 Kozintsev, *Trilogiia o Maksime,* 55–56.

15 K. Iukov, "Tikhii Don" (The Quiet Don), *Proletarskoe kino* 10/11 (1931): 17.

16 Ibid.

17 Stalin, *Voprosy leninizma,* 503.

18 A. Macheret, *Khudozhestvennye techenie v sovetskom kino* (Artistic Currents in Soviet Cinema) (Moscow, 1963), 153.

19 A. Fadeev, *Literatura i zhizn'* (Literature and Life) (Moscow, 1939), 95.

20 N. M. Iezuitov (1899–1941) was a film scholar and teacher; see his "Pereverzevshchina v kino" (Pereverzevism in Cinema), *Na literaturnom postu* (On Literary Duty), No. 1 (1930): 68.

21 K. Iukov, "O RAPPizme v kino" (On RAPPism in Film), *Kino,* 17 May 1937.

22 M. Tkach, " 'Strogii iunosha' i ne strogie roditeli" (*A Stern Young Man* and Parents Who Are Not Stern), *Kino,* 28 July 1936.

23 M. Romm, *Izbrannye proizvedeniia v trekh tomakh* (Selected Works in Three Volumes) (Moscow, 1981), 2: 185–86.

24 S. Dreiden, "Maksim—Chirkov," *Kino,* 28 May 1937.

25 A. Tolstoi, "Zadachi literatury (literaturnye zametki)" (The Tasks of Literature [Literary Notes]), in *Iz istorii sovetskoi esteticheskoi mysli 1917–1932 godov* (From the History of Soviet Aesthetic Thought, 1917–1932), ed. G. A. Belaia (Moscow, 1989), 189–90.

26 Ibid., 189.

27 N. L. Berkovskii, *O mirovom znachenii russkoi literatury* (Leningrad, 1975), 12.

28 Quoted in N. Ignateva, "Priznana 'ideino porochnoi' " (Pronounced "Ideologically Unsound"), *Isskustvo kino* 10 (1989): 81.

Hans Günther

WISE FATHER STALIN AND HIS
FAMILY IN SOVIET CINEMA

Stalin valued cinema as "the most important means of mass propaganda" which ought to be "taken into our own hands."[1] Cinema, however, was not only a means to influence the masses or a medium subject to the control of the Party and the attention of the leader himself; it also constituted a particular mythopoeia in its own right.[2] Of all arts, the cinema of the 1930s and 1940s most amply developed Soviet myths—among them the myth of the Great Family, which was fundamental to the Stalin era.

Understood ethnologically, the Great Family extended the features of the natural, "restricted" family to the entire society. Applying this notion in her analysis of Soviet consciousness, Katerina Clark focuses on the central aspect—the relationship of heroic "sons" (for example, Stakhanovites or pilots) to their authoritarian "father," Stalin. This relationship, which had a vertical character, displaced the horizontal ideal of brotherhood of the First Five-Year Plan. The structural distribution of roles in the Great Family model never changed, that is, the sons always remained sons, never achieving the mature adulthood of the father.[3] Such immortalizing of the heroic "youth," or infantilizing of society, is a characteristic tendency of all totalitarian regimes.[4]

While Clark treats the family paradigm of the 1930s in the context of a new anthropology, here I relate the emergence of the Great Family myth to another phenomenon: the canonization of such key notions as the "people" and the "motherland" which took place in the mid-1930s. With the emergence of the notion of the "national/popular spirit" an entirely new aspect of the Soviet social mentality was brought to the fore—its feminine, motherly quality. This shift in the deep structure of Soviet culture enabled the triangle of the Great Family to be formed, with the "father," the "Motherland," and the "sons and daughters" its connecting vertices.

In the Russian understanding, *narod* (the "people"), its masculine gender notwithstanding, is conceptually aligned with the feminine element. The fact that "narod" is etymologically close to such words as *rod* (lineage), *rodit* (to give birth), *rodina* (motherland), *rodstvennik* (relative), and *roditel* (parent) is very revealing. Nikolai Berdyaev, among many others, has re-

marked on the feminine character of the Russian people (always awaiting a "bridegroom" from the outside) and, more specifically, on the feminine quality of Russian religious faith, which he defines as a "religion of collective biological warmth."[5] The German word *Volk* (like the Slavic *polk*— "regiment"), on the contrary, signifies a military unit, which is why the formula "Volk und Führer" of National Socialism could not be applied to Soviet society, in which Stalin occupied the position of the "father" vis-à-vis the people rather than that of a military Führer.

The binary opposition between "father" and "mother" is based on archetypal notions. The archetype of the "mother," according to Jung, is manifested above all in the familiar image of the Magna Mater common to many religions. Central to this archetype is the female body symbolized as a vessel of peace and of fertility. Like all archetypes, the Magna Mater represents an intricate complex of controversial qualities nonetheless. Thus the "good mother," who symbolizes birth and fertility, is counterposed to the "terrible mother," a tellurian deity of voracity, death, and the abyss.[6]

The Magna Mater is correlated with the masculine archetype of the Wise Old Man, who, in the Jungian schema, possesses traits similar to those of the helper described by Vladimir Propp. The Wise Old Man appears when a hero is in desperate need of help or authoritative advice. A personification of the spiritual principle, this figure is often depicted with symbols of the sun or fire. The Magna Mater, by contrast, personifies the material element. In any given context, therefore, a synthesis of these two archetypes which, according to Jung, play key roles in individuation, is especially interesting. As a result of the clash between these masculine and feminine archetypes, a union of matter and spirit, or the spiritualization of matter, occurs. This synthesis, Jung argues, lies at the core of the doctrine of the Virgin Mary's Ascension, the hidden meaning of which is its justification of the material, or earth principle.[7]

Soviet culture of the early 1930s abounded in actualizations of different aspects of the Magna Mater and the Wise Old Man. Moreover, these archetypes were conditioned on each other in the process of their evolution. The more the various personifications of the feminine, maternal element were accentuated, the more conspicuous the features of the wise father and teacher of nations became. It is in this framework that I will focus on the films of two Russian directors, Dziga Vertov and Mikhail Chiaureli.

Vertov's 1934 film *Tri pesni o Lenine* (Three Songs of Lenin) is extremely interesting in this context precisely because it shows the vacant place of

the father—literally, his lack. The role of a bench, "familiar from photographs,"[8] on which Lenin used to rest in Gorki is of primary importance. We see the bench from different perspectives, deserted, then with Lenin sitting on it, in springtime, and covered with snow.[9] (We will return to this mythic bench later in the context of discussing Chiaureli's *Kliatva* [The Oath].) In Vertov's film (as Bulgakova points out in her analysis), the bench represents one of the many alternately metonymic and metaphoric substitutes for the dead Lenin. The leader of the Revolution lives on in the consciousness of the Soviet people, to whom he has given freedom and education, and is transformed into different objects of the electrified land.

However, despite all this play of symbolic substitutions and the incantation "Lenin is more alive than the living," the film is a work of mourning for the dead father. Lenin, of course, in becoming immortal, has been symbolically dissolved in the happy people and their material achievements; the anguish over the loss of a real father prevails, however. In the "First Song," rooted in folk tradition, a woman sings:

> We have never seen him.
> We haven't heard his voice.
> But he is close to us as a father;
> Moreover, no father has ever done for his children
> As much as Lenin has done for us.[10]

The second song is devoted to Lenin's funeral, as well as the transporting of the red coffin to Moscow and, via Red Square, to the House of Unions. Besides the shots of mass scenes, individual saddened faces, most of them women's, are shown:

> LENIN
> but he is motionless
> LENIN
> but he is silent.[11]

In the third song Lenin, whose body now lies in state in the mausoleum-tent (*kibitka*), is symbolically resurrected by the dynamics of the First Five-Year Plan, by the enthusiasm of builders and collective farmers, by the speed of the planes and the heroic deeds of the *Chelyuskin* people,[12] by international workers' demonstrations, and by his own slogans and books. At the center, however, stands not the leader of the proletariat himself but an enormous statue of Lenin.

Vertov's film, produced between 1932 and 1934, shows a country that has lost its father. The bench in the park reminds us that the sons and daughters have been orphaned. The Great Family myth already exists structurally but with a lack. *Three Songs of Lenin* also reveals some profound shifts in the director's creative method. As Vertov wrote in 1936: "I haven't come to the folk tradition all at once. I followed a difficult path of experiment, staggered and rose again, experimenting successfully and unsuccessfully hundreds of times." [13] Elizaveta Vertova-Svilova has reminisced about this period as well: "Literally all our work was restructured when Vertov took the path toward the folk songs of the Soviet Union." [14] After having heard the songs of an *akyn* (a folksinger), he declared, "This is how we will design our film about Lenin." [15] Thus did the Great Family myth grow from the soil of nationalism. Vertov's film also speaks to the necessity of the feminine element in this myth, especially in the "First Song."

Kolybel'naia (The Lullaby), Vertov's 1937 film, logically extends and elaborates the line sketched out by *Three Songs of Lenin*. The Great Family myth unfolds in a more detailed way: on the one hand, the role of the feminine element is emphasized, while on the other, "Father" Stalin finally assumes his rightful place. This is a poetic documentary about the "daughters'" relationship to their beloved "father," with the "people" represented exclusively as a collective of women. The motif, variations on which are shown throughout the film, is a mother with child. We see mothers with babies at their breasts, laughing children in a hammock, their happy mothers at their side, newborns in a hospital, and mothers rocking cradles. Frames of the Eastern women liberated by Soviet power alternate with those of female high school and college students as well as shots of young women working in the fields or factories. The credits and songs (above all, the "lullaby" itself) glorify the grief of the past overcome and the joyful happiness of the present, the care of the Motherland for her daughters, and the unlimited opportunities for the Soviet woman created by Stalin's constitution.

A long sequence of cuts organized by the poetic rhythm of pictures of mothers' and other women's happiness suddenly shifts into a strong centripetal movement as women pilgrims of all nations head for Moscow—taking trains and riding bicycles, horses, and camels, skiing and walking—all with the same goal, to see their "father" in the Kremlin. He delivers a speech at a meeting, and all the women applaud and give him bouquets of flowers. The frames of women pilots and parachutists, of girls

reciting poetry and, again, mothers with infants, are spliced with shots of Stalin. He listens kindly and attentively to speeches and recitals, laughing and shaking hands. Young women enthusiastically hug and kiss him. The daughters' love for their father reaches its apogee in the shots of marches and parades. Enormous icons of the leader are shown, as well as his portrait with a child and the slogan "Thanks to dear Stalin for our happy child-hood!" Women athletes and dancers march, as do children of both sexes. Such scenes of blissful happiness abound in flowers—those that frame Stalin's portrait and those that decorate the floats and garland the women in the parades.

As one critic has recently observed, the film depicts the "pathological passion" of daughters for their father and the father himself as "fertilizing women with invisible emanations." [16] Apart from Stalin (and brief appear-ances by Voroshilov and Molotov), there are no men in *The Lullaby*. Stalin is obviously the source of all abundant fertility, both human and floral. Vertov, however, hardly had Freudian incest in mind. It is significant that the entire film is made from a woman's perspective, and children's incestu-ous fantasies, as Jung points out, serve to emotionally enrich their psyches with their parents' experience.[17] Other explanations are also plausible. Ac-cording to a widespread tellurian idea, Mother Earth, as a personification of fertility, gives birth to life herself, with no need for an inseminating father.[18] In this sense, the "father of the native land" must play the role of a patron of universal flourishing rather than that of a biological father. The archaic pagan tradition inherent to Vertov's films is quite apparent,[19] with childbirth a sign of nature's bounty and, like the abundance of fruit and flowers in nature and the Moscow parades lavishly decorated with gar-lands.

On the Russian soil, the archetype of the mother is mainly personi-fied in three closely related images: Mother Earth, the Holy Mother, and the biological mother.[20] The pagan cult of Mother Earth is transposed to the Holy Mother, with the Russian feminine image corresponding to the Greek images of cosmos and king: "Mother Earth is, in the first place, the dark, bearing womb, a breadwinner, mother of the plowman, which is manifested by the Russian expression *mat-zemlia syraia* (moist mother earth)." [21] All of this merely confirms the dominance of the feminine arche-type in Russian culture. During the Stalin era, starting in the mid-1930s, this archetype underwent a revival, and Vertov's films participated in this mythopoetic process. According to one contemporary critic, Vertov was a

poet of a beautiful world who conveyed on screen the healthy and exhilarating happiness of mothers, the active builders of a new life. This phenomenon can be viewed from different perspectives. When we see it as an aspect of ideological functionality, we are dealing with a certain embellishment of reality tending toward the idyllic [22] and culminating in the slogan "The beautiful is our reality." Looking at it from a psycho-mythological point of view, however, draws our attention to the deep-rooted images of Russian culture—in this case, the maternal archetype actualized in the Stalin era.

It is interesting to consider the personification of this archetype in Vertov's films. One critic finds in *The Lullaby* a polemic with the image of the mother in D. W. Griffith's *Intolerance,* where the mother is shown rocking a cradle in a world shattered by hatred. Vertov's mother figure, by contrast, appears "calm and confident in her child's happiness." [23] The director's artistic method of imaging woman is especially interesting in this regard. Here is how Vertov himself defined his approach:

The mother rocking the baby in *The Lullaby* and from whose perspective the story is told is transformed in the course of the film into a Ukrainian mother, then into a Russian, then into a Uzbek mother. However, the mother in the film is, as it were, the same. The image of the mother is distributed among different characters. The image of a girl is also composed of a range of characters. What we have here is *the* Mother, not a mother, and *the* Girl, not a girl . . . not man, but Man.[24]

Vertov, the avant-gardist of documentary films celebrated for their eye-witness quality and original montage, worked under conditions that demanded the transmutation of myths in synthetic images. In *The Lullaby* he pushes the artistic possibilities to their limits. This mythological generalization is achieved by the cumulative effect of the extensive documentary footage. First of all, the mother for him is a collective being. Second, what is striking is that all the mothers in Vertov's film are very young. There is no figure of a mature mother/Motherland, but only young girls who have just stepped into this new role in their lives. This peculiarity of *The Lullaby* can be regarded as an aesthetic echoing of the First Five-Year Plan, with its collectivism and predominantly horizontal, "brotherly" relationships.

It is no accident that Vertov was not particularly successful with *The Lullaby,* which was screened for only five days, apparently because it was out of step with the spirit of the times. Unlike Vertov, the director Mikhail

Chiaureli succeeded in the 1940s with his allegorical figure of the (capital M) Mother. Thus the Great Family myth took a different direction.

In Chiaureli's 1946 film *Kliatva* (The Oath), the emphasis shifts to the relationship of Father Stalin with the Motherland. The action takes place in two symbolically loaded places—Tsaritsyn (the future Stalingrad) and Moscow. The film consists of three parts, each of which corresponds to a different period in Soviet history. In 1924, near Tsaritsyn, the kulaks kill Stepan Petrov, who was about to send a letter to Lenin. After her husband's death his widow, Varvara Mikhailovna, sets out for Gorki with this letter, but Lenin has already died. In the central moment of the film, Stalin stands alone, lost in thought, in a blizzard in Gorki. He meditates near the bench (familiar to us from Vertov's film) where, according to legend, he used to sit with Lenin.[25] The sacredness of the moment is emphasized by the passionate symphonic music of composer Andrei Balanchivadze and by the lighting effects. Later, having returned to the Kremlin, Stalin is shown drawing Lenin's profile. Then, as he delivers a speech on Lenin's will from a stand in Red Square, Varvara Mikhailovna passes her husband's letter to Stalin, who, according to Henri Barbusse's well-known formula, is "Lenin today." Like everybody else there, the widow takes the oath to Stalin, which becomes the "symbol of faith" of the entire nation.

The action of the film's second section takes place during the period of the First Five-Year Plan. Ivan Ermilov, Varvara Mikhailovna's brother, dreams of planned construction, whereas Sasha, her son, is not so sure about it. But when the enormous Stalingrad tractor factory is constructed in a "sacred place," all of Varvara Mikhailovna's children, including Sasha, take part. Although her daughter Olga dies during an act of sabotage, Varvara Mikhailovna doesn't lose heart, but stands up to the wreckers: "We are paying for each step with our blood. . . . Do you think you can stop us?" Following some documentary footage of the successful construction, we see the builders heading for the Kremlin, "as if it were a holiday." Ruzaev toasts the "mother of the people," and the leader offers a toast to Varvara Mikhailovna's health. At the end of this section, Stalin talks to her about the impending war.

During the days of the Battle of Stalingrad, we see Varvara Mikhailovna tirelessly caring for the wounded and writing "Die but do not surrender!" on the tanks. When Sasha is about to go into battle (with no military experience), she informs him sternly that everybody is a soldier

now. Her daughter Kseniya says to her: "Mother, you have become so. . . . One wouldn't recognize you. You have no pity for anybody." Sasha dies a hero under a rain of German bullets. After the victory, the mother and her younger children watch as German prisoners are marched through Stalingrad. Her grandson and his friends are shown sitting on a shattered tank. At a Kremlin reception for the victors, Stalin immediately greets Varvara Mikhailovna and thanks her "on behalf of the motherland," bending over to kiss her hand respectfully. She declares, "We stood steadfast! We fulfilled our oath!" Stalin, noting that "millions of Soviet mothers have raised excellent sons," adds, "The blood, shed by our people, will give rise to a great harvest."

In *The Oath* both Stalin, as a father, and Varvara Mikhailovna, as a mother, grow to monumental allegorical proportions. In the first part, Stalin is recognized as Lenin's heir; in the second, he becomes a miraculous builder; and in the third, he is glorified as a victor over history. Through him death turns into life: when he pronounces his oath in Red Square, the flag with the portrait of the "resurrected" Lenin is hoisted; as the great builder, he lays the foundation for gigantic constructions; and as the victor, he proclaims that the people's blood will produce a great harvest. The figure of Varvara Mikhailovna likewise grows before our eyes, a growth charted by Stalin's increasing attention. In the first part, at the funeral meeting, she stands before him as an anonymous woman of the people. (It is also important that, as she passes him the letter addressed to Lenin, she acknowledges him as Lenin's heir.) The second time Varvara Mikhailovna stands before him — also in Red Square — Stalin immediately recognizes her. At the Kremlin reception for the builders of the new life, the leader toasts her health, and in response she "bows low, in the Russian manner." [26] Then Stalin even deigns to talk to her about the impending war. Finally, at the reception for the victors, he kisses her hand, with the camera angle positioning them as equals. The concluding scene represents something of a "Holy Wedding" (hierogamy) in which the paternal and maternal archetypes, spirit and matter, unite. As Grigory Alexandrov pointed out, Chiaureli, "having resorted to broad generalizations, has made a film on the 'unification of the leader and the people.' " [27]

Unlike Vertov's ode to women's fertility and the flourishing land, Chiaureli's film shows, in the person of Varvara Mikhailovna, the other, "austere" side of the maternal archetype, its blood-and-sacrifice side. At each stage of *The Oath,* the mother/Motherland sacrifices one of her family

members. The death of her husband, killed by the kulaks, opens a path for her from the "small" family to the "great" one and eventually leads to her unification with the father of the people. Her daughter Olga's death during an act of sabotage only strengthens her determination ("We are paying for each step with our blood"). During the war she encourages a fight to the last drop of blood and, without hesitation, sacrifices her own son for the sake of the victory. But, like Father Stalin, the mother/Motherland trans-forms death into life. In shattered Stalingrad, her little grandson Petya is shown playing with other children, confirming that "the blood [has given] rise to a great harvest." The image of Varvara Mikhailovna has pronounced features of the "terrible mother" who demands sacrifices for the com-mon cause.[28]

The father's love for the heroic "sons and daughters" informs a later (1949) film by Chiaureli, *Padenie Berlina* (The Fall of Berlin). Its plot is modeled on a fairy tale, with the main characters a teacher, Natasha Rum-yantseva, and a steelworker, Alyosha Ivanov. We see Natasha surrounded by children singing about happiness and the blossoming land, and Alyosha decorated with the Order of Lenin for his steelworking achievements. He loves Natasha but, out of shyness, can't tell her so. Stalin invites this worker-hero to his countryhouse, where they talk about industry, the im-pending war, and Alyosha's love for Natasha. Stalin, advising Alyosha not to be intimidated either by the poetry that Natasha recites or by his love for her, encourages him. After Alyosha returns from a walk through fields of wheat, Natasha tells him of her love for him and he tells her about his meeting with Stalin. Just when happiness seems to be at hand, it is suddenly disrupted by the invading enemy, that is, by attacking German planes.

After spending three months in bed recovering from his wounds, Alyosha sets out to fight the Nazi dragon who has snatched Natasha away from him and transported her to Germany. Still searching for his kid-napped bride after numerous battles, Alyosha finally reaches Berlin. Mean-while, Natasha, who has been liberated from captivity, is also looking for her betrothed. But their meeting finally takes place only due to Father Stalin, who arrives in Berlin by plane. Although Natasha and Alyosha are just steps away from each other at the airport, they are, alas, unaware of that as they watch Stalin get off the plane and address the enthusias-tic crowd: "Alexei is only two steps away from Natasha, but she is not even thinking of him at the moment. All her thoughts are with Stalin."[29]

When Natasha finally does recognize Alyosha standing next to her, "Stalin is within steps of them; he stops, watching with tenderness the meeting of two souls who had lost each other in the whirlpool of the war. He looks at them in a paternal way, as if blessing their union with his smile."[30] Natasha then asks the leader, "May I kiss you, comrade Stalin, for everything you've done for the people and for us?" She comes close enough to kiss his shoulder. Stalin not only rules history and leads the way to victory, but he also plays the role of the loving God, the Father who "thinks with care of every single person, every single soldier, and of the motherland as a whole."[31] He is, of course, supposed to approve of their actions and to bless "their union with his smile." Indeed, without his assistance and patronage, the happiness of the children would be less than complete.

All of these films about Stalin are infused with this atmosphere of immediate-family intimacy. Vertov's young mothers embrace and kiss their beloved father, while in *The Oath* anyone in need can come to Moscow and readily meet Stalin in Red Square. Worker-heroes, all members of the Great Family, arrive at a Kremlin reception ("as if going to a party"), where the hospitable "host" immediately greets everybody whom he has already met at least once before. In *The Fall of Berlin* Stalin even engages in matchmaking, first helping the shy hero find a bride, then blessing their union at the end. (Of course, there are different degrees of intimacy: the victor over history is to be kissed only on his shoulder.)

The "father," however, has another, tougher side, as revealed by his name ("Stalin" comes from the Russian word for "steel"). This quality links him to the "steel" heroes of war and industry.[32] (In *Three Songs of Lenin* Vertov makes an allusion to the "steel hands" of tractor operators and the "steel party" founded by Lenin.) It is not incidental that Ivanov, the son of the people in *The Fall of Berlin,* is a steelworker; Natasha mentions the importance of steel and machinery in her speech to a club, while Alyosha's conversation with Stalin at his dacha covers the same subject. "Steel will decide everything in the future war," says Stalin.[33] (He also says, in the "tractor scene" of *The Oath*, "Metal is the basis for everything.") Alyosha notes that steel can't be produced easily because it is "alive": "I give birth to this steel as mothers give birth to their babies."[34] Steel, iron, machinery, and factories are all symbols of masculinity in Soviet culture and are counterposed to those of the opposite archetype—the fertility of the earth and of women. Just as at the mythic level of the Great Family we witness all kinds of unions and approximations, so at the level of subject mat-

ter and symbolism Soviet cinematography continually created new ways of synthesizing both extremes—steel and flowers, machinery and soil, factories and the vast motherland. The image of a tractor plowing a field revives the ancient mythological image of matter's insemination by the spirit of the father.

The image of Stalin acquires monumental dimensions in Chiaureli's films. The concluding scene of *The Fall of Berlin,* in which the leader, like a god descending from heaven, emerges from the plane in a pristine military uniform, is the unsurpassed apogee of such monumentalism. In Soviet art of the 1940s, the static mise en scène and statuary figures of the characters were enhanced by the predominance of the color white.[35] In Vertov's film we are still dealing with documentary footage of the leader, whereas in Chiaureli's the statuesque effect is reinforced by Mikhail Gelovani's performance as Stalin. André Bazin was the first to point out Soviet cinematography's "mummification" of the leader in his well-known article of 1950. Stalin's image is not defined by psychology but by allegory. Besides being identified with history, he is endowed with such qualities as omniscience, infallibility, high political intelligence, resolution, kindness, and so on. Stalin is not just an intelligent man or even a genius in these films: he is "a familiar god himself, or incarnated transcendence." Any incidental human features could only "disrupt this almost hieratic image, reducing it to our contingency."[36]

The sacralization of the monarch, the identification of the emperor with God in Byzantine or Baroque fashion, has a long tradition in Russian culture.[37] Chiaureli himself remarked on the means used to reveal the essence of this "greatest man of all times and nations." In an article on embodying "the image of the great leader," he referred to Greek harmony, Roman realism, and—not coincidentally—to the monumentalism of ancient Egypt. If one looks closely at Egyptian hieroglyphs of the Pharaohs, according to Chiaureli, one can clearly see "how by barely outlined images they convey generalized features, strength, grandeur, dominant traits of character, everything that can be called the interior essence of the image understood in an idolized and ideal way."[38]

Only cinematography, with its mobile icons, could develop the myth of the head of the Great Family in monumental images. "The most true, complete, profound, and effective image of I. V. Stalin," noted one critic of the 1940s, "is created by the most important and most popular of all arts—Soviet cinematography."[39] Whereas the visual arts, the press, and

literature reproduced only elements and fragments of this myth, cinematography enabled it to unfold to its fullest in its living pictures.

—Translated by Julia Trubikhina

Notes

1 I. V. Stalin, *Sobranie sochinenii* (Collected Works), 13 vols. (Moscow, 1948), 6: 217.

2 See Iu. M. Lotman and Z. G. Mints, "Literatura i mifologiia" (Literature and Mythology), in *Trudy po znakovym sistemam,* Works on Semiotics 13 (Moscow, 1981), 35–55; quotation from 45–46.

3 Katerina Clark, *The Soviet Novel: History as Ritual* (Chicago, 1981), 127–29.

4 See Hans Günther, *Der sozialistische Übermensch* (Stuttgart, 1993), 179–83; and E. Dobrenko, " 'Vse luchshee—detiam' (totalitarnaia kul'tura i mir detstva)" ("All the Best for the Children": Totalitarian Culture and the World of Childhood), *Wiener Slawistischer Almanach* 29 (1992): 159–74.

5 N. Berdiaev, *Sud'ba Rossii* (The Fate of Russia) (Moscow, 1990), 10.

6 See E. Neumann, *Die Große Mutter: Eine Phänomenologie der weiblichen Gestalten des Unbewußten* (Olten, 1989), 81; and C. G. Jung, *Gesammelte Werke,* 32 vols. (Olten, 1976), 9.1: 97.

7 See Jung, *Gesammelte Werke,* 221–69.

8 *Tri pesni o Lenine,* ed. E. I. Vertova-Svilova and V. I. Furtichev (Moscow, 1972), 19.

9 See O. Bulgakova, "Die Gartenbank oder wie ein ikonischer Diskurs entsteht: Vertovs 'Drei Lieder über Lenin,' " in *Kultur im Stalinismus,* ed. G. Gorzka (Bremen, 1994), 204–5.

10 Verfova-Svilovna and Furtichev, eds., *Tri pesni o Lenine,* 12.

11 Ibid., 17.

12 *Eds.' note:* The *"Chelyuskin* people" refers to a highly propagandized expedition headed by Otto Yulevich Shmidt, who sailed out on the ship *Chelyuskin* in 1933 with the goal of navigating directly from Murmansk to Khabarovsk. In the Bering Strait, the *Chelyuskin* became ice-bound, then drifted to the Chukhotka Sea, where it was crushed by the ice in 1934. The survivors of the expedition were rescued by air.

13 Vertova-Svilova and Furtichev, eds., *Tri pesni o Lenine,* 107.

14 Ibid., 108.

15 Ibid., 107.

16 See L. Mamatova, "Model' kinofil'mov 30-kh godov" (Patterns of Soviet Films of the 1930s), *Iskusstvo kino,* No. 11 (1990): 103–11; quotation from 104.

17 See D. Vertov, "O liubvi k zhivomu cheloveku" (On the Love for the Living Man), *Iskusstvo kino,* No. 6 (1958): 99; and *Wörterbuch Jungscher Psychologie,* ed. A. Samuels et al. (Munich, 1991): 116.

18 See M. Eliade, *Die Religionen und das Heilige* (Frankfurt, 1986), 273–301.

19 See Bulgakova, "Die Gartenbank," 203.

20 See B. A. Uspenskii, *Izbrannye trudy* (Selected Works), 2 vols. (Moscow, 1994), 2: 69–73.

21 G. P. Fedotov, "Mat'-zemlia (K religioznoi kosmologii russkogo naroda)" (Mother-Earth: On the Religious Cosmology of the Russian People), in *Sud'ba i grekhi Rossii* (Fate and Sins of Russia), 2 vols. (Saint Petersburg, 1992), 2: 74.

22 See V. S. Listov, "Vertov: Odnazhdy i vsegda" (Vertov: Sometimes and Forever), *Kinovedcheskie zapiski* 18 (1993): 121–42; quotation from 132.

23 I. P. Abramov, *Dziga Vertov* (Moscow, 1962), 143.

24 Vertov, "O liubvi k zhivomu cheloveku," 99.

25 On the falsification of the photograph, see A. Siniavskii, "Vstrecha v Neapole" (Encounter in Naples), *A–Ia* 5 (1983): 53–55.

26 M. Chiaureli, *Izbrannye stsenarii kinofil'mov* (Selected Film Scenarios) (Moscow, 1950), 119.

27 Quoted in ibid., 9–10.

28 Neumann, *Die Große Mutter,* 264.

29 Chiaureli, *Izbrannye stsenarii kinofil'mov,* 77.

30 Ibid., 78.

31 D. Eremin, "O narodnosti sovetskogo kinoiskusstva" (On the National/Popular Spirit of Soviet Cinematography), *Iskusstvo kino,* No. 5 (1949): 5.

32 See Günther, *Der sozialistische Übermensch,* 196–97.

33 Chiaureli, *Izbrannye stsenarii kinofil'mov,* 22.

34 Ibid., 28.

35 Mamatova, "Model' kinofil'mov," 111.

36 André Bazin, "The Stalin Myth in Soviet Cinema" (1950), in *Movies and Methods: An Anthology,* 2 vols., ed. Bill Nichols (Berkeley, 1985), 2: 29–40; quotations from 36, 38.

37 See Uspenskii, *Izbrannye trudy,* 1: 210–18.

38 M. Chiaureli, "Voploshchenie obraza velikogo vozhdia" (Embodiment of the Image of the Great Leader), *Iskusstvo kino,* No. 1 (1947): 8, 9.

39 R. Iurenev, "Obraz velikogo vozhdia" (The Image of the Great Leader), *Iskusstvo kino,* No. 6 (1949): 5.

Sergei Zimovets

SON OF THE REGIMENT
Deus ex Machina

The boy slept. From one moment to the next, the expression on his face would change. At times it would be frozen in horror, or an inhuman despair would distort it; or the sharp, deep lines of an inescapable grief would be cut around his sunken mouth, his brows raised, tears dripping from his eyelashes; or suddenly, he would start gnashing his teeth wildly, his face becoming angry, merciless, his hands clenching into fists with such force that his nails would be driven into his palms, and mute, squeaky sounds would drift up from his tension-squeezed throat. — Valentin Kataev, *Syn polka*

Valentin Kataev's 1945 novella describes a discovery made one night by military spies on their enemy's home front: a boy named Vanya Solntsev.[1] Vanya would end up in the front ranks, ultimately remaining there as a "son of the regiment." More than two years of wandering in the woods and leading a nearly animal existence are what the boy's tormented dreams reflect in the fragmentary and rapidly changing expressions described above. Such a pure micronarrative, made visible in the boy's facial expressions, is the most reliable means of conveying that relentless process which the psychic energy of delirium pervades and liberates in a game of mimicry. Vanya's dream has no homogeneous self-possession, no self-sovereignty; it is instead decentered, incommensurable with the singular, unique character-as-subject. The boy's long individual existence may be said to have accumulated a multiplicity of situations and intensities, exceeding and exploding its initial singularity, displacing it from the privileged center of a subject who is simply acted upon by changes, distinct from them. That singularity becomes here a multiplicity: the formula for the forest-Vanya is always $X \pm 1$, but never 1.

Such is the logic of becoming an animal: to exist in several different directions at once, to be situated beyond isolation from one's surrounding conditions; in other words, never to be equal to oneself, or localized, but rather to belong to the molecular order of events, of elements, of intensities. Indeed, Sergeant Yegorov's assessment of Vanya is absolutely accurate: "[He] became completely wild, grew his hair. Became vicious. A real

little wolf." [2] There are only two man-made objects that still connect Vanya to the world of people: a weapon (a large, sharpened nail) and an alphabet primer (a general source of signification). And if the first may be utilized to reactivate his lost sense of sovereignty, the second can restore his communicative connection with others. One way or another, these two things slow down or prevent the dehumanization of this Russian Mowgli, keeping him from finally dissolving into nature. They tend to pull him back from the forest, to return him to the human world; their frankly phallocentric anthropomorphism preserves him from an ultimate breakdown of identity. That is their meaning.

Thus the forest lets Vanya go, allowing him to regain a human dimension, to experience an environment with controllable distinctions, without disorienting hyperspeeds.

Sergeant Yegorov—the Other—enters Vanya's life in two ways: as if from within, as the signal of danger that wakes him up, and from without, through the bright rays of a flashlight. The dark force of intuition drives the boy to pull, quick as lightning, his sharp weapon in defense, but the light and voice from outside reduce the speed of this gesture. The intensity of the beast is replaced by the commensurability of presence and the acquisition of a meeting-space—one which encompasses within its borders all the fragments associated with bestialization, the whole kaleidoscope of situational games, drawing those boundaries with the gravitational force of human sovereignty.

It is significant that his return to the human world requires the forest-Vanya to produce "his own story," to create the sort of macronarrative that would order the chaos of eventfulness linearly, gathering it up rationally and unidirectionally. And the gaps, displacements, and ruptures, the concrete multidirectionality and the swarming multiplicity: all this must be subject to exclusions, since the full microphysics of bestialization is untranslatable on the plane of plot narration. With the help of the narrative of history, the boy grafts himself onto the great social machine, subordinating himself to its means of production, to those procedures which organize the social world and the whole universe of the nature that surrounds him. Such are the first preconditions we know about for a return to humanity.

His return makes Vanya receptive to social investiture. He himself becomes a field of possibilities, having previously been torn apart by catastrophes, exhausted by the forest's spontaneous reconfigurations. The child's condition before his return is labeled an illness, the clinical symptoms of

which are engraved on his face and body. The boy's clinical image corresponds to that fundamental disintegration of the world which is ascribed to the irrationality of nature in and of itself, that is, nature understood as being beyond the human dimension. And thus a return from that disintegrated state will be marked by signs of health and normality. This is where the boundary of the inhuman is drawn, the boundary of that which is kept by social forces far beyond the reality principle.

The first thing Vanya receives on *this* side of that boundary is the name "Little Shepherd," which caters to the peasant-fixation of all the adults around him. We can assume that the nomadic function subtending this name is by no means accidental. Name-giving, as the initiation for any entry into society, is performed in accordance with the principle of the universal book, the ABC primer, whose grammar is recognized not only as constituting the structures of communication and connection, but also as localizing the consciousness of the referent in acts of semiotic identification. The name inscribed in the primer completes its bearer, drawing him into a semantic context; it makes possible his semiotic presence in various chains of signification and makes it possible for him to be both a sender and a receiver of messages. Once inscribed within the symbolic structure, Vanya must thereafter function according to his anonymous grammar. His name represents the phantasmatic object of collective speech; in other words, "Little Shepherd" attests to the existence of that object at the very moment when collective speech enunciates the name itself. But along with the name comes the right to be present at and to participate in collective linkages of utterances. In this way Vanya's taking upon himself of an *imago,* a self-picture or self-identification, halts the flux of transformations posited by the forest and ultimately normalizes the mechanism of identification, letting the "I-function" assume a stable anthropomorphic gestalt.

Yet the forest will assert itself several times, when two disparate strategies intersect within its domain. Thus it will become Vanya's ally when he runs away from Bidenko-the-Skeleton. Against the rationally calculable technology of a military raid, which cartographically dismembers the forest's landscape, the forest will oppose the disorienting dynamics of a situational game: in hiding there, Vanya will dissolve into chlorophyll as if it were his native element. And only by means of an indissoluble human object—that ABC primer again—will the boy be restored to society. Like attracts like.

It is inevitable that the forest will stand in opposition to the social

organism and that their battle for possession of Vanya won't end with his departure for the world of people. Meanwhile, we must remember that the social organism into which the "Shepherd" is absorbed, and which uses his field of possibilities, is structured like a war machine. A communal, military organization is the primary site of socialization in the process of reactivating the human dimension; collective investiture will be decisive here for private and familiar vested interests as well, those characteristic of the new European.

Vanya is a boy, and an orphan through and through. Insofar as his sexual identity is concerned, that is defined immediately and unequivocally by Kataev: the keen eyesight of spies operates infallibly in a nocturnal encounter with a sleeping child, as will be discussed later. Vanya's orphanhood, however, requires further discussion. His ontogenesis was conditioned by the Russian peasant patriarchal structure, which doesn't correspond to the structure of the European family. Indeed, the European family structure and the Russian idea of communality represent an initial binary opposition between different types of sociality, an opposition within whose framework are formed multiple relations of socializing power, personified not only through the name of the Father, but also through the schizoid structure of communal organization. These conditions form various identificatory mechanisms which either produce or restrict the production of the I-function.

The new European type of sociality translates into family structures that readily lend themselves to Oedipal triangulation. The organization of the space of personal sovereignty, which is the basic cell or unit of the social body, relies upon the individual's identifying first with his or her own mirror image and then with the image of the Father (for a boy) or the Mother (for a girl). The symbolic field of the mirror, through which the European "I" reveals and fashions himself, is organized by the legislative gaze of the Father, who commands and underwrites the child's I-function. Later, the mental and psychic constant of the "I" is reinforced by language and by the enactment of the Oedipal drama.

Unlike the European model, in which a private or familial (triangular) structure is sufficient for identificatory processes, the symbolic matrix of the Russian "I" is constituted not by personal geometry, but rather by the multiple relations inherent to communal power, with the social strategy one of domesticating the body in communal ensembles, where the individual is opposed not simply to an Other (the Father), but to a whole

horde — a collective farm, a regiment, or a Party meeting of undifferentiated others. Sociality here is less of a family affair; indeed, the family itself, in its patriarchal aspects, cannot be reduced to the triangulation of Daddy-Mommy-and-Me. Communal or other types of group life do not as a rule allow the constituting of a Father-Lawmaker as head of a social triangle. In the patriarchal family, the role of the Grandfather turns out to be essential and unique: here is the source of that whole pantheon of Russian grandfathers, from the mythic Grandpa Mazai to Grandpa Lenin, from Granddad Brezhnev to the so-called grandfathers of the Soviet and Russian armies — senior soldiers who subject new recruits to violent, occasionally fatal, hazing. In such a system the father supervises the son, but the grandfather supervises the father, thus reducing him in turn to child status. The Grandfather (or his substitute: the Boss, the General, the Leader) is the true adult in the communal structure. His role forces us to double or multiply Oedipus, to promote him in rank, invariably producing what Eduard Nadtochy calls the *Dvazhdy Edip Sovetskogo Soyuza* (Twice-Oedipus of the Soviet Union). Reducing the father to a child turns the original Twice-Oedipus child into someone who is essentially fatherless, an orphan yet somehow still a son, a "son of the regiment."

Thus Vanya's orphanhood is something more than a biographical fact. In a broader sense, it is the ontological manifestation of Russian culture itself. The communality of the regiment as a war machine does not allow the "Shepherd" to form a space of personal sovereignty. The regiment's group mirror does not reflect the orphan Vanya as a homogeneous image; its multifaceted surface fragments his self-image, reassembling his body as a communal, a-personal reflection, a medium for group thinking. The ontological orphanhood of the Russian individual emerges as what explicitly correlates Vanya's "I" with the regiment as a whole: the former is *adopted* by the latter.

Given such a communal structure, therefore, Vanya should not be capable of any arbitrariness, any willfulness, any self-sufficiency — in a word, any selfhood. All these attributes are delegated to the Boss instead. Thus does the communal ensemble, training the orphan for a peculiar existence-in-the-multiple, produce a lack, a shortage, an insufficiency — a partiality of the individual that implies an inability to make himself compatible with his own reality without recourse to supplementation by some massive, multiple organism. Significant in this regard is the gripping episode of the reconnaissance operation in which Vanya takes part and

is first imprisoned, then freed. In accordance with the logic of the communal strategies and technologies of war, Vanya is given a chance to test his communal-nomadic identity: the Shepherd enters military intelligence. The intelligence group is a special subdivision of the military machine noted for its great speed, its hyperspeed. Before a battle even begins, this group will radically transform the terrain of the planned attack. The scouts render the diverse landscapes and topological wrinkles of the earth into smooth planes; that is, they destroy the land's depth, polysemy, and mystery by means of their continuous scanning and visualization. The planar structure they produce lets them perform maneuvers in hyperspeed, eliminating space and condensing time, achieving success in the unexpected and the unforeseen. The cartographic optic of the military is naturally focused upon points of defeat and capture, creating an agenda of priorities. Thus it is no accident that the scouts' strategy is based on a nomadic movement, the most speed-focused strategy in the history of society. Vanya the Shepherd outdistances the old warhorse Serko on enemy territory, while the scouts accompany him unseen, destroying all the secrets of the uneven landscape, making the invisible visible. "Shepherdness" becomes the basic engine that drives this nomadic movement.

But Vanya is captured. As in the Bidenko episode, the forest cannot save him when he is again betrayed by those same obvious signs of humanness, by that same unlucky book, the ABC primer. (Certainly, this primer merits analysis in its own right. The signs inscribed on its pages qualify as signs of criminality. They speak for themselves, regardless of and contrary to Vanya. Their testimony testifies to Vanya's willfulness and arbitrariness; Vanya thus destroys his own prior norms.) The principle of the forest dovetails precisely with the principle of communal partiality: the forest's lessons are negated by human elements just as communal organization is negated by an individual's excessive self-esteem. Vanya wants to be whole, autonomous, self-sufficient; one could say that he wants to be European — and for this he is severely punished.

In this social constellation, communality is inimical to Europeanness. The latter is revealed to be nothing but a distortion of humanity. The privately incarnated Ego, the autonomous consciousness, is the source of what is coded here as the epitome of evil: fascism. It is the source of the wickedness that is opposed to all that is organic and natural, including the forest and the earth itself. Vanya's deviance from the communal norm is punished, and the instrument of this punishment is paradoxically the very pole

toward which his deviance was directed. The Shepherd doesn't recognize in his own behavior the presence of his sworn enemy, but this only makes the subsequent lesson all the more effective and purifying. These events lead one to conclude that the statuelike wholeness of the national war machine can recognize the individual only as something included within itself; excluded, the individual remains an unprotected, fragile, nonautonomous body. Communality assimilates the individual, who thereby accepts the communal as his or her very essence, as a refuge for identity-forming processes. The figurativeness of the communal body, as defined by military strategy in general, is precisely what gives Vanya a new formula for existence. Being Russian, according to that formula, means being a son of the regiment, its communal offspring—one who belongs to the national order, in which wholeness can never be privatized.

Vanya's story is not intricate, but it is telling. Having experienced the drama of imprisonment and the joy of liberation, and having learned the appropriate lesson from that experience, the Shepherd approaches the rites of initiation in all earnestness. Becoming a son of the regiment—that is, becoming Russian—acquires an institutional character: Vanya is supplied with full military rations and a soldier's uniform. A bath and a regulation haircut represent a certain process of sterilization, bringing him closer to the socially accepted norm. His own face, which is also someone else's face that Vanya sees in the mirror, is a face marked with the stigmata of the collective body, a face on which the regiment records its social codes, thereby legitimizing the son's status. The end point of these initiation rites is an act performed by the "grandfather" of the regiment, Captain Yenakiev. His "nonrecognition" of the Shepherd, who addresses him improperly, marks the boy's final transformation into a true regimental son, into a Russian soldier. Vanya's uncontrollable emotionalism at this moment is likewise subjected to normalization by the war machine: "And only now did the boy realize that, preoccupied with his own uniform, he had forgotten everything else in the world—who he was, where he was, who he had reported to."[3]

Once again, Vanya's fate takes a new twist: he becomes battery liaison officer. But the law of change in communal organisms is not the same as the spontaneous changes of the forest, since, unlike the multidirectional and situational transformations Vanya experienced there, change here is tightly controlled, bound up with rank. In obedience to this law, the son of the regiment must accommodate and assimilate all metamorphoses strictly by

the numbers, namely, those assigned to the members of the gun squad. "But what especially struck the boy's imagination were the guns. Even the very word itself—"guns"—had always sounded exciting and alluring to him. It was the most military of all the military words that surrounded Vanya." The theme of weaponry is central to the narrative—and not by chance, since the figurativeness of the communal bodily ensemble must be correlated with a stable sexual identity. That is precisely why this theme is underscored by the marked eroticism of Kataev's writing, the emotionally detailed descriptions, the fragile and masterful uncovering of the boy's spiritual experiences, as well as his perceptions of erect steel guns. The dominance of the phallus in the war machine is evident even in the fact that the artillery is dubbed "the god of war": "Vanya knew that they called the artillery 'the god of war.' And dimly imagining a powerful and huge deity, Vanya clearly heard the single word spoken by that god: 'guns.'"[4]

The theme of guns forms a complex knot of connotations by which a series of symbols is manifested in the narrative. Thus Vanya's last name, Solntsev (Sun), refers to an archaic cult of Yarila in Russian pagan culture, while the phallic symbolism of this pagan idol refers in turn to the deus ex machina, the god from the machine: here, the cannon. The series of sun references ("heliotropes," as it were) is closed. It is as if Vanya's involvement with the artillery were foreseen, overdetermined.

Moreover, throughout cultural history, the phallus has functioned as a symbol of power and pleasure; consequently, a phallomorphic "god of war" will connote the power functions of a war machine. In other words, through its own semiotic investitures it will define the rank-based architectonics of the communal organism. What this means for Vanya is that the phallic norm becomes decisive in the organization of that field of sociality to which he now belongs. Thus yet another series of symbols is brought full circle to completion: becoming a son of the regiment means getting closer to the symbolic origin of power, closer to the "grammar" whose laws govern the regiment's body.

The universal signifier that establishes the conditions of human existence also determines the means of satisfying the desire for partial communal inclusions. The undoubtedly homosexual desire of the war machine creates an asymmetry among the machine's collective organs, with its libido code represented as a mere metonym of the social code. Absolutely inseparable from the phallus, therefore, is a socialized anus: a collective field for the application of power. If Vanya solicits regimental love (love of

or from the fathers), he must respect those processes which have been accepted for military communality in order to satisfy his desire.

The collective servicing of guns gives Vanya an essential life experience. He begins to understand that the phallic power of the artillery is launched as a complex supplementary system consisting of numbered (that is, private yet socialized) individuals. The technological schema followed by the attendant personnel determines the behavior and the tactics of every last man, assembled on its own foundation as a cooperative organism of corresponding intensiveness and quickness. Behind this system, on the horizon of the social code, lies a principle of communal assembly based on the phallic function of power: power emerges as the basic technological schema structuring the social organism. In other words, that organism is structured so as to realize and reaffirm power by its supplementary activity. The symbolic function of the phallus is seen here as the fulcrum around which the communal universe is assembled and ordered.

The intensification of the collective artillery-servicing activity is described by Kataev in frankly sexual terms. The generalized erection that has seized the half-cannon/half-human organism grips Vanya as well, when he finally holds the cannon's trigger-cord:

He gripped it so hard that the knuckles on his fist grew white. It seemed that no force in the world could tear away from him that big leather sausage with a ring on the end. The boy's heart was beating furiously. Only one feeling possessed his soul at that instant: the fear that he would do something wrong and misfire.[5]

Predictably, the collective military Eros reaches its ecstatic climax in the episode's orgasmic finale:

He felt that the cannon had in one single instant roused itself into motion beside him, jerking and striking as if it were alive. A broad square of fire swept out of the gun muzzle. His head started ringing. And the noise of Vanya's shell, flying off to Germany, resounded far and wide throughout the forest.[6]

It is noteworthy that the noise of Vanya's shell pervades the forest and, for an instant at least, assembles its chaotic cosmos into a uniformly structured space by means of a sonic invasion and its resonance. But that human presence or force is activated only for an instant, at the end of which the forest returns to itself, to its free indefiniteness and indeterminacy.

Another series of events then brings about a new twist in the fate of this son of the regiment: he is sent off to the Suvorov military school. And

the first thing Vanya encounters there is a new principle of social organization, or, more precisely, the same global technological schema as before, with merely a different phallic instrument for synthesizing the communal organism: a bronze bugle.

Here everything was accomplished by bugle-call. The bugle governed all the unseen life of the house. The bugle suddenly brought forth the mingled sounds of hundreds of voices, the shuffling of hundreds of feet. Or else it installed . . . a deathly silence. . . . Once, a small red-haired boy appeared on the second landing of the staircase. . . . Judging by the careful manner in which he groped his way along, one could conclude that the bugle's call forbade him to come out at this moment.[7]

The sound of the bugle territorializes (i.e., gives dimensions, boundaries, and structure to) the communal body, defining its movements and its stopping-points, its speed and the consequentiality of its actions, permitting some things, forbidding others.

The story ends in the manner of a rondeau, that is, precisely as it began, with a scene of Vanya sleeping. It is surprising that, despite his domestication, in his sleep the Shepherd is seemingly liberated from the despotic and normalizing effects of his social environment. His condition again assumes the form of a spontaneous becoming, of a hopscotching through scattered dreams; the social investitures break down into various circuits of varying speed and directionality which preclude any homogeneous, centered unification. Once again the boy's face changes expression continuously: this is the resurgence of the forest, the forest that will not let Vanya go, swarming into his dreams, playing its own alluring and disordered games, insisting on Vanya's identity-blurring equation $X \pm 1$. The forest once again directs him toward an elemental freedom. It makes one more effort, which is apparently to be its last one:

It was night. Through the whole forest the frost was crackling. The tops of the ancient firs, spectrally lit up by the stars, shone hazily, as if they had been rubbed with phosphorus. The firs that stood up to their knees in the snowdrifts were gigantic."[8]

Vanya's dream wanders among the trees, while he himself stands mournfully at the head of the bed, along with the firs, the snow, and the stars, bidding farewell to Captain Yenakiev, he who had used his power to extend the human field of sovereignty over Vanya Solntsev. The socializing sign of the war machine, the deus ex machina, is dead.

Now the boy will become part of the forest element again, sans circumstances, sans meanings, sans fate or phallic associations. The forest has no enslaving technological schema; it is open to pure becoming, drawing in the elements of the world, pushing away the despotism of the universal signifier. This is a world without mediator, without macronarrative rituals. To be in it is thus to be absent; not being thrust violently into a table of coordinates, free from the human sadism of the machine and the sodomy of power, to be in it is to dissolve into the molecular foundation of things, into ungraspable multiplicities.

But then the dream magically changes: "Suddenly, some sound rang out in the dark depths of the forest." The fact that this sound does not belong to the disorder of the forest is obvious. This is the voice of a social code— territorializing, establishing a connection, awakening Vanya's yearnings for the collective, forcing him to return. "Vanya immediately recognized it: it was the sharp, demanding voice of the bugle. The bugle was calling him." And Vanya is compelled to submit to the despotism of the bugle, pushing himself away from the forest, once again overcoming his formula, $f(X \pm 1)$:

And immediately everything changed magically. The firs by the side of the road turned into the gray capes and the shaggy felt boots of generals. The forest was transformed into a radiant hall. And the road turned into a huge marble staircase surrounded by guns, drums, and bugles.[9]

This conversion of the woods into a regiment of old generals in a sunnily radiant hall, encompassing Vanya in a rigidly structured space, ultimately renders the forest's uncontrolled transformations impossible. And now there is no chance of his breaking away from that space and escaping it, since the phallic structures of power that have brought him into their dense surroundings are so numerous and so persuasive. Now, higher up on the staircase, the tenacious hand of old Suvorov, Catherine the Great's much-lauded general, has already grabbed him, and, insincerely appealing to Vanya's bravery, has started dragging him up to the top.

— Translated by John Henriksen

Notes

1 Valentin Kataev, *Syn polka* (Moscow, 1988 [1945]).
2 Ibid., 21.

3 Ibid., 110.
4 Ibid., 116–17.
5 Ibid., 131.
6 Ibid., 132.
7 Ibid., 162.
8 Ibid., 166.
9 Ibid.

Julia Hell

SOFT PORN, KITSCH, AND POST-FASCIST BODIES
The East German Novel of Arrival

> Perhaps a dead father would have been
> A better father. The best father
> Is a stillborn father.
> —Heiner Müller, 1959

A few months before the German Democratic Republic evaporated in
1989, one of its most prominent intellectuals, the author Christa Wolf,
explained her allegiance to the socialist project of the early East German
state with the curious concept of a "potential, not yet realized guilt":

At the age of fifteen, sixteen, under the crushing realization of the full truth about
German fascism, we had to distance ourselves from those who in our eyes had
become guilty during those twelve years by being present, by collaborating, by
remaining silent. We had to discover those who had become victims, who had
resisted. We had to learn to empathize with them. Of course, we were not able
to identify with them, we had no right to do so. That means that when we were
sixteen, we could not identify with anyone. . . . We were then presented with an
attractive offer: you can rid yourselves of your potential but not yet realized par-
ticipation in this national guilt by actively participating in the construction of the
new society, a society which represents the exact opposite of the criminal National
Socialist system, the only radical alternative. . . . In my specific case, but not only
in my case, you also need to consider the close relationship with communists and
antifascists through my work in the writers' organization, starting in 1953. . . .
A teacher/student relationship emerged; they were our models, absolutely and in
every respect; we were the ones who were supposed to listen and learn, in every
respect.[1]

Later in the interview, Wolf refers to these relationships between teach-
ers and students as "father/son, mother/daughter relations." As she herself
emphasizes, this process of becoming a communist subject by replacing
"real" with "ideal" parents, a process based on guilt and the hope for a new
order radically different from the fascist past, does not merely describe her
individual experience. Rather, this story captures the experience of an en-

tire group of East German writers and intellectuals, a "morally inclined minority,"[2] for whom the East German Communist Party's discourse of antifascism, presenting itself and the new East German state as the successor to the anti-Nazi resistance, was as important as, if not more important than, its project of socialist construction. And, as I will argue, this is also the story which informed the genre that in retrospect turned out to be the GDR's own particular contribution to socialist realism, the so-called *Ankunftsroman,* or novel of arrival.

This GDR-specific genre might be defined as the East German version of the classical novel of formation in the context of the Bitterfelder Way (*Bitterfelder Weg*), a term referring to the Communist Party's attempt to initiate a "second socialist stage of cultural revolution."[3] This broad cultural movement, occurring between two conferences (1959 and 1964) held in a chemical factory in the industrial city of Bitterfeld, encouraged artists to work in factories and called upon workers themselves to become cultural producers. *Bitterfeld* has been analyzed by critics from both East and West as yet another effort to involve East Germany's authors in projects oriented toward the "new" reality of socialism rather than dwelling on the catastrophe of the immediate past.[4] The novel of arrival was part of this political-aesthetic program. It is a genre that produced stories in which the protagonist finds his or her place in the emerging communist order, often narrated as integration into the work collectives of the vast construction sites of steel and coal, the mythical "Wild East" of East Germany's heroic "era of construction." The genre's designation was derived from Brigitte Reimann's 1961 novel *Ankunft im Alltag* (Arrival in Everyday Life). Standard literary histories in both East and West Germany distinguished a subgenre of the novel of arrival, the so-called novel of development (*Entwicklungsroman*). This subgenre consisted of texts published during the same time period that chronicled the transformation of young, former Nazi soldiers into — more or less ardent — supporters of the new order. The canonical example of the novel of development is Dieter Noll's 1963 *Die Abenteuer des Werner Holt: Roman einer Heimkehr* (The Adventures of Werner Holt: Novel of a Homecoming). While the master plot of the novel of arrival described by those critics generally involves the protagonist's evolution from "idealism" or "romanticism" to "realism," the central transformation of the novel of development is from the ideology of National Socialism to an East German version of Marxism-Leninism.

Reimann's and Noll's novels, together with a third text, Christa Wolf's

1961 *Moskauer Novelle* (Moscow Novella), constitute the founding texts of this new genre and share a common story, an Oedipal narrative that is deeply implicated in the German past. Thus, instead of reading these texts as narratives of changing consciousness, I focus on the conscious and unconscious fantasies inscribed within them. This focus provides access to a level of psychosocial meaning beyond the genre's explicitly inscribed political discourse, the project of integration into the collective.[5] It also enables us to transcend the paradigmatic Cold War reading of East German literature, which tended to reduce the literary and psychosocial complexity of these texts to the explicit political message embodied in their various master plots. Finally, this focus promises to transcend the well-established categories that have conventionally defined the novel of arrival by highlighting the transformation of its "master plot" into lowbrow socialist literature "for the masses." For that is indeed what we are dealing with: a literary genre that is modeled on the sacrosanct texts of German literature, Goethe's *Wilhelm Meister* novels, but that also incorporates, in the name of socialism, the most successful strategies of pulp fiction — purple prose with a strong reddish glow.

The most fundamental assumption of my project is that the narratives constituting the novel of arrival contributed to the construction of the new state's hegemonic fabric; more precisely, they participated in a discourse that organized the postwar imaginary as a new paternal order centered on the figure of the (communist) father. My project also rests on the basic, now widely accepted insight that ideology cannot be reduced to a (more or less coherent) system of ideas. Any hegemonic formation, to be even partially successful, has to "work at the most rudimentary levels of psychic identity and the drives."[6] And any non-reductionist form of ideology critique needs to investigate the psychic force of ideological processes, the work of fantasy in ideology. For if we do not take into account what Freud termed "psychical reality," the core of which is constituted by unconscious wishes and their associated fantasies,[7] we not only fall into the trap of a positivist conception of reality, but, more importantly, continue to think in terms of an unmediated dichotomy between public and private, social-political and psychic, life and remain unable to account for the transactions between the two. It is in the "area" of the unconscious that these transactions take place, and they concern, above all, the operations of fantasy, which always lie at the heart of our perceptions, beliefs, and actions. And, thanks to the work of several feminist and psychoanalytically oriented crit-

ics of popular literature, we also know that the power of such literature draws precisely on the domain of desire.[8]

The narratives comprising the genre of the novel of arrival let us read this psychic investment of the political in an exemplary way. All of these cultural narratives revolve around a conflict between young communists and their "new" parental figures. This conflict takes place on the terrain of psychosexuality, that is, of the pleasure involved in the production of conscious and unconscious fantasy scenarios.[9] The novel of arrival resolves this conflict by the subject's final submission to the Law of the Father. This subjection takes a very specific form, involving the production of a *post-fascist body,* as conceptualized along the lines of Slavoj Žižek's notion of the *sublime communist body.* Žižek argues that the body of the communist is marked by a form of redoubling, a split similar to that which traversed the body of the medieval king, dividing it into the sublime and its material support: the communists "are the 'objective Reason of History' incarnated, and in so far as the stuff they are made of is ultimately their body, this body again undergoes a kind of transubstantiation; it changes into a bearer of another body within the transient material envelopment." [10] Žižek conceives of the sublime dimension of the totalitarian leader's body as the Lacanian *objet petit a,* this "thing" that the subject desires in order to fill the lack which characterizes it after its entry into the symbolic, the moment when the acquisition of language—and thus the "absence" of the thing referred to—coincides with the separation from the mother's body—and thus the absence of the imaginary unity of mother and child. He then connects this "objet petit a" to the idea of the revolutionary as an instrument of History, embodying the "higher truth" of Stalinism's infamous "iron Laws of historical Progress," by arguing that the totalitarian leader constitutes himself not as *subject,* but as *object* of History/the Other (the "objet petit a" functioning as the object of the Other's desire). Finally, Žižek argues that, within the communist imaginary, it is only the material part of the communist's body, "this fragile materiality charged with a mandate to serve as a transient support of another body," which can "go wrong and introduce disorder," disorder referring, of course, to the threat that perennially lurks in the soul of every communist, the threat of "deviationism," "revisionism," and so on.[11] Hadn't Lenin been preoccupied with Gorky's body, his health, when they corresponded about the latter's continuing (and, according to Lenin, rather problematic) interest in the philosophy of God-building? Žižek asks. And didn't the communists' practice of embalming the leader's

body, their whole architecture of mausoleums, betray the same obsessive preoccupation with the body as the precious, but always fragile, envelope of the sublime thing? Žižek's approach thus radically shifts the focus from consciousness to the fantasies surrounding the (communist) body. And, as we will see, these fantasies take on a very specific form where the body has been previously "polluted" by the protagonist's investment in the ideological universe of National Socialism, in the novel of arrival.

In *Moskauer Novelle, Werner Holt,* and *Ankunft im Alltag,* the "sublime communist body" appears in a slightly refracted form, signifying the "transient material support" through sexuality. Sexuality is constructed in these texts as that which is tied most inextricably to the fascist past — and which therefore has to be split off, disciplined, contained. This "containment" is an integral part of the protagonists' insertion into the GDR's new paternal order, which symbolizes power as the power of the Father, holding up *his sublime body* — the disciplined and ascetic body of the communist fighter — as the image for identification.

At this point, we have to resist the seemingly compelling slippage from sublime to sublimation: the weight of my argument rests on the *fantasy* of the "purified," "asexual" body, not on any act of sexual repression itself. To clarify, I am not making a Reichian argument about communist puritanism, the repressive character of Stalinism's libidinal economy and its "sexual-moral-authoritarian regulation" of sexual energy.[12] On the contrary, I am attempting to break through this all-too-familiar paradigm, which reduces the unconscious to a libidinal, ultimately biological, force to be liberated or repressed. These fantasy scenarios about sexuality and the body reveal a shared cultural imaginary that is both reflected and reproduced in a number of different narrative textualizations of the workings of fantasy, whole scenarios devised for the "mise-en-scène of desire"[13] within a historically specific ideological formation.

One of the most canonical, officially celebrated novels of arrival, Noll's *Werner Holt* chronicles its protagonist's search for his place in the new postwar order after he returns from the war, sick, exhausted, cynical, and disoriented. Noll's rather conventional bildungsroman, spanning the period from April 1945 to September 1946, narrates this search as an Oedipal story. Noll maps the son's Oedipal trajectory onto the ideological landscape of East German socialism and celebrates his subjection to the father (and thereby to the new paternal order). In this text, however, the father/

son constellation is doubled: Holt occupies the position of the son with re-spect to both his "real" father and another figure constructed as paternal authority, the Party secretary. The emergence of the post-fascist body also involves a double identification: with the father and with Schneidereit, a young communist who occupies the structural position of son vis-à-vis the Party's representative and also functions as the protagonist's ego ideal. The identification with the "real" father involves a body/mind dichotomy. On the one hand, this results in an identification with the father as intellectual, but, more importantly, it involves the erasure of the body of both father and son through a gesture that exiles the mother/the body as that which belongs to the fascist past. The identification with the "other" son, Schnei-dereit, revolves around the latter's ascetic and disciplined body. Together, these identificatory processes generate Holt's new identity, one resting on the sublime body as a post-fascist body.

In contrast to the other two texts I will analyze, *Werner Holt* does not eliminate the "biological" father in favor of his substitute(s). Instead, the whole narrative is aimed toward the moment when the son's identifica-tion with his father is reaffirmed. The Oedipal narrative underwrites other structures of authority, insofar as the son's identification with, and submis-sion to the authority of, the father serves as a model for other relations—just as it should, one may be tempted to add. Holt desires recognition by the father, but the dynamic of the Oedipal identification with the one who represents the Law also sustains the desire invested in the Party secre-tary. However, one has to go "beyond" the structuring crisis of the Oedipal triangle to explain the association of past/mother/body and its violent ex-pulsion. In this respect, Kristeva's concept of the *abject* will be of crucial significance.

Noll's text is constructed so as to make the reader measure Holt's "progress" against the standard set by its most authoritative voice, that of the Party secretary, Müller, whose archetypal life story of a communist re-sistance fighter endows him with mythic proportions in Holt's eyes. The protagonist's quest is constructed as two, intertwined stories: one plot re-volves around Holt's rivalry with Schneidereit, the head of the communist youth organization, for the love of a woman named Gundel; the other plot centers on the conflict between Holt and his parents. What propels both story lines is the experience of loss, a loss of ideals which once guaran-teed an (imaginary) unity between subject and world, Nazi soldier and Nazi regime. This unity has been deeply shattered: Holt is now "jetsam," "dirt," as a result of the irreparable gap that has opened up between him-

self and his radically transformed world.[14] Throughout the course of the novel, the theme of dirt—the subject in his "condition of waste, reject, abject"[15]—resurfaces obsessively, grounding the protagonist's subjectivity in self-loathing and hatred.

Holt thinks of his condition as a choice between two solutions: to persist in his loss or to find a new source of unity, whose essence comes to be alternately signified by "homeland," "meaning," "truth," or a collective "we," but which continues to elude him. Much of the novel thematizes the suspension between two different modes of being, yet why does the Oedipal story figure so prominently, and how is it inscribed, in this narrative? From its inception, the novel focuses on the conflict between father and son, which Noll motivates by Holt's rebellion against paternal authority and against a generation whom he holds responsible for his personal catastrophe. After a rather hostile confrontation with his father (the director of a chemical factory now run by the communists), Holt decides to join his mother in the American Zone. After many "detours," however, he returns to his father and to the future socialist state.

Holt is thus depicted as facing a choice between the worlds of his father and his mother, with the mother representing Holt's bourgeois origins, and the father his "will to change."[16] And while the father becomes a *figure of identification,* the mother figure is most savagely excluded from the narrative. Why this violence, and against what is it directed? I would argue that it is his own past—bourgeois *and* Nazi—which Holt attempts to eradicate by exiling the mother, since origin, particularly class origin, is conceptualized in this novel as a tie to the mother, not the father. It is the most abject elements of Holt's self, this past which makes him "dirt" and is still part of him, that are projected onto the figure of the mother. Part of this projection involves associating motherhood with National Socialism. During the final meeting between mother and son, Holt's thoughts drift toward the conventional "ideal: security, home, harmony between mother and son," which he then discards as embedded in Nazi ideology: "This disastrously recalled a certain 'Gospel of Women,' and in general this whole seductive, incomprehensible rotten magic."[17] Linked to National Socialism through its idealization of the maternal, the figure of the mother thus unambiguously comes to represent what is most abject, the Nazi past. The long passage narrating Holt's separation from his mother reaches its climax when he defines himself as *the son of his father* ("My name is Holt"), an identity which he understands as a gesture of opposition to his mother and her family. Choosing his "father's path," he discovers the force which will

liberate him from these foul emotions of National Socialist motherhood—hatred.[18]

Assuming the Name-of-the-Father and separating himself from the mother leads to an identification with the father as intellectual: Holt now wants to become "a scholar of my father's stature."[19] This post-Oedipal subject position is further reinforced by the process of Holt's transformation, which essentially recapitulates the story of his father's life. Like his father, he will now strive to find happiness in his work, after having been, again like his father, "once deeply unhappy": as his father lost his mother, Holt loses Gundel.[20] Reliving his father's life also means, of course, experiencing not only the loss of Gundel, but of the mother herself, a point to which I will return.

Now Holt's quest, grounded in his identification with his father and centered on Marx's "cold, critical revision" of the past, becomes a "path to Gundel," as he tries to "win her back." Holt thinks of Gundel as the one who will be able to save him from his past, to redeem this thing inside himself which is "distorted, warped and frozen."[21] But this quest soon develops into another story, that of Holt's identification with Schneidereit. For despite their rivalry, Schneidereit soon emerges as not only the idealized heroic worker, but Holt's ego ideal, who, he tells Gundel, could have saved him from becoming a Nazi. Holt is both fascinated and threatened by the impressive, overpowering physical appearance of this worker who commands everyone's attention as soon as he enters the room—"big, strong, broad-shouldered."[22] Holt's "becoming" Schneidereit is played out on the terrain of the erotic body, the body as "the agent and object of desire."[23] Because Gundel refuses to choose between Holt and Schneidereit, Holt turns to other women. These encounters characterize him as a "bourgeois" who divides women into wives and whores, driven by the "dirt" he harbors within. Noll's novel thus ultimately poses the question of a new, non-fascist, and "truly human self" as a moral issue, its testing ground being Holt's relationship to women, and, ultimately, his control over his sexuality. Significantly, it is the communist worker Schneidereit who functions as a countermodel in a scene in which he overcomes his desire for Gundel, who teaches him the new socialist morality that she has learned from her mother. This scene, which mixes the steamy atmosphere of Harlequin romances with Gundel's sentimental account of her mother's words, causes the narrative to degenerate into a rather pious form of communist "soft porn." It opens with Schneidereit sweeping Gundel into his arms, ready to carry her off to bed, and ends with him kneeling before her,

reflecting on "the radical overthrow of all existing order." [24] Remembering his father and Müller, he realizes that this revolution also involves a transformation of all of his personal habits—and he tears himself from Gundel and his desires.

In this scene, the sublime communist body is "disciplined" to serve a higher historical mission, a process which the novel's main character replicates. At the end of a series of encounters with various women, Holt identifies with the image of Schneidereit's strong, masculine, but disciplined body. Moreover, following the narrative's fierce logic of exclusion, the making of this post-fascist "body without dirt" occurs within the Oedipal triangle: when Holt visits his mother, she encourages him to spend time with prostitutes and to have an affair with their maid. The world of the mother is thus a world of whores, which Holt rejects for the world of his father(s), a "pure" world of idealized women figures.

One might therefore be tempted to read *Werner Holt* as the story of a former Nazi soldier's coming-to-consciousness, securely underwritten by the Oedipal structuring of subjectivity which positions the son in *his place* in the symbolic order. Such a reading seems to be supported by the novel's closing scene: before leaving to take up his studies, Holt meets with Angelika, the woman who has come to replace Gundel, and promises her that he intends to continue their relationship even after his departure. Is this not the perfect moment of closure? Holt has submitted to the Law of the Father, having replaced his mother with a substitute who provides him with an identity and a task. Yet this is not the end of the story. On the same day, Holt also meets another woman, Judith Arnold, a survivor of Ravensbrück.[25]

There is something deeply disturbed about this text which has to do with the magnetic force that emanates from the figure of the excluded mother. To put it simply, Holt's exact relationship to each of these three women remains unclear at the end. For instance, one can read the merging of Gundel's "indelible face" with Angelika's in the last scene as Holt's continued attachment to Gundel—as a mother or a lover. And the same can be said about his relationship to Judith. One could read this proliferation of women/mother figures as a "breakdown of objects of desire," the sign of a narcissistic crisis which, according to Kristeva, involves the fragility of the symbolic function and the emergence of what she calls abjection:

There looms, within abjection, one of those violent, dark revolts of being, directed against a threat that seems to emanate from an exorbitant outside or inside,

ejected beyond the scope of the possible, the tolerable, the thinkable. It lies there, quite close, but cannot be assimilated. It beseeches, worries, and fascinates desire, which, nevertheless, does not let itself be seduced. Apprehensive, desire turns aside; sickened, it rejects.[26]

This ambiguity of inside and outside, revulsion and fascination, is implicated in the dichotomy between purity and filth, which Kristeva traces to a moment prior to the Oedipal crisis, even prior to the mirror stage. Abjection is related to this stage when there is neither a subject nor an object, neither the "I" of the symbolic order/of language nor the ego of the imaginary, but only something "opposed to I," the maternal body which is/is not yet different. Abjection preserves the "immemorial violence with which a body becomes separated from another body in order to be"; it is thus related to the archaic mother, its experience taking the "ego back to its source on the abominable limits from which, in order to be, the ego has broken away." The experience itself is located in the superego, as an unshakable identification with the Law and its prohibitions is necessary to hem in the "perverse interspace of abjection."[27] When the ego loses its Other (the order by which it is constituted and in whose representatives it recognizes itself) and its objects, the boundaries of this space are threatened and need to be reinstated.

Kristeva allows us to better comprehend why loathing, or self-loathing, and its connection to a National Socialist past is tied to a *maternal* origin, indeed to the body, in *Werner Holt*. The breakdown of the National Socialist regime is thus a narcissistic crisis which has shaken the subject's very foundations, leaving it in a condition of abjection: the experience of its source in the death of the ego, an archaic moment characterized not by its "triumphant" recognition in the image of the (m)other, but by its earliest experience of one body's difference from another, is both fascinating and frightening. With the collapse of paternal law, which the defeat of Nazi Germany represents for Holt, emerges the sense of this "pre-objectal" relationship and the threat it poses to the ego. Holt's Oedipal narrative not only resettles the subject firmly in its superego(s) on the condition of separation from the mother, that is, in response to the father's symbolic threat of castration, but also redeploys this act of separation in response to the experience of abjection, which has its roots in the pre-Oedipal mother — the "excluded ground" — that Kristeva calls the "magnetized pole" from "which he does not cease separating."[28] It is this experience that lies behind

the violence with which the mother is excluded, literally exterritorialized and banished, since she is the reminder of the painful and fragile origin of that ego/subject which is now in crisis. This same logic ultimately accounts for the ideological fantasy of the post-fascist body, the necessary exclusion of that part which is not sublime, but merely material, not pure but filthy.

Brigitte Reimann's *Ankunft im Alltag* (Arrival in Everyday Life) centers on three students, Recha, Curt, and Nikolaus, who postpone their studies to spend a year on one of the GDR's most colossal and legendary construction sites, the "Schwarze Pumpe" at Hoyerswerda. The novel has been canonized as a coming-to-consciousness story, with the young protagonists' accepting the daily routine of socialist production, socialism's "everyday life," as their generation's "struggle" — a struggle no less heroic than their fathers' legendary resistance to the Nazi regime. This is indeed one of the stories that this collective bildungsroman tells. However, I will focus on Recha's story, which follows the normative pattern of a daughter's Oedipal trajectory, but with more than a slight twist: her parents are dead, so the paternal figure has to be reconstructed, and the daughter's identification with "the ideal parent of the respective gender" leads her to identify with the dead mother. Recha's story follows the logic of what Andreas Huyssen calls a "politics of identification," [29] since the production of the post-fascist body again involves the mother, but this time in an act of identification with the Jewish victim of fascism.

As the novel opens with the protagonists' arrival at the train station, Reimann immediately confronts the reader with the major flaw that Recha has to overcome to achieve socialist maturity, as well as the two central themes of the story: the transformation of foreign territory into *home* (through its integration into the site of production), and the overcoming of "a fantasy image painted by [Recha's] vivid imagination" in favor of a more realistic view of socialist life.[30] Also established in this first chapter is the central organizing plot of Recha's bildungsroman, whose successful closure will involve choosing the "right" man. Reimann constructs this as a choice *against* the father of Recha's past: her mother, a Jew, had died at Ravensbrück, while her father, "the Aryan," had disappeared at the front. Recha holds him responsible for her mother's death because he divorced her in 1941 — under pressure, as the narrator informs us. Recha herself grew up as a "bastard" in a National Socialist orphanage and bears her mother's name: Recha Deborah Heine. But there is yet another story behind this one: "She

did not know how her mother had looked, what kind of hair and eyes she had had, but she was convinced that she resembled her. . . . A Polish comrade . . . once said that—with her dark eyes and small, prominent nose—she looked like the young Rosa Luxemburg, and Recha took this as a compliment ever since she had read her wonderful prison letters." [31]

Against her better judgment, Recha becomes involved with Curt, whom Reimann portrays in a relentlessly negative light. The son of an upper-level functionary, Curt constantly boasts about his father's high status and his heroic, antifascist past, without himself believing in any of his father's principles. He has come to Hoyerswerda only to escape military service, and he tries to avoid any difficult work. Already a rather unlikely hero of any novel of arrival, Curt is further characterized with easily recognizable Western traits: he listens to American radio (appropriately bursting into "Don't Fence Me In" as he recklessly races around in his father's fancy car) and wears a silver chain around his neck—in short, he corresponds perfectly to the stereotypical image of the 1950s West German "greaser." [32] Within a few days of their arrival, Curt has seduced Recha into taking advantage of the "unlimited freedom" their new environment represents, encouraging her to drink heavily and adopt a rather lax attitude toward the socialist work ethic. Recha is torn between the need to make a good impression on the head of their brigade, Hamann, who functions as the text's paternal authority, and the new freedom she enjoys with Curt. Reimann quaintly signifies Recha's "wildness" through her shoes, bright red high heels in which she occasionally totters through the mud of Schwarze Pumpe.

Recha's story slowly evolves toward its turning point. In her case, the students' "test," which comes when Hamann asks them to volunteer for a special night shift—an effort described in the heroic register of the Soviet production novel—is only of secondary importance. For this female protagonist, there will be a more significant turning point to do with her "correct" romantic choice, not her commitment to socialist production. Although she has already abandoned Curt for Nikolaus, Recha quarrels with Nikolaus over their staid, "virtuous" life and allows Curt to persuade her to meet again. At this meeting, Curt assaults her; only Nikolaus's intervention prevents him from raping Recha. What is important about this passage is the way in which sexuality and the body are once again constructed as the link between the subject and the fascist past, although the link here is different from the one forged in *Werner Holt*. Recha remembers

her father's face whenever she looks at Curt: "Frightened, she thought: whenever I thought about my father during the last weeks (this happened rarely, however, and against her will), he was no longer anonymous. Suddenly, I can imagine him: he is like Curt, blond and victorious and ruthless."[33] Earlier, Recha had told him: "I despise your blond victor's face," so we are not surprised when the attempted rape culminates in her horrified recognition of a "strange terrible face," that of her "Aryan" father, in Curt's "victor's face."[34] Recha's relationship to Curt is highly ambivalent. He represents what is most forbidden—both the fascist father/past *and* the proto-fascist West/present—and Recha's physical attraction to him is as strong as her moral critique.

This brief scene, a rather explosive example of the work of fantasy in ideology, represents an intricate, complex entanglement of desires and prohibitions, its transgressive power drawing as much on the political domain as on the psychic. Reimann's ideological fantasy not only transgresses the prohibitions against incest, but also those accruing to the fascist past: it is a fantasy of incest with the fascist father in which the daughter takes the place of the Jewish mother, her body merging with that of the dead mother. The mother's story (and the daughter's identification with her mother's history of persecution) has already begun to intrude on the daughter's story as Recha and Curt leave for the forest: bothered by Curt's behavior, Recha remarks that he acts as if he were arresting her and bringing her in. Through a metonymic displacement from Curt to the fascist father, this scene signifies the subject's relationship to the past via the Oedipal triangle, implicating her body and her sexuality. It is a fantasy rigidly policed, delimited, and contained: Recha's desire for the most forbidden—for the fascist father—and its sado-masochistic scenario is interrupted not once, but twice: first, on the literal level, with Recha's rescue by Nikolaus, who had followed her and Curt into the woods; and second, with a rather unexpected narrative move on the author's part, as the dramatic narration of the attempted assault is suddenly interrupted by an account of Hamann's life story, contrasting old and new, negative and positive, fascist and antifascist father figures.

This peculiar Oedipal story results in a number of expulsions and substitutions which distance Recha from the Nazi past (and, by implication, from the temptations of the West). Through her decision to finally separate from Curt and end a relationship in which sexuality plays a dominant role, Recha replaces her father, first with Hamann, and then with Nikolaus. The

communist subject thus emerges as a daughter who chooses the man sanctioned by the communist father figure. She also emerges as the communist whose body is no longer tied to the past, either by desire for the father or by identification with the mother's body.

However, the identification with the Jewish victim is maintained on the spiritual level in Recha's imaginary identity with the figure of Rosa Luxemburg. This identification defines Recha in her relationship with Nikolaus, who notices her resemblance to Luxemburg when they first meet and who feels compelled to reassure her that the Nazi past will not be repeated: "In our country, there will never again be crematoria, you know that as well as I do." [35] Together with Nikolaus, Recha is now prepared to put into practice the idealistic principles she learned at the "red fortress," the school she attended before coming to Schwarze Pumpe. Of course, the narrative deployment of sexuality and the body is overdetermined: by choosing Nikolaus, Recha also accepts her place as a communist subject of production in a novel that explicitly thematizes the communist discourse on the nexus between sexuality and the work ethic, the "revolutionary sublimation" of the Soviet Freudian Zalkind.[36] But, in Recha's case, this discourse is clearly subordinated to the fantasy of the post-fascist body.

Moskauer Novelle, Christa Wolf's first published text, focuses on Vera, a young doctor from East Berlin who travels to the Soviet Union in 1959 as a member of a delegation. The delegation's translator, Pawel Koschkin, is a former Red Army officer who fought in Germany in 1945. Vera and Pawel have met before, in a small village in Mecklenburg where Vera worked as the mayor's secretary immediately after the war. It was Pawel's influence that had made her abandon National Socialism for communism. Now, both are married, yet they are immediately drawn to each other again. Vera's extended inner monologues make it clear that their relationship involves massive guilt on her part, not only because she is married, but also because she is the daughter of a Nazi, and, most of all, because in 1945 she had failed to denounce a couple of former Nazis who severely wounded Pawel as they burned the Red Army's headquarters. Only in Moscow does she learn that his wounds had prevented Pawel from studying medicine. The story of their relationship and of Vera's decision to return to Germany is framed by two scenes, conversations between Vera and two figures representing the older generation: Vera's Party school instructor, Walter Kernten, who happens to be the delegation's leader, and Lidia Worochinowa, a Soviet doctor, both of whom play the roles of parental figures.

Wolf's novella tells several stories: the story of a forbidden love, the story of a young woman's inscription into new family relations, and the story of her own past. The "real" transgression explored here is not Vera's brief experiment in *red love,*[37] but rather her history as a Nazi. This transgression is linked to the more mundane one of Vera's "illicit" love through a discourse on disciplining the body. Similarly to the Noll and Reimann novels, Wolf's novella narrates the making of the sublime body as an act of separation from the past.

Like the Party representatives in those novels as well, Walter Kernten, the man who replaces Vera's father, represents the communist with an exemplary biography: one of the first members of Spartakus,[38] he spent years in a concentration camp and, toward the end of the Hitler period, fought in the antifascist resistance. As Vera's teacher at the Party school, Kernten took over the function of Vera's father after the latter's death. Reflecting on Kernten's significance in her life, Vera remembers the "emptiness" he filled, which was caused not only by her father's death, but by his silence under Hitler. Her father, Vera thinks at one moment, "lived his life wrongly." [39] The man who "lived correctly," Walter Kernten, functions as Vera's conscience, as she herself states following a confrontation with him. Here she addresses Kernten as a parental figure, turning her love story into an act of rebellion, a conflict with the instance representing socialist ethics. Walter assumes the role of the parental superego in a most comprehensive fashion when, having observed Vera's first encounter with Pawel, he offers her his "protection":

— I will be like a mother to you.
— Like mother and father, Walter.
— Good. Mother and father.[40]

With Walter's help, Vera realizes that Pawel's passion for her is his way of avoiding painful decisions, and she decides to end their relationship. Wolf thus presents the resolution as an independent act on Vera's part, an act which Lidia Worochinowa, a Soviet doctor of the same generation as Walter Kernten, and the text's "other" mother figure, nevertheless has an opportunity to approve. At the end of her last meeting with Vera, Lidia declares: "You know . . . that I was secretly a little bit curious to see how it would work out between you two? We old people tend to see young people critically because we envy you. I am always happy when I see young people as strict and uncompromising toward themselves as we were." Having renounced Pawel, Vera now embodies what she herself be-

lieves to be the most important characteristic of the "New Socialist Man": "strength of character, self-discipline." [41]

Thus far, the story seems quite transparent. What is less obvious is the other transgression it touches upon, Vera's past. As soon as Pawel appears, her father's face (that is, the past) also reemerges, pursuing her in her dreams. With Pawel, Vera is forced to remember what she has so successfully forgotten. He is the only one who knows her from "that time" when she was a sixteen-year-old girl, "dazed, stuck in fanaticism." With this particular history, being in love is dangerous, since it means being spontaneous and uncontrolled, being "driven" by something. For the protagonist of *Moskauer Novelle,* desire generates anxiety. Sitting in her room at night, motionless, Vera experiences a "flood" which rises and falls, comes and goes, as she realizes that "for the first time, she was afraid." Vera's anxiety is associated with the experience of losing control over her emotions, and she overcomes the lack of control and discipline through her "power" to make herself "cold" and "quiet." [42]

Separating from Pawel means cutting herself off from the past once more, since it is a separation from that part of her which is tied not only to Pawel, but to the past: her body. When Vera speaks to Pawel about the "curious" fact that one seems deliberately to forget so much of one's own life, she asks herself when it was that she had burned her diary, which bore the inscription: "Loyalty is the German's Honor." And she tells Pawel that the most difficult thing to control is the impulse to sing Nazi songs: " 'The songs were the worst,' she told Pawel. 'They are very difficult to forget. *Can you imagine suspiciously watching every sound that wants to escape your lips?'* " Here Wolf creates an analogy between guarding one's voice and guarding one's body, both involving the strictest discipline: "She armored herself. . . . She watched herself keenly, when she was with him." [43]

When Vera and Pawel finally sleep together, the tone of the narrative is curiously altered. Their affair takes place outside of time, during the five days when the group leaves Moscow for Kiev. In the opening passage of this section, an unbearably kitschy tone is introduced, and sexuality itself, the body and its desire, suddenly vanishes, leaving in its stead the travesty of desire transformed into socialist realist kitsch. Under such "innocent" conditions, it comes as no surprise that Vera suddenly sings, and in public. In a scene that grotesquely perverts the traditional literary idyll, Vera and the other members of the delegation are invited to a collective farm where, predictably, everyone starts dancing and singing in the evening, after a

meal under the "collective" oak, with the obligatory stream of vodka. At the very center of this country idyll stands Vera, who sings a German folk song about love, never taking her eyes off Pawel. The logic that motivates this rather stunning episode of hard-core socialist realist kitsch is, on the one hand, the granting of absolution: Vera is absolved of her guilt, namely, the past, because the delegation's sojourn at the collective farm has explicitly reconciled Germans and Russians; on the other hand, the scene rests upon the elimination of a "body out of control," a kind of love that, in Vera's song, is signified by a German fairy tale brook that quietly murmurs and never "loses itself."

The plot of *Moskauer Novelle* thus eliminates the daughter's past by eliminating the only character who knew her "in those times" — together with any part of her that is associated with him. What at the beginning seems likely to be the engine of the story's plot — the desire to "remake her entire life" which Vera voices after meeting Pawel so unexpectedly — undergoes a strange narrative displacement, since it is Pawel's life, not Vera's, that changes radically.[44] Without a hint of irony, Wolf sends him to Siberia, now no longer a simple translator, but an instructor of German literature. Yet Vera does undergo a radical transformation nonetheless, for she is now a woman without a past, a woman who, having nothing to hide, is rendered transparent and without a "mask." But what she now incarnates, above all, is the sublime body, one whose "fragile materiality" (to recall Žižek) has been subjected to the strictest discipline, has been indeed all but erased.

More explicitly than either Noll or Reimann, Wolf posits sexuality, in a truly Foucauldian move, as the truth of the ideological subject. Throughout *Moskauer Novelle,* she uses the metaphor of the eyes as the mirror of the soul, the face as the transparent reflection of the character's innermost ideological "core": when Vera and Walter meet, "a look into the other's eyes [was enough] to know what was going on"; when Walter stands in front of the Kremlin, Vera looks at him and reads his expression as totally transparent — "his innermost being shone through"; and when Vera understands that she must capitulate to this force stronger than herself, she decides that she will then have to wear a mask to hide her feelings — a mask no longer necessary at the end of her story.[45]

Even more explicitly than Reimann, Wolf has her character live the past on the level of her body, but in a rather contradictory way. As in the other texts, the post-fascist, desexualized body requires the production

of that which it denies, it needs the act of transgression. But in *Moskauer Novelle,* the sexual act signifies not only transgression, but also redemption. Vera redeems herself through her desire for a Red Army soldier; but she subsequently renounces desire. When Vera explains to Walter why she has stopped resisting Pawel, she claims to have acted out of guilt for having destroyed his future. To herself, she admits that she did not prevent the attack because she "wanted to be able at least to hold onto her hatred." Thus the love affair between Pawel and Vera belatedly enacts a reconciliation between former enemies, demonstrating, again on the level of the body, Vera's transformation from a fanatical Nazi, who panics when she meets the Red Army soldier for the first time, into a communist, and Pawel's transformation from an object of terror and hatred into an object of love.[46] In *Moskauer Novelle,* the production of the post-fascist body as an asexual one thus follows upon an act which represents both transgression *and* reconciliation, an act which one might be tempted to call sacrificial. Incidentally, this sacrificial gesture also colors the rape scene in Reimann's narrative.

The role of the Oedipal narrative in Wolf's text, however, contrasts with its role in *Werner Holt,* where it structures the entire novel, and in *Ankunft im Alltag,* where the decisive moment in the protagonist's development arises from an Oedipal fantasy. Instead, the Freudian notion of the "family romance," the fantasy of revising one's family origins, seems to impose itself more forcefully on *Moskauer Novelle.* Here, "the child's imagination becomes engaged in the task of getting free from the parents of whom he now has a low opinion and of replacing them by others, who, as a rule, are of higher social standing." [47] The postwar variant of this fantasy elaborated in *Moskauer Novelle* involves the desire to separate from parents identified with National Socialism via the substitution of the "real" father first by Pawel, the Red Army officer, and then by Walter, the hero of German antifascism.

And yet this story can also be read within an Oedipal framework, with Vera's separation from Pawel read as the elimination of a competing father figure, thus centering the whole narrative on the figure of the German communist. What this still leaves open, however, is the question of the third Oedipal figure, the mother. Vera is introduced with a patrilinear genealogy, as the daughter who "always loved her father," "already resembling him as a child"—her mother is never mentioned.[48] But far from being eliminated or repressed, the figure of the mother constitutes a loom-

ing presence, as the primordial role of Lidia Worochinowa demonstrates, although it is slightly at odds with her otherwise quite insignificant role in the story. For it is Worochinowa who utters the sentence that gives meaning to Vera's transgression ("I am always happy when I see young people as strict and uncompromising toward themselves as we were"). In contrast to Walter Kernten, who is portrayed as the understanding father figure, Lidia Worochinowa represents the law in all its strictness.

Let's move on to a later text by Wolf, her famous 1968 novel *The Quest for Christa T.* Deliberately blurring the boundaries between autobiography and fiction, as she often does in her work, and chronicling the experiences of her generation through forty years of "real, existing socialism," Wolf describes the process of becoming a communist subject from a distance. This self-reflexive distance is forced upon Wolf by the invasion of Czechoslovakia, the event which marked the definitive end of a period of intense discussion about the future of the East German socialist experiment.[49] Recalling the early years of the German Democratic Republic, the narrator says:

> We were fully occupied with making ourselves unassailable. . . . Not only to admit into our minds nothing extraneous—and all sorts of things we considered extraneous; also to let nothing extraneous well up from inside of ourselves, and if it did so—a doubt, a suspicion, observations, questions—then not to let it show.
>
>
>
> The idea of perfection had taken hold of our minds . . . and from the rostrums at meetings came in addition a great impatience: verily, I say unto you, you shall be with me today in paradise! . . . We were . . . arguing whether or not our paradise would have atom-powered heating. . . . *Who, but who would be worthy to inhabit it? Only the very purest, that seemed a certainty. So we subjected ourselves afresh to our spiritual exercises.*[50]

The psychoanalytically oriented reading of the novel of arrival which I have proposed traces the constitution of this particular East German identity to its relation to the past, demonstrating that the hegemonic power of antifascism may have outweighed the influence of the Communist Party's Marxist-Leninist discourse.[51] Moreover, this reading has uncovered the precise psychological mechanisms and unconscious scenarios of these stories, revealing a whole level of ideological inscription which a reading based only on a plot of "changing consciousness" is simply bound to miss.[52]

In particular, the cultural narratives which constitute this genre show

the inextricable articulation of fantasy and ideology, of the psychic and the social. Here, the relation of past and present becomes a stage on which the most intimate fantasies are enacted, interweaving "political" and "private," "social" and "individual" history to a degree that renders these respective terms meaningless. As *Werner Holt, Ankunft im Alltag,* and *Moskauer Novelle* all show, the protagonists' insertion into the GDR's social-symbolic order follows the Oedipal structure; moreover, this process of structuring subjectivity involves a very particular fantasy of the body—the post-fascist body, modeled on the heroic body of the antifascist fighter, the paternal figure so central to the new symbolic order. It is with this figure that all these protagonists—male and female—identify. The paternal figure provides the mirror which Kaja Silverman posits as the indispensable focal point of a hegemonic project: "Hegemony hinges upon identification, it comes into play when all the members of a collectivity see themselves within the same reflecting surface."[53]

The Bitterfeld genre of the novel of arrival thus played a central role in the ideological production of the early GDR. Like the various other forms of early GDR literature, this specific narrative paradigm was often discussed, both inside and outside the GDR, as the epitome of East German *realism.* Indeed, many Western critics used to point to the publication of Christa Wolf's *Quest for Christa T.* as the moment when modernism finally broke through, liberating itself from the chains of a cultural politics committed to a "premodernist" Lukácsian aesthetics.[54] It's a nice story: the final triumph of "true" (i.e., Western) art. Yet a close reading of three of the core texts of this "premodernist" genre reveals that the dichotomy between (socialist) realism and modernism might miss a crucial point: East German socialist realism—the 1950s novel of construction (*Aufbauroman*) and novel of production (*Produktionsroman*) as well as the 1960s novel of arrival and novel of development—was *mass* literature, often produced under the same conditions as similar products in the West. The archives of the Mitteldeutscher Verlag, the major publishing house of the Bitterfelder Way, show that many authors wrote their books on site, in close collaboration with their editors and under great time pressure, because "the masses needed to be educated"—and entertained. As we have seen, with the use of "purple prose," fantasies of the (post-fascist) body entered into (socialist) realism, making its "lowbrow" dimension the actual site of the Oedipal production of ideology. This suggests the need to replace the dichotomy of modernism and realism with a distinction between "high" realism and

modernism, on the one hand, and mass literature, on the other. Of course, the Communist Party did emphasize the notion of "popular spirit" (*Volkstümlichkeit*), attempting to foster the production of "high literature" accessible to "the masses"—Balzac, not Joyce. But, as we have seen, there is no need to take this rhetoric at face value. Most often, this effort resulted in a novel like *Werner Holt* rather than *Les Illusions perdues*. But this does not make the former any less interesting—at least not to someone who loves endlessly long, wonderfully boring books about the making of a new society that is not going to work out.

Notes

1 Christa Wolf, "Unerledigte Widersprüche: Gespräch mit Therese Hörnigk," in *Im Dialog* (Frankfurt, 1990), 29–30. All translations from the German are my own unless otherwise indicated.

2 Ruth Rehmann, *Unterwegs in fremden Träumen* (Munich, 1993), 30.

3 Wolfgang Emmerich, *Kleine Literaturgeschichte der DDR* (Darmstadt, 1989), 107.

4 In the late 1940s, the Party initially focused on appropriating the "classical bourgeois heritage." What Emmerich calls the "struggle between two cultures" began around 1950. The motto of the second writers' conference, in 1950, was: "Our new life demands representation"; quoted in Manfred Jäger, *Kultur und Politik in der DDR* (Cologne, 1982), 29.

5 For a discussion of the formal constraints of genre in the East German context, see my "Christa Wolf's *Divided Heaven* and the Collapse of (Socialist) Realism," *Rethinking Marxism* 7 (1994): 62–74.

6 Jacqueline Rose, "Introduction: Feminism and the Psychic," in *Sexuality in the Field of Vision* (London and New York, 1991), 5.

7 See Jean Laplanche and Jean-Bertrand Pontalis, "Fantasy and the Origins of Sexuality," in *Formations of Fantasy,* ed. Victor Burgin, James Donald, and Cora Kaplan (London and New York, 1986), 8.

8 This approach breaks with the tendency in the work of critics—from both East and West Germany—to accept the Communist Party's taboo on psychoanalysis. Freud's first text, *Trauer und Melancholie: Essays,* appeared in the East only in 1982; see Antal Borbely and John Erpenbeck, "Vorschläge zu Freud," *Deutsche Zeitschrift für Philosophie* 35 (1987): 1021. By 1989, his complete works were still unpublished in the GDR. Another founding theorist, Simone de Beauvoir, was luckier: her *Second Sex* was scheduled to appear in the fall of 1989—which it did, taking on a sudden, unexpected significance in the brief but explosive emergence of an

organized feminist movement, the Independent Women's Confederation. This independent women's party disappeared, along with so many other experiments in radical democracy, at the moment of German unification.

9 According to Juliet Mitchell, these fantasies involve a "range of excitations and activities that produce pleasure beyond the satisfaction of any basic physiological need"; see her "Introduction—I," in *Feminine Sexuality,* ed. Juliet Mitchell and Jacqueline Rose (New York and London, 1985), 2.

My article is part of a forthcoming book in which I focus on the role of fantasy in the formation of East German ideology and argue that immediately after the war, as part of its symbolic politics of power, the SED deployed narratives of the paternal family in an effort to fill the empty locus of power with images of the (communist) father. I trace the continuing effectivity of this particular discourse as it was constructed within the realm of literature throughout the forty years of East German socialism.

10 Slavoj Žižek, *For They Know Not What They Do: Enjoyment as a Political Factor* (London, 1991), 258. In this context, Žižek recalls Stalin's statement: "We, the Communists, are people of a special mould. We are made of special stuff" (256–57). One of the many East German versions appears in another novel of arrival: "This man [the Party secretary] was invincible, the Party sat inside of him like life in the body of an animal, it even outlived his consciousness"; Erik Neutsch, *Spur der Steine* (Trace of the Stones) (Halle/Saale, 1964), 291–92.

11 Žižek, *For They Know Not What They Do,* 260.

12 Wilhelm Reich, *Die sexuelle Revolution* (Frankfurt, 1973), 167.

13 Elisabeth Cowie, "Fantasia," in *The Woman in Question,* ed. Parveen Adams and Elisabeth Cowie (Cambridge, 1990), 159.

14 Dieter Noll, *Die Abenteuer des Werner Holt: Roman einer Heimkehr* (Berlin and Weimar, 1983 [1963]), 21. This is the second volume in what was intended to be a trilogy. The first volume, *Die Abenteuer des Werner Holt: Roman einer Jugend,* was published in 1960, and the third volume was never finished.

15 Julia Kristeva, *Powers of Horror: An Essay on Abjection* (New York, 1982), 16.

16 Noll, *Werner Holt,* 270.

17 Ibid., 268, 269.

18 Ibid., 264, 263.

19 Ibid., 297.

20 Ibid., 499.

21 Ibid., 355, 471, 388.

22 Ibid., 290.

23 Peter Brooks, *Body Work: Objects of Desire in Modern Narrative* (Cambridge, 1993), 5.

24 Noll, *Werner Holt,* 465, 399.

25 Ravensbrück was a Nazi concentration camp for women.

26 Kristeva, *Powers of Horror,* 15, 1.

27 Ibid., 10, 15, 16.

28 Ibid., 8.

29 See Andreas Huyssen, "The Politics of Identification: 'Holocaust' and West German drama," in *After the Great Divide: Modernism, Mass Culture, Postmodernism* (Bloomington and Indianapolis, 1986), 94–114.

30 Brigitte Reimann, *Ankunft im Alltag* (Berlin, 1961), 6.

31 Ibid., 16.

32 Ibid., 8.

33 Ibid., 174.

34 Ibid., 51, 247.

35 Ibid., 39.

36 See Richard Stites, *The Women's Liberation Movement in Russia* (Princeton, 1990), 380.

37 *Red Love* is the title of the American edition of an Alexandra Kollontai novel, originally (and somewhat more laboriously) called "Love of the Worker Bees" in Russian.

38 Spartakus was a revolutionary organization, founded by Rosa Luxemburg and Karl Liebknecht in 1918, which preceded the German Communist Party (KPD).

39 Christa Wolf, *Moskauer Novelle*, in *An den Tag gebracht: Prosa junger Menschen*, ed. Heinz Sachs (Halle/Saale, 1961), 166. In 1973, Wolf distanced herself from her "tractatus" and its "dissemination of pious opinions"; see Christa Wolf, "Über Sinn und Unsinn von Naivität," in *Die Dimension des Autors* (Frankfurt, 1990), 1: 47.

40 Wolf, *Moskauer Novelle*, 150.

41 Ibid., 210, 183.

42 Ibid., 165, 175.

43 Ibid., 166; my emphases.

44 Ibid., 152.

45 Ibid., 174, 158.

46 Ibid., 178, 151.

47 Sigmund Freud, "Family Romances," in *The Freud Reader*, ed. Peter Gay (New York and London, 1989), 299.

48 Wolf, *Moskauer Novelle*, 166.

49 This period of discussion was made possible by the stabilizing effects of building the Wall in 1961. In East Germany, the decisive break with reform communism happened in 1965, at the infamous eleventh plenary session of the Socialist Unity Party, which brought all decentralizing tendencies to a halt and severely censured the burgeoning socialist avant-garde that had developed between 1961 and 1965; see Therese Hörnigk, " 'Aber schreiben kann man dann nicht': Über die Auswirkungen politischer Eingriffe in künstlerische Prozesse," in *Kahlschlag. Das 11. Plenum des ZK der SED 1965: Studien und Dokumente*, ed. Günter Agde (Berlin, 1991), 231ff.

50 Christa Wolf, *The Quest for Christa T.* (New York, 1970), 51, 52; my emphases.

51 As the example of Wolf and other intellectuals of her generation shows, antifascism retained its legitimating force to the very end. As we now know, it accounts for the fact that many East German intellectuals hesitated to articulate their critique more overtly, creating a much-discussed gap between East Germany and other East European countries.

52 In the third part of my forthcoming book, I trace this nexus of ideology, body, and voice in Wolf's major novels.

53 Kaja Silverman, *Male Masculinities at the Margins* (London, 1992), 24.

54 See Wolfgang Emmerich, "Gleichzeitigkeit: Vormoderne, Moderne und Postmoderne in der Literatur der DDR," in *Die andere deutsche Literatur: Aufsätze zur Literatur aus der DDR* (Opladen, 1994), 138.

Antoine Baudin

"WHY IS SOVIET PAINTING HIDDEN FROM US?"

Zhdanov Art and Its International Relations

and Fallout, 1947–53

Within the socialist realist system, the visual and plastic arts occupy a singular and problematic position. As their status of patent secondarity in this system is distinguished from the primacy of the literary arts, their own nature has allowed them regularly to escape Western research on Soviet culture, except of their accessory imagery. This is the case in particular with the visual practices of the Zhdanov period, which saw the true crystallization of this doctrine and the apogee of its effects inside as well as outside the USSR.

When socialist realist art is viewed from the perspective of modern art and the values and norms of its interpretation, things do not seem any better. The ideological and aesthetic polarization between the West and the USSR produced an artistic antagonism that was certainly more visible than in the other disciplines. The definitive institutionalization of "artistic modernity's" new Western norms and values, founded on aesthetic autonomy and transgressivity, seems to have long since justified the almost complete occultation of the Zhdanov period's artistic production on the grounds of its being the incarnation of academic regression and the political instrumentalization of art. Post-Stalinist Soviet historiography applied a strategy of increased interference and euphemization to this period that threw a veil over most of the artworks and the real mechanisms of artistic life.

The West had to await the context of Gorbachev's perestroika and then the disintegration of the USSR before getting to see the first series of studies specifically devoted to socialist realism in the visual and plastic arts.[1] Despite the information they convey and the perspectives they adopt ("postmodernism" or "sots art," totalitarianism or a classical linear approach), these works rarely highlight the paroxysmal phase of the years 1947–53 or the international effects of the artistic politics of Zhdanovism.[2] Nevertheless, focusing on this phase and its effects can illuminate the paradoxical strategies of the diffusion and presentation of Soviet art, as well as the issue of the very "exportability" of socialist realism in this domain.

In the visual and plastic arts, as in Soviet culture generally, Zhdanovism represented the realization of total artistic organization, the primary characteristic of socialist realism. Projected for 1949, the constitution of a monopolistic and Pan-Soviet artistic union was not achieved until 1957, but in the meantime other arrangements were made for its institutionalization, beginning with the establishment of an organizational committee (*Orgkom*) and, above all, with the creation of the Academy of Arts of the U S S R in late 1947. It was under their authority that the institutionalization of Zhdanov perestroika was realized, which entailed the purge and reacademization of artistic instruction and the concentration and hierarchization of production and circulation. The specific instruments of the operation were the annual "Pan-Soviet Exhibition" and the bimonthly art review *Iskusstvo,* henceforth the only specialized organ for the entire U S S R. Guaranteeing increased political control, these institutional measures tended toward the imposition of an absolute consensus on the very nature of the objet d'art and of the artist's labor. It goes without saying that the underlying prescriptions were primarily of an ideological order—the famous trinity of "Partymindedness," "ideological commitment," and "national (or "popular") spirit" (*partiinost, ideinost, narodnost*)—and perhaps thematic (selective and positive representations of "Soviet reality" in service to the Party's directives), insofar as they applied to all practices of socialist realism. But they were also of a more specifically pictorial and plastic order, from a traditional and national orientation: the restoration of a hierarchy of techniques and genres dominated by easel painting, with representational norms that were largely pre-Impressionist and drawn from a "Russian Realist school" of the nineteenth century (the *Peredvizhniki,* reclaimed toward the end of the 1930s, were held up as models), and opposed to the Western Modernist tradition in its cultural and stylistic dimensions (see Figure 1).

As in other domains, it was the specific postwar and Cold War conditions that stimulated the constriction of the system. The responsibilities which, beginning with the states of the new "socialist camp," were entailed by propagating the Soviet model undoubtedly enhanced the already sharp aggravation between two complementary (but sometimes contradictory) attitudes. These were, on the one hand, a return to national "socialized" values and, on the other, an unprecedented expansion of international aggressiveness under the banner of socialist realism, which was proclaimed the "most modern art in the world," its own modernity stemming from its ultimate referent, "Soviet reality." This tension between artistic autarky

Figure 1. Aleksandr
Ivanovich Laktionov,
Pis'mo s fronta (A Letter
from the Front), 1947.
Oil on canvas, 88½″ ×
45″. Stalin Prize, 1948.
State Tretyakov Gallery.
Reproduced from *Iskus-
stvo*, No. 1 (1948): 18.

and internationalist vocation undoubtedly influenced many systemic dic-
tates, most notably aesthetic ones. It will suffice us to note the role of pure
denegation which underlay this alleged autarky. The negative example of
Western modernity, rather than the positive reference to "national heri-
tage," was globally invoked to justify most of the arguments of this new
current. The anti-Impressionist campaign of 1948–49 can therefore be
seen as the application, in the visual arts, of the policy against "servility to
the West," with its attendant "anti-cosmopolitan" motif.

From that point on, the international artistic relations of the USSR dur-
ing the Zhdanov era were characterized by a double imperative: defense
against all external sources of contamination (by verbal imprecation and
by the occultation of practically all Western production), and promotion
of socialist realism, which remained essentially discursive. The articulation

of these two objectives proved to be both easy and singularly problematic, since at the level of the individual works and even their reproduction, all direct confrontation and reciprocity with the West was precluded. This ban covered even the production of the communist "New Realists," well-known emulators and brokers of the Zhdanov model, whose works would not be disseminated in the USSR as long as they too were infected with Western germs. This illustrates the special status of the visual and plastic arts, especially in comparison with literature, which was much more easily accepted in its "classic" or "progressive" form in Russian translation. (Indeed, exceptionally, the Stalin Prize was awarded to André Stil in 1952.)

In attempting to evaluate these relations and the specific effects of socialist realism within the visual arts more generally, we must carefully distinguish between the situation in the USSR and the incommensurable conditions under which art operated in the East European "popular democracies" and in the West. The community of aesthetic programs and even the ideological justifications of the system of relations that linked the artist to the "total" political institution (Party art) notwithstanding, Soviet socialist realism appeared to be intrinsically unexportable and impracticable outside of "Soviet reality." Such a situation rendered the rushed—and still regularly proposed—assimilation of Soviet art with its counterparts in Eastern Europe and the West highly improbable.

The rupture in communication with the West was manifested more concretely, and much more explicitly than in other disciplines (such as literature or film), by an almost total moratorium on international art exchange. It was for this reason that no representative Soviet exhibition passed through the Iron Curtain during this entire period except to "limit" countries like Finland (1950) and India (1952), who were in turn invited to Moscow in 1953, while no Western presentation, individual or collective, was exhibited.[3] Only very rarely in the West at that time could one see selections of Soviet graphic art (mainly posters), discreetly organized by certain "Friendship Associations" with the USSR (e.g., in Italy or France), as well as some isolated works featured in a few militant pro-communist exhibitions. All of these cases were strictly political operations that had not the slightest impact on artistic life within the countries concerned.

Certainly, such a state of paralysis can be attributed in part to the objective conditions of the Cold War and to the virtual Western blockade of Soviet artworks, which benefited less from the privileged channels that

communist editions and national dissemination networks provided for literature and film. But the particular reticence of those channels with respect to the Zhdanov model must also be taken into account (an issue that I will return to later). The principal, if not the only, venue of Zhdanov visual arts in the West was their distribution as the select reproductions which the Soviet journals intended for exportation published in variable but always modest proportions; the journals themselves (*Soviet Literature, Soviet Union, Soviet Woman*) were often distributed discreetly, even clandestinely.[4] Conversely, no major administrative obstacle could impede the dissemination of Western works in the USSR, that is, apart from the isolationist tendency of the Zhdanov institutions themselves. Moreover, they applied themselves with equal energy to "internal" decontamination, attempting to purge all vestiges of European artistic modernity in the Soviet Union. For example, in Moscow the Museum of New Western Art was liquidated in 1947 and used to house the new Academy of Arts, while the international collections of the Pushkin Museum were frozen as of 1949 to leave room for the permanent exhibition of gifts received by Stalin.

In the same way, the place, the profile, and the mode of presentation of Western art in the specialized media and press reflected these policies. Proclaiming itself in art as in other domains the inheritor and the bulwark of civilization, the Zhdanovian *Kulturkampf* substituted national "precursors" ("Russian primacy") for the great figures of the "world's heritage" (an important reference up until the end of the 1930s). Zhdanovism could, of course, still celebrate this heritage in order to legitimate itself or merely to monopolize it. Nevertheless, in terms of mass reproduction, prints of his signature bouquets of flowers by the henceforth "deformist" Van Gogh were still being reproduced up until the end of 1947, while the Russian museums' rich holdings of classic Western art were only stingily exploited (with a mere twenty to thirty reproductions appearing annually, according to the periodic catalogue *Letopis' izobrazitel'nogo iskusstva*). The review *Iskusstvo* addressed this art only on the rare occasions of "great anniversaries," the frequency of which significantly increased at the end of the period in response to the so-called crisis of the system (thus the Goya, Daumier, David, and Cranach tributes in 1953). *Iskusstvo* published articles on contemporary Western art even less frequently, on average rarely more than once a year; instead, it alternated denunciations of "decadent formalism" with "critical" promotions of the communist New Realists. The main thrust of these articles was their imagining of the Parisian situation (five

texts out of seven from 1948 to 1953) and even more so—from an exclusively negative perspective—of the American context, sketching out the favorite poles of Zhdanov artistic-political reference. All of these articles featured an ultra-selective iconography—usually so selective, indeed, that no reproductions of the works being promoted, critiqued, or abused appeared at all. (An equally opinionated vigilance was brought to bear on artworks reputed to be worthy of encouragement, namely, those of the "progressive" Realists.)

Evidently, the most rigorous visual censorship was reserved for "negative" images, which were targeted for vehement invective. All forms of abstraction seem to have been absolutely excluded from postwar reproduction. In 1947, Vladimir Kemenov's article "Cherty dvukh kul'tur" (Characteristics of Two Cultures), which had in fact inaugurated the anti-Western campaign, could still make good use of photographs of scandalous works by Henry Moore, Pablo Picasso, and Roberto Matta.[5] Two years later, Lidya Reingardt illustrated her contribution, "Po storonu zdravogo smysla" (On the Side of Common Sense), the Soviet version of Nazi "entartete Kunst" themes, with only four, almost illegible vignettes of American origin, one of which was by Yves Tanguy.[6] These would be the last negative examples of Western art "visualized" in *Iskusstvo;* in 1952, the last article of absolute denunciation spared the Soviet reader such a subversive ordeal.[7]

The same tactic of visual occultation was adopted in 1951 through a unique editorial operation of this kind, which was then disseminated throughout the entire Soviet bloc; I am referring, of course, to the publication by Vladimir Kemenov and others of the collection entitled *Protiv burzhuaznogo iskusstva i iskusstvoznaniia* (Against Bourgeois Art and Aesthetics).[8] Undertaken, on one hand, to defend the Renaissance as a "positive" historical phenomenon (e.g., V. Lazarev's and M. Alpatov's articles), the work tried above all to show modernism as an instrument of "American imperialism" (e.g., the articles by B. Vipper, I. Kuznetsova, and N. Chegodaeva). Although not without "historical" basis, the argument was cast purely in terms of political conspiracy: Soviet criticism predicted that New York, heir to the "worst, decadent artistic currents of Europe," would play the leading role in matters concerning modern art. But this "factual material, demonstrating the state of degeneration reached by the bourgeois art of American and European capitalists,"[9] was significantly bare of any illustration. The works discussed were more than once termed "indescrib-

able." Thanks to the principle of verbalization of the image (one of the tenets of socialist realism), it was literally impossible to reproduce them.[10]

In these conditions, the particular international artistic relations of Zhdanovism were essentially limited to the socialist camp, which was conceived of as a "natural" extension of the Soviet model. As such, the situations of the different countries concerned (still not well-known in most cases) were surely diverse, and their respective attributes merit individual analyses in their own right. But a largely similar and almost simultaneous process of alignment unfolded in each case in response to the definitive installation of Communist power and to the establishment of the Total State.

The first phase of Zhdanovism (1945–48) was characterized by the persistence of a sort of artistic pluralism; official tolerance extended all the way to acknowledging public criticism of the Soviet productions then being discreetly exhibited in these socialist countries, often for the first time in their history. These were exclusively sector-based exhibits of graphic arts or otherwise restricted exhibitions which toured various East European capitals.[11]

Poland, by far the best-documented and studied example (except precisely in its relations to the Soviet model), at this point demonstrated a very advanced institutionalization of "Modernist" plastic art of local or Parisian origin. Encouraged by the authorities, the resumption of prewar discussions of the artist's social responsibility surely raised questions about the hedonism of the dominant Colorist current (*kapizm*) in painting. However, the different formulations of "realism" then being promoted could refer to the avant-garde tradition (e.g., Wladyslaw Strzeminski, Henryk Stazewski, Marek Wlodarski, and the "Kraków Group"), to post-Cubist developments (e.g., the "Young Painters in the French tradition"), or to the French Surrealist influence (e.g., the "reinforced realism" of the "Young Kraków artists"), all of which were implicitly or explicitly opposed to Soviet socialist realism. The latter was scarcely mentioned in the journals of the professional Union of Polish Artists (*Glos plastykow* in Warsaw, *Przeglad artystyczny* in Kraków), and then only to be sharply contested.

The Soviet exhibition of 1946 in Poland, which still had very little to do with Zhdanov paradigms at this point, provoked a number of unkind comments in the art press, such as "anemic and lifeless perspective on reality today"; "banal and sterile naturalism"; and "photographic style."[12] And it was not until the end of 1948 (in the first sign of a political im-

perative in this matter) that the Kraków journal *Przeglad artystyczny* would devote a special issue to Soviet art. Again, the reader was spared the most compromising current images and accounts. All of the contributors to this issue were Russian, with the exception of the old avant-gardist organizer Konrad Winkler, who did not hesitate to express his doubts: "Can we reduce the notion of realism to such purely exterior forms? . . . A work which is formally non-organized is not a work of art." [13]

It is, therefore, not surprising that alarm was expressed by the Soviet institutions; at the time of the first session of the Academy of Arts in November 1947, its all-powerful president, Alexander Gerasimov, was already insisting on the individual responsibility borne by those who were associated with popular democracies. Even if the Soviet exhibitions presented up to that point in Eastern Europe had been a "great popular success," they were nevertheless threatened by an "activation of Formalist currents" and even an "unbridled reactionary campaign against Soviet art in the press" which justified energetic decontamination measures.[14] Gerasimov would therefore reiterate the "offer of Soviet service" in the spring of 1949, attesting to the persistence of Formalist and cosmopolitan influences, especially in Poland and Czechoslovakia.[15]

Actually, in Poland, even though the political pressure was growing and provoking increased antagonism within the artistic milieu, the Zhdanov model would remain at the periphery of the debates until the fall of 1949. In the guise of an implicit resistance, the "socialist realist method" was nevertheless declared the only "correct" one in June by the Fourth Congress of the Union of Polish Artists in Katowice. An impressive degree of Soviet cultural penetration seems to have already occurred in literature, the cinema, and the theater—all loci of specialized "festivals." At the time of the May 1949 conference, Party promoters of the so-called method would refer to their model of literary or architectural origins only in a pro forma way while remaining completely silent on the subject of the fine arts.[16] The most radical young artists demanded their share of a Primitivist "neo-barbarism" (the "Grupa samoksztalceniowa" of Andrzej Wroblewski and Andrzej Wajda et al.), and an early Stalinist artistic rhetoric was already being practiced in accordance with the model of Edouard Pignon or André Fougeron (e.g., by the Krajewskis, Juliusz and Helena). Meanwhile, their challengers (e.g., Zbigniew Dlubak, Marian Bogusz, Tadeusz Kantor, Jerzy Nowosielski) persisted in calling for the continuation of the most modern Western traditions.[17]

The installation of the definitive Soviet model would be equally imposed in each socialist state. Initially, beginning in 1949, the installation proceeded through a standard institutional process of normalization: the unification of groups of artists in a single, monopolistic union (these unions already existed in certain countries, such as Poland, and were modeled on labor unions); centralized organization of artistic life, including dissemination and control of the media and of exhibitions (within which were organized the essential annual, national "inventory" and the state prizes); the reform of education toward a more traditional mode; and the creation of administrative and supreme "scientific" institutions. From 1950 on, the organizational, doctrinal, and aesthetic Soviet program, henceforth the absolute standard, could be applied or "adapted" (i.e., in accordance with the principle of "socialist in content, national in form"), with all of its pragmatic detours and its entire generic or thematic hierarchy.

In Poland the process began with the creation of the Central Bureau of Exhibitions in 1949, followed in 1950 by the State Institute of Art, which was reserved for "theoreticians." (The Institute published the series *Materialy do studiow i dyskusji*.) The leadership of the Union of Artists was bestowed upon those considered "secure" (Juliusz Krajewski was named president), and the union controlled, among other things, the only authorized review; *Przeglad artystyczny,* henceforth a bimonthly journal modeled on *Iskusstvo,* was relocated from Kraków to Warsaw and edited by Helena Krajewska. Modeled on the Pan-Soviet Salon, the first Pan-Polish Exhibition (OWP) was conceived as a manifesto of and a general mobilization for the new path. It took place in March 1950 after several months of feverish preparations and with large subsidies to promising artists. The reorganization of higher education (via the Academy of Plastic Arts in Warsaw) followed in the fall. It must be noted that the executive responsibilities, notably for the decontamination of art infected by Modernist germs, fell, for the most part, to activists who were not suspected of aesthetic traditionalism. They were the former products and agents of an avant-garde or "transgressive" tradition which they were then appointed to liquidate (e.g., the young critics Mieczyslaw Porebski and Janusz Bogucki).

Other East European countries (e.g., Bulgaria and Hungary) underwent an analogous, simultaneous evolution. Romania, however, was a bit more precocious, having already mounted an exhibition in honor of Stalin's seventieth birthday in late 1949, but its organization of artists would nevertheless not take shape until the end of 1950. The evolution oc-

curred later in Czechoslovakia (with unification inaugurated in 1949, but not achieved until 1950, and the first national inventory completed only in 1951), as in the very new GDR, with the creation of the Akademie der Künste in March 1950 and the Union of Artists (VBKD) the following June. (Total alignment did not occur until March 1951, with the resolution by the SED's Central Committee, followed by the first exhibition of the new path, on the theme of peace, in December.) In all of these cases, side by side with the "national Realist heritage," the theory and practice of "the avant-garde art of the USSR" was exalted, with "formalism" rejected "in favor of socialist realism." In 1950, Polish Vice-Minister of Culture Wlodzimierz Sokorski linked this policy to a cardinal tenet of "nationalist deviation" (*gomulkowszczyzna*), warning his constituents that "without bypassing the snobby and fundamentally reactionary mistrust which reigns with respect to Soviet art, there cannot be and will not be great art for our people."[18]

It was thus during Zhdanovism's second phase that the original Soviet corpus would really be vigorously promoted within each country, either by means of an essentially discursive mode or through the moderate and rather derisory, yet nevertheless coercive, mode of reproduction. From 1949 to 1953, the East European capitals rarely received more than one representative Soviet exhibition, that is, one which included any paintings; Berlin and Budapest each hosted two (1949 and 1953), while Warsaw (1951) and Bucharest (1953) received one each; Sofia and Prague were apparently allowed to exhibit only graphic arts and only once (1950). Other sector-based and essentially political exhibitions (of caricatures, posters, or folk art) toured throughout the Soviet bloc or were grafted onto international demonstrations (e.g., industrial or commercial fairs, Youth Festivals in Budapest, Berlin, or Bucharest, etc.). On the other hand, displays of Soviet "masterpieces" in *reproduction* increased, principally in the provinces, where their function was at once ceremonial and didactic. Occasionally, a certain work which had paradigmatic origins "accompanied" a national exhibition, such as the Stalin Prize-winning *Lenin at the Third Congress of Komsomol* exhibited during the second (1951) OWP in Warsaw. But only the Bucharest Museum seems to have had a collection of replicas of exemplary Soviet paintings (by Alexander Gerasimov, Boris Joganson, Semyon Chuikov, and Fyodor Surpin, among others). Whether the works were originals, replicas, or reproductions, their positions would be unified in any case by the ritualized use to which they were put.[19]

The impact of such a strategy for the dissemination of artworks is particularly difficult to evaluate. In the USSR, only the first "missionary" expedition of 1949 (when sixty-seven paintings toured Berlin, Dresden, and Budapest) was reputed to have "finally conveyed the truth about Soviet art." This exhibition was said to have been instrumental to the process of organizing Hungarian artists.[20] The Warsaw exhibition of October 1951 (190 pieces showcasing all sorts of techniques), by contrast, served only as "confirmation"; even in Poland, where works of some types were displayed for the first time, the exhibition elicited ceremonial commentary but not the slightest bit of analysis. This was also the case with touring exhibitions of reproductions and with Soviet artwork published in the general or specialized press, where the discourse manifestly triumphed over the image and remained the primary instrument of dissemination. Save for a handful of graphic art albums intended for explicitly political use (e.g., work by Boris Prorokov in 1951, and by the Kukryniksy in 1952), the Polish press did not publish any illustrated work of historical or current synthesis devoted to the "model." Such parsimony, while undoubtedly characteristic of Soviet Zhdanovism, was even more evident in the popular democracies. The press celebrated Soviet art and life in a moderate and selective way—essentially in their most ritualized manifestations—through the translation or compilation of authorized sources. In all cases, allegiance to (political) principle notwithstanding, the formal solutions of Zhdanov socialist realism were neither an object of analysis nor a matter of personal stakes. For instance, if *Przeglad artystyczny,* its chronicles aside, devoted on average two or three illustrated articles per issue to Russian and Soviet art, these were merely offshoots of the journal's purpose—publishing texts from its model, *Iskusstvo,* and by members of the Academy of Arts of the USSR. Only "mixed" historical subjects involving questions of the Polish "heritage" (e.g., by Ilya Repin and Jan Matejko) warranted publishing original interventions by indigenous authors.

The same held true for the clearly doctrinal statements, abundantly available in translation—although primarily for "internal" use—as an expression of historical and undoubtedly exemplary destiny, but one whose form remained rather exotic.[21] In Poland's case, the incantation, the anathema, and the pure invective which constituted the style and substance of this discourse would never really become the norm—despite all the rhetorical excesses provoked by the accelerated Marxization of that milieu and except, of course, among the people committed to carrying out

the immediate ideological and political tasks (e.g., Wlodzimierz Sokorski or the Krajewskis). Confronted by the Soviet corpus through the familiar medium of an academic organ (the series *Materialy do studiow*) and eventually soliciting the latter for political goodwill, but never for the justification of its practices, Polish historical and critical reflections of this period maintained an incomparable use value, whatever might later become of such a well-founded methodology and weight of ideology.

From another perspective, Polish artists and critics, whose Union consisted of a section affiliated with the Polish–Soviet Friendship Association, seem to have rarely been invited to the USSR, and those who were remained remarkably discreet about their impressions. The delegation of artists who went to the USSR in 1952 wrote about it in certain magazines, but did not breathe a word to the art press, except to extol the prerevolutionary Russian art in the important museums or the treasures of the Hermitage in *Przeglad artystyczny*. Conversely, it was the "mission" of eminent Soviet dignitaries to visit and advise all of the Eastern bloc countries, but only on such occasions as exhibition-inventories and national congresses. This was the spirit in which Alexander Gerasimov participated in the Warsaw conference that evaluated the first OWP in 1950. The next year would witness a tour by the winners of the Stalin Prize, Tatyana Yablonskaya, Konstantin Finogenov, and the theoretician German Nedoshivin, who lectured at the plenary session of Romanian artists in 1952.

From one country to another or even within a particular country, the actual effects of these policies could differ markedly. The adaptation or literal application of imported doctrinal and organizational imperatives resulted in formal effects that varied according to the degree of local policing, but also in functional effects relative to the specific traditions and the varying degrees of engagement of the "modern" artistic culture. In Poland, particularly, annual inventories and regular thematic exhibitions (e.g., on "The Fight for Peace" in October 1950 or on the work of Feliks Dzierzynski in July 1951), which continued until the "rout" of 1954 (at the Fourth Pan-Polish Exhibition), were considered relative failures, as were even those works awarded prizes. Despite the political goodwill (or the opportunism) that Polish artists demonstrated in responding to iconographic directives, rare was the one who would follow them to the point of totally sacrificing the specificity of his or her language, at the risk of euphemizing certain procedures. The extreme Sovietizing activism of the first phase was then tempered in late 1951 by the withdrawal of the most aggressive pro-

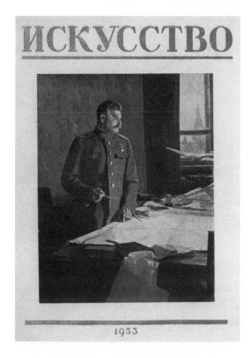

ИСКУССТВО

1953

Figure 2. Fyodor Pavlovich Reshetnikov, *Generalissimus I. V. Stalin*, n.d. Oil on canvas, 58″ × 46¾″. Stalin Prize, 1949. State Tretyakov Gallery. Reproduced from the cover of *Iskusstvo*, No. 1 (1953), commemorating Stalin's death. The only art journal published in the Soviet Union from 1947 to 1956, *Iskusstvo* was a model for the satellite countries.

communist militants (Helena and Juliusz Krajewski). This move served the interests of a "national retreat," which illustrates the effectiveness of the political editorializing of *Przeglad artystyczny,* henceforth edited by Mieczyslaw Porebski. Beginning in 1952, with the foregrounding of prewar visual and plastic arts by a series of National Awards honoring established artists, such as the Colorist Eugeniusz Eibisch in painting and Tadeusz Kulisiewicz in engraving, the Soviet model seems to have been effectively warded off (see Figures 2 and 3).

Above all, it should be noted that in the majority of national contexts, the label "socialist realism" would remain virtually unacknowledged in terms of production, as much by Moscow as by the local institutions in their obligatory discourse of contrition. At most, the meritorious disciples of Zhdanovism would get approval for their "first steps" or their progress on the decidedly tortuous road to the ideal of socialist realism. The critical discourse of *Iskusstvo,* however, provides a homogenous catalogue of qualifications with respect to this generalization. The fifteen texts which the review devoted to the "popular democracies" up to 1953 for the most

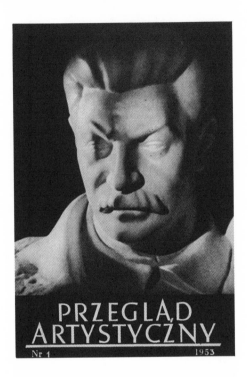

Figure 3. Fragment of an unidentified sculpture by Matvei Manizer, one of the leading Soviet sculptors during the Zhdanov era. Reproduced from the cover of *Przeglad artystyczny*, No. 1 (1953), commemorating Stalin's death. This art journal was the Polish counterpart of *Iskusstvo*, but it reveals a characteristic difference in terms of the imposition and the use of the image.

part pertain to the exhibitions of variously representative or generic work that the satellite countries presented in the Soviet capital. They routinely highlighted their different "national heritages" at the expense of contemporary works, which were nevertheless exhibited as control cases (significantly, works from the most "backward" countries, such as the GDR and Czechoslovakia, were dispensed with). The undoubtedly warm yet artistically circumscribed reception which Moscow reserved—to the exclusion of all the other Soviet cities—for its East European emulators, like the restricted dissemination of their works in the USSR, also demonstrates the strict limits of what was an essentially unilateral "exchange."

The critics undoubtedly congratulated themselves on the "Realist options" of an adequate thematic profile, even of certain formal effects prompted by the "model," which were particularly sensitive and precocious in Romania and Bulgaria. And yet none of this could have occurred without condemning the vestiges of schematic or post-Impressionist traditions everywhere.[22] As for the Polish formula, first presented in Moscow in 1949 by Felicjan Kowarski and Ksawery Dunikowski, the only veteran "stylizers" and "primitivizers," it illustrated "the need for Polish art

Figure 4. Wojciech Weiss, *Manifest* (The Manifesto), 1949. Oil on canvas. Grand Prix, Poland, 1950. Reproduced from *Przeglad artystyczny,* No. 4 (1950): 14. A veteran of Polish "modern painting," Weiss was already active by 1900 in the Symbolist movement.

to liberate itself from decadent formalism" through the inspiration "of the Soviet example."[23] On returning from an oversight mission to the first OWP in 1950, Alexander Gerasimov would confirm the diagnosis while praising the goodwill of the local institutions despite their disorganization. In particular, the state of artistic instruction struck him as comparable to that of the Vkhutemas (acronym for *Vysshie gosudarstvennye khudozhestvenno-tekhnicheskie masterskie* [Higher State Art-Technical Studios]) during the 1920s, which was the epitome of ideological and aesthetic confusion.[24] The Moscow exhibition of 1952 would scarcely modify the "Formalist" image of Polish art, despite the artists' acknowledged progress under the "beneficial influence of the Soviet example." But the exhibition's viewers and critics generally disapproved of the modest group of contemporary works which had been selected precisely for their exemplary Realist qualities and which had almost all won National Awards (see Figures 4 and 5).[25]

The position of China in this context was not comparable to that of Communist countries in Europe. After China had proclaimed itself the People's

Figure 5. Eugeniusz Eibisch, *Walka o pokoj* (Struggling for Peace), 1950. Oil on canvas. Reproduced from *Przeglad artystyczny,* No. 1 (1951): 26. A major representative of the "hedonistic" Colorist current in Polish painting, Eibisch was criticized for the "dematerialization" of the characters in this work.

Republic in October 1949, its "artistic emergence" with respect to socialist realism undoubtedly coincided with that of the East European countries, but was also enhanced by the "Sovietization" of its cultural institutions (the July 1950 Conference of Art and Culture Workers in Beijing notably included the first Pan-Chinese exhibition of plastic arts, with its attendant multilingual catalogue) and, finally, by the 1950 Sino-Soviet treaty. The dissemination of Chinese art, at first limited to contemporary prints, rarely occurred without reference to Mao Zedong's "theoretical contribution" (i.e., the Yan'an Lectures, which were promptly translated) before 1950. The Soviet promotion of this art culminated in October 1950 with the monumental historic exhibition which toured Moscow and Leningrad, and then, in 1951, Berlin and Warsaw. The exhibition selectively emphasized the richness of China's most ancient traditions. The modest selection of contemporary works privileged vernacular techniques, especially graphic

art, at the expense of those imported from Europe (e.g., oil painting and Realist sculpture). But the iconographic material in the catalogue and related publications which followed the exhibition in the USSR would significantly invert these proportions, as though to better characterize the political-artistic "reality." [26]

There is no doubt as to the ambiguity which enveloped the Chinese version of socialist realism. A selective, that is, "anti-Mandarin," national heritage, which was several thousand years old and claimed to be more or less Realist, was established as the formal antithesis of the academic traditions favored by Zhdanovism. The cultural politics of the latter allowed the Soviets to ignore the conventions (i.e., a certain Primitivism) of representations that were considered nationalist and/or Modernist vestiges in the Oriental republics of the USSR. Soviet critics would thus play up the most recent developments and techniques in Chinese art, as these showed an explicitly Soviet influence and were revered, of course, by both parties. Such developments included the easel, which was emphasized as the best proof of conformity but which would not be used much in China until the last phase, political caricature, and "socialized" imagery, which was created through traditional means (scrolls, prints) that were progressively altered and Westernized, thus emphasizing narrativity or a "European" perspective. The rapid evolution of color prints, which culminated in the introduction of relief (i.e., "life") while preserving an unmistakable national connotation in the composition and in certain representational conventions that were incompatible with Soviet norms, would be particularly embraced. The same phenomenon occurred, although more strikingly, with xylographs of urban unrest in black and white (reoriented since the 1930s under German influence), which maintained a spontaneous, Expressionist character by means of their violent contrasts. These two artistic practices, tolerated and at times even celebrated in the USSR as China's most specific contribution to the common capital of socialist realism (however minor their status in the generic hierarchy), perhaps constituted a relatively dynamic and hence welcome alternative, if only for their exoticism and uncertain conformity, to the "typicity" of Soviet socialist realism.[27] Finally, this same ambiguity undoubtedly explains the spectacular success of the prints depicting Chinese unrest with Communists in the "popular democracies" and in the West. Indeed, in the press of the latter, Chinese prints seemed to represent a substitute for an overly compromising "artistic" Soviet imagery (see Figure 6).

Figure 6. Zhang Yangxi, *Women de duiwu laile* (Here Come Our Troops), n.d. Woodcut, 10″ × 13″. Reproduced from *Konferentsiia vsekitaiskikh khudozhestvenno-literaturnykh rabotnikov v iiule 1949 goda* (Conference of the All-Chinese Artistic-Literary Workers in July 1949), catalogue (Beijing, 1949).

In Eastern Europe, another substitute for or alternative to both Soviet modes and Western artistic culture emerged, one that was even more important than Chinese engraving: the European "New Realisms" which were formulated after communication with the West was disrupted in 1949. The New Realisms seem to have been afforded a measure of the legitimacy denied them by both Moscow and the "modern" West in the Soviet satellite countries. Thus in Poland, which was undoubtedly favored by virtue of the liaison role that the international peace movement had assigned it, French, Italian, and Mexican engravings (at first), as well as Anglo-American drawings, were regularly reproduced, commented on, and—more unusually—exhibited and sold, just as artworks from the other "popular democracies" were. Their dissemination seems to have begun as a pretext for launching denigratory campaigns against

"bourgeois, artistic decadence," for which they represented an antidote and a mode of internal subversion. This was to be the USSR's first and only use of these artworks, and it was the "progressivists" themselves who claimed them. They would nevertheless soon come to function implicitly as alternative models to the stereotypes of Zhdanovist "non-art."

While the New Realists were unable to compete quantitatively with their official Soviet mentors, rare was the issue of *Przeglad artystyczny* which did not devote at least one article to them during their first activist phase. (Works by the Frenchmen André Fougeron and Boris Taslitzky, the Italian Renato Guttuso, the American William Gropper, the Englishman Paul Hogarth, and the Mexican engravers were exhibited at the National Museum in Warsaw beginning in 1950.) In 1952, Guttuso was awarded a Polish National Award (for his illustrations of an "Italian" story by Julian Stryjkowski), although his first one-man exhibition in Warsaw did not tour Prague, Budapest, and Bucharest until 1954. And even if Picasso, the star of the 1948 Wroclaw Congress and the winner of the 1950 World Grand Prize for Peace in Warsaw, at first saw his publicity stingily rationed, a 1952 exhibition of French art (i.e., "progressivist" art) nevertheless allowed his *Massacre in Korea* to be presented as though it had been smuggled in. Works by Gromaire, Pignon, and Léger, even a quasi-abstract cutout gouache by Matisse, himself the doubtful hostage of the French Communist Party, were also exhibited (see Figures 7 and 8).

This phenomenon makes more sense if we understand the ostracism to which the work of these Western "progressivists" was subjected in the USSR. Paid lip service for their political merits, these artworks would still not be publicly displayed or even often reproduced, and never under the rubric of socialist realism. By contrast, Parisian productions were the subject of five *Iskusstvo* articles devoted to Western "resistants" during this period. Paris thus retained its privileged referential status. But we must distinguish between the different strategies of Moscow and the French Communist Party, for Picasso, Léger, even Matisse, the extraterritorial stars of the cultural auto-legitimation of the French Party, were designated formalism's quartermasters par excellence by the Soviets. This would not preclude a strictly political use of Picasso and his doves as emblematic figures of the peace movement, but his work remained external to New Realism's Parisian configuration. Even if this movement had been the object of Moscow's solicitude, almost none of the New Realist works would have captivated the Zhdanov eye: Fougeron's and Taslitzky's "schematism"

Figure 7. André Fougeron, *Défense nationale,* 1950. Oil on canvas. Reproduced from *Przeglad artystyczny,* No. 2 (1951): 46. An emblematic work of French New Realist painting, it was part of Fougeron's exhibition "The Mine Country" at the Bernheim–Jeune Gallery, Paris, in January 1951. Hidden or criticized by the Soviet press, this series of works was extensively circulated in the "popular democracies." The painting is believed to have been deposited in the Bucharest National Museum.

and/or "expressionism" were the first to be targeted for criticism that became increasingly sharp over time.

Significantly, only one of the five *Iskusstvo* articles included reproductions — a dove and a head of Maurice Thorez by Picasso, as well as Fougeron's hotly criticized *Death of André Houiller,* which had been given to Stalin for his seventieth birthday, although it is unclear whether or not it was actually exhibited to the Soviet public at the time.[28] As for the only Soviet book devoted to the French New Realists, it also dispensed with all visual support, and one searches in vain for a description of any truly admirable work.[29] By the end of the period, far from having been moderated in the name of "typicity," most of the criticism seems to have intensified with regard to "bad artistic will," especially that of Fougeron, who rejected Soviet advice and persisted in his own techniques (montage, extreme expressiveness) and his less than respectful interpretation of the "classical heritage."[30]

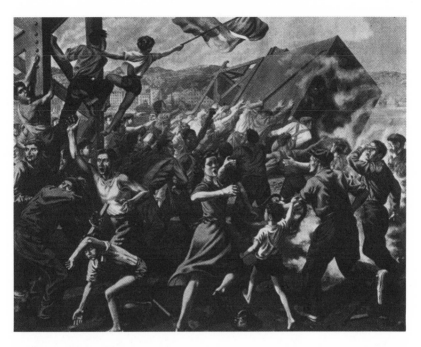

Figure 8. Gérard Singer, *Le 14 février à Nice,* 1950. Oil on canvas. Reproduced from *Przeglad artystyczny,* No. 3 (1951): 38. Part of the exhibition of French art in Warsaw in 1952, the painting was eventually bought by the Polish state and deposited in the Szczecin Museum of Fine Arts.

Zhdanovist criticism seems in any case to have taken note of something that the Parisian New Realists themselves, the contemptuous "bourgeoisie," and practically all subsequent historiography have struggled to refute: these artists' irremediable attachment to modern Western culture, despite certain appearances and declared intentions. The same held true for the other national groups or currents of New Realism, all of which were more or less distinguished by Primitivist or Modernist references—a quasi-subversive dimension (in comparison with the Zhdanov model) that was confirmed by the USSR's later recognition of it as well as by the circumstances surrounding it. Such artists as Renato Guttuso and even the Mexicans, who led the "anti-imperialist" offensive on the North American continent, would not have access to *Iskusstvo* until 1954 or 1955. And it was not until 1960 that they were allowed to exhibit in Moscow, and then merely as an auxiliary to the Soviet milieu's internal fight for the renewal

of socialist realist forms. At that point, these artists, who had visited the USSR more than once, could be invoked and sometimes interviewed, and their works frugally reproduced, in the general press. But the first documented article on the Italians in *Iskusstvo* dates from the end of 1954, and Paul Hogarth and other British artists would, like the Mexicans, not appear until 1955.[31] On a trip to Moscow to get treatment for his cancer, Diego Rivera, who had just been readmitted to the Mexican Communist Party after ten years of purgatory for Trotskyite deviationism, expressed his views on Muralism, without neglecting to pay tribute to the superiority of Soviet art.[32] Meanwhile, the public knew nothing about the "Open Letter to Soviet Artists" read during the same period to the USSR Academy of Arts by his old rival, David Alfaro Siqueiros, an unequivocal Stalinist who did not hesitate to denounce the Zhdanovites' "Formalist academism."[33] Finally, it should be noted that 1955 was also the year when the important Mexican exhibition which toured Warsaw, Sofia, Bucharest, and Berlin, leaving a strong wake in its path, stopped at the USSR border. The USSR did not allow this exhibition to be shown until 1960, then daring to present only works by Leopoldo Mendez and his popular engraving studio, which had an analogous function to the prints showing Chinese agitation.

Although pale substitutes for modern artistic culture in the "popular democracies" and "objectively subversive" in Zhdanov's USSR, the New Realisms could nevertheless be used as a sort of lure, a major alternative instrument in the Soviet offensive against the West. Likewise, at the Venice Biennale, in which the USSR did not participate between 1934 and 1956, "socialist realism" was exemplified in the interim by mostly heterodox specimens: in 1952, a Polish selection fresh from a Moscow exhibition, and in 1954, an even less conformist choice (since the engraver Tadeusz Kulisiewicz won the UNESCO Prize) of Romanian and Czech art. No matter how it may have appeared, it was the Mexicans (in 1950) and, above all, the Italians (with the manifesto-canvases which Guttuso prepared for each Biennale) who truly exemplified socialist realism. At least, that was the perception until the 1954 Biennale, when the infamous American counteroffensive was launched with Ben Shahn's democratic "social realism." Although he was being hassled by the McCarthy hearings, Shahn's work was nevertheless deployed against (highly hypothetical) socialist realist positions.[34]

Iskusstvo's anxious solicitude, however, once again confirmed Paris as the universally acknowledged center of artistic modernity, and thus the privi-

leged target of the Zhdanov offensive. The United States, benchmark of the Modernist-imperialist plot, proved to be practically inaccessible and, in contrast to the literary domain (provided with such "positive" brokers as Howard Fast or Albert Maltz), functioned only as a figurehead artistic barricade. We must also consider the importance of the French Communist Party and the existence at its core of a "Party art," the nature and amplitude of which was unique in the West. Its artists were thus the only ones who could truly experience—albeit partially, due to the open and pluralistic environment of French artistic life—the alienating conditions with respect to the absolute institution to which their East European counterparts were subject. The ambivalent objectives of the French Communist Party, divided by the need to follow Soviet orders, to assure sui generis cultural subversion, and to preserve a legitimacy or respectability at all costs (in the face of a "modern" culture incarnated by a Picasso or a Léger), undoubtedly determined the equivocal purposes of the art that the Party funded and then, beginning in 1953–54, contributed to its rapid decline.

However, the task of inverting socialist realism from the postulated norms of Parisian modernity fell to the New Realists of the French Communist Party. And it was to this end that they were sometimes involved in the operations of "bypassing" or transgressing art, such as the scandalous "First Communist Rooms" (composed of political and social themes) of the *Salon d'Automne* or Fougeron's irreverent 1951 exhibition ("The Mine Country"), for which hordes of people were mobilized by the Party and poured into the sanctuary of the Bernheim–Jeune Gallery. This was the moment when transgression in art, at the height of its autonomy and newly sacred form, was finally instituted as a norm of the Parisian market.

The relatively well-documented history of Parisian New Realism has never been studied in terms of its significant relations to the Soviet model (i.e., no more than its counterparts in the other Western Communist parties, all of which demonstrated the same basic alignment with Zhdanovism).[35] Rejected in the West as artistically illegitimate both for its "academic regression" and its offenses against the rules of the game of art, French New Realism would crystallize the original representations of socialist realism which Paris had fashioned. However, if New Realism voluntarily embraced the Zhdanov theoretical program and, above all, its political justifications in France (like its counterparts elsewhere, particularly in Italy), it would not usurp either the designation, reserved unconditionally for the Soviet practice, or the form of socialist realism. There is

every reason to believe, in fact, that New Realism went to great lengths to hide this similarity of form—which was what André Breton tried to show in his famous article of January 1952: "Pourquoi nous cache-t-on la peinture russe contemporaine?" (Why Is Contemporary Russian Painting Hidden from Us?).[36]

We have already highlighted not only the absence of Soviet art in the West, but also its selective and discreet presentation by the Russian reviews published for exportation. However, we must consider the avoidance strategies which the organs of the French Communist Party in particular exercised with respect to this restriction as well. After staking out a unique (critical) position in 1946 and providing some current information, the Party's specialized review, *Arts de France,* published illustrations of Zhdanovist art only once, in its last issue (1952), and then without any commentary other than the political.[37] The cultural organs, such as *La Pensée* and *La Nouvelle critique,* would address this issue only periodically and from a "theoretical" perspective by compiling Soviet statements, but without any reproductions, as did the weekly *Les Lettres françaises.* The same was true of the communist press in other Western countries. As for the "progressives" who were initiated into the mysteries of the Soviet art world, their travel accounts abstained from any mention or evaluation of that art. In Fougeron's case, the New Realist leader justified "the very great esteem in which we must hold Soviet culture" with the example of the Tretyakov Gallery, "which has such beautiful icons."[38] However, Soviet literature and cinema, Zhdanov and Lysenko, and "linguistic" or "philosophical" Stalin idolatry could be found everywhere in this same communist press. And if there were technical or administrative reasons for the physical absence of socialist realist works—despite the demands of the Western "masses," to which their Moscow promoters regularly referred—nothing could justify the resulting censorship of their reproductions (which, as we have seen, was an essential mode of distribution) even in "friendly" territories. Such impudence touched Western communists themselves; it was with an unconvincing air of nonchalance that Louis Aragon felt compelled to respond, however awkwardly, to André Breton in his "Réflexions sur l'art soviétique" of January 1952.[39] Illustrated by images which worried French militants, this masterpiece of evasion served only to confirm the Parisian sense of the complete strangeness of this "other language" (Aragon's terms) and the impracticability, outside of "Soviet reality," of a socialist realism perceived entirely as a "means of moral extermination," as Breton put it in his first attempt to respond to the Parisian presentation of socialist realism.[40]

As for the rest: "The idea content of Soviet painting (which [was] no different from the idea content of the other arts in the Soviet Union) once laid bare, as with its relationship to its modes of expression, [would] allow us to make (as though instead of having a book in a foreign tongue, we possess[ed] it in translation) all the comparisons we might want."[41]

— Translated by Gayle Levy and Thomas Lahusen

Notes

1 See Boris Groys, *The Total Art of Stalinism: Avant-Garde, Aesthetic Dictatorship, and Beyond,* trans. Charles Rougle (Princeton, 1992); Igor Golomstock, *Totalitarian Art* (London, 1990); Matthew Cullerne Bown, *Art Under Stalin* (Oxford, 1991); *Art of the Soviets,* ed. Matthew Cullerne Bown and Brian Taylor (Manchester, 1992); *Soviet Socialist Realist Painting, 1930s–1960s* (catalogue), ed. Matthew Cullerne Bown and David Eliott (Oxford, 1992); and *Russie-URSS 1914–1991: Changements de regards* (catalogue), ed. Wladimir Berelowitch and Laurent Gervereau (Paris, 1991). See also the periodic characterizations and testimony which appeared from late 1987 in the Soviet reviews *Iskusstvo, Tvorchestvo,* and *Dekorativnoe Iskusstvo SSSR* until these journals were discontinued.

2 This is the case with a recent study of the confrontation on the artistic front between the USSR and the West: Christine Lindey, *Art in the Cold War* (London, 1990).

3 See the (incomplete) catalogue *Vystavki sovetskogo izobrazitel'nogo iskusstva* (Exhibitions of Soviet Fine Arts), No. 4 (Moscow, 1975).

4 For a description of these journals, see Antoine Baudin, *Le Réalisme socialiste de l'ère Jdanov: Situation des arts plastiques* (forthcoming).

5 Vladimir Kemenov, "Cherty dvukh kul'tur," *Iskusstvo,* No. 4 (1947): 38–46.

6 Lidiia Reingardt, "Po storonu zdravogo smysla," *Iskusstvo,* No. 5 (1949): 77–87. For comparison, the Polish translation of the same text was illustrated by several abstract works of Auguste Herbin and Antoine Pevsner and even by some "informal" works of Hans Hartung and Wols; see Lidya Reingardt, "Po stronie zdrowego rozumu" (On the Side of Common Sense), *Przeglad artystyczny,* Nos. 3–4 (1950): 39–42.

7 I. Tsyrlin, "SShA, oplot reaktsii v iskusstve kapitalisticheskogo mira" (The USA, Stronghold of Reaction in the Art of the Capitalist World), *Iskusstvo,* No. 1 (1952): 84–89. There were also a number of literary reviews that solicited the extremely scarce texts on Western art written by a number of dubious artists; see, for example, Sergei Gerasimov, "Marazm amerikanskoi zhivopisi" (The Decay of American Painting), *Znamia,* No. 6 (1952): 156–63. *Znamia* also published contributions by the prodigious American artist Sergei Konenkov, whose illustration

of three examples of sculpture by Jacques Lipchitz, David Smith, and Seymour Lipton served as an object of derision and auto-criticism; see "Iarmaka iskusstva" (Artistic Fair), *Znamia,* No. 2 (1953): 127–31.

8 Vladimir Kemenov et al., *Protiv burzhuaznogo iskusstva i iskusstvoznaniia* (Moscow, 1951).

9 Vladimir Kemenov, "Protiv reaktsionnogo burzhuaznogo iskusstva i iskusstvoznaniia" (Against Reactionary Bourgeois Art and Aesthetics), in Kemenov et al., *Protiv burzhuaznogo iskusstva,* 7.

10 On the "verbalization of the image," see Vladimir Papernyi, *Kul'tura "Dva"* (Culture "Two") (Ann Arbor, 1985), 171–87; and Antoine Baudin and Leonid Heller, "L'Image prend la parole: Image, texte et littérature durant la période jdanovienne," in Berelowitch and Gervereau, eds., *Russie-URSS 1914–1991,* 140–48.

11 In 1946, Warsaw and Kraków received the most important exhibition among these, with a total of 370 works of graphic art on view. The next year, an exhibition of works by Alexander and Sergei Gerasimov, Arakady Plastov, and Alexander Deineka (although considered exemplary in 1947, the work of the last three would be disqualified in 1949) visited Belgrade, Sofia, and Prague (the latter still welcomed young Ukrainian painters). But the initiation of the "popular democracies" could also proceed through the promotion of the "Russian Realist heritage." This was the subject, for example, of an exhibition of reproductions from the Tretyakov Gallery in Warsaw in July 1948, followed by an ensemble of original works in November. See Andrzej Korzon, *Polsko-radzieckie kontakty kulturalne w latach 1944–1950* (Polish-Soviet Cultural Contacts in the Years 1944–1950) (Warsaw, 1982), 226–35.

12 Jerzy Malina, "Wystawa grafiki, akwarel i rysunku artystow Zwiazku Radzieckiego" (Exhibition of Soviet Prints, Watercolors, and Drawings), *Przeglad artystyczny,* Nos. 11–12 (1946): 13; this critic also called for examples of Western art.

13 Konrad Winkler, "Uwagi o plastyce w Zwiazku radzieckim" (Remarks on the Arts in the Soviet Union), *Przeglad artystyczny,* Nos. 10–11 (1948): 6. Furthermore, Winkler referred to the 1934 Soviet exhibition in Warsaw—for lack of more recent representative works—very few components of which would then have pleased the eye of any Zhdanov censor.

14 *Akademiia Khudozhestv: Pervaia i vtoraia sessii* (Academy of the Arts: First and Second Sessions) (Moscow, 1948), 24.

15 Aleksandr Gerasimov, "Mysli khudozhnika" (Thoughts of an Artist), *Literaturnaia gazeta,* No. 16 (1949); reprinted in A. Gerasimov, *Za sotsialisticheskii realizm* (For Socialist Realism) (Moscow, 1952), 305–12.

16 See Wlodzimierz Sokorski, Jan Minorski, and Juliusz Krajewski, *Nowe Drogi,* No. 4 (1949): 129–39.

17 On this transition to socialist realism, see especially Wojciech Wlodarczyk,

Socrealizm: Sztuka polska w latach 1950–1954 (Socialist Realism: Polish Art during the Years 1950–1954) (Paris, 1986); *Oblicza socrealizmu* (Faces of Socialist Realism), exhibition catalogue of the National Museum in Warsaw (1987); and *Sztuka polska po 1945 roku* (Polish Art after 1945) (Warsaw, 1987).

18 Quoted in *Przeglad artystyczny,* Nos. 5–6 (1950): 14.

19 In terms of Russian and Soviet painting, it was the Tretyakov Gallery which seems to have furnished the principal corpus of reproductions for the various traveling exhibitions (no catalogue exists). In Poland, the review *Przeglad artysty- czny* noted exhibitions beginning in late 1949 and culminating in 1950–51. These were often of a purely occasional character and had political themes (e.g., agi- tation, the peace movement, celebrations of "Polish–Soviet Friendship Month"). Similarly, Romania was able to organize a "Soviet Art Week" in all cities in Au- gust 1951. The imperatively paradigmatic artistic virtues of Russian and Soviet work were displayed more rarely, such as the anthology of reproductions from the Soviet Salon of 1950, solemnly presented in Kraków in February 1952 as well as in Prague and other major Czech localities.

20 V. Salimova, "Uspekh vystavki sovetskogo iskusstva" (Success of an Exhibi- tion of Soviet Art), *Iskusstvo,* No. 2 (1950): 91–92.

21 Besides the translations (in brochure form) of Zhdanovist dogma, beginning in 1948–49, followed by basic texts on Leninist–Stalinist and socialist realist aes- thetics (by A. Sobolev, B. Meilakh, M. Neuman, and P. Sysoev), the dissemination of Soviet doctrine in Poland proceeded primarily via the periodical *Materialy do studiow i dyskusji* (Materials for Study and Discussion), which published about forty translations between 1950 and 1954, mainly of texts from the Soviet collec- tions of the Academy of Arts and Sciences, or, with respect to aesthetics, from the review *Voprosy filosofii* (Problems of Philosophy). But other academic texts were also translated and distributed in mimeograph form for the internal use of the Art Institute.

22 See A. Tikhomirov, "Iskusstvo Rumynskoi Narodnoi Respubliki" (The Art of the Romanian People's Republic), *Iskusstvo,* No. 2 (1950): 56–59; I. Tsyrlin, "Iskusstvo Bolgarii" (The Art of Bulgaria), *Iskusstvo,* No. 6 (1950): 49–60. The tone would be harsher with respect to the Hungarians, who were called upon to purge their ranks at the time of their first inspection (see Aleksandr Zamoshkin, "Zametki o vengerskom iskusstve" [Remarks on Hungarian Art], *Iskusstvo,* No. 4 [1950]: 59–70), and whose works practically never appeared in *Iskusstvo* even after the Moscow exhibition of 1951, when V. Yakovlev in fact recognized the need to "observe the best artists with great sympathy in order to move from a formalism lacking ideas to the search for new Realist directions," and where one could even see "the very first results"; see *Iskusstvo,* No. 5 (1951): 53–54.

23 Aleksandr Zamoshkin, "Vystavka pol'skogo izobrazitel'nogo iskusstva" (An Exhibition of Polish Fine Art), *Iskusstvo,* No. 6 (1949): 43.

24 Aleksandr Gerasimov, "Izobrazitel'noe iskusstvo demokraticheskoi Pol'shi"

(The Fine Arts of Democratic Poland), in *Za sotsialisticheskii realizm,* ed. Aleksandr Gerasimov (Moscow, 1952), 323–29.

25 See B. Sursis, "Iskusstvo pols'kogo naroda" (The Art of the Polish People), *Iskusstvo,* No. 5 (1952): 20; and the document compiled by Jerzy Zanozinski, "Poklosie wystawy plastyki polskiej" (Comments on an Exhibition of Polish Plastic Art), *Przeglad artystyczny,* No. 4 (1952): 43–46.

26 See, for example, the series of documents published as "Khudozhestvennaia vystavka Kitaiskoi Narodnoi Respubliki" (An Art Exhibition of the People's Republic of China), *Iskusstvo,* No. 6 (1950): 11–31.

27 See N. Vinogradova, "Kitaiskii narodnyi lubok" (Chinese Popular Print), *Iskusstvo,* No. 1 (1953): 55–61.

28 See N. Gavrilov and Iu. Rubinskii, "Po stranitsam *Arts de France*" (On the Pages of *Arts de France*), *Iskusstvo,* No. 3 (1951): 77–83.

29 I. Tsyrlin, *Frantsuzskie khudozhniki v bor'be za mir i demokratiiu* (French Artists in Their Struggle for Peace and Democracy) (Moscow, 1951). Strangely, works by these same artists can be found in periodicals of greater distribution but less artistic responsibility than *Iskusstvo,* such as *Sovetskoe iskusstvo, Literaturnaia gazeta,* and even *Ogonek.* See N. Gavrilov, "Belyi golub' Picasso" (Picasso's White Dove), *Sovetskoe iskusstvo,* No. 90 (1950): 4, with an abbreviated biography of the artist; and "Fuzheron i *Smert' Andreia Ul'e*" (Fougeron and *The Death of André Houiller*), *Literaturnaia gazeta,* No. 95 (1949): 4; see also Iu. Zhukov, "Chest' khudozhnika" (The Honor of an Artist), *Ogonek,* No. 36 (1949): 15–16—again on Fougeron.

30 See V. Prokof'ev's article in *Iskusstvo,* No. 2 (1953): 85–90; and O. Nikitiuk and V. Prokof'ev's article in *Iskusstvo,* No. 6 (1953): 65–69. A revealing paradox should be noted with respect to these two virulent articles: translated and reprinted in the French communist review *La Nouvelle critique* (48 [1953] and 52 [1954]), they were used to solve internal problems, which provoked Aragon's abandoning of Fougeron and, soon after, the French Communist Party's desertion of New Realism; the Soviet accusation of "formalism" served here to proscribe New Realism, but it led to the gradual reintegration of the communist artists into the heart of Modernist institutions.

31 See E. Kherskonskaia, "Progressivnye khudozhniki sovremennoi Italii" (Progressive Artists of Contemporary Italy), *Iskusstvo,* No. 6 (1954): 48–56; D. Smarinov, "Vpechatleniia o sovremennom angliiskom izobrazitel'nom iskusstve" (Impressions on Contemporary English Fine Art), *Iskusstvo,* No. 2 (1955); and Dzhon Berdzher, "My poidem vpered" (We Shall Go Forward), *Iskusstvo,* No. 2 (1955): 70–78.

32 Diego Rivera, "Sovremennaia meksikanskaia zhivopis'" (Contemporary Mexican Painting), *Iskusstvo,* No. 5 (1955): 59–64.

33 See the French translation in David Alfaro Siqueiros, *L'Art et la révolution* (Paris, 1973), 211–17.

34 See Frances K. Pohl, "An American in Venice: Ben Shahn and United States Foreign Policy at the 1954 Venice Biennale," *Art History* 1 (1981): 80–114.

35 See, especially, the chronology of the French movement in *Paris–Paris 1937–1957,* catalogue of the Centre Pompidou (Paris, 1981), 206–12; Jeannine Verdès-Leroux, "L'Art-de-parti: Le Parti communiste français et ses peintres," *Actes de la recherche en sciences sociales* 28 (1979): 33–55; and *Au service du Parti: Le Parti communiste, les intellectuels et la culture, 1944–1956* (Paris, 1983); Denis Milhau, "Présupposés théoriques et contradictions du 'nouveau réalisme' socialiste en France au lendemain de la Seconde Guerre mondiale," in *Art et idéologie: L'Art en Occident 1945–1949* (Saint-Etienne, 1979), 103–31. On Italy, see Nicoletta Misler, *La via italiana al realismo: La politica artistica de P.C.I. dal 1944 al 1956* (Milan, 1973), which nevertheless lacks any comparison with the Soviet model. The classic work by David Egbert, *Social Radicalism and the Arts: Western Europe* (London, 1970), remains the most complete factual panorama for all of Europe, despite the linear and literal character of his interpretations. The same motif of "alignment" which is so dear to Egbert can be found again, this time for all of New Realism, in Lindey, *Art in the Cold War,* 84–85. (This author does reveal the delayed acceptance of Guttuso by the Soviet institutions.)

36 André Breton, "Pourquoi nous cache-t-on la peinture russe contemporaine?" *Arts,* 11 January 1952; reprinted in André Breton, *Flagrant délit* (Paris, 1964), 135–50. The recent Russian translation seems to retrospectively confirm the premonitory and cathartic nature of this piece; see André Breton, "Pochemu ot nas skryvaiut sovremennuiu russkuiu zhivopis'?," *Iskusstvo,* No. 5 (1990): 34–37.

37 Henry Mougin, "Formalisme et peinture soviétique," *Arts de France,* No. 6 (1946): 75–83; and "Une fête de la culture soviétique," *Arts de France,* No. 35 (1952): 38–43.

38 André Fougeron, "Tchernikov et le percussionisme," *Les Lettres françaises,* No. 276 (1949): 1. See also Paul Eluard and Boris Taslitzky's account of their voyage to the USSR, "Voyage en URSS," *Les Lettres françaises,* No. 314 (1950): 1, 4. The same elements could be found in the United States in such accounts as William Gropper's "An American Artist in the Soviet Union," *Soviet Russia Today* (July 1949): 12–13; or the Canadian painter F. B. Taylor's "A Canadian Artist Eyes the USSR," *New World Review* (October 1951): 51–52.

39 Louis Aragon, "Réflexions sur l'art soviétique," *Les Lettres françaises,* Nos. 398–411 (1952). Some excerpts (the least compromising) were reprinted in Louis Aragon, *Ecrits sur l'art moderne* (Paris, 1981), 86–97.

40 André Breton, "Du *réalisme socialiste* comme moyen d'extermination morale" (On *Socialist Realism* as a Means of Moral Extermination), *Arts,* 1 May 1952; reprinted in Breton, *Flagrant délit,* 151–68. This polemic, which was taken up by other reviews (see, e.g., André Wurmser, "Le Sujet en question," *La Nouvelle critique,* No. 33 [1952]: 122–25), aroused an internal debate among communist art-

ists and helped to open up slightly the pages of French Communist Party organs to Soviet visual art at precisely the moment when New Realism as Party art would be abandoned.

41 Aragon, "Réflexions sur l'art soviétique," *Les Lettres françaises,* No. 401 (1952): 10.

W. E. B. DU BOIS AND SOVIET COMMUNISM

The Black Flame as Socialist Realism

Despite the recent renaissance in scholarship on W. E. B. Du Bois and the inclusion of Du Bois's writings in the canon of American literature, little attention has been paid to his fiction, especially his later work. The reasons given for this neglect range from the aesthetic (i.e., his novels are not very good or organic to his oeuvre) to the ideological (i.e., they are rigidly or transparently or tediously political). Yet in these judgments one can see standards or values that merit closer scrutiny. These standards, as typically happens in canon formation, uphold traditional definitions of literature and privilege works that follow a Western cultural model. In the twentieth century, this privilege has primarily been extended to works informed by modernism. However, these Western cultural standards also have a political dimension which in this period corresponded to the distinction between the capitalist countries of the West and the communist countries of the Soviet bloc. In the exclusion of his later novels from the Du Bois canon, one can see the influence of standards that reinforce distinctions between fiction and nonfiction, good literature and bad, which correspond to the political distinctions between East and West and reflect the policies of the Cold War. This problematic can be fruitfully explored by examining one of Du Bois's late works of fiction, written when he stood at a crossroads, challenging his own and his readers' notions of patriotism, national identity, and social responsibility. Unfortunately, since the publication of these works too few have been willing to pick up the gauntlet.

The Black Flame: A Trilogy has frustrated many of its readers since its publication in the late 1950s and early 1960s.[1] It also frustrated its author, as it never attained the popular audience he had hoped for. Many questions surrounding the trilogy focus on why Du Bois wrote it and what he hoped to accomplish. Started in the "last decade of [his] first century,"[2] the three novels comprised a monumental project totaling 1,032 pages and detailing the lives of three generations of three families. Although its aspirations are clear, its motivations remain obscure, at least to American audiences, for the trilogy's narrative logic is unfamiliar and off-putting to most of Du Bois's home audience, largely due to its elements of socialist realism.

Socialist realism was a literary methodology developed in the Soviet Union to support that country's communist government. In transplanting that methodology to American literature, Du Bois was both furthering leftist ideas in the African American community and ritually affirming his own allegiance to that ideology.[3] This is not to argue that Du Bois was pledging allegiance to the Soviet Union in a crude way, since he considered himself a patriotic American, loyal to the founding ideals of the republic; however, he did see the Soviet Union as a model for democratic government and through his writings hoped to convince the people of the United States to adopt some of its measures.[4] Reading these novels in the context of socialist realism helps to clarify the enormous stakes of his ideological argument. These novels are epic, taking the modern world as their subject matter and striving not just to describe, but to guide and influence. For Du Bois this foray into fiction represented an alternative manifestation of his political activism, which the novels' link to socialist realism brings into sharp focus.

Reading *The Black Flame* as socialist realism opens the trilogy to critical analysis as other approaches have not. Socialist realism facilitates an understanding of the novels' formal and political levels, as well as the connection between them. Ultimately, whether these novels are labeled socialist realist or not is academic; the crucial question is why it may be useful to read them as such. Since their publication, they have been little studied under any rubric, with scholars consigning them to the dustbins of history along with other late works by Du Bois. Reading these novels under the rubric of socialist realism allows a more productive analysis, revealing the complex dynamic of Du Bois's increasing allegiance to communism and his long-standing commitment to fighting for the rights of African Americans. These two groups—his ideological allies and his ethnic compatriots—demanded different things from an author; how Du Bois balanced and integrated these needs will be my focus here.

Studying *The Black Flame* can also enhance our understanding of both socialist realism and modern American literature by revealing their respective formative assumptions—not least by raising questions about the conventional wisdom regarding cultural exchange between the United States and the former Soviet Union. First, any influence of the Soviet literary style on an American author is typically denied by Western critics because the rhetoric of the time has precluded any recognition of a connection unless it were traitorous or otherwise betrayed American ideals. In the Soviet

Union, any such interchange was similarly disavowed, and the export-ability of socialist realism doubted.[5] Nevertheless, Du Bois did bring these literary spheres together through an exploration of common issues. Ana-lyzing his position will shed light not only on the neglected field of Soviet/American artistic interaction, but also on the scholarly reluctance to ac-knowledge it and the threat to existing canonicity that it poses. At issue is whether the problematic common to *The Black Flame* and to socialist real-ism resulted from an actual link between the two or arose independently but in parallel due to common cultural forces. Making this determination will situate Du Bois in the literary landscape and reveal the politics and tensions which assailed him.

The trilogy provides a snapshot of Cold War attitudes, although it postdated the worst of the Red Scare. The novels appeared at a time when the American Communist Party was rapidly losing members following Khrushchev's revelations of Stalin's atrocities. The worst of the red-baiting was over in the United States, and even the Soviet Union was experiencing a thaw as restrictions on artistic freedom were eased. Yet *The Black Flame* was a product of the Cold War nonetheless. Stephen Whitfield notes that after 1956 the moral distinctions between the superpowers were not as clearly drawn; Du Bois, however, reinforced these distinctions.[6] This is not to say that Du Bois was unaware of a change in the political climate, but rather that he was aware of the lack of change in the political sphere that most interested him, namely, the violence to which those of African de-scent were still subjected. This was a Cold War issue because much of the effort directed at communist containment in the United States targeted progressive social action involving the African American community. De-spite the change in the international political situation, African Americans were still experiencing the racism which was a legacy of the failure of Re-construction. Du Bois continued to see the best hope for U.S. progress on civil rights in the tenets of communism and the example of the Soviet Union, although they needed some modification as well.[7]

In adapting socialist realism to the U.S. context, Du Bois introduced an issue that he felt to be fundamental in American culture and fundamen-tally neglected in Marxist discourse — race. His work was therefore differ-ent from other U.S. fiction inspired by socialist realism. Although there is a long tradition of socially conscious or Marxist literature in the United States, produced by such writers as Upton Sinclair, Michael Gold, John Steinbeck, Howard Fast, and Erskine Caldwell, these authors tended to

focus on the immigrant or white working classes, while works by African American Marxist writers, such as Lloyd Brown, quickly fell into obscurity. In terms of Marxism, the issue of race complicates standard analyses of labor that subordinate race to economics in driving social forces; socialist realism is thus likewise complicated by the introduction of race as a theoretical issue in its own right. By writing about race in a socialist realist form, Du Bois essentially introduced African American concerns into the Soviet Communist enterprise for their mutual benefit.

Making U.S. racism an international issue had been a goal of both Soviets and African Americans for some time. As historian Deming Brown noted over thirty years ago, literature about African Americans had long interested the Soviets because they saw African Americans as a potential force for revolution in the United States.[8] Du Bois scholars in the Soviet Union insisted that U.S. racism should be a concern of the international community,[9] while groups in the United States involved with African Americans, particularly the National Association for the Advancement of Colored People (NAACP), felt that focusing international attention on U.S. racial problems would make their solution a higher priority for the government. For example, in the late 1940s, the NAACP drafted a resolution, for submission to the United Nations, to internationalize the discussion of U.S. racism. When the United States refused to present the resolution, the Soviet Union did so. Although the U.N. resolution was not passed, the U.S. government did respond by expanding the Justice Department's civil rights section.[10] The administration apparently made this concession to the civil rights groups in hopes of protecting the country's reputation abroad and neutralizing any internal revolutionary forces.

Yet although the Soviet Union acknowledged and spoke out against U.S. racism, it continued to define the problem in exclusively economic terms—a stance that perhaps led to Du Bois's long delay in officially joining the Communist Party, despite having been considered a reliable fellow traveler for some time.[11] Officially a Socialist for only one year (1911–12), Du Bois had been a socialist sympathizer since his first encounter with it in Berlin in the 1890s. His commitment to communism came later, but Du Bois had supported the Soviet Union since its inception, despite criticism in the United States, and he maintained that support even through the purge trials of the Stalin era when many others did not.[12] In his autobiography Du Bois declared, "I have studied socialism and communism long and carefully in lands where they are practiced and in conversation with

their adherents, and with wide reading. I now state my conclusions frankly and clearly: I believe in communism."[13] Du Bois acted on that belief by supporting the Soviet Union vocally, by introducing communist ideas into his writings, by contributing to many leftist periodicals, and, on 1 October 1961, by finally joining the American Communist Party.[14]

The Black Flame appeared as Du Bois was about to take that final step, and it shows his increasing commitment to communism as practiced. If we accept that Du Bois saw himself as a communist writer, then it becomes clear why he would have employed socialist realism. Under communism as it was then officially practiced, the author had an obligation to submit to that methodology and become an ideological representative. Moreover, according to Howard Fast, the American Communist Party criticized departures from the party line on the part of both members and progressive nonmembers.[15] As one writer of the time rather idealistically put it, "Be he writer, artist, film-producer or scenario writer he suddenly realizes that he is being swept forward by a vast and mighty current to which he wishes to add all his own powers. Almost unconsciously he becomes a spokesman as well as an artist."[16] Du Bois accepted this proselytizing role with relish. He lauded the accomplishments of the Soviet educational system and urged his readership to integrate Russian methods into the American "way of life."[17] Furthermore, he incorporated these ideas in *The Black Flame,* thereby attempting to reach a larger audience of Americans and fulfilling another demand made of socialist realist novelists — that they be popular. Du Bois energetically applied himself to the dissemination of these novels, promoting them at his speeches and selling them wherever he could. As Gerald Horne notes, Du Bois approached the "sale and distribution [of these novels] like the political works they in fact were."[18]

The trilogy was apparently considered ideologically sound by Soviet critics of the time, as Du Bois was often lauded in the Soviet press. Du Bois received the International Lenin Prize in 1958 and was awarded an honorary doctorate of letters by Lomonsov State University, Moscow, in 1959. His biography was also published in the "Lives of Remarkable People" series begun by Gorky in 1933 as a way of providing models for exemplary Soviet behavior. His work appeared in *International Literature,* which published foreign authors with acceptable credentials.[19] *The Black Flame* was translated soon after its U.S. publication and was the second full-length work by Du Bois to be published in Russian (the first having been a 1925 novel called *Quest of the Silver Fleece*).[20] Furthermore, the translations were

produced by a prestigious Moscow publishing house whose print runs averaged 40,000 copies, in contrast to the considerably smaller ones of the novels' U.S. publisher, Masses and Mainstream. Although the number of copies produced or sold cannot be equated with the size of a book's actual readership, the initial audience for *The Black Flame* in Russia may well have exceeded the number of American readers.[21] In contrast, the most popular work by Du Bois in America, *The Souls of Black Folk,* has not, to the best of my knowledge, been published in Russian in its entirety.[22] This supports Deming Brown's conclusion that "it is in the choice of works to be translated, rather than in the process of translation itself, that the practice of censorship operates most severely." [23] Clearly, Soviet readers were getting more out of these novels than most Americans.

Elements of socialist realism can be seen in *The Black Flame*'s structure and plot. Katerina Clark's exploration of the Soviet novel enabled her to extract and formulate the general characteristics of socialist realist fiction. Using the tools of structural anthropology, Clark identified a number of ritual patterns in the symbols, motifs, and tropes of Soviet novels that allowed her to outline a socialist realist master plot and to analyze its changes over time. Herman Ermolaev and Evgeny Dobrenko have also produced useful historical accounts of the genre, and socialist realism has been theorized as well by Georg Lukács, Dmitry Markov, and Alexander Ovcharenko.[24] Ermolaev has provided a political/historical account of the early years of socialist realism before it was codified in the 1930s, while Dobrenko studied the myths and metaphors of socialist realism of the Zhdanov period in his theoretically informed critique of the genre.

Clark found that most socialist realist novels have a dual plot, with the hero's progress toward enlightened consciousness enacted in the process of fulfilling a state-assigned task.[25] The individual comes to understand that his public and private roles are inseparable; as Dobrenko notes, there is a confluence between the individual and his role in the existing world order.[26] Any conflict that arises between the individual and society is resolved such that the impulses of individuals will reflect the best interests of society.[27] In *The Black Flame* we need go no further than the individual novels' titles to see the same basic plot movement. The first volume of the trilogy is entitled *The Ordeal of Mansart* and chronicles the growth to manhood of our hero, Manuel Mansart. Mansart struggles with internal conflicts stemming from his upbringing in a racist and class society and

with the external obstacles posed by economic and racial discrimination. In the second volume, *Mansart Builds a School,* the hero becomes the head of a state university serving primarily African Americans and struggles to achieve his goals through this state-appointed position (i.e., his "task" is set by the government, but mandated by the people). The third volume, *Worlds of Color,* brings Mansart closer to enlightenment while enlarging the scope of the trilogy by having the hero travel and by focusing more on Mansart's extended family. The novel ends with Mansart's death and his family's vow to continue the work he began. The overall plot follows the master-plot structure of biography cum Bolshevik myth.[28]

In her study of Soviet novels, Clark found both symbolic patterns and details that remained remarkably consistent over the majority of socialist realist works. Such symbolic patterns as a mentor's bringing a disciple to enlightenment, a character's suffering death and transfiguration (sometimes martyrdom with a symbolic resurrection), and a political family's supplanting the hero's natural family[29] are also evident in *The Black Flame.* Finding these similar patterns is not surprising, as they are hardly exclusive to socialist realism; however, the conjunction of these larger patterns with a multitude of details characteristic of the "method" strains the plausibility of coincidence. Many of these details concern the hero's childhood. Although Mansart does not display the fondness for horses that Clark claims is characteristic, he is, like most socialist realist heroes, fond of nature. Moreover, he had a childhood marked by poverty and discrimination; he grew up without a father; he struggled to get an education; and he precociously showed signs of an embryonic "consciousness." Mansart lost his father to a lynch mob in the opening pages of the trilogy, and his mother was forced to work as a servant. As a child, he experienced discrimination firsthand when he was almost arrested by a white police officer for defending himself from a white bully. Mansart's mother died as he was finishing high school, and he had to work his way through college. He encountered socialist ideas early through a teacher, Miss Freiburg, and displayed sympathy when he first heard of the Russian Revolution. When he was appointed to his state-university position, he threw himself into the work, thus demonstrating willpower and "voluntarism."[30] These details add up to a portrait of the conventional communist hero; of course, they are also the barely disguised facts of Du Bois's own biography.

The Black Flame also follows socialist realist conventions for characterizing the enemy.[31] While the need for vigilance remained constant in the

Soviet novels, the nature of the threat would change over time to reflect the diverse dangers confronting society.[32] At first, the threat came primarily from malicious class enemies or counterrevolutionaries perpetrating sabotage, as when they destroyed the ropeway for moving lumber in Fyodor Gladkov's *Cement*.[33] By the 1950s, when Du Bois was writing his trilogy, socialist realist villains were less evil than misguided; often, they would be bureaucratic opponents.[34] The fight against the enemy not only allowed the hero to act on his principles, but it also showed the lines of authority and conveyed judgments of legitimacy. In the Khrushchev years, socialist realist works elaborated this issue, exploring the problems of the modern bureaucratic state.[35]

The villains in Du Bois's novels are of two types. At the highest level and glimpsed only rarely is a family of capitalists who are part of a worldwide conspiracy to control production and manipulate workers for their own gain. At a lower level and more typical of social "enemies" are the well-meaning men who are too weak to act on their principles or the misguided men who do their best, but just follow convention. Although Du Bois did deal with the same type of bureaucratic villainy that was prevalent in contemporaneous Soviet novels, this was not a case of simple borrowing. The disillusionment caused by Khrushchev's revelations about Stalin's crimes led to a questioning of traditional authority in socialist realism, at least to the extent that leaders were closely scrutinized before being accepted and their genealogies usually bypassed the upper echelons of Stalin's state. In contrast, Du Bois's doubts about the legitimacy of government had very little to do with Stalin. Although Khrushchev was in power during most of the period when Du Bois was writing these novels, Du Bois himself remained a Stalinist. He not only eulogized Stalin in 1953, but continued to defend him even after the Communist Party Congress in Moscow had revealed Stalin's misdeeds in 1956.[36] Du Bois questioned not the legitimacy of the Soviet Union's government, but rather that of the U.S. government. For example, the state government of Georgia is shown to be untrue and unworthy because it does not even follow its own laws. The law has been coopted by white groups, while voting is a farce and power is passed through secret caucuses.[37] Rather than embodying the law, the government is shown to have perverted it to seek its own ends. Thus Du Bois's text parallels the evolution of Soviet socialist realism not by simple linkage or translation, but in terms of a similar home-grown disillusionment with his country's government.

There are other intriguing differences from the typical Soviet novel that reflect Du Bois's different environment. As a case in point, Mansart progresses through the trilogy toward consciousness and enlightenment, but without the typical help of mentors. The mentor in a Soviet novel is typically a father figure, that is, male and paternal, infused with the authority of the government, the preeminent example being Stalin himself. The closest equivalents to such figures for Mansart are the women in his life. While some men are presented as models, such as Sebastian Doyle, a politician's aide who protects the interests of workers and African Americans, they play no direct role in Mansart's life and are often killed early in their own. He learns of socialist ideas from his teacher, Miss Freiburg, and then comes to understand and sympathize with communism through the influence of his second wife, Jean Du Bignon. The role these women play is not incidental, nor is it simply to help men along the road to consciousness, as in many Soviet novels.[38] These women are often better able than the male characters to understand the social forces at work in a situation. Perhaps, for Du Bois, all male authority in the United States was suspect because men were complicitous in the economic system as women never could be.

Another difference from typical Soviet novels is that Du Bois's hero is not completely positive, although he does strive toward the positive, which is perhaps all that is required. Mansart does not complete his evolution to consciousness; he dies as his children are enumerating his shortcomings. At the end of the trilogy, an unidentified voice says, "I'm damned tired of patience. Yes, any kind of patience—even the patience of Manuel Mansart, bless him. I want to fight."[39] Mansart only began a journey that his children and his readers must finish. His death has led to a symbolic resurrection not because Mansart's life inspired it, but because it remained necessary. Thematically, the lack of an entirely positive hero forces the reader to acknowledge that a person cannot simply rise above his circumstances, but must change them (and in the United States, Du Bois felt, there was still much to change).

Each of the surface similarities between socialist realist fiction and *The Black Flame* enumerated above, from the hero's childhood to his enemies, could be taken as evidence of influence. Yet the possibility of alternative explanations begs the question of whether the Soviet and the Du Bois novels are a related or a parallel phenomenon. Examining the underlying theoretical bases of socialist realism could shed light on this question.

Socialist realist novels blur the line between fact and fiction,[40] and

The Black Flame is no exception. The central theoretical issue is summed up in the classic formulation of socialist realism as "the truthful, historically concrete depiction of reality in its revolutionary development." While this definition gives the novelist some leeway, the role of the author is complicated by a twist in the understanding of mimesis. In Soviet socialist realism, there is an erasure of the distinction between reflection and representation in literature, a key distinction of modernism. On the one hand, literature was taken to be a clear reflection of Soviet culture, and, for good or ill, the author was judged on the basis of his fictional situations' typicality. On the other hand, this presumed literary reflexivity was scrupulously monitored and controlled by those in power. By denying any distinction between reflection and representation, socialist realism set itself against modernism, and its corresponding perception of history was explicitly set against that propagated in Western politics.

The blurring of fact and fiction followed from a conceptualization of truth as less a matter of fact than of a proper understanding of the progress of history. In specifying how history should be represented in literature, Lukács insisted that it should not simply reproduce surface reality, but represent its underlying "totality" and "significance." The writer had to "pierce the surface to discover the underlying essence."[41] The epistemology was Neoplatonic—a superficial world was to be abandoned for a higher order of truth, so there were two orders of time and place, mundane and "higher." This distinction was especially evident in high Stalinist culture, which at one point included plans to construct Moscow buildings taller than elsewhere in the country.[42] Du Bois's writings reflect this epistemology as well, especially those in which he differentiated a higher order of justice from the lower-order legal system that only partly instantiated it. This was a surface/depth model of history, where the surface or everyday reality and its perception obscured the subject's understanding of the underlying totality. The idea of history is thus so profoundly teleological that historical events seem merely instantiations of the telos. While mimesis continued to be the basis for literary representation, what was fact and what was fiction became more difficult to determine, as surface facts might be mere noise while the underlying truth could be discerned only by the enlightened few. In the Soviet context, for example, Gorky's series of "Lives of Remarkable People" were in many ways more faithful to the tenets of socialist realism than they were to historical truth.

This surface/depth model of history had both spatial and temporal

ramifications, as the underlying reality elides temporality by means of a synthetic rather than a diachronic relationship to space. The higher order of truth, which is also the underlying reality of history, appeared in socialist realism as a timeless utopian space dissociated from chance and other temporal chaos. As Dobrenko has noted, socialist realist literature "from the outset . . . is *nontemporal,* it reflects the catastrophic, zero Soviet time — time that does not exist."[43] This epic/mystic realm, hierarchically situated above the realistic, imparted a permanence and stability to the communist worldview.[44] Significantly, this view of history relied on a change in perception rather than in context since the surface/depth model allowed these two streams of history to be maintained side by side. While the resulting reification of the state may have provided an illusion of utopian perfection, it also entailed stasis and thus exposed a weakness of the structural model. I would argue that the Soviet government's imposition of this model says less about the strength of its institutional apparatus than about its fear of its inherent instability. As Dobrenko sees it, the text reflected a state that was using the text to prove its own existence, even to create itself in the reader's mind. Unlike the multiple reflections created by Du Bois in *The Black Flame,* which reveal a profusion of alternatives, the Soviet novel reflected a single image, a single interpretation of history, as if reflected in two mirrors facing each other, while all other images receded into obscurity. Many of the same theoretical constructs appear in Du Bois's work, although their genealogy and function differ somewhat. For example, the inclusion of historical "fact" in these works of fiction similarly elides the distinction between reflection and representation — not to privilege reflection over representation, but to underscore the constructedness of both. This move opened a discursive space for an alternative history, making history a contested site and permitting Du Bois to emerge as a new speaker.

Whereas in socialist realism the blurring of fact and fiction served primarily to authenticate the ideology, for Du Bois it also authenticated the African American speaking subject. According to Robert Stepto, ancillary texts and empirical evidence in Du Bois's work are held to a standard of proof higher than that of white opinion,[45] a standard that enhanced the work's realism and challenged racism, which could not withstand such scientific scrutiny, thereby establishing the basis for an alternative history. In a postscript to the first volume of the trilogy, Du Bois set up this complex play among history, truth, and fiction: "Here lies, then, I hope, more history than fiction, more fact than assumption, much truth and no false-

hood."[46] The novels deploy several different kinds of knowledge—factual, experiential, and imaginative. That Du Bois judged each of these to have value and truth is not surprising, as he had been blurring the boundaries between them throughout his career. In his sociological work, for example, he began early on to listen to people's stories and to present them as history—a then controversial method. Du Bois maintained that pluralism in his trilogy. Rather than abandoning surface reality for the truth of the underlying teleology, his fiction shows his ambivalence about subordinating everything to ideology. His exploration of alternative kinds of knowledge precludes a totalizing vision of history and presents his readers with choices. Perhaps his negative experience with the totalizing ideology of racism/capitalism made him wary of generalizations, of simple explanations and cure-alls.

This depiction of multiple alternatives appears symbolically in the autobiographical elements of the trilogy. In all of his writings Du Bois used his own life as a lens through which to apprehend the world and the forces driving it. In the trilogy, many Du Bois personae appear in different geographical, racial, and gender situations.[47] First, Manuel Mansart grows up in a family situation similar to Du Bois's—fatherless and with a hardworking mother who dies as he is completing high school. Like a family romance, Mansart's father's absence is depicted as heroic and tragic, in contrast to the mundane absence of Du Bois's own father through divorce and distance. A second stand-in for Du Bois is the only slightly disguised character James Burghardt, who teaches at Atlanta University, comes from the North, and edits the journal *Crisis*. Finally, we can see Du Bois in the figure of Jean Du Bignon, who shares his racially "impure" heritage, his early interest in socialism, and his tendency to be indicted for failing to register as a foreign agent. Even her French name, with its masculine spelling, connects her to Du Bois.

Du Bois himself thus becomes a control subject in this experimental understanding of the social forces affecting an individual (albeit a "control" who was also affected by those forces). We can see how his life was distorted by the forces of prejudice, whether racial or, in the case of his alter ego, Du Bignon, sexual. Rather than showing how the same character endures over time, Du Bois showed how the same character could come to very different ends. Significantly, they all suffer racial prejudice and economic hardship, which Du Bois felt would be mitigated in a communist state.

The surface/depth model of history is also evident in the trilogy, but rather than relying on teleology to prove its truth Du Bois made an effort to provide other factual support. In *The Black Flame* there is a smooth continuity from supposedly abstract forces to historical participants and finally to their fictional counterparts so that the levels become impossible to differentiate and the reader is constantly made aware of the effect of individual actions on the overall historical development. Du Bois called this type of writing "historical fiction."[48] Entire passages of the text read like a history textbook and were most likely taken from Du Bois's more explicitly historical writings. In addition, the fictional characters frequently interact with fictionalized versions of historical figures, such as Tom Watson, Huey Long, and Franklin Delano Roosevelt. We also see the effects of historical events on the characters' lives; history is not experienced as an abstract force by those people who live it. Even such an event as the San Francisco earthquake, which seems beyond human cause or control, is linked to the actions of individuals.[49] In his postscript to *The Ordeal of Mansart,* Du Bois writes that this interweaving of historical fact and fictional reality could help readers overcome the "insuperable difficulty" of interpreting history and gain "sufficient understanding rightly to weigh its cause and effect."[50] In the end, these novels themselves try to become an active part of that larger history, recalling its past and influencing its future.

Du Bois was aware of the strong ideological impetus behind the construction of an underlying progressive history, and, as befit an author suspended between two ideologies, he presented two alternative views of history, each with its attendant utopian realm. History is thus depicted as contestable, with a special emphasis placed on the role of the reader in determining its outcome. In *The Black Flame* we glimpse these higher levels of history, which embody the teleology, through the visions of the prophets who appear periodically. Although it may seem paradoxical to encounter prophecy, an example of the irrational, in a socialist realist text, it conforms to a view of progressive history as what can be discerned only by enlightened individuals. However, placing this history in the realm of the nonrational emphasizes the role of belief and faith, which has its own ironies.

Two types of prophets appear in the novels, capitalist and Marxist. The capitalists predict that African Americans will die without slavery, that the freedmen will be unable to educate themselves, and that they will not use

their votes intelligently. A powerful group of such capitalists appears periodically, conspiring to further imperialism and block progressive action. Their utopia is reached by boat, as one white character finds; it is an island of luxury where the inhabitants appropriately lose track of time. Over the course of Mansart's life, each of these capitalist prophecies proves false, and the vulnerabilty of those who believe in them is exposed. Thus, in the Atlanta riot described in *The Ordeal of Mansart,* those African Americans who have tried to comply with the system are the very ones targeted for violence, since white rioters dare not enter the black neighborhoods where there has been resistance.[51]

In contrast to the false prophets of capitalism, the prophets of Marxism speak the truth, but are not understood. Du Bois's novels contain several characters who seem both crazed and yet absolutely sane. They are not constrained by existing at any one point in time, but are able to perceive reality through the obfuscating effects of temporal existence. These figures, though locked away by their families and misunderstood by their audiences, nevertheless have the power to stop readers in their tracks and make them question their own interpretations of events. For example, the woman who claims that the earthquake in San Francisco months before resulted from the human devastation then occurring in the Atlanta riot is not constrained by the conventional notions of human or temporal causality. "Time," she explains, "is but our habit of thought. Reason is more than time, and Deed embodies Reason."[52] But the most interesting figure in this regard is Old Dr. Baldwin, a white educator who, with others, is responsible for Atlanta's burning down. Baldwin, who claims to have come to Atlanta to warn the people, is described as "a man of original mind, difficult for reactionaries to understand."[53] He passes judgment on Atlanta, sentencing the city to fall as Babylon and Rome did. These characters, whether viewed as mad for their interpretations of the past or for their predictions of the future are ultimately vindicated. Although their fellow characters do not understand their warnings, the reader is clearly meant to do so—and perhaps to be spared the fate of those who deny the truth: death by violence and another world war. The presentation of these truthtellers as *rejected* may indicate Du Bois's feelings about his own place in the American cultural landscape; it also suggests his bleak prognosis for this country, unless the American people use their agency for productive change and to alter their perceptions.

What pierces the veil of everyday perception to reveal the true under-

lying reality is invariably a crisis, a number of which punctuate the trilogy. Du Bois, like Lukács, regards crisis as what tears the veil from our eyes. In terms of the surface/depth model of history, a crisis at the surface can break the illusion and allow us to see the underlying history. What in calmer times appeared to be the forces of history are exposed by crises as mere constructions of the surface, erected to discourage change. Rather than being a chaotic aberration or disruption of historical continuity, these crises reveal its genuine nature. Thus a military draft involving his sons, which is an unusual occurrence, opens Mansart's eyes to the way in which these young African Americans were devalued, as they did not qualify for educational exemptions and were much more likely to be assigned to frontline divisions. As Du Bois's characters perceive the higher truth, they are confronted with manifestations of abstract forces that may embody history but, being symbols, lack the dimension of time. Thus, during war scenes, Crime and Disease are seen stalking the countryside, and during various riots the same anonymous black man repeatedly fuels the flames. The closer the novels get to the higher order of truth, the more static and abstract its manifestations become, perhaps because the closer one comes to teleology, the less one needs to rely on the historical moment as a referent and value marker. Apparently, the closer one gets to this underlying reality, the less one is subject to time—a new sort of immortality, although since this immortality truly belongs to the totalizing sytem, one can ask whether the individual survives at all.

One could argue that the African American characters in *The Black Flame,* like their U.S. counterparts, are always in crisis due to their position in American culture and the ubiquitous racism they face. This perspective would support the Soviet conclusion that African Americans were more likely than white Americans to develop a revolutionary consciousness. Far from being marginal or extrinsic to American culture, they are the perfect subjects to study for an understanding of the underlying forces and relations within that culture, as Du Bois claimed throughout his work, although that position has been slow to gain critical acceptance. While African Americans may have seemed the best potential U.S. allies for the Soviets and were targeted as such, how Du Bois and other African American leaders used that Soviet interest was less simple. For Du Bois that relationship should have been one of coalition and mutual benefit, not subordination. As he saw it, African Americans and the Soviet Union shared

the same enemy, capitalist oppression, but Du Bois made it clear that the issue of race still had to be dealt with. He certainly used the Soviets' interest in African Americans to further his aims, although whether this was a case of true love or a marriage of convenience is still in question.

At times *The Black Flame* seems paranoid, with secret meetings deciding the fate of the world. This conspiracy view of capitalism accords with socialist realist representations, but it also reflects Du Bois's own experiences in the early 1950s and the rhetoric of the still relatively recent Red Scare. The United States government made the same claims for its system of democracy as Du Bois did for the Soviet Union, that it alone provided freedom of choice and direction while the Other tried to control people's minds and bodies. Du Bois neatly turned this rhetoric inside out, placing the United States on the ethical defensive. He even characterized the harassment of American communists as another ploy by big business to boost industry at the cost of civil rights.[54]

The rhetoric of the Red Scare and Du Bois's relation to it can be seen in his fictionalized account of his own indictment: Jean Du Bignon's trial in *Worlds of Color*. In 1951, Du Bois was indicted, as a member of the Peace Information Center, for failing to register as a foreign agent. Peace Information Center members had been asked to register because they had earlier canvassed for signatures for the Stockholm Appeal to outlaw nuclear weapons. Jean Du Bignon is likewise asked to register as a foreign agent after speaking of international peace movements and socialism in the classroom and mentioning the Stockholm Appeal, which was interpreted by the government as an aggressive move against the United States, especially in light of the Soviet Union's support of the Appeal.[55] The charges were dismissed in both the factual and the fictional case, and the government was depicted by Du Bois as staffed with irrational and malicious individuals unworthy of leading the people.

The judgment of the court may have been straightforward, but Du Bois's relationship with the Soviet Union was more complicated. Clearly, there need not have been any connection between the peace movement and the government of the USSR, and even if there had been a connection, it need not have been traitorous. Yet Du Bois's involvement in the peace movement was praised by the Soviet Union not only as a model for its own citizens, but also as an embarrassment for the United States on the international stage. As I have already mentioned, the NAACP's United Nations resolution was presented by the Soviets, who were surely not motivated by compassion alone, but also by a desire to hurt the reputation of the United

States. The same may be said of the Soviet Union's support for Du Bois's peace initiatives, in which case Du Bois and the Soviet Union were using each other. Du Bois got international support for African Americans, while the Soviet Union gained support for itself and condemnation of American capitalism from within the United States.

In fulfilling these aims, however, Du Bois went one step further and linked them: that is, in the novels the negative aspects of capitalism are always linked to race. In addition to showing the economic ills of capitalism, Du Bois's trilogy depicts capitalism as spawning imperialism, war, and divisive nationalism. Capitalists are the ones who want war, which Du Bois viewed as the ultimate crime against humanity. In *Worlds of Color* an international group of capitalists meets to plot out the future of their domain and the war that will secure their profits and power: "Those whom we represent must have war. War alone will insure our present profits and bring greater profits and power in the future."[56] Furthermore, capitalist systems are unstable, needing the resources of colonies that must be constantly controlled. For Du Bois, war and racism were connected through colonialization, which exploited racial differences for economic gain.[57]

Race is not an issue in most socialist realist novels, especially those of the Soviet Union. In the communist ideology, racial discord is a relic of capitalism that will disappear as the economic structure of society changes and the lower classes are empowered to participate in the political process. Therefore, a focus on race only diverts attention from the pressing need for economic reform. Significantly, Russian scholars of Du Bois thought he overemphasized race in his discussions of history, which may explain why I have been unable to find a complete Russian translation of *The Souls of Black Folk*. Although Du Bois clearly believed that racism was rooted in economics, he also saw it as a problem in its own right. These views illustrate the gap that existed between Marxist discussions of race and Du Bois's own formulations. As David Roediger states, Marxist analyses of race focus on the ruling class's creating a racial dynamic and then imposing it from above on working-class "victims" or "dupes." However, Du Bois argued that racism was more complex, that poor whites and workers also contributed to the U.S. racial system and derived benefits from it.[58] In a key description of labor in the United States, Du Bois observed:

Whenever Negroes were hired in a mill or at any work not recognized as their usual work, the white unions struck and usually secured the dismissal of the person. . . . When, however, the white workers struck to better their own working

conditions they usually lost, and always met the threat of Negroes being hired to replace them. . . . [Racial bias] tied white labor to the same race superiority as the owners of property and in a way foreshadowed the day when all whites would be rich and all blacks their servants.[59]

Racial prejudice in industry kept wages low by discouraging unity and breeding competition. Through racism, white workers were given a symbolic wage; although they were also economically oppressed, they could look down on African Americans and feel themselves better. Rather than changing the system, which would have allowed black workers better access to jobs, these white workers waited. Seeing themselves as heirs to the property owners, they wanted to ensure that they would have workers beneath them when they made it. Willie Avon Drake, a scholar of Du Bois, notes that "while the complete works of Du Bois' writings reflect his desire for working class unity between blacks and whites, his writings also depict white labor as selfishly opposed to the idea."[60] Thus a change in the economic structure would not be enough to change the country's racial dynamic since racism permeated all social levels and social interactions.

Both the traditional Marxist formulation of race and Du Bois's more radical view surface in the trilogy, revealing this issue as a point of tension for Du Bois. On the one hand, he portrayed capitalist conspirators, in line with traditional Marxist analyses of race; on the other, he characterized the racism of poor whites as not only arising from their situation, but also codified by themselves. These workers created racial divisions which are then exploited by rulers. Jean Du Bignon's experiences at a factory in *Worlds of Color* provide a case in point. After she is dismissed from the university because of her indictment, she gets a job in a textile factory and does volunteer work for the textile union. In her factory experiences, we have a mini production novel. This is the form of many socialist realist novels—a person with talent is almost crushed by her work in the factory (Jean Du Bignon takes to bed for a month from exhaustion), but comes to a true understanding of her position as a member of the proletariat (she knew the importance of unions before, but now understands the state's role in controlling labor) and leads her fellow workers to higher political consciousness and a strike against the capitalist tyrants.[61] However, the world of the production novel does not quite fit that of Mansart and his family: Du Bignon must pass as white in order to become a "production novel" character; otherwise, she could not work in the factory or belong

to the striking union.[62] A communist economic system would not have helped Du Bignon because, as an African American, she would not have been accepted by white workers as a partner in the struggle.

Du Bois endeavored to unite these workers by showing their interests and their future as interrelated. His linking of race and capital was central to that goal. This theme arises in *The Black Flame* both overtly, as examined above, and symbolically, in the relations among characters, especially their familial relationships. Clark notes that in the Zhdanov era the "little family," or immediate relatives, and the "great family," or the state, were depicted more analogously than in socialist realist novels of other periods.[63] In Du Bois's trilogy, it is difficult to make the distinction at all. *The Black Flame* traces three Southern families: the Mansarts, who are black; the Breckinridges, who are white aristocrats; and the Scroggses, who are white and poor. These families together symbolize the "great family" of the state since they embody the class system; they also reflect the political system, since the members of these families include law-abiding citizens, protesters, criminals, several politicians, and a judge. However, since the three families are related by blood or marriage, they form a "little family" as well. These relationships, of course, have political consequences, given the trilogy's historical context. Miscegenation was taboo, and even relationships across class boundaries were frowned upon, as we see when a character from a well-to-do family marries a poor white worker. Yet, in *The Black Flame,* each family is constitutive of the others and therefore cannot be ignored or forgotten. This ties in with one of Du Bois's aims in writing African American history, which was to show that, the rhetoric of denial notwithstanding, African Americans are an intrinsic part of America.[64]

In the same way, these novels show that race is constitutive of economic relations. Any analysis or plan of reform which did not take racism into account would, Du Bois believed, reinscribe those racial inequalities. Furthermore, racism had to be acknowledged not simply as an economic reality, but also as a psychological construct that could not be rationally explained or dismissed. Affinities based on color sometimes influence the characters in the novels even more than those of class or economics. Thus Mansart praises Japan for beating the European capitalists at their own game. Although this approval of Japan is not unqualified (Jean Du Bignon, in particular, has some reservations), the overall view of Japan presented in the novels seems positive. As Mansart says, "I am, I admit, prejudiced in its favor. . . . First of all, it is colored."[65] Although Man-

sart has some misgivings when Japan attacks the United States, he still exults when the European forces are repelled.[66] He is likewise impressed by black entrepreneurs, such as Sarah Walker and Alonzo Herndon, who, he says, positively affected their communities.[67] In these cases, an identification based on race, with its corresponding relationship to the dominant race, counts for more than shared economic aims or a similar social status.

Race, for Du Bois, had its own claim to attention, although it was typically discounted in Marxist discussions of social change. By bringing race into the socialist realist novel, Du Bois foregrounded that issue and attempted to make it a communist concern.

The Black Flame, written in the United States of America by a man of African descent, is hardly typical of socialist realism. Neither does it sit easily as a work in the American tradition, especially as canonized. Arnold Rampersad claims that the novels display "the ideological rigidities, the wild accusations, the limitations of technique . . . [of] an unfulfilled work of art."[68] However, I would argue that the novels' difficulties reveal not a flawed creative vision, but rather the points of tension between Du Bois and the ideology he was trying to communicate. Reading these texts through the lens of socialist realism allows *The Black Flame* to be much more insightfully analyzed. The trilogy can thus be read as an effort to balance Du Bois's investment in communism with his knowledge of the persistence of "the color line." We can also understand why he undertook this monumental task at such a late age and how he used these novels to clarify for himself his position as a communist writer. Finally, we can appreciate the labor of construction and understand the trilogy's structure as a socialist realist work, rather than dismissing it as rigid and "unfulfilled."

If Du Bois did undertake the writing of these novels as a socialist realist project, he did so in a very different environment than that of the typical Soviet author, who had an institutional impetus that Du Bois lacked. However, such a lack of bureaucratic support for his work was nothing new for Du Bois; from the time he left Atlanta University in 1910 to edit *Crisis* he had been an independent scholar. Du Bois had long been suspicious of institutional authority, which was another reason for his reluctance to join the Communist Party officially. The fact that this choice was then completely free, or at least mandated by his conscience rather than by his government, makes it interesting. We might expect to find a predisposition to the theory behind socialist realism in Du Bois's work, and, in fact,

the genre and its philosophical underpinnings corresponded to many of his own formulations. The progressive idea of history, for example, had been evident in his work since his early theory of a "Talented Tenth" that would lead African Americans to a new cultural plateau.[69] Nor did the diverse levels of time and reality, and the consequent slippage between fact and fiction, constitute a radical departure from Du Bois's earlier practices. In its engagement with these ideas, the trilogy was in effect a crystallization of Du Bois's thought, although many Du Bois scholars see *The Black Flame* as a radical departure. Examining the novels as socialist realist works makes this dynamic more visible.

There is another way to interpret the fact that the trilogy can be read as a socialist realist work. One question that I have raised here is whether the common problematic these novels share with socialist realism demonstrates a direct link or a parallel context: Was Du Bois influenced by Soviet writers or did he share their concerns? Deciding that it was a matter of influence would in a sense be easier to justify since it would not undermine an oppositional distinction between East and West. Seeing Du Bois's criticism of American culture as due to an enemy's influence would also render any recognition of internal problems within the United States unnecessary. On the other hand, reading the similarities between Du Bois's fiction and socialist realist writing as a product of parallel concerns or contexts could be more subversive because it would then logically follow that the Soviet novelist and the black American one were driven by similar ideological forces, including coercion, oppression, and a recognition of the need for radical solutions. In that case, Du Bois's linking of capitalism and race was not just strategic, but profoundly radical—equating the system that led to the Russian Revolution with the system of racial oppression that threatened to provoke violence in the United States and elsewhere, implying that racial oppression was worldwide and could not be countered by reasonable means, but only by revolution. In this reading, we can see the seeds of the black militarist and nationalist agendas which arose in the 1960s and claimed Du Bois as an influence. Although the direct influence of socialist realism would thus be denied, this reading would paradoxically enable these issues to surface.

If socialist realism has only lately become unreadable "at home," American audiences have always ignored it. Among those U.S. readers who have been exposed to socialist realist fiction, its blurring of the distinction between fact and fiction, its overt ideological message, and its rigid plot

structure have typically been interpreted as a lack of creativity and spirit. In addition, when socialist realism is set against modernism, which has been very influential in American letters, socialist realist aesthetics seem utterly "impossible." Yet it was within this form that Du Bois creatively managed to address the concerns of his audience, negotiate the conflicting demands made upon him as an American communist, and irrefutably establish race as an issue in Marxist discourse. The unwillingness of scholars to deal with these novels cannot be put down to their lack of value, since they provide an invaluable picture of the effect of Cold War cultural politics on the African American community, as well as instantiating Du Bois's views on the relationship between race and labor and the constitutive role of African Americans in U.S. culture. Apparently, the taint of communism continues to hover over these works and, in conjunction with their different aesthetic basis, has led scholars to overlook them. This is unfortunate because these novels are part of a tradition of American leftist literature which deserves and repays study. Rather than being alien to American culture, this literature embodies the quintessential American desire to question authority and puncture complacency. Whether we understand a commitment to communism as a tragic mistake or an unrewarded idealism, its function and presence in American literature is undeniable and should be studied. Denying this aspect of American letters only impoverishes our understanding of the greater cultural tradition.

Notes

I would like to thank Robert Phillips, Thomas Lahusen, Nahum Chandler, Teresa Chung, Xudong Zhang, and Eleanor Kaufman for their critical comments and support.

1 W. E. B. Du Bois, *The Ordeal of Mansart* (New York, 1957); *Mansart Builds a School* (New York, 1959); and *Worlds of Color* (New York, 1961).

2 W. E. B. Du Bois, *The Autobiography of W. E. B. Du Bois: A Soliloquy of Viewing My Life from the Last Decade of Its First Century* (New York, 1968).

3 Katerina Clark notes that the socialist realist novel is fundamentally a "ritual act of affirmation of loyalty to the state"; see *The Soviet Novel: History as Ritual* (Chicago, 1981), 13.

4 See, especially, W. E. B. Du Bois, *Color and Democracy* (New York, 1945), 114–22.

5 See the contributions by Antoine Baudin and Thomas Lahusen to this volume of *SAQ*.

6 Stephen J. Whitfield, *The Culture of the Cold War* (Baltimore, 1991), 205.

7 See William E. Cain, "From Liberalism to Communism: The Political Thought of W. E. B. Du Bois," in *Cultures of United States Imperialism,* ed. Amy Kaplan and Donald Pease (Durham, 1993), 456–73.

8 Deming Brown, *Soviet Attitudes Toward American Writing* (Princeton, 1962), 124–25.

9 See, for example, G. B. Starushenko, L. O. Goldin, and M. I. Kotov, *William Du Bois, Scholar, Humanitarian, Freedom Fighter* (Moscow, 1971), 51.

10 See Gerald Horne, *Black and Red: W. E. B. Du Bois and the Afro-American Response to the Cold War, 1944–63* (Albany, 1986), 75–80, 278. This is one of the few studies which examines Du Bois's late work; among others, see Willie Avon Drake's *From Reform to Communism: The Intellectual Development of W. E. B. Du Bois* (Ann Arbor, 1985); and Cain, "From Liberalism to Communism." These recent interventions see Du Bois's late writings as a natural progression of his thought rather than as an aberration. My own study of Du Bois's novels here can be seen as an extension of those projects.

11 See Whitfield, *Culture of the Cold War,* 16.

12 Ibid., 8–9.

13 Du Bois, *Autobiography,* 57.

14 Du Bois contributed to the following journals, among others: *The American Socialist, The Daily Worker, March of Labor, Red Funnel, The Socialist Call, Soviet Russia Today* (later retitled *The New World Review*), and *World's Work.* For a complete list, see Herbert Aptheker, *Annotated Bibliography of the Published Writings of W. E. B. Du Bois* (Millwood, NY, 1973). On Du Bois's Communist Party membership, see Herbert Aptheker, *The Correspondence of W. E. B. Du Bois* (Amherst, 1973), 3: 438.

15 Howard Fast, *The Naked God: The Writer and the Communist Party* (New York, 1957), III.

16 Wanda Wasilewska, "The Contributions of Writers and Artists to the Cause of Peace," *Soviet Literature* II (1953): 151.

17 W. E. B. Du Bois, "Russia, An Interpretation," *Soviet Russia Today* 17 (November 1949): 32; "The Most Hopeful State in the World Today," *Soviet Russia Today* 16 (November 1947): 24.

18 Horne, *Black and Red,* 270.

19 Brown, *Soviet Attitudes,* 176–77.

20 *The Ordeal of Mansart* was published as *Ispytaniia Mansarta,* trans. V. Kuznetsov (Moscow, 1960); *Mansart Builds a School* as *Mansart stroit shkolu,* trans. V. Kuznetsov and I. Tikhomirova (Moscow, 1963); and *Worlds of Color* as *Tsvetnye miry,* trans. N. Vasil'eva and I. Tikhomirova (Moscow, 1964). See Paul G. Partington, *W. E. B. Du Bois: A Bibliography of His Published Writings* (Whittier, CA, 1977), 168; and V. A. Liberman, *Amerikanskaia literatura v russkikh perevodakh i kritike: Bibliografiia 1776–1975* (American Literature in Russian Translations and Criticism: A Bibliography 1776–1975) (Moscow, 1977), 118–19.

21 According to Horne, *Black and Red,* "Du Bois wrote to Leo Huberman that the *Ordeal of Mansart* 'has sold poorly, perhaps 1,500 copies, and has not been reviewed by any respectable publication' " (271).

22 *The Black Flame* translations appeared contemporaneously with Russian translations of *John Brown* and the *Autobiography.* My sources for this publishing information on Du Bois are Partington, *W. E. B. Du Bois: A Bibliography,* and various Soviet encyclopedias.

23 Brown, *Soviet Attitudes,* 7.

24 Herman Ermolaev, *Soviet Literary Theories 1917–1934: The Genesis of Socialist Realism* (Berkeley, 1963); Evgeny Dobrenko, "The Literature of the Zhdanov Era: Mentality, Mythology, Lexicon," *SAQ* 90 (1991): 323–55; Georg Lukács, "Realism in the Balance," trans. Rodney Livingstone, in *Aesthetics and Politics: Ernst Bloch, Georg Lukács, Bertolt Brecht, Walter Benjamin, Theodor Adorno,* ed. Ronald Taylor (New York, 1980); D. Markov, *Socialist Literatures: Problems of Development* (Moscow, 1984); and A. Ovcharenko, *Soviet Realism and the Modern Literary Process* (Moscow, 1978).

25 See Clark, *Soviet Novel,* 65.

26 See Dobrenko, "Literature of the Zhdanov Era," 342.

27 See Clark, *Soviet Novel,* 15–16.

28 Ibid., 44.

29 Ibid., 49.

30 Ibid., 124, 102.

31 See Dobrenko, "Literature of the Zhdanov Era," 349.

32 See Clark, *Soviet Novel,* 188.

33 Feodor Gladkov, *Tsement* (Moscow, 1925).

34 See Clark, *Soviet Novel,* 188, 203.

35 Ibid., 222–23.

36 See Horne, *Black and Red,* 316.

37 See Du Bois, *Ordeal of Mansart,* 176, 223, 272.

38 See Clark, *Soviet Novel,* 183.

39 Du Bois, *Worlds of Color,* 348.

40 See Clark, *Soviet Novel,* 123.

41 Lukács, "Realism in the Balance," 33, 36.

42 See Clark, *Soviet Novel,* 142, 145–46.

43 Dobrenko, "Literature of the Zhdanov Era," 325.

44 See Clark, *Soviet Novel,* 39–41.

45 See Robert B. Stepto, "The Quest of the Weary Traveler: W. E. B. Du Bois's *The Souls of Black Folk,*" in *From Behind the Veil: A Study of Afro-American Narrative* (Urbana, IL, 1979), 62.

46 Du Bois, *Ordeal of Mansart,* 316.

47 See Arnold Rampersad, *The Art and Imagination of W. E. B. Du Bois* (Cambridge, MA, 1976), 281.

48 Du Bois, *Ordeal of Mansart,* 316.

49 About a riot in Atlanta, one of the characters says, "I know now that the riot caused the earthquake [in San Francisco five months previously]. . . . That murder and flame came from the hate and horror of Atlanta" (ibid., 250).

50 Ibid., 315.

51 Ibid., 244.

52 Ibid., 250.

53 Du Bois, *Mansart Builds a School,* 34.

54 Du Bois, *Worlds of Color,* 225.

55 Ibid., 263. See also W. E. B. Du Bois, *In Battle for Peace: The Story of My 83rd Birthday* (New York, 1952), 124.

56 Du Bois, *Worlds of Color,* 170.

57 See Du Bois, *Color and Democracy,* 100–113.

58 See David R. Roediger, *The Wages of Whiteness: Race and the Making of the American Working Class* (New York, 1991), 9.

59 Du Bois, *Ordeal of Mansart,* 236.

60 Drake, *From Reform to Communism,* 172. See also Du Bois's "Postscript," in "The Negro and Communism," *Crisis* 38 (1931): 313–15, 318–20.

61 See Du Bois, *Worlds of Color,* 311–12.

62 See Roediger, *The Wages of Whiteness,* 9.

63 Clark, *Soviet Novel,* 204.

64 This idea appears throughout Du Bois's oeuvre, but especially in *The Souls of Black Folk;* in *Writings,* ed. Nathan Huggins (New York, 1986); and in *The Gift of Black Folk* (New York, 1975 [1924]).

65 Du Bois, *Worlds of Color,* 68.

66 Ibid., 180.

67 See Du Bois, *Mansart Builds a School,* 116, 171–73.

68 Rampersad, *Art and Imagination of W. E. B. Du Bois,* 287.

69 W. E. B. Du Bois, "The Talented Tenth," in Huggins, ed., *Writings,* 842–61.

<center>*Xudong Zhang*</center>

THE POWER OF REWRITING

Postrevolutionary Discourse on Chinese Socialist Realism

This essay is a criticism of criticism. It is therefore not a report on the history of Chinese socialist realism or a close reading of one or more texts to elucidate the concept, nor is it yet another repudiation of the genre in the face of a Party state at low tide, with its discursive domination ebbing. Here socialist realism becomes a signifier of a faded "authenticity," historical and textual, rendered palpable precisely in the dissolution of its discursive totality into the fragments which, under different social and cultural conditions, had first prefigured, then configured that totality. In other words, it becomes a cultural as well as a political problematic precisely as it disappears into history.

Chinese socialist realism comprises a number of related, even loosely interchangeable, labels or categories (e.g., "proletarian mass culture," "Yan'an literature and art," the so-called Maoist genre or *Mao wenti,* and the "political mode of writing," including the all-purpose classification of "official discourse"), and the problematic of socialist realism is simultaneously deconstructed and reactivated in the ongoing effort to "rewrite literary history," a literary-critical and intellectual current bent on challenging the oppressive uniformity of official discourse on modern Chinese literature. This new discourse has emerged in response to postrevolutionary circumstances that promise to put the literary culmination of the Cultural Revolution and Chinese socialism in a new perspective. Different voices, positions, and tendencies have evolved from this intervention, where an envisioned reencounter with the past not only prefigures the future—the perspective from which the past must be "rewritten"—but also reconfigures the past as an integral part of the present, and vice versa. To this extent, socialist realism has become an unrecognized part of everyday, postrevolutionary intellectual life, part of the very space or conditions of possibility in which "alternatives" take shape. This configuration raises questions concerning the complexity of the historical experience of Chinese modernity and Chinese socialism, the complexity of the forces that give rise to a historical style. The resolubility of these questions is deeply embedded in the utopia and ideology of the collective effort to create not only history, but also its narration, its narrativity, its culture.

The meaning or historicity of Chinese socialist realism lies not so much in its capacity to forge homogeneous, subjective, and teleological modes of representation as in its origins. Like any other literary genre, it has become a symbolic and ideological frame for the social, political, cultural, and intellectual possibilities and crises that have historically defined its situation. Any impulse to separate this particular genre from the totality of social and literary history, to set it apart from the ranks of romanticism, realism, and modernism, is itself an ideological position that harbors a political agenda. Situated in a disoriented society, Chinese postrevolutionary discourse on socialist realism, precisely because of its radical, explicit, and often antagonistic politics, renders the rhetoric of ideological neutrality (which is always unambiguously associated with the liberal assumptions of the cosmopolitan West) self-defeating. In order to appeal to different sociohistorical forces and interests, and in hopes of gaining the upper hand in a relentlessly "theoretical" debate—as the whole revisionist project has based itself upon technological or "methodological" loans from contemporary Western theoretical discourses—even the most ahistorical dismissals of socialist realism have had to deal with the genre more or less historically and to blur linear rationality in order to reshape it as a contested field of modern Chinese history. Thus these discussions have objectively, if often negatively, laid the ground for a historical, critical investigation of socialist realism in the broad context of Chinese modernity.

Associated with the revolutionary ideology of Chinese communism, and culminating in the state discourse of the PRC, the genre of socialist realism has certainly tended to bestow an epistemological and teleological uniformity and hierarchy on a diverse reality. It has thus had an oppressive effect on the heterogeneous space from which it arose in the first place. If we can see socialism as a historically "rational" project of modernity in certain circumstances (no matter how "irrational" and maddening the circumstances of this rationality were or always have been), we may be ready to acknowledge the fact that socialist realism is, after all, a radical form of modernism and a radical formulation of the mainstream Enlightenment idea of modernity. The central characteristic of Chinese socialist realism, then, lies both in its radicalism, reinforced by a "catching-up" model of modernization and modernity, and in the internal heterogeneity, resistance, and supplementation provided by the peculiar course of the Communist revolution (as a peasant-intellectual revolution) and by the persistence of a native, traditional cultural and ethical structure.

Just as socialism has brought about a temporary shelter, a massive

transformation, and an often grotesque compression of a host of historical factors, socialist realism, too, has provided, within its notorious formulaic rigidity, an allegory or parody of a history of genres ranging from classic epic and tragedy, Scholastic philosophy via Enlightenment pedagogy, romanticist lyric and realist novel, all the way to the aesthetic cosmology of modernism. It is of cultural as well as political relevance to examine the way in which this enormous architecture has been built, vis-à-vis the Being that surrounds it, and to make sense of its construction in response to the minute social dynamism that often draws on fragmentary sources beyond the monuments of bourgeois culture. We confront this architecture only as ruins of history, to be sure. But the fact that it has crumbled does not mean that the collective and individual efforts to create an alternative culture amidst the historical failure of both the gentry-literati tradition and the Chinese bourgeoisie are deprived of all historical meaning and political relevance.

Obviously, Chinese socialist realism has never fully or intimately confronted the bourgeois century and its cultural heritage as its Soviet model did—a model which, for its Chinese pupils, has been as much "proletarian" as sufficiently "European." The different social and cultural environment to which Chinese socialist realist literature has been exposed, however, opens up a new front for socialist realism and to some extent contributes to its basic problematic. This new front for a theoretically international and proletarian genre is the indigenous cultural, aesthetic, and ethical tradition of the Chinese masses, especially the Chinese peasantry, a tradition besieged both by the menace of imperialist/colonialist power and by its internal pressure to change. The historical situation that gave rise to the Communist revolution and enabled its perseverance is also the situation that endowed Chinese socialist realism with its unique dialectic of heterogeneity and homogeneity, with a cultural and historical complexity that cannot be talked away by denunciations of the state violence done to literature as a form of art. Similarly, what has been resistant to a subjectivist and explicitly teleological understanding of modernity in this literature also points to something both persistent and vulnerable, something that today is at work in complicating the situation and rendering it more dialectical as China's intensified penetration by global capitalism becomes evident.

The recognition of this "content" may lead to different approaches to the "form" of this literature, for the discursive and ideological structure of socialism is historically formed and should be viewed, accordingly, as

a narrative device, a frame, a register of events and ideas for the temporal space that called it into service in the first place. As a literary genre, socialist realism is entangled with the diverse and conflicting domain of a social reality, with its utopian impulses and ideological reifications. Chinese socialist realism, in imposing its form upon the entirety of the social experience, has also absorbed a whole range of social and cultural forces and traditions, producing a new crystallization of them. The analysis of this discourse, the critical thawing of this crystallization, is not in pursuit of the ideological pleasure of deconstruction, but rather in a painstaking reconstruction of a situation — a space of various forces and positions, a field of tension, conflict, antagonism — which comprises and creates the subjects and categories of history and its representation.

As defined by the "official" literary critics and historians, socialist realism is an artistic and literary-theoretical intervention consisting of a specific cluster of works of literature, film, and art that appeared in the late 1950s and early 1960s, such as Yang Mo's *Qingchun zhi ge* (The Song of Youth [1958]), Du Pengcheng's *Zai heping de rizili* (In the Days of Peace [1958]), Li Zhun's *Li Shuangshuang xiao zhuan* (The Story of Li Shuangshuang [1960]), and Wang Wenshi's short stories of that period. The impressive productions of such filmmakers as Cui Wei (e.g., *Qingchun zhi ge, Xiaobing zhangga* [Little Soldier Zhang Ga], *Laobing xin zhuan* [The New Story of an Old Soldier]), and Xie Jin (*Hongse niangzijun* [The Red Women's Brigade]) are considered model cinematic versions of the genre. With the single exception of Xie Jin, none of these auteurs is particularly famous, if known at all, outside China or even beyond that particular moment in the history of the People's Republic.

After 1949, although the new regime anxiously sought to cut its ties with its prehistory in order to maintain the total illusion/representation of a certain timelessness of social experience, its social, ideological, literary, and theoretical links to the entire history of modern Chinese literature were not only preserved, but actually invoked to make such a totality discursively and formally possible. If the discursive space of Chinese socialist realism always remains radically heterogeneous, then its official "theoretical" formulations tend to be produced by a bureaucratic abstraction that regards "reality" in terms of philosophical principles. The Soviet definition of socialist realism (which was formulated by Stalin himself), although downplayed to give prominence to Mao's theory of "literature for workers,

peasants, and soldiers," is still the heart of the Chinese state discourse of socialist culture:

Socialist realism, as a basic methodology of Soviet literature and Soviet criticism, requires the artist to describe reality realistically, historically, and concretely within the revolutionary development of reality. Simultaneously, the realism and concreteness of the artistic description must be combined with the task of transforming and educating the working people in terms of socialist spirit.[1]

Like its Soviet model, the Chinese notion of socialist realism emphasizes the socialist ground of the realist style. Since this ground, as an actualized social existence, was the USSR itself, the Soviet notion of socialist realism became a theoretical orthodoxy in the Chinese search for a socialist mode of representation. Feng Xuefeng's writings make it clear that the intense process of constructing a socialist cultural sphere in the first decade of the PRC was focused on implementing and breeding a communist worldview, one that was based on dialectical materialism and historical materialism, both of which mandate the writer's grasping the law of the development of modes of production. The bureaucratic institutionalization and socioeconomic reconstruction were reciprocally reinforcing in this period, and both succeeded with massive Soviet aid and influence. Maoism, at its peak of political accomplishment, was somehow absorbed into everyday life and moral consciousness. The early socialist realist experiments during and after the Yan'an period (1937–48), such as the folklore movement and the rural-based literary production of Zhao Shuli, among others, were marginalized and displaced by more "intellectual" and "theoretically informed" literary works focusing on urban and industrial themes. It is therefore a bit ironic that the warmly remembered "golden age" of Chinese socialism was actually a moment of creative submission to an established pattern or scheme of progress, a moment of "self-forgetting" labor, a moment of utopian alienation. "Socialist realist literature serves the cause of socialism," continues Feng's definition. "It must play an active role in educating the people and creating a new life. It is absolutely necessary for it to represent the Party's spirit; its production must strongly implement socialist thought."[2]

By licensing the authenticity of socialist realism, the state bureaucracy also defined the official reality to be represented, the Party line which exclusively embodied the truthful unfolding of history and development of man. In so doing, the state excluded a whole range of writers and works

from the domain of socialist realism, rendering them mere blips on the evolutionary course of the genre that could alone capture the truth of history. As a result, the works of Ding Ling were to be excluded from this category, for her long writing career marked the transformation necessary to the genre's historical coming into being rather than socialist realism per se, even though her 1948 novel, *Taiyang zhaozai sanggan heshang* (The Sun Shines over the Sanggan River), was widely celebrated as opening up new prospects for Chinese writers. As the second-place winner of the 1951 Stalin Literature Award (the Nobel Prize in Literature of the Socialist bloc), it is probably among the better-known works of contemporary Chinese literature. Both its "method of production" and its subject matter (namely, the radical rural land reforms carried out by the CCP in the Sanggan River region from 1946 to 1947) seem to accord perfectly with the general requirements of socialist realism, yet the novel was nevertheless classified as (merely) an "artistic reflection" of the "new democratic moment of the Chinese revolution." In other words, the work could not be considered a socialist realist one, for the important historical frame of reference, namely, Chinese socialism, was missing. This "transitional effort striving for socialist realism" not only indicates the workings of a macroeconomy of social evolution from the "bourgeois revolution led by the proletariat" to the socialist revolution under the state power of the People's Republic, but also suggests those of a microeconomy of personal-intellectual change: the transition from "petit bourgeois" ideology to "communist worldview," of which Ding Ling's complicated writing career seems to provide a textbook example.[3]

The first decade of the People's Republic saw a massive social and cultural reorientation in which the Soviet Union became the grand model for China, a future world realized in the present. To that extent, the futurologist craze for Western technology and social management in post-Mao China found its archetype in the national project of imitating the USSR throughout the 1950s.[4] For the Chinese Communist Party as well as for the ordinary citizen of the People's Republic, Soviet industrialization and social engineering represented the epitome of modernity. Soviet values and aesthetics, in turn, provided the ideologic legitimacy for undertaking massive industrialization/modernization and thus making manifest the evolution of world progress. This picture was exactly what the newly established state and its newly emerging public needed; both could see their future reflected in the Soviet culture of that period.

Soviet literature therefore served as both a theoretical doctrine and a symbolic space. In his memoir, "Xuexi suliao wenxue huiyi diandi" (Drops of Recollection Regarding Learning from Soviet Literature), Du Peng-cheng, whose 1958 novel *Zai heping de rizili* was considered one of the exemplary texts of Chinese socialist realism, describes the way in which Soviet literature had by then become literally part of everyday life in socialist China. According to him, such novels as *The Iron Flood, The Rout, How the Steel Was Tempered, A Story about a Real Man, Virgin Soil Upturned, Days of Our Life, Far from Moscow, Cement,* and *Steel and Slag* to a great extent shaped the cultural landscape of the first decade of the People's Republic; the heroes and heroines of these works became the living and breathing companions of the new generation.

As euphoria prevailed within the Chinese Communist Party, the Maoist passion for reaching out to the people and declaring their renewed life to be magnificent poetry that had gone unheard in the class society of the past was subtly appropriated by the political impulse for radical rationalization and a systematic cultivation of the new social order. At this point, the historical, if not ontological, value of socialist realism appears to have been fully addressed by the here-and-now construction of the "reality" that this mode was supposed to "represent." After the social and political mobilization that occurred during the Korean War (1950–1953), after the "intellectual reformation campaign" of the early years of "New China," after the persecution of the so-called Hu Feng Counterrevolutionary Group in 1955, and especially after the "antibourgeois rightists campaign" (*fanyou yundong*) that swept the whole country in 1957, the intellectual influence of the "new democratic" intelligentsia (a residue of the national united front policy) was virtually wiped out. The success of the First Five-Year Plan (1953–57) laid the ground for a quasi-modern industrial and state infrastructure, which required a more articulate voice to produce a social ideology compatible with it. The beckoning of a "great reality" reached its high point when Mao launched his "Great Leap Forward" (*Da yuejin*), a mass movement or "people's war" of economic growth that was supposed to place China ahead of the old imperialist powers. This was also the moment when socialist realism found its designated bedfellow, "revolutionary romanticism." Borrowed from Soviet writers and critics (e.g., the work of Gorky), "revolutionary romanticism" was not merely a supplement to "revolutionary realism." Rather, it was intended both to register an escalating revolutionary fervor and to include the massive social, cultural, and symbolic

resources that had somehow been left out of the potentially bureaucratic, technocratic notion of socialist realism. At the 1958 Chengdu meeting, Mao suggested that the "form" of the new poetry be that of folklore, with its "content" the "contradictory unity" of realism and romanticism. Under the rubric of "revolutionary romanticism," Mao and his followers tried to challenge a nascent yet already formidable bureaucratic establishment by evoking social and cultural images that were as "pre-socialist" (or "pre-state") as they were "revolutionary." It thus indicated a subtle attempt to break free from the social and cultural institution of the new state (founded by Mao himself) and go back to the countryside, to the people, in order to displace the petit-bourgeois intellectuals who had been at the forefront of creating a "New Culture" since the 1919 Chinese "Enlightenment." This subaltern and resistant current remains an integral part of the notion of Chinese socialist realism, broadly defined (as in this article), although it is perceived as symptomatic of a lack of historical and symbolic resources rather than of their manifestation in literature and art.

Whereas Mao consistently emphasized the need for literature and art to "serve the workers, peasants, and soldiers" and the need for "literary and art workers" to reform their "worldview"—the basic arguments of his "Talks at the Yan'an Forum of Literature and Art"—the socialist realist project implicitly entailed overcoming an antecedent epistemological and representational hierarchy in pursuit of a higher order of sociohistorical truth and artistic persuasiveness. Here the grassroots spontaneity and originality that Mao stressed were to be replaced by the more rigid intellectual and artistic training needed for a planned encounter with the truth claims of literature and art. While the Maoist idea of the "literary and art worker" might be embodied by a folklore collector who was to realize him/herself as both teacher and student in the larger world of the people, the image of a socialist realist writer was more often than not that of an educator whose development was informed by a transcendental point of view, a spokesperson of history who was accountable to a higher order and a deeper truth—be it the historical telos immanent in the immediate future or the social conflict that underlay the revolutionary situation—and to that truth alone. This difference manifested itself as a temporal distinction between the Maoist idea of revolutionary mass culture and the later phenomenon of socialist realism. Mao saw revolution as permanent; for him, time was a Heraclitean flow, and history always in the making. Socialist realism, on the contrary, stressed the representation or revision of reality as

a timeless spatialization. This utopian space was where the historical telos would manifest the projected completion of an ongoing socioeconomic and ideological construction. It is noteworthy, however, that unlike its Soviet model, the official theory of Chinese socialist realism has always been combined with "revolutionary romanticism." Although this term was employed by some Soviet literary theorists of the 1930s, its function in Maoist theory was clearly to signify a residue or surplus of the Chinese revolution, if not indeed the internal diversity and richness of this revolution's historical quality. The supplementary notion of revolutionary romanticism was not only intended to leave elbowroom for spontaneous popular cultural production, which was essential for Mao as a populist, but also to serve as a pre-text for the Chinese revolutionary literary discourse that evolved from a complex social, cultural, political, and intellectual environment.[5]

The admitted disaster of the Great Leap Forward campaign led to Mao's self-criticism and his consequent retreat from day-to-day policy making. A more "rational," pro-Soviet bureaucracy was instituted (even though the decisive split between the two parties was already imminent) to get the economy back on track, a brief upsurge of the narrowly defined Chinese socialist realist production in literature, theater, and film followed. This discrepancy between socialist realism and the Maoist ideal of revolutionary mass culture notwithstanding, they both, amidst a swift, often dazzling process of social change, constituted the "official" means for capturing the "truth" and "dynamism" of an "epic" by interweaving an ideology and a set of writing procedures into the emergent everyday sphere.

The major theoreticians of Chinese socialist realism, such as Zhou Yang and Feng Xuefeng, made a great effort to integrate the Maoist idea of revolutionary literature with the institutionalized mode of socialist realism.[6] One strategy for achieving this integration was to emphasize the organic link between Chinese socialist realism and the modern Chinese literature of the preceding decades, a literature whose relationship to the experience of the Communist revolution had already been safely established.[7] Yet even for the participants in that historical process, a dogmatic line had to be drawn between the period of "new democratic revolution" and the "socialist revolution," as well as between revolutionary mass culture and the received style of Soviet socialist realism. These periodizations and labels are not merely conceptual, but refer to different topologies of social experience, different symbolic systems, and different intellectual problematics. For instance, whereas Mao Dun's work provided a social allegory of

a semi-bourgeois China in the Yangtze Delta region, Zhao Shuli's writings addressed the social revolution in northern China through the folklore and other vernacular literary traditions of the peasantry. While Ding Ling engaged socialist realism with the literary sensibility of the 1930s and a political awareness of the period of land reform, for such writers as Du Pengcheng, Zhou Erfu, Yao Xueyin, and Yang Mo, both the social landscape and the literary horizon were shaped by the dawning of "New China" and its state literature.

During its heyday in the late 1950s and early 1960s, socialist realism was not just expected to deliver the political program of a social transformation "poetically," but also to provide the aesthetic concreteness and palpability — through its artistic focus on "details" and "typical figures" in "typical environments" — which were otherwise tantalizingly scarce in a life-world being built from scratch. Both "Chinese" and "socialist" in the national fantasy, this "imagined community" (in Benedict Anderson's term) impatiently sought for a new form of cultural production that would be popular as well as intellectual-discursive. A socialist new culture was called for, to serve both as a dream factory producing "spiritual food" to be distributed among its citizens and as an artistic and theoretical engagement with the most "truthful" picture of human history. Just as the everyday sphere was politically a product of the state, the popular dimension of socialist culture seems to have been nothing more than a theoretical effect of the intellectual-educational project which was integral to the collective effort to create a new society.

While Mao's Cultural Revolution was intended to dissolve the state bureaucracy and open the way to a "permanent revolution," the 1966–76 decade saw the evolution of ideas and methodologies for turning literature into an illustration of political correctness and an instrument of fractional struggles. Realism vanished from the picture, replaced by an idiosyncratic mixture of revolutionary fanaticism and dogmatism, on the one hand, and a pragmatic experimentalism, on the other. It might well be argued, as Xia Zhongyi did in a 1989 article, that it was the extremist logic and rigid procedures of cultural production demonstrated by the "model drama" that finally brought down the seemingly impervious construction founded on socialist realism and Mao's theory of literature and art.[8] Moreover, Xia and other likeminded critics have traced this self-destructive escalation back to its source, arguing that it could not have been otherwise, since the notion of literary production made explicit by the model drama was simply im-

plied in Mao's own efforts to construct the discursive institution of a socialist cultural sphere. Xia and the "Rewriting Literary History" group seem to share the assumption that the problem actually lies in the whole discourse of Chinese socialism as a discourse of modernity. Consequently, a meaningful and honest understanding of history has to start with a systematic critique and total deconstruction of what Li Tuo has called the "Mao genre," or the Mao discourse (*Mao wenti*).

It is important to note that the critical heresy expressed by Xia and Li arose in conjunction with Deng's Reform Decade and was an implicit constituent of the mainstream intelligentsia of the New Era (1979–89). While the 1980s have been described by the official media as a decade of emancipation, it is unlikely that those who experienced the critical interrogation of the history of revolutionary literature (and literary historiography) see it as anything other than an integral part of a general discursive liberation. When the post-socialist experience of the Chinese reforms became an object of interrogation in the context of the post-Tiananmen development of commodification and globalization, however, revolutionary China and its literary mode of production reemerged as a new historical problematic. The ideological, aesthetic infrastructure of the state discourse, once it was no longer official, could adapt to two institutions.

On the one hand, socialist realism as a collective folklore has, in its fragmentary form, merged with an emergent mass culture, a merger that has spawned an avalanche of melodramatic miniatures not only of the good old days, but also of a contemporary life-world in search of its social and ideological identity. From soap operas aired on national TV to local tabloids chronicling the daily adventures of the postrevolutionary masses, one sees the commercial bottling of the "state discourse" as nostalgia and legend, packaged in a gothic style as distinct as the American Jazz Age style of the 1920s. Following a period of disgrace, the revolutionary model drama is once again becoming a national hit, this time probably through the channels of compact discs and karaoke bars. After being abandoned by the masses, the old revolutionary narratives, with their neatly tailored episodes, are sneaking back into print and onto the screen as the "national treasure" of a new entertainment industry. Socialist realism, just like the Soviet-built residential districts, Lei Feng (the Maoist model soldier), and the image of Mao himself, has become an emblem of a remote age, or rather a medium that rendered both that age and its community "real" and

memorable. The characters and locales of socialist realist works are being exploited by a successful advertising campaign that relies largely on tracing the sensitive links of an increasingly uniform collective unconscious in an increasingly diverse and pluralistic world.

On the other hand, socialist realism also seems to be making a comeback in cultural criticism as a particular episode in the experience of Chinese modernity, although the political and theoretical interests of these critics vary and even contradict one another. As many have argued, socialist realism, broadly defined, can be viewed as a test case for the cultural (in)feasibility of a social experiment, as well as for the social (in)feasibility of a cultural experiment; in this regard, the method encompasses both the historical documentation of a consciously molded everyday world and the "formal" mode that made this documentation possible. In both its intended reality in the making and its epistemological and narrative effort to recodify a discrete world, socialist realism entailed the utmost ambition and the most extreme fantasy of modernity, in its ordinary sense. To be revolutionary (or socialist), at least in theory, however, meant that this modernity was to be fought for all the more radically in the name of a deprived and oppressed majority. Thus a socialist mode of cultural production and a socialist aesthetic epistemology were by definition a form-giving intervention, a discursive utopia that sought to bridge the gap between idea and existence. Here, a family resemblance can be established between socialist realism and high modernism: both would have superimposed in the most invisible (that is, ideological) terms—either by the myth of style or by the myth of historical truth—a utopian pattern on the chaos of being, endowing static space with temporality or, at times, spatially framing an otherwise incomprehensible temporal flow. Both appealed to a higher reality, the purview of either a modernist inwardness or a revolutionary vantage point yielded by historical movement. Soviet socialist realism was a social-cultural product of the Stalin era at its peak. Just as Stalin himself was arguably the greatest modernist (as has been suggested in a certain context), the impact of Soviet socialist realism may be viewed in the context of modernist culture as having been equivalent to the sweeping success (and the horrifying problems and hollowness) of Soviet industrialization.

The reassessment of Chinese socialist realism—despite the amorphous nature of the notion itself, historically as well as theoretically speaking—cannot be untangled from the ideological struggle to come to terms with

the historical experience of Chinese socialism. And Chinese critics must engage this struggle by recognizing two basic facts: One is that socialist realism is part of the problematic of Chinese modernity, which endows this literature with its historicity. The other is that this modernity and this historicity can no longer be separated from the global context, but rather must be understood and captured from within this context, which is now clearly defined by the intensified and expanded capitalist world market, coupled with the triumphant rhetoric of the end of socialism (or the end of History). Locally, any critical reevaluation of Chinese socialist realism must unfold against the grain of a prevalent revisionism and conformist universalism which sees the demise of socialism—or any other social and political alternative—as the necessary requirement for membership in the global market. This ideological tendency cuts across different disciplinary terrains, such as historiography, literary criticsm, political science, and economic theory, and is rooted in the dynamism of post-Mao China. It originated in the socioeconomic and political-ideological diversity of what has been problematically referred to as "Greater China"— meaning mainland, Taiwan, Hong Kong, and Singapore, plus the transnational Chinese business, technocratic, and intellectual communities (a considerable proportion of each of which is anchored in North America). This socio-empirical and ideological diversity has not only given rise to an inter-Chinese politics through which global contradictions articulate themselves, but has also formed an immediate power relationship through which the local history and the local experience (such as the particular historical moment of Chinese socialism) are integrated into a "world history."

My concern, then, is not with what the constructive implications of socialist realism may leave us, but rather with the deconstructive meaning it retains as the infrastructure of a state discourse that, in its very oppressive form, encompasses and conceals the seeds of an economic, social, and political alternative in both its prehistory and its post-history. Socialist realism, as utopia and reification in one, emerges as the discursive link between the two.

Throughout the "New Era," the need to disengage from socialist realism in the literary sphere was felt by both humanists and modernists, the two major intellectual-cultural forces in post-Maoist China. Although these two groups had different, sometimes clashing, social and political agendas throughout the 1980s, both strove to separate the New Era from its prehistory in order to attain a cultural-ideological semiautonomy in

anticipation of China's structural integration into the New World Order. Both were rendered sentimental, if not irrelevant, however, when the state itself took the lead in promoting market globalization in the early 1990s. Both groups were put on the defensive in the face of a mass culture characterized by an emergent consumerism. Ironically, only when both humanists and modernists were squeezed out of the feast of "modernization" did socialist realism become a historical problematic to be engaged in critical terms by these "alternative" positions; whereas for the surviving state, socialist realism had already become a matter of bad faith, as played out in state-sponsored TV melodramas preaching family values or national pride. In the face of rising consumerism, the social and political differences between the former humanists and modernists have been reduced to matters of mere taste. The void created by the "dominant mode" ironically reveals the moral as well as cultural vacuity of those "marginal" discourses.

Adapting themselves to the global discourse of laissez-faire liberalism (although some cultural differentiation may apply, "East Asian value" and "Confucian capitalism" being among the handier markers), both humanists and modernists are trying to stay afloat within the Chinese cultural sphere by cultivating an intellectual elitism funded with global symbolic capital. This elitism, which used to be dependent on the "enlightened" state or on the aesthetic institution of Western high modernism, now can rely only on the international market (e.g., international film festivals, or first world foundations).

The instrumental, methodological innovativeness and the ideological-discursive sophistication visible in recent discussions of Chinese socialist realism may be attributed to the internalization of its cultural and social situations by the pre-1989 Chinese cultural elite. Not only have many members of this group been exposed to first world academia, but the intensified communication necessitated by the interaction of local and global economies has rendered the national border less and less significant, thus exposing Chinese intellectuals at home to the influx of a global culture and ideology. Their enhanced methodologies also point to a changed cultural (and implicitly political) agenda for the rereading of Chinese socialist realism. This has mainly been due to the younger generation of scholars inside and outside mainland China, who are generally better trained in literary theory and who encounter the problematic of socialist realism not as an oppressive institution to be experienced in daily life (as was the case for older scholars and critics), but as a historical text to be reconstructed through

a reading experience. This is not to say, of course, that their ideological position is any less problematic, or their knowledge about the past more "objective." They are situated in the same social, ideological, and discursive environment as everyone else. The only difference (and one that may imply a new starting point) is that for them the past belongs to an autobiographical pre-world, to the realm of political forgetting. Dialectically, however, the reading of the *text* may become an exercise in historical self-understanding, a ritual capturing of a collective unconscious that has been repressed by the New Era (in which they spent their formative years). As products of Deng's China, characterized by social and ideological ambivalence and uncertainty, the new generation yearns for a social and cultural self-positioning, which it has been seeking amidst a truly global maelstrom of signs and images. Their encounters with the revolutionary past, with the cultural sphere generated by mass mobilization and the molding of a new everyday reality, then, give them not just the raw material for a textual analysis, but a new platform for the critique of ideology. Equally important is the utopian inspiration for the construction of a new culture and a new social subjectivity that they find in the revolutionary past. This is all the more obvious given their open detachment from, if not their hidden discontent with, the cultural-ideological tendency of the New Era, namely, the revamped humanism that has randomly alternated between advocating the "rationalization" of the political state and calling for its dismantling in the name of "universal value."

Liu Zaifu, former director of the Institute of Literature at the Chinese Academy of Social Sciences (CASS) and one of the leading figures among Chinese intellectuals in exile, has tried to incorporate this new-generation scholarship into the framework of "rewriting literary history." In his foreword to a selection of critical essays by younger scholars, he redefines the project of rewriting literary history as "literary and aesthetic criticism of the literary phenomena of the twentieth century, which are characterized by a universal failure." This universal failure applies as much to the left-wing writers of the 1930s as it does to the "eight exemplary plays" of the Cultural Revolution. From this perspective, Liu praises the authors included in this volume for "taking advantage of the freedom in the new cultural environment, breaking new ground, and joining the experiment of 'rewriting' "; for him, this is a "challenge to vulgar critical perspective and vulgar critical language." While appreciating their "placing literary phenomena into historical context" and "closely studying the process of

the production" of knowledge, subject positions, and language, Liu also expresses his anxiety over their pursuit of the "complexity of this process." In his view, the "overelaborate anatomies and the over-conceptualized analyses" produced by these authors risk transfiguring the "vulgar object that can hardly be called literature."[9] By requesting that the younger generation of scholars not indulge in the "artificial labyrinth of notions," by asking them not to read (theoretical and historical) complexity into simple problems (e.g., socialist realism), Liu expresses his faith in the "new perspectives and new interpretations that are being generated all over the world."[10]

Initiated by a group of junior literature professors in Shanghai in 1988 to challenge the official historiography of modern Chinese literature, "rewriting literary history" (*chongxie wenxueshi*) may be taken as an echo of the general cultural-discursive reconstruction of Chinese modernism in the 1980s. Its original critical and historiographical pointedness was more specific, its ideological position somehow more abstract. Its major discontent with official literary history is the latter's disproportionately scanty discussion of such modernist schools as the "New Perception" movement and the "Nine Leaves" poets and its dismissive treatment of some politically moderate yet stylistically accomplished writers, such as Zhou Zuoren, Shen Congwen, Qian Zhongshu, and Zhang Ailing. All these names and works are invoked, along with imported modernism and/or postmodernism, to support the cultural "experimentation" by which the movement strives for a discursive semiautonomy.

Interrupted by the Tiananmen Square bloodshed, the project of "rewriting literary history" now seems to be finding an afterlife abroad, where its ideological suspension and discursive incompleteness are being appropriated for a distinctly antisocialist rhetoric in the ambitious project of cultural studies undertaken by a surviving (and self-renewing) Chinese intelligentsia in exile. It has become a staple of such internationally sponsored journals as *Jintian* (Today). In Liu Zaifu's view, its continuation in the post-Tiananmen era is marked by its "refusal to take a given political ideology as the constructive principle and critical measure, to make living writers puppets of political-ideological narrative, to describe many works remote from the nature of literature and the mainstream of literary history, which is turned into a copy and footnote of political history." For Liu, the project of "rewriting literary history" should promise a dual "transcendence," namely, the "transcendence of political utilitarianism and

vulgar critical perspective" and the "transcendence of political-ideological language in criticism."[11]

Liu Zaifu and Lin Gang view violence as implicit within a mode of political writing which is "preconditioned by a certain political ideology's analysis of social politics" and determined by its methodology to "make fiction an interpretation and reformulation of that political ideology."[12] These authors explore the relationship between this mode of writing and the underlying notion of temporality, history, and progress derived from Marxism. Identifying Mao Dun's 1932 short story "Chun can" (Spring Silkworm) as marking the "onset" of what they call "the idiographic illustration of political ideology," they go on to give an outline of the intellectual atmosphere which was its condition of possibility:

By then, the three big debates taking place in the Chinese intellectual field — the debate of "problems versus isms," the debate between Lu Xun and the Creation Society [*Chuangzao she*], and the debate over the nature of Chinese society — were finished. Marxism as a political ideology started to play a dominant role in cultural and intellectual life; its reinterpretation and reconstruction of Chinese society and Chinese history already commanded an overwhelming superiority. Under these circumstances, Marxist ideology penetrated into the narrative of fiction. As a gigantic intellectual system, Marxism is characterized by its "totalism" and "universalism"; not only can it interpret the various problems of the universe, history, and social life, it also offers a specific analysis of existing political and economic systems. It supplies the writer with a ready-made intellectual mode for explaining social life; therefore its influence on the narrative of fiction is immediate.[13]

For humanists such as Liu Zaifu, the "question-and-answer" narrative, the codification of images and characters according to Marxist social analysis, as it is demonstrated in Mao Dun's story, ominously foreshadows the predominance of politics and ideology over literary production. Yet the stage of "the critique of reality and critique of history" would be transcended, as Liu and Lin argue, by the very logic of this mode of political writing. In Ding Ling's *Taiyang zhaozai sanggan heshang,* these critics sense the escalation of an "exaggerated and brutal form," an "apology for bloodshed," in short, a certain Jacobinism in literary narrative, that is associated with a Marxist notion of history. Praised in official literary history as "artistically representing the unprecedented changes in rural China," Ding Ling's novel is subjected to a critical rereading in Liu and Lin's essay. Against the conventional criticism of Ding Ling's "lack of a writer's transcendental posi-

tion," of her "turning literature into an illustration of political cognition," Liu and Lin provide a more interesting analysis of the combined "process of narration" and "political value judgment" present in Ding Ling's novel. For them, this is again "characteristic of a Marxist mode of political writing":

One of the important characteristics of the Marxist notion of time and history is to combine the temporal process with value judgment. The centrality of the new soul attained by left-wing literature in the 1930s is precisely its animation by the Marxist notion of temporality, or its transforming of the Marxist notion of temporality into its own logic of narrative. The notion of temporality in Marxism is a mature and systematic one; once the writer acquires the inspiration of this notion of temporality, he or she will also pick value judgment over "the great truth and the great falsehood" [*da shi da fei*], "the great good and the great evil" [*da shan da e*] of the historical course of human beings. Classic Chinese novels are often dominated by the notions of causality and retribution, which is an indication that they lack any mature and systematic notion of temporality, because the order of causality and retribution contains no hierarchy of value. Marxism is just the opposite; its notion of temporality is intertwined with its description of human history and contains the idea of "progress" which is a product of the Western Enlightenment. Reflected in human history, this progress is the objective will advancing from primitive communism, slavery, feudalism, capitalism all the way to socialism and communism.[14]

Within this framework, Liu Zaifu and Lin Gang consider Ding Ling and Zhao Shuli (whose *Li jiazhuang de bianqian* [Changes in Li Village], is also analyzed in their essay) precursors of the literary engagement with "discovering the criminal of history" which would evolve into a convention of the official discourse of socialist realism in the decades to come. Thus Liu and Lin articulate their understanding of the narrative logic of socialist realism in terms of a humanist denunciation:

The logic of temporality is also the logic of value. Since human history is a flow of time running from its starting point in primitive society to the high point [of communism], a radical binary opposite can be found in its course: one goes with the historical trend and the forces pushing it forward, which are the progressive and revolutionary ones in human history; the other runs counter to the trend of history, being the obstacle to the stream of historical forces, which are the reactionary, corrupted ones. The two extremes of these historical forces are represented by different classes. Once this judgment is made, the big discovery comes,

the discovery of the historical criminal. . . . This grave discovery, and the cruel logic implicit in it, is the avant-garde idea of the last century, namely, the idea of historical determinism. It becomes the intellectual pillar of the "revolutionary novel," broadly defined. . . . After Mao's 1942 "Talks at the Yan'an Forum on Literature and Art," this idea is intertwined with the actual political movements and the literary movements serving them. Revolutionary literature has transcended the political mode of writing demonstrated in "Chun can" during the period of left-wing literature; it has transcended the mere critiques of reality and of history to evolve into a great squaring of the historical criminal; it becomes an apology for all the cruelty and bloodshed generated by this struggle.[15]

By looking at the "dual quality" of the "revolutionary literature," namely, its "literary aspect" and its "class aspect," one can see, according to Liu, that the process of its practice is a mixture of success and failure. The success of this practice is embodied in such works as Mao Dun's 1932 novel, *Zi ye,* which, Liu contends, "is invested with a new class aspect yet can still be called literature." By contrast, Ding Ling's novel is an utter failure in which "the primary quality of literature is eliminated by its new class aspect." [16] For Liu, the general tragedy of modern Chinese literature lies in the fact that many writers—including the most highly regarded ones, such as Ba Jin, Lao She, and Cao Yu—have pursued revolution and the "new class aspect" at the price of a "grave artistic transgression." To this extent, the evolution from left-wing literature in the 1930s to the establishment of socialist realism in the 1960s depicted in the official literary history is, Liu concludes, a "significant failure."

After the breathless succession of "aesthetic innovations" and ideological revisionisms during the New Era, the reemergence of the problematic of socialist realism, broadly defined, is itself of some ideological and theoretical significance. It reveals the intellectual elite's desire to disengage from the state discourse (a desire that underlies the current intellectual skepticism toward the idea of modernity in general). It also indicates, however, a newly awakened awareness of the political relevance of engaging past experiences in the face of sweeping global capitalism and its cultural hegemony, from which not even the dead are safe, and in which the dead have to be evoked one way or another so as to contribute to the ongoing social and cultural struggle.

Ironically, the recuperation of a need to reconsider socialist realism

requires not only the dissolving of the discourse itself, but also the disso-
lution of its immediate competitor. At the outset of the New Era, when
Deng systematically rehabilitated en masse the bureaucrats and intellectu-
als purged during the Cultural Revolution, the euphoria of the literature
of the New Era anticipated the full restoration of that bureaucratic utopia.
This fantasy was soon to be challenged (and later smashed) by a flood of
innovations aimed, under the banner of modernism, at a "higher" order of
"contemporary world culture." While the intellectual elite denounced the
official mode of representation as sheer propaganda, they made socialist
realism (broadly defined) the radical opposite of the cultural vision which
evolved from radical social transformation, as well as of anything touted
by the West as the spatialized image of the future. The 1980s saw an in-
tense disengagement from the state discourse, which in turn embraced
the newly generated social experiences and codified them in terms of the
international language of modernism. The various new waves in Chinese
literature, cinema, art, theater, and architecture all defined themselves vis-
à-vis socialist realism thus reinvented. This negative reinvention of socialist
realism, when viewed alongside the way the modernist discourse defines
itself, reveals the shared ground and the sociopolitical dependence of the
new upon the old, which is an implicit theme of Chinese modernism in the
New Era. Kept alive by the tragic, heroic struggle to disassociate social-
ist reality from Chinese modernism, this association was recuperated in a
comical way in the 1990s, when modernism and (socialist) realism became
two homeless brothers roaming through Chinese cities overflowing with
foreign capital and packed with domestic consumers. Seen in this light,
the recent rise of interest in socialist realism not only looks like a wish-
ful continuation of the revisionist project of "rewriting literary history" of
the late 1980s, but also seems to be a reenergized attempt to dismantle the
historical structure of Chinese modernity (which, in this case, is *almost* the
structure of the socialist state) in the age of multinational capitalism and
free-floating intellectuals.

From a perspective intertwined with, but strategically distinguished
from, the humanist denunciation of socialist realism, Li Tuo examines the
mechanism of production of what he calls the Maoist genre by tracing the
"not so simple" personal-intellectual history of Ding Ling. Li, a former
writer from the mainland, was not a conspicuous participant in the "rewrit-
ing literary history" project until very recently. Yet as an overseas spokes-
man for and promotor of this project, his writings can sometimes be taken

as an exemplification of the ideological and institutional context in which the postrevolutionary (especially post–1989) discourse on Chinese socialist realism operates. In his article on Ding Ling, Li insists on maintaining a distinction between what is commonly termed "Maoist discourse" (meaning the official, literary, and cultural institutions of Chinese socialism) and his own "Maoist genre"(which sounds more equivocal). For him, the advantage of "genre" lies in its distinction from the Foucaldian theory of discourse, in its reference to the "stylistic edge" by which the practice of the "Maoist genre repels and oppresses other discourses," and the relative ease with which the complexity of that practice can be analyzed.[17]

Under the rubric of complexity, Li describes the failed effort by Ding Ling—the former petit-bourgeois writer who achieved literary success in the foreign concessions of Shanghai—to "challenge the Maoist genre" that was already well established in Yan'an. But more attention is paid by Li Tuo to how difficult it was for Ding Ling to "forget" her own language, to the way in which she creatively and passionately submitted herself first to the collective cause of perfecting the hegemonic order and later to the discursive terror of the "Maoist genre." At the end of his article, Li concludes:

There were tens of thousands of intellectuals who, like Ding Ling, were inspired by the Maoist genre and engaged in the production of culture and knowledge under its rule. Despite numerous campaigns of denunciation, despite the anti-rightist attack and the Cultural Revolution, the majority of these intellectuals, in reference to the entire process of democratic revolution and New China, are neither pitiful creatures who suffered all along nor a bunch of passive, mechanical gears and screws. Under the guise of different versions of the "history of suffering," one fact remains: these intellectuals all had their romantic and idealist experience of "taking part in the revolution"; they all had the passion of "building up communism"; they have all chanted proudly, "American Imperialism is a paper tiger." These memories must not be erased. Moreover, as producers and transmitters of knowledge, they all contributed their enthusiasms, gifts, and "most precious youth" to reproducing the Maoist genre, although they have been oppressed by it throughout their lives. Even in their most difficult days, in the most awkward moments of abandoning others and being abandoned, of persecuting others and being persecuted, of denouncing others and being denounced, many of them still persisted in producing the Maoist genre, in which they turned self-criticism, criticism, and persecution into particular forms of that genre. These memories must not be forgotten, either. If the conception and development of the Maoist genre

can be said to be a historical process, it was a process made possible by the wisdom and endeavor of tens of thousands of intellectuals; if the Maoist genre can be said to represent an unprecedented unification and consolidation of the modern Chinese language, which has gravely hindered the intellectual production of Chinese people through its total control, then those intellectuals are precisely the ones who have sincerely applauded and hailed that control. We have to make even more of an effort not to forget this. Not only must we not forget, but we who have lived through that period must take it as our unavoidable responsibility to provide an account of those phenomena, an account which is compatible with our present context and awareness.[18]

Li Tuo's negotiation between the humanist agenda and the contemporary, global context can be used as an introduction to the younger critical generation's reading of the socialist realist tradition, which differs markedly from Li Tuo's, both theoretically and politically. To Li Tuo, the paradigmatic framework for rereading literary history is still an ideological and cultural attack on communism voiced in humanist rhetoric. His sometimes bitter and cynical comments on the socialist realist tradition not only reveal a triumphant confidence in the "global" ideology that underlies this kind of writing, but also betray a theoretical limitation in critically and historically interrogating Chinese socialism's claim to a totality of historical experience. Here "aesthetics" serves as a crucial yet abstract notion, formally as well as morally. It is in the name of this aesthetics and in accordance with this "aesthetic" judgment that products of a particular historical moment are to be rejected once and for all by means of a postrevolutionary *jouissance*. This position sometimes leads to a confused rejection of modernity as a historical and cultural problematic and a crucial frame of reference, a rejection which indicates an unwillingness to come to terms with the undeniable complexity of the relationship between a historical style and a historical experience.

It is at this point that the critical writings of younger critics, such as Meng Yue, Ma Junxiang, Dai Jinhua, and, to a more limited degree, Chen Sihe, take a different path, one that leads to a laborious inquiry of the internal diversity, contradictions, and dynamism of Chinese modernity in order to reconstruct the problematic of "revolutionary literature" as a historical subject. Among these writings, Meng Yue's essay on *Baimao nü* (The White-Haired Woman) is exemplary as well as methodologically instructive. Meng examines and compares the different versions of this story

about the misery and revenge of a peasant woman, meticulously tracing the concrete process of its transformation from rural legend to folk opera, as a symbol of the Yan'an "revolutionary popular culture," and, later, from a primal film text of the 1950s to a "modern revolutionary ballet" and one of the eight model dramas of the Cultural Revolution. At every stage of its transformation, as Meng demonstrates, a complex and innovative mechanism is at work amidst the convergence and interaction of different social, cultural, political, and "aesthetic" forces. Each version of the text marks a crucial intellectual and literary restructuring which registers and negotiates among these historical forces, formulating a new common ideology at the historical conjuncture.

For Meng, the transmission and multilayered rewriting of *Baimao nü* not only shows an ideological uniformity superimposing itself upon a diverse social and cultural context, but, equally importantly, it shows that the text has a "relatively diverse and heterogeneous context,"[19] that the suturing of an ideological-discursive totality was not and never could be seamless. Resulting from a political intervention, the emergence of Yan'an literature is also relevant to an "interweaving [of the dominant discourse] into the convoluted texture of the cultural history of modern China, into a context beyond the horizon [of that discourse]."[20] According to Meng, this literary crystallization of a social chemistry has much to tell us. Through a brilliant combination of gender analysis and ideological criticism, Meng turns the sutured totality of the state apparatus of ideology into an open ground where the rural, native resources and the communist discourse of modernity and revolution penetrate and legitimize each other to constitute the foundation of an up-and-coming state literature (a combination of "revolutionary realism" and "revolutionary romanticism").

The refreshing final observation of Meng's article, then, is that the discursive space opened up between the native and the revolutionary, due to the fusion of traditional forms of rural and local culture with "official" discourse, leaves us "more gaps and possibilities" than the mainstream, urban, intellectual discourse of the Chinese Enlightenment.[21] In the current ideological atmosphere and theoretical context of China, these gaps operate strategically as an "apolitical, cultural problematic." Yet Meng makes it clear that her "cultural" concern is immanently political, aiming at an alternative understanding of the relationships among the intellectual New Culture (or the mainstream culture of Chinese modernity), subaltern culture (instantiated by the masses, the native, the local, the rural, the

popular, folklore, and women), and the new political authority (and realist principles) of Chinese socialism. In doing so, Meng historicizes the genre and debunks the pseudo-question of a caricatured totality of political writing. Here socialist realism, far from being a totality of representation, is a product of the totality of modern Chinese culture.

Ma Junxiang's reading of Cheng Yin's 1958 film *Shanghai guniang* (The Girl from Shanghai) also takes on the analysis of Chinese socialist realism in the paradoxical context of revolution and modernity. Challenging the conventional understanding of the mythmaking, dream-factory function of the post–1949 Chinese film industry, Ma examines the way in which an ideological education is energized by and actualized through the new socio-libidinal economy of an emergent socialist everyday world, an economy whose narrative mechanism is qualitatively different from the Hollywood system. By means of a close reading of the "redistribution of gender roles" in the film, Ma argues that the heroine's confrontation with the imaginary control over the narrative exercised by the male gaze actually redeploys libidinal energy (i.e., sexual fantasy) in the new symbolic order, namely, the transcendental law of a revolutionary superego.[22] In this process, Ma suggests, the desire to gaze is overcome by the cinematic construction of a revolutionary self-consciousness.

Although Ma is quick to point out the defeminization of the heroine through which the violence of the state discourse is expressed, he also tries to demonstrate that the transformation of the libidinal drive into the ideology of revolutionary discourse is realized not through horror and mortification, but rather through pleasure and enjoyment. Contrasting his own analysis with Laura Mulvey's observations that in Hollywood culture it is male desire and its practice that propel and manipulate narrative, Ma argues that the film production of New China virtually created a new system of cinematic narrative driven by a different sociocultural motivation. Ma sums up his arguments in three questions:

(1) Who is watching the film? The answer is that *Shanghai guniang* was explicitly made for the "revolutionary workers" of New China. Whereas the Hollywood film provides, through all kinds of signifiers of desire, a pleasant yet retrogressive moral and emotional experience, the revolutionary film encourages its viewer to overcome the egoistic fantasy and fetishism of gazing so as to gain the satisfaction of identifying with the revolutionary hero and the revolutionary cause. To this extent, as Ma argues, revolutionary films choose and create their own audiences and

help them to accomplish the self-transformation which is repression and sublimation in one.

(2) Who arranges the images? The answer is that neither the scriptwriter nor the director does in the revolutionary film; instead, it is the ideological codes introduced by the positive characters that effectively structure the cinematic chain of signification. In this sense, the revolutionary film is the radical opposite of the Hollywood one.

(3) Why are these films made? The answer is that the goal of the revolutionary film is clearly and undoubtedly to educate and inspire the people.[23]

Ma's article thus ends with a paradox: As a pedagogical instrument of the revolutionary mass media, revolutionary film refuses to be a source of sensual pleasure. But the pedagogical function is to be achieved precisely through the meaningful satisfaction of pleasure-seeking and the celebratory enjoyment which are essential, indeed ontological, elements of labor. Thus, pleasure and enjoyment are taken by Ma as social signifiers of the "unprecedented stability of the status of the superego and the universal realization of social value" in the early years of the People's Republic.[24]

It is hardly the intention of the new generation of Chinese scholars to redeem a failed revolution—or an "impossible aesthetics"[25]—by arguing for its relevance to the immediate future. Nor does their primary concern seem to be analyzing the historical experience of socialist realism, whose formal history may be taken as a crystallization of the social thematic of Chinese socialism. Situated amidst a whirlwind of signs and discourses, the postrevolutionary discourse on socialist realism, like all intellectual discourse in China, is preoccupied with the need to come to terms with the historically new, while retaining a sense of history and a critical distance that must be derived "internally." This is the intellectual context in which the complexity of Chinese socialism, or rather Chinese modernity itself, must be engaged via a productive encounter with its textual artifacts, an encounter aided by all kinds of front-line critical and theoretical discourses from the West. The conclusions drawn by these younger scholars are necessarily provisional, their arguments often risk regressing to the "pre-theoretical," as they are so entangled with the different social forces and ideologies that underlie the discursive space in which they operate. From the perspective of a historical imagination and critical sensibility which flourished under the rule of forgetting (followed by the restoration of memory), the institution of Chinese socialist realism, like the sociohis-

torical epoch to which it belongs, cannot be perceived as anything other than ruins and wreckage in an increasingly commercialized Chinese landscape. But the breaking up of its forced totality seems precisely the premise of an allegorical reading of the moment of historical conjuncture that once animated the institution of Chinese socialist realism and that persists even today in terms of a renewed urgency for historicization, for cultural politics and social critique. It is in the debris of socialist realism as a state project that the monster becomes an object of beauty, of historical knowledge cast in melancholic contemplation. In the light of allegory, we can see the diverse social and cultural resources that Chinese socialism has mobilized and appropriated in its formation. The popular spontaneity and intellectual originality it once commanded have become discernible once again. Its utopian contents, stripped of state power, can now be seen to persist, even in their most reified form. It is clear that only when the historical situation of socialist realism has been critically reconstructed will the genre and the "reality" it was intended to pro-create become a "scholarly" topic—which seems to be the humble objective of Meng's and Ma's brilliant writings.

This historical-critical reconstruction also promises liberation from the spell cast by the legitimized power and violence of the state ideology—the violence of naming, of writing history or narrative, and of constructing and defending a state apparatus of ideology. That is the reason why the past to be reconstructed is not just another myth or nostalgic utopia to be revered, but rather a construction of the present now to be defined by the unfolding history of the future. This construction, to be sure, bears all kinds of ideological and symbolic traces of social emancipation from oppressive state discourse during the New Era, as the problematic of Chinese socialist realism and Chinese socialism has emerged with historical, cultural, and political implications beyond the Reform Decade and the concrete social, political, and intellectual texture of Deng's China. The postrevolutionary discourse on Chinese socialist realism is embedded in the historical irony that a decisive "jointing the rail" (*Jiegui*) with global capitalism is also the condition of possibility for a reactivated search for alternatives.

Notes

1 Feng Xuefeng, "Guanyu shehui zhuyi xianshi zhuyi" (On Socialist Realism), in *Wenji* (Collected Works) (Beijing, 1981), 3: 311. All translations are my own.
2 Ibid., 319.

3 As early as 1925, Mao Dun initiated a discussion of the "proletarian literature."
A decade later, his *Ziye* (Midnight) was touted as a landmark Chinese "histori-
cal novel," in the Lukácsian sense of the term. Qu Quibai, the early Communist
leader, also anticipated the "vernacular language" movement, which led to a wide-
spread and long-lasting discussion of experiment in "revolutionary mass culture"
during the 1930s and 1940s. This discussion, together with the progressive urban
intellectuals' movement of "going to the people," heralded Mao Zedong's 1942
Yan'an talk, which in turn set off a heated "revolutionary mass culture" movement
in this Communist region. The literature produced by Zhao Shuli can be viewed
as one of the important achievements of this prolonged experiment. Meanwhile,
the "self-transformation" of petit-bourgeois writers such as Ding Ling provides
another formation narrative of revolutionary literary discourse, to which "socialist
realism" is considered the legitimate and culminating successor.

4 In a 1952 article, the title of which translates as "Thoughts about China's
Today, Tomorrow, and the Day after Tomorrow, upon the Opening of Naviga-
tion between the Volga and the Don," Feng Xuefeng expressed his conviction that
the Soviet Union, a more advanced social organization, was also technologically
superior to the West. Quoting from a *People's Daily* feature report (by the Soviet
writer Polevoi), Feng shared the awe registered by the reporter at the fact that no
human being was to be seen at the gigantic construction site on the Volga:

> Instead, an enormous Grassland Warrior E III–14–65 excavator was dig-
> ging out the earth in immense quantities. Its bucket takes fourteen cubic
> meters of earth at once; a sixty-five-meter-long steel arm raises it sky-high,
> then sends the earth to a spot that is more than a hundred meters away
> [and] throws it onto a slope which looks like a mountain. This gigantic
> machine takes care of the work that used to be done by tens of thousands
> of manual diggers; yet it is operated by a crew of five persons. . . . While I
> walked around the construction site, I saw the great victory of Soviet tech-
> nology.

Feng went on to comment that the spectacle of "two or three million Chinese peas-
ant workers working along the Huai river" would "by no means be overshadowed"
by the technological spectacle on the Volga. "In terms of their essential spirit, the
two are comparable," declared Feng, although he quickly added that, "in saying
so, I have no intention of downplaying the significance of high technology"; see
Feng Xuefeng, "Zai Fuerjiahe, Dunhe tonghang ri xiangdao Zhongguo de jintian,
mingtian he houtian," in *Wenji*, 2: 474–75.

5 For a useful account of Ding Ling's dilemma and the complex role played by
intellectuals under the Maoist institution, see Li Tuo, "Ding Ling bu jiandan"
(Ding Ling Is Not a Simple Matter), *Jintian* (Today Magazine) 3 (1993): 222–42.

6 Feng Xuefeng was one of the founders of the *Hupan shishe* (Lakeside Poets Society), a progressive literary group of the 1920s, and later an intimate protégé of Lu Xun. Zhou Yang was one of the leading figures of the *Zuo lian* (League of Left-Wing Writers) in Shanghai in the 1930s.

7 Liu Zaifu, "Chongxie lishi de shenhua yu xianshi" ("Rewriting" the Myth and Reality of History), in *Zai Jiedu* (Reinterpretation: Mass Culture and Ideology), ed. Tang Xiaobing (Hong Kong, 1993), 8.

8 For Xia Zhongyi, the theatrical experiment of Jiang Qing is but a "logical" development of Mao's literary theory; see his "Lishi wuke bi hui" (History Must Be Told), *Wenxue pinglun* (Literary Review) 4 (1989): 5–20.

9 Liu Zaifu, "Chongxie lishi," 11

10 Ibid., 7.

11 Ibid.

12 Liu Zaifu and Lin Gang, "Zhongguo xiandai xiaoshuo zhong de zhengzhi xiezuo moshi" (The Political Mode of Writing in Modern Chinese Fiction: From *Spring Silkworm* to *The Sun Shines over the Sanggan River*) in Tang Xiaobing, ed., *Zai Jiedu*, 92, 93.

13 Ibid., 95.

14 Ibid., 96.

15 Ibid., 96–97.

16 Liu Zaifu, "Chongxie lishi," 7.

17 Li Tuo, "Ding Ling bu jiandan," 241 n. 2.

18 Ibid., 240.

19 Meng Yue, "Baimaonü yanbian de qishi" (The Revelation from the Evolution of *The White-Haired Woman*: On the Historical Heterogeneity of Yan'an Literature and Art), *Jintian* 2 (1993): 135–47; quoted in Tang Xiaobing, ed., *Zai Jiedu*, 72.

20 Ibid.

21 Ibid., 88.

22 Ma Junxiang, "Shanghai Guniang," in Tang Xiaobing, ed., *Zai Jiedu*, 129–46.

23 Ibid., 141.

24 Ibid., 145–46.

25 Here I allude to the subtitle of Régine Robin's *Socialist Realism: An Impossible Aesthetics,* trans. Catherine Porter (Stanford, 1992).

PRIMITIVE COMMUNISM AND THE OTHER WAY AROUND

Most socialist realist texts embodied movement: from spontaneity to consciousness, from darkness to light, and from the "realm of necessity" to the "realm of freedom." These temporal journeys involved the final vanquishing of the past by the future conceived in terms of universal history ("leaps" from capitalism to communism) or of individual biography ("lives" from birth to immortality). The natural venue for both leaps and lives was the USSR-as-universe, but the duration of the journey varied according to the identity of the traveler (peasants, poets, and proletarians were not equidistant from timelessness). The group that brought up the rear consisted of hunters, gatherers, and reindeer herders from the "Extreme North" and the extreme past. Variously known as (noble) "savages," "Russian Indians," "wandering aliens," or "backward tribes," they were the ultimate travelers (nomads), the ultimate "survivals" ("primitive communists"), and the ultimate juveniles ("children of nature" as well as "small peoples"). They were also easily recognizable: much of what Russian readers knew about primitive communism had been revealed to them through V. K. Arsenev's Dersu Uzala—a natural man and self-sacrificial interpreter of the only morality "completely free of the vices that urban civilization brings with it." [1]

The standard 1930s "Long Journey" usually began with the arrival of the Russians. [2] Protected by the name and the image of Lenin, they would enter a sleepy native encampment and make speeches "about big houses, big men from big cities, big theaters, girls who jump with parachutes," and schools "where even grownups come to study and where happy and well-fed children laugh and sing." [3] The natives did not always understand the meaning of the words, but they could sense the greater truth that they revealed. The long polar night and the darkness of ignorance retreated before the sound of Lenin's name and the voices of his emissaries. "It seemed that the river, the forest, and the sky were singing together with these fair-haired and blue-eyed men." [4] They were always men, very tall and not very young, tempered by privation, fire, and discipline. (Nordic—as opposed to northern—features did not become obligatory until the very end of the decade.) Their manner was rough and their faces stern, but their eyes never failed to suggest a "teasing but good-natured smile." [5]

The light brought by the Russians illuminated the inequality and abuse that were to be found in every tent: "The entire tribe was there, but people were not sitting in their usual places. New groups were being formed — social differentiation had begun, as if the mere sound of Lenin's name had called up new forces that would shake loose this petrified and lethargic tribal structure."[6] On one side were all the women and children, "the most exploited group"; a short distance away were the men, young and old; and apart from everybody sat the elder and the shaman, "the representatives of social and spiritual power."[7] The downtrodden knew very well whose side they were on: "The Reds respect the poor and persecute the rich. And what about me, Vaska the Giliak, aren't I poor and aren't I mad at the rich?"[8] More important, the dirt in the native tents was so disgusting, the social organization so unfair, and the customs so patently absurd that the unbiased and "the talented" among the natives needed but a mild rebuke to make them rub their eyes and see the light. If not for the shaman's intrigues, would a normal person — no matter how backward — want to kill his own father? Or live in an unhealthy environment? Or carry out blood vengeance against someone he liked personally? Or marry his late brother's old wife?[9] Of course not. And so, one after another, the good natives realized the full extent of the "malice, hunger, and ignorance" in which the bad natives had kept them. As Bogoraz's Yukagir boy says to the formerly terrifying spirits, "It turns out that you don't even exist; it's all lies, deceit, and old fairy tales. . . . I'm going to see Lenin."[10]

Many of these "talented" northerners were free-spirited young daughters of poor but proud widowers.[11] Direct descendants of Ivan Kalashnikov's *Kamchadalka* as well as the more lightly dressed *sauvages fatales* from the Circassian villages and Gypsy tents, they no longer had to choose between a Russian lover and the wide-open spaces. The Russian was now a father, and the girl's role consisted in bringing the rest of the tribe under his protection. This was no easy task. For the activists, elected at birth and marked with special qualities, the Russian truth was absolutely self-evident and transparent, but the others demanded proof and tangible advantages so that much of the plot revolved around the Russian hero's economic projects, which, in the interests of suspense, usually did not succeed right away.

The delays were due to sabotage on the part of the tribe's villains ("the enemy"). Old, vicious, and with faces chronically contorted by "scornful smiles," the kulaks and shamans stood to lose their privileges, their influence, and the whole dark world of "medieval savagery" that they had been

able to maintain for so long.[12] For all their cunning and desperation, how-ever, they could not offer their kinsmen anything but the long-discredited slogans of the past: independence, pride, sacred customs, and the honor of the ancestors. The frequently invoked Mohicans stood firmly on their heads; now only villains preached romantic freedom, and Kratt's "Ula-khan the Last" was last because he had led a doomed attempt to flee from the Russians, and hence from true freedom as "perceived necessity." "For many winters I have waited for just people," explains Ulakhan's sen-sible opponent (and the father of a free-spirited young girl). "And they have come. They have driven out the merchants, brought cheap goods, and given reindeer to poor people." Later, when a spy catcher ex machina comes to Magadan to flash a "teasing but good-natured smile" and deliver the final judgment, the sensible man offers him the highest praise that a proud native could give a Russian official: "Looks like he's going to be a good master [*khoziain*]." [13]

The kulaks and shamans could not be reformed or reasoned with. Defeated, they returned to the wilderness where they belonged—to the forest, tundra, or, like Ulakhan, "back to the distant and forbidding mountains . . . useless and alien to everything." [14] In post-1936 texts they reappeared for one last battle, this time as spies or terrorists.[15] The vil-lain in Gor's northern series, for example, starts off as a rather amusing buffoon, but turns progressively more sinister and finally becomes a mur-derous Japanese agent bent on senseless destruction.[16] What began as nostalgic demagoguery became bourgeois nationalism ("Chukotka for the Chukchi") and an eventual sellout to the foreigners and to the false Rus-sians, who were marked as impostors by their shifty eyes, false teeth, or glasses.[17]

In the end, light prevailed over darkness and "the resurrected tribe" was able to march on toward cultural and economic development. As Gorky said about Selvinsky's Umka, "He quit walking on all fours and stood upright." [18] The only remaining challenge was to test the firmness of the newly established union between the real Russians and the reformed natives. Inspired by Jack London, Chukchi women chose to starve in the snowy desert rather than touch the food stockpiled by border guards, Eskimo detachments accompanied Russian explorers to desert islands, and injured geologists crawled for miles to get help for their loyal native guides.[19] The Long Journey had been successful; the native had become part of the family. And when a Tungus Rip Van Winkle emerged from the

forest, he found that there were no more bribes or vodka and that people were friendly, debts had been abolished, and furs fetched good prices.[20]

The wartime discovery of Russia's uniqueness and the introduction of the Imperial Age of prophets presaging the socialist revolution resulted in a new version of the "northern awakening," in which the native's education commenced with the arrival of the first Russian pioneer. It was a tale of adventure set in the exotic locale of the Far Eastern frontier and built around the struggle between righteous Russians and felonious foreigners, with the natives serving as witnesses for the prosecution and as legitimizers of Russian territorial claims.[21] Still, the standard account persisted. Indeed, it picked up speed with the emergence (graduation) of the first generation of fully Soviet-educated native intellectuals trained as teachers and, in the most promising cases, promoted as authors of fiction. They wrote chiefly in Russian and became full-fledged (even, for the time being, eager) members of the Soviet "creative intelligentsia." Their works contributed significantly to the development of the Long Journey paradigm without introducing any important elements that had not been present in the oeuvres of their non-native teachers and friends. The Chukchi Rytkheu inherited Semushkin's plots and characters and the Nanai Khodzher faithfully continued the frontier epic begun by Fadeev and Zadornov. In this sense, the government's nationalities policy had been a resounding success: the socialist realist fiction of the 1940s and 1950s reflected the official reality in not exhibiting any ethnic-based differences "in content." [22]

This does not mean, of course, that the content itself had not changed. While the theme of a giant yet relatively painless leap from the most remote past into the present/future continued to be central, some very important changes had taken place. With the leap having been accomplished by the mid-1930s, the Long Journey became a historical theme, which could be introduced as a series of flashbacks by a triumphant but now serene protagonist.[23] Alternatively, it could be rescued from the past by the discovery of a forgotten tribe or temporarily restored by the war, which brought back the defunct creatures of darkness and thus provided new opportunities for the heralds of light.[24] In any case, the new certainties of ethnic messianism and the Cold War, as well as the artistic discoveries of the novels set on the pre-Bolshevik frontier, combined to affect the nature of the journey itself.

In the literature of the 1930s the native characters had been offered

a single alternative to the status quo: the Bolshevik way to communism. Now they almost always began their travels at a crossroads, with the foreigners providing the alternative. In other words, the standard Long Journey text had incorporated the perfect structural symmetry of the pioneer narratives (having been moved to Chukotka and the Amur for that purpose). On one side were the Bolsheviks, all of them ethnic Slavs; and on the other, the foreigners, all of them villains.[25] Neither side had come unannounced: the Bolsheviks were "the descendants of Ermak and Poiarkov" returning to "the historically Russian [*iskonno russkie*] lands," while the Americans (the ultimate foreigners) were "the descendants of ancient pirates" bent on "getting devilishly rich or starving to death like a hungry old wolf."[26] In fact, the postwar Bolsheviks resembled Zadornov's Cossacks more than they did their fellow Communists from the 1930s: they all had eyes the color of "the blue sky on a long clear day" or like "the blue seawater in still weather when the sea seems to be asleep, with not even the tiniest ripple," and sometimes like both the sky and the sea plus "the radiant, warm little sun."[27] This was an ethnic-specific peculiarity, so a reference to the Party secretary's "simple Russian face" would have been enough to conjure up images of benign nature.[28] By the late 1950s, the Russian role of protecting the natives from foreigners had become so important that on at least one occasion a fatherly Party secretary was replaced by a local KGB chief concerned with border violations (his face was "of the ordinary Russian type").[29] In another instance, the Long Journey involved relocating a group of Eskimos from Chukotka to Wrangel Island for the sole purpose of asserting Soviet territorial claims in the area. Thus a raised consciousness coincided with a recognition of the sacred nature of national defense. Consciousness (civilization) was fully covered by patriotism, and patriotism was wholly built on the trust placed in one "tall, fair-haired Russian lad."[30]

The Americans' true character was also revealed in their eyes. While their dress—high boots and pistols tucked into their belts—had "predator" written all over it, their words—*"goddem!"*—never failed to announce their plans, and their actions—rape and murder—spoke louder than words; but it was their eyes—colorless and "clouded"—that showed what they really were: dead souls and ghosts whose true place was not under the Jolly Roger but on the *Flying Dutchman,* condemned by a terrible curse to be eternal ambassadors of evil. In a less sinister vein, and to ensure that there was no mistaking their character, most foreigners bore the usual stamps of falsehood: gold teeth, glasses, grotesquely big noses, or extraor-

dinary amounts of facial and bodily hair.[31] They represented Hell. "The accursed land" (usually Alaska) from which they came and whither they vanished unless apprehended by Soviet border guards was a place where all human values were deliberately trampled upon: parents abused their children, sons spat in their mothers' faces, friendship did not exist, and freedom meant robbery. Most significantly, all whites there were racists and all nonwhites were persecuted, ridiculed, starved, and sometimes lynched. (In the case of the Chinese, racism was replaced by cultural imperialism.) If not for the "happy shore" across the water, there would be no hope of salvation.[32]

The happy shore, meanwhile, stood firm in spite of all attempts to penetrate it with spies and contaminate it with U.S. canned food, which caused diarrhea, or with special germs prepared by Japanese doctors and tested by the FBI on Alaskan natives.[33] In the Manichean world of the postwar opposition between "the two systems," the USSR represented paradise, a place where dreams came true. Later, after Aitmatov's "White Steamer" had become a common metaphor for lost innocence and elusive happiness, Rytkheu published a story about a Chukchi woman who is seduced by an American captain and then spends the rest of her life vainly waiting for the return of the "beautiful ship." Her last words sum up the wisdom of the only world she knows: "The most beautiful ships always pass by." But that was before the Long Journey. When the woman's daughter grows up and becomes subject to some of the same yearnings, she finds a large Soviet ship commanded by a newly trained Chukchi captain dropping anchor opposite her settlement.[34] The wait was over—for her and all the native peoples of the USSR. As Yuvan Shestalov put it,

> My shore is rich with people,
> Like a green meadow with flowers.
> The flock of white steamers
> Is thicker than a flock of swans.[35]

But what exactly was happiness? As in other postwar Soviet utopias (including those of field ethnography), the image of an urban paradise with tall buildings and gigantic construction sites had given way to one of private bliss with cozy interiors and young mothers wearing "nice shawls with tassels." When the ship finally arrived, it brought marriage and motherhood, and perhaps a TV set as well.[36] But some things had not changed. Most significantly, paradise still meant an escape from freedom, under-

stood as freedom for evil spirits, "freedom for wild beasts." [37] In a short story by Yu. I. Shamshurin, a domesticated reindeer escapes to the tundra only to be attacked and almost killed by a pack of wolves. Saved by its former master, the chastened animal "obediently follows him" home. " 'Live with the humans,' recommends his savior, 'it's safer that way.' " Reinforcing this analogy, Rytkheu's Eskimos obediently follow the youthful Bolshevik to Wrangel Island, where "the main dreams of the inhabitants . . . come true" because all the important decisions are made for them by the "tall, fair-haired Russian lad." [38]

Once the native had chosen between the worlds of light and darkness, the tactics and personality of the "Russian lad" became the center of the plot. The shamans and elders, acting as American agents, had a much harder time swaying their kinsmen than they had had as agents of the past. In fact, they rarely tried, limiting themselves to single acts of terrorism and, when defeated, to piercing, "ratlike" squealing.[39] As a result, in the postwar Long Journey the question of allegiance lost some of its importance due to the obvious unattractiveness of evil. The choice lay not so much between "our way" and "the right way" as between the right (Russian) way and the wrong (non-Russian) way, with the unacceptability of the status quo apparent from the outset. In the novels set during the war the problem of choice was very marginal indeed (most protagonists having already attained the state of consciousness), and by the late 1950s representations of the hell lying beyond the border were much less prominent. With the question of whether or not to launch the expedition out of the way, then, the new generation of Long Journey texts concentrated on the best and fastest ways of reaching the final destination. Given that a Party functionary was in charge of all aspects of the project, the real challenge was to find the right man and provide him with the correct guidelines.

There were usually two main candidates, who disagreed considerably, though amicably, on how to deal with the natives. Communist Number One was a rough, naive, and lovable proletarian bully who wore a trenchcoat, brandished a revolver, relied on his class instincts, and defiantly disregarded "the objective conditions" as he herded the masses down the road to progress. He was, in other words, the hero of the Great Transformation—at his best when exposing enemies and storming fortresses, but not altogether comfortable around "nice shawls with tassels." He represented the heroic, public past and was regarded with nostalgic respect and friendly condescension by those who had fully attained consciousness, which was now called "culture." It was precisely that culture, understood

as formal education and proper manners, that distinguished Communist Number Two. He was solid, reserved, dignified, sensitive, and tactful. He had a college degree and demonstrated an indefatigable attention to detail. Most important, he specialized in individuals rather than the "masses," skillfully playing on the personal strengths and weaknesses of his charges, while not neglecting his own private happiness.[40]

Significantly, in novels set during or even after the war (as in the postwar discovery of a forgotten tribe), both characters could be ethnic natives, though clearly Russian "in content." They were, in fact, male versions of those erstwhile rebellious girls who had acquired culture and risen to leadership positions. (Party bosses were still fathers to their natives, which made the sex change obligatory.) In this version, outmoded "heroic" behavior could be attributed to youthful belligerence or insufficient education.[41] The essence of the conflict is captured in the following exchange.

Communist No. 1: But why, why are they the way they are, these people? You pull them with your hands and your teeth toward the light, toward clean air, but they drag their feet like a lassoed reindeer!

Communist No. 2: Why pull them? We should reach out to them, reach out with our hearts, so that they will believe us and come by themselves. That is how we should convince them. When a person is being pulled, he will always drag his feet.[42]

"Reach out" meant verbal persuasion, and skillful verbal persuasion always worked because the native northerners were essentially reasonable and thus ultimately open to the message, although in some difficult cases one still had to perform a few miracles (usually by curing the sick). The true key was tact: if you burned idols, the idol-worshipers would rally and remonstrate; but if you chose the right words and guaranteed a plentiful harvest, they—and certainly their schooled children—would burn their idols themselves. As Khodzher's Pavel Glotov, a tactful Bolshevik, says:

I don't believe in the Russian God or in the Nanai enduri, or in any other gods. . . . But I respect people, respect you, and cannot allow anybody to offend you and your faith in my presence. You still believe in your shamans—well, go ahead and believe in them, but your children are not going to believe in them, just like I don't.[43]

In later texts, Communist Number One could be reinterpreted as a dry, unimaginative bureaucrat who was not able to see the real people behind the forms and circulars, or even as an official of the secret police who mind-

lessly followed all orders, even though some of them may have been issued by "false" Russians.[44] The basic point, however, remained the same. The Party functionary among the indigenous peoples was not a fiery crusader but a respected village priest (a Russian Orthodox one, for he had to be married to do a good job).

The correctness of the new approach was testified to by the natives themselves, who were obviously "grateful to the Russian for not openly ridiculing their customs."[45] According to Khodzher's fishermen, "The Russians [unlike the Japanese] do not take the Nanai encampments away from them and do not kick them out into the forest."[46] A much more serious endorsement of the policy change came from Party higher-ups. If in the fiction of the 1930s the Bolshevik usually acted alone, supported only by the name and the image of Lenin, in the postwar novels he always had a superior in the Party's district headquarters, whose job it was to appear at crucial moments and legitimize the politics of personal touch. This was particularly important if the junior Communist was a native, in which case the Russian mentor was a surrogate father and lifelong sponsor. In terms of plot development, however, the most important test of the "native disciples" was their amorous and professional success. In almost all of the postwar Long Journey texts the central characters—the Spontaneous Native Disciple and the Native Local Leader (both male and sometimes one and the same person)—faced serious challenges on two fronts. One was the usual task of overcoming backwardness and getting the rank-and-file natives to follow suit; the other, a determined effort to become united with a beautiful woman who was kept away and usually abused by her traditionalist husband or father. The dramatic dénouement would involve the creation of a kolkhoz and the rescue of the love interest. The hero would be rewarded by simultaneous marriage and promotion.[47]

This scheme accorded well with the dominant socialist realist paradigm of the first postwar decade.[48] Indeed, in its basic form the Long Journey narrative persisted into the 1980s, reenacting the unprecedented leap "from patriarchy to socialism" over and over again for as long as that view of the past remained the officially accepted one. This was precisely the problem, however. The journey having been formally completed, this kind of narrative could only be "historical" at a time when Party ideologues were demanding more representations of the socialist present. What was the "national form" of perfection?

All evil had become temporary: its agents were smuggled in from hell (overseas) and expelled immediately upon detection, while homegrown

deviations from total goodness could be caused only by regression to the past, or by psychological maladjustment. The new life of the native peoples included material proofs of their well-being: the Russian-type houses, boarding schools, hospitals, and clubs; the usual home interiors, with bright curtains, typewriters, sewing machines, and well-salted Russian meals on "neatly ironed tablecloths"; and the well-educated and contented people, proud of their kolkhoz's productivity, their Russian haircuts, and their imported furniture.[49] If these people ever argued, it was "in a good-natured kind of way: they [did] not know what to do with all the money they were making."[50] In *Poezd prishel na Tumnin* (The Train Arrived in Tumnin), Bytovoi offered a marvelous metaphor for the native peoples' literary transformation. If in the past the Oroch had acted like children or Amazons, now it was the old folks' home that served as the symbolic center of the settlement and "the pride of the inhabitants of the former encampment": "The elders and consequently the most respected people from all clans live in this light, spacious building provided with all the necessities. The State feeds them, clothes them, looks after their health, and makes sure that nothing casts a shadow over their old age." In their leisure the elders take reading courses, work as volunteers, sew warm, traditional shoes for Comrade Stalin, and sign petitions for international peace. Even the shaman, who used to scare the village children, gives up his pranks and lets his granddaughters donate his robe and sacred bones to the local museum.[51]

If this is how the narrative began, what could its ending be? Where could one go from paradise? One possibility was to take refuge in 1930s-style folklore,[52] but there was no escaping the writer's primary responsibility—"to portray life as it is [*pravdivo otrazhat zhizn*]." Thus in the 1960s and 1970s the "legends" and historical Long Journeys both had to take a back seat to what could only be termed "Short Journeys"—usually short stories dealing with the last vestige of untamed spontaneity, the conflict being between very good and very good indeed. The basic proposition is well illustrated by the following exchange from Semyon Kurilov's "Uvidimsia v tundre" (See You in the Tundra): "The Yukagir have started living really well," exclaims a young man, back in his native land after two years in the army. " 'Yes, but they've got to live even better,' says the secretary of the district Party committee."[53]

Each such story represented a small, irreversible step toward consciousness, culture, and Russianness. In the absence of villains, it was essentially an inner journey by one hero, as he (almost never she) purged himself of his

last remaining trace of backwardness: a former shaman throws his wooden idols under a tractor to help the Russian driver get out of a ditch; an old patriarch becomes a housewife to support his daughter's record-breaking productivity; a dying hunter ignores an ancient curse to lead his geologist son to a rich mineral deposit in the tundra; an old kolkhoznik fishes in a taboo spot and comes back with a spectacular catch; an elderly couple find happiness after they are finally persuaded to move into a Russian-type house; a young man sees the light when a Russian doctor saves his wife and newborn child who were almost killed by traditional practices; and two young lovers from the same exogenous clan get married and live happily ever after. Interspersed with these were stories that assumed total national equality "in content" and dealt with the last few wrinkles in the "neatly ironed tablecloth" of Soviet life without making any reference to their heroes' indigenous origins. The hero's challenge was to pass a dramatic test "at work" or in his "personal life" and thus clear himself of all suspicion of puerile impetuousity or doddering complacency.[54]

Meanwhile, having been relegated to the "historical novel" category, the Long Journey narrative was losing its inner wholeness along with its dominance. If the 1930s Bolshevik had found it easy to be a father to the natives, his blue-eyed postwar successor had to struggle to maintain this role even as everyone around him began combining business with plea-sure and he himself became more personally involved in the intimate lives of his charges. By the 1970s his youth and virility had become sources of strain. Istomin's Bolshevik, for example, broods and agonizes until he is almost seduced by the alluring daughter of a kulak. He does pull back at the last moment ("We're of different faiths! . . . I'm a Bolshevik from the working people! And she's a rich girl, the daughter of an enemy of the people's power"), but some of the mystique and the inner conviction is lost forever.[55] No matter how firm the Bolshevik may be, there is nothing he can do about his effect on the native women. Increasingly, the willful and determined Amazon's decision to mobilize the population in support of the Russian is due to her romantic interest in him: "Wherever you go, I'll go with you. I want to walk by your side."[56] Even Rytkheu's Ushakov, impeccably ascetic and asexual in the traditional mold, cannot help notic-ing the peculiar electricity produced by one of his very first appearances among the Eskimos: " 'My dear friends and comrades,' Ushakov began and looked over the audience. It seemed to him that Nanekhak was suddenly shaken by a kind of strange tremor and a fleeting smile appeared on her round face with its still childish features."[57]

What follows represents a considerable challenge in terms of plot development. Nanekhak, married to a colorless but virtuous fellow, is Ushakov's staunchest disciple, but her devotion is obviously based on physical attraction and thus potentially subversive. The model of the Russian/ native relationship sanctioned by and reproduced in the Long Journey narrative required the Russian to be godlike and the natives to achieve a perfect state of happiness. In *Ostrov nadezhdy* (The Island of Hope), however, these two conditions cannot both be met: either he will have to surrender his aura of mystery or she—and hence the people she represents— will have to remain unhappy. The solution is suggested by Christianity, an old ally of Soviet mythmakers. During a sea hunt Ushakov falls into the icy water and is saved from death by hypothermia by Nanekhak, who (in her husband's presence) takes off her clothes and warms him with her body. Shortly afterward she becomes pregnant and declares that the child is Ushakov's. The reader, the husband, and Ushakov himself all know that it is not true ("Nothing really happened between us," he protests), but Nanekhak will have none of that. She goes on to produce a son and names him after Ushakov, whom she has officiate at the ceremony of "Soviet baptism." The Bolshevik thus remains divine, while the Amazon attains complete fulfillment. The first fruit of the Russian/Eskimo alliance issues from an immaculate conception.

Such plot resolutions represented precarious balancing acts at a time when most scholars and writers were questioning—no matter how obliquely—the infallibility of the Bolshevik mentor. Whether he had been too dogmatic or had "broken too many eggs," he was overcome by self-doubt.[58] In at least two Long Journey novels, the Russian hero broke down, fell in love, and finally consummated his relationship with the native girl.[59] Before this could happen, however, she had to cease being a loyal disciple and empty vessel: if he must fall, she has to provide a truly powerful temptation; if he must be demoted from patriarch, she has to outgrow her filial status by acquiring autonomy and mystery in her own right. In a dramatic reversal of the fictional native hierarchy, she becomes a shaman. Rather than rebelling against the oppressive obsolescence of her tribe, she becomes its guardian and main representative, "the mistress of the taiga": "There is fire in her black eyes; her braids tremble on her breast with a tinkling of coins, her gestures are energetic and imperious."[60]

It is, of course, no accident that she looks like a Gypsy or a Circassian, but neither novel breaks with the Long Journey paradigm. There is no doubt about the superiority of the Russian way (progress), and the Bolshe-

vik, although fascinated by the magnificence of the shaman's "art," never considers conversion. She, not he, is a tragic figure, "a knight of woeful countenance." [61] He loses his chastity, but keeps his faith; she has to surrender her very identity if she is to find love. In the end, she makes the right choice and, in Kuzakov's *Liubov' shamanki* (Shaman's Love), quite literally relegates the image of the clan's founder, along with her own vestments, to the museum. For obvious reasons, we are not shown the conjugal bliss that follows: he loves her mysterious poetry, but agrees to marry her only on condition that she forsake it. The proud "mistress of the taiga" could not survive in front of a TV set or a sewing machine.

A subspecies of the Long Journey narrative—the education of a young northerner in a big city—was also undergoing important changes. In the 1930s the youngster's quest had resulted in the discovery of social justice (along with high technology and human warmth); in the first postwar years he had been struck by the unique qualities of the simple Russian people; and by the 1970s he was writing his memoirs and talking almost exclusively about "culture." Living in Moscow and Leningrad and looking back on their pilgrimage, college-educated northern writers told a story of physical and spiritual liberation. Their origins were painful and grim, as all Long Journey origins had to be: "A cramped and dark dwelling with an earthen floor, with rows of beds from one wall to another, with smoke flues under the beds and the dirty rags of the shaman's children, never seeing light in the winter and always scorched by the sun in the summer—did we really live like that at the turn of the century and for a thousand years?" [62]

It was no longer the image of Lenin, however, that opened a boy's eyes to a new world of light and freedom. It was Pushkin. Or Lermontov. Or Tolstoy. "The Russian book. It took me very far away from the usual howling of a blizzard outside, from the frosty tinkling of the high Siberian stars." [63] Rytkheu's young hero quite explicitly models himself on Gorky's *Childhood* as he devours book after book in his dark hiding place; the books themselves "were the little rays that lit up the world hidden from Rintyn." [64] Thus, the traditional light/darkness opposition took on a new, more "elemental" meaning as it pit the poles of "nature" and "culture" against each other:

Nature is the fur of the bearskin and my fears. The blizzards. The world of beauty is school, books, and Russian speech. Nature enslaved me; culture liberated me. I wanted to get away from nature and move into the world of culture.[65]

As a guide into the world of culture thus defined, a Bolshevik would not do. Only a true member of the Russian intelligentsia, a priest at the altar of Pushkin and Gogol, could introduce the novice to the mysteries of spiritual freedom. Both Rytkheu's and Kile's heroes are orphans, and as they look for Russian surrogate fathers, they look for erudition and book learning. In his remarkable memoir, Pyotr Kile evokes unmistakably Bulgakovian images of the heavy dignity of the tradition-bound aristocracy of the spirit: "Some doors, according to the ancient custom, have brass plaques: 'Professor So-and-so.' And I like that." In one crucial scene, the narrator is taking an entrance exam from a college history professor, a benevolent old *intelligent,* when he realizes that their mentor/disciple relationship extends far beyond the classroom: "It was always like this in my life when I met real Russian *intelligenty.* I had realized it early on, and my dream of a great life was often associated with my being adopted by just such an old man and his old wife, who would live in Leningrad"—not in the city of Lenin's revolution, that is, or of Peter's empire, but in the city still haunted by Pushkin and Dostoevsky. The equality attained through membership in the intelligentsia is cemented by friendship with a Russian. "It was uncanny how we, living one thousand miles apart—I in the taiga wilderness and he in Leningrad—had thought about basically the same things and discovered the same writers. And it was pleasant to realize that we were equal, that I liked him and he liked me." [66]

At the end of his journey, the pilgrim usually acquired a Russian wife and became a Russian writer or teacher.[67] The child of their marriage (a "gift from Russia") would grow up entirely in the world of culture (in Russia), while the fruit of the pilgrim's creative labors was clearly destined for his new and true peers, the Russian intelligentsia.

There is no point in writing in my native language because out of eight thousand Nanai living in this world, any who read poetry read it in Russian. There is no need to translate Pushkin into Nanai. I love Pushkin in the element of Russian speech and I cannot reject it. In any case, writing poetry in any other language strikes me as strange. And who knows to what extent Russian has become my native language? [68]

By 1972, when Kile's book came out, the nature/culture dichotomy had become a popular theme. A growing number of people, however, disagreed with Kile as to the relative value of the two categories. Ever since the Twentieth Party Congress in 1956, writers had been sending their

young heroes away from the big cities in search of fulfillment elsewhere. The emperor, as his heirs proclaimed to the people, did not have a full suit of clothes, and to the eyes of some members of the cheated generation, neither did his heirs. The reassertion of family values after the Great Transformation and the promotion of bureaucratic sensitivity after the war had already softened Soviet revolutionary urbanism; now a whole cohort of authors was rejecting "culture," as represented by Moscow and Leningrad, in favor of "nature," as represented by faraway wooded places. The mecca for young northerners was increasingly seen by its native inhabitants as a world of *poshlost,* of triviality, vulgarity, and falsehood. The Thaw had placed the past in question and hence obscured the future, with the present still dominated by the productive and occasionally adulterous little family eating borscht in their cozy little apartment. Where, asked the stifled and jaded young hero, was the place for true feelings, time-tested certainties, true love, and eternal friendship? The farther from "shawls with nice tassels" the better was the answer, as dozens of fictional youngsters streamed out of the capitals to hunt, hike, or join geological expeditions.[69]

Once again, the "Extreme North" emerged as a dangerous and harsh (*surovaia*) wilderness, a perfect place to separate the "real people" (*dostoinye liudi*) from the "dudes" (*pizhony*).[70] "The tundra does not like the weak," proclaimed the title of a typical book on the subject.[71] But if the snowbound desert of Stalin's romantic explorers had been an enemy to be defeated and contained once and for all, the North of the 1960s was a stern mentor, a repository of true values forgotten by the decadent, effeminate urbanites. "The tundra helps a person understand himself and find his place in the world," and it could do so because "the harsh conditions force one to break with all things meaningless and futile."[72] The old North had been largely uninhabited—there was no place for indigenous foragers in a world of polar exploration and technological advances; the new North, as it turned out, was populated by people who had had the benefit of this harsh, meaningful life for many generations. Just as refugees to other areas had rediscovered the beauty and purity of remote Russian villages, polar travelers found that unspoiled nature produced unspoiled, natural people: "The North does not coddle people. It demands from them a total emotional and physical commitment. It was probably the harsh northern landscape that had tempered small peoples of a very special kind. Their character and customs are just as simple, laconic, and beautiful as nature itself."[73]

Thus, for the first time since the 1920s, native northerners were re-

appearing in Russian literature as the artless, unaffected, and noble children of nature who were always willing to instruct the misguided representative of "culture." An unbiased city dweller who spent some time in their midst would eventually stop looking for "politely indifferent smiles concealing ill will" and would realize that "here in the tundra there was no distinction between yours and mine; grief and joy were divided equally among all." [74] Even professional ethnographers, writing in their institute-sponsored publications about ethnic merging and rising living standards, put quotation marks around "civilization" when they were addressing a popular audience. In the 1960s and 1970s many young authors and their young readers agreed that it was time to embark on a long journey in the opposite direction. "Their settlements may have electric light and radio, but even today the life of the Evenk is full of adventure and danger, of the joys and disappointments of people who live within nature and not outside of it." [75]

What were these natural people like at close range? The socialist realist tradition had defined "spontaneity" as a lack of "consciousness" (and later, culture), as a world of darkness from which to escape. If one wished to reverse the equation, one had to look elsewhere. Two obvious alternatives were the Amazons of early Russian romanticism and the "redskins" of James Fenimore Cooper. Both were well-known companions of Soviet adolescent readers, and as early as 1951 a young Chukchi Party secretary could gain prestige by posing as a Mohican: "His aquiline nose and tightly pressed lips gave a stern expression to his face. His proud posture and the dignity apparent in his every gesture and glance made him look like an Indian chief." [76] While each model proved fairly productive, neither was quite right for the USSR of the 1960s because of their unavoidably tragic finale: the Indians derived their nobility from being doomed, and the Circassian girl had to die or disappear to remain attractive. These outcomes clashed with the essential optimism of the new Soviet romanticism, which assumed that the fugitive from culture would be accepted by nature. What was needed was a noble savage who could repeatedly enlighten the urbanite without losing his nobility. What was needed was a Dersu Uzala.

In fact, the death of Arsenev's solitary hunter and philosopher was totally accidental. The narrative did not require a direct confrontation between the wise old man and the corrupt world of false civilization. To be himself, all Dersu Uzala needed was his native environment and a disciple who was willing, even eager, to cast off the blinders of civilization and be

instructed in the art of living. Arsenev could have killed off his hero after the very first expedition, or not at all: Dersu's only function was to serve as a guide—physical and spiritual. When a new generation of Russian romantics arrived in the taiga, therefore, the old pathfinder was brought back into service. His most popular reincarnation was Fedoseev's Ulukitkan, a wise Evenk hunter and the loyal friend of Siberian geodesists. In the intervening years he has aged and mellowed a great deal; now over eighty, Ulukitkan is "tiny, frail, and always meek," "almost transparent." His coat is old and worn-out, his fur boots old and barely patched up, his gun old and unwieldy. "His hands do not have their former nimbleness; his old back does not bend too well; and when his feet fall through the snow, he can get up only with my assistance, like a helpless child."[77] All the more remarkable, therefore, that preserved intact are his wisdom, his tenacity, his "imperturbable calmness," his ability to "comprehend the nature of things" as well as all things in nature, "his total ignorance of the meaning of lies, hypocrisy, and weakness!"[78] In a key episode, Ulukitkan loses his eyesight, yet even blind he can see more than his vigorous Russian friend and employer. Always the guide, he can lead the narrator to safety because his strength and knowledge are of a different kind: he is at one with the mystery of nature. Curiously—and invariably—he also went one on one with nature. According to Fedoseev, the "law of the taiga" (jungle) required that an individual learn its ways the hard way—on his own.[79] City dwellers, who were fleeing frantic crowds, false intimacy, and enforced collectivism, understandably (and presumably to the dismay of students of primitive communism) found the natural man to be a Byronic loner and a committed individualist. When the narrator suggests that Ulukitkan sing along with him, the old Evenk snaps: "Even if two men live in the same tent, eat out of the same pot, and walk on the same trail, they think differently. How is it possible to sing together?! . . . No, you sing your song, and I'll sing mine."[80]

This did not mean, however, that light and darkness should switch places completely or that the long journey had to be reversed. When Fedoseev, himself a geodesist and an explorer, moved from travelogue to more structured and more "novelistic" forms, he had young Ulukitkan suffer under the old regime and sacrifice his own family in order to lead a giant Bolshevik to a rich mineral deposit in the mountains.[81] How could these tensions be reconciled? Other than censorship, was there anything that Soviet power could bring to the already wise native northerners? Ap-

parently so. In an ironic twist, one role of the Russian disciple was to force his guide to be more consistent in his philosophy. If being natural involved understanding nature, and if "to understand it meant to know how to fight it," then most traditional beliefs were superstitions obscuring the great truth of the law of the taiga.[82] "I know perfectly well," says Fedoseev's narrator, "that all this stuff [Ulukitkan's belief in spirits] is but an echo of the past. In fact, he believes only in his own strength and his knowledge of nature."[83] Thus, in typical Short Journey mode, Russian disciples challenged their misguided mentors to disregard the taboo, to go to an "enchanted" spot and recognize, once and for all, that the gods stood for weakness, while true knowledge stood for self-reliance. One of Ulukitkan's doubles, a deaf-mute old hunter more eloquent than most mortals, ends up killing an evil spirit (in fact, a man-eating bear) to save his Russian friend. "The old man understood that man was stronger than the spirit. And everything that he had inherited from his ancestors suddenly collapsed."[84]

"Everything" was obviously an exaggeration, but most authors still agreed that some elements of tradition owed their existence to true backwardness and had to go: "Today you aren't going to obtain fire the way your grandfather did — you've got matches. It's been a long time since you last hunted with a crossbow. And what about the radio in the tent? Your grandmother would never have dreamed of that!"[85] Another narrator, waxing nostalgic on the quaint little settlements of his childhood, interrupts himself with the question: "Would you really want your children to grow up in this godforsaken hole, not knowing what television, theater, and the Palace of Young Pioneers are? Of course not. It's not for nothing that I have betrayed the taiga myself." His guide, an old Evenk woman, shares his sentiments, ridiculing a romantic writer who has bemoaned the disappearance of this earthly paradise: "Let him come and live in the taiga by himself, and then tell us all about paradise."[86]

The Soviet State, then, was to abolish the backwardness, dirt, and isolation while preserving the ancient wisdom, purity, and "imperturbable calmness." The true goal of the Long Journey was to combine the best of nature and culture, to ensure a harmonious merging of town and country. In a sense, the Russian State was to inherit the best of the indigenous traditions, building on them and weaving them into the modern world. In symbolic recognition of this fact, Vladimir Kornakov's old Cheglok, "the Last of the Falcon Tribe," passes his "baton" to the geologists he has

served for many years. They have learned true wisdom; they understand that people should not destroy the house in which they live.[87] Similarly, Agishev's Aianka works as a professional forest ranger, urging his geologist friends to "look after the green house." [88] The indigenous tradition and the State interest had become one and the same thing.

This called for further plot adjustments. Nikolai Shundik, the first novelist to dress up Party secretaries as Indians, constructed a traditional Long Journey narrative in which the native convert is a "white" (good) shaman, a wise old man with an Indian profile who can communicate with all living things. A peculiar Dersu-meets-Komsomol-girl character, he enthusiastically accepts boarding schools, hospitals, and collectivization, while introducing his fascinated teachers to the anthropomorphic world of his forebears. The Bolsheviks need the white shaman because they realize that true social justice is but one element of a broader natural harmony. In the USSR, as in the West, the new romantics had discovered environmentalism, and their noble savages had no choice but to do likewise.

How many people like that are still left on this planet, people who understand the animal soul as if it were their own, understand their language and behavior and, most important, understand how much man needs a natural link with his little brothers, and not only with them, but with every leaf, every blade of grass, everything that comprises the great concept of life? [89]

Even Yuri Rytkheu, creator of Long Journeys par excellence, joined the fold in putting quotation marks around "the civilized world" and in arguing that the circumpolar peoples had created a unique civilization of their own, having "discovered" their environment long before the European explorers and having generally acquired "truthful information about nature and man that had allowed these people not only to exist in extreme climatic conditions, but also to create an amazing material culture, a moral code, and popular medicine." [90] (Much of this culture, it turned out, had been transmitted by the shamans — not the "scarecrow" that Rytkheu and others had been "guilty" of depicting, but "the most knowledgeable and experienced person of the tribe." [91]) Yet this subtle and fragile civilization would probably have perished under the onslaught of the predatory whites had it not been for that very special brand of whites — "the true knights of the idea of social transformation," who had understood the real but inarticulate aspirations of the indigenous peoples.

The new ideology corresponded fully to the innermost dreams of the inhabitants of the northeastern tip of Asia. . . . The ideas of social equality based on a just attitude toward work as the true measure of everything real and human—these were the very things that constituted the foundation of the philosophy of the Chukchi-Eskimo working community, never formulated but practiced for centuries.[92]

Thus, the revived dichotomy of native (nature) versus Russian (culture) was overcome by the discovery that natives had a high (communistic) culture of their own and that Russians were sensitive to the environment. Moreover, as a growing number of writers discovered purity and true values in Russia's rural present and remote past, this unique consonance was once again extended back to the pre-Soviet period. Now, however, amidst the increasing popularity of folkish romanticism and retrospective environmentalism, the unifying force was no longer the Russian State, but an alliance of like-minded and tradition-bound peasants and foragers. In a bizarre elaboration on this theme, Alexander Sheludiakov populated northwestern Siberia with the animist descendants of Novgorodian refugees from Christianity who "worship the beauty and spirit of nature" in the same way as their indigenous brothers and sisters. In similar customs and rituals, both groups celebrate "the fabulous kingdom of birds and animals, the amazing sea of flowers in the meadows . . . the mysterious sky and that wonder of wonders of the Universe—the immortal sun." [93] Indeed, it turns out that "the conservation of nature and ancient graves became law in Russia in the ninth century: at that time Russian princes and communes were already limiting wood-cutting and protecting certain rare animals." They were not mindless preservationists, however. For centuries the native northerners and the "glorious descendants of the Novgorodian divines" have been extracting petroleum for their own use. No wonder, therefore, that they greet the new oil and gas industry with open arms: laying pipelines through their forests indicates respect for their ancient traditions.[94] In the end, Sheludiakov's wise old Evenk woman and the district Party secretary (the grandson of a Civil War hero) agree on the need for both continuity and oil exploration. The traditional representatives of nature and culture have nothing left to quarrel about.[95]

This resolution was precariously balanced. Every once in a while even the most serene of Dersu's sons would complain that young school graduates could "not tell a dog's tracks from a wolf's," could not find their way in the taiga, and could not speak the language of their elders.[96] Was it

possible that TV sets and pipelines could not, after all, be reconciled with nature—and if nature and native culture were synonymous, was it possible that they were inimical to native life? In an age when Russian authors were looking for unspoiled rural sources of a nonbureaucratic Russian identity, it could only be a matter of time before a similar opposition was formulated by a northern writer.

In fact, by the late 1960s, Vladimir Sangi, a Nivkh folklorist and fiction writer, had essentially rejected the idea of Russia as social paradise, brother-protector, guide to world culture, or even fellow-guardian of traditional values. Sangi's heroes are wise old tribesmen who not only epitomize tradition and continuity, but refuse to serve as guides to curious Europeans. Their tradition is for their people only and is supposed to stay that way. They are the only mentors, and their Russian-educated grandchildren the only students. Indeed, the youngster might have a college degree or a fancy job; he might have taken many an exam from Russian school teachers, Party secretaries, or university professors, but his one true test, his real rite of passage, is the traditional test of the taiga. In the course of the ordeal (usually a hunt), the elder proves his continuing wisdom and relevance, while the youth proves that he is "not a youth but a man"—a real Nivkh.[97] In his short novel *Lozhnyi gon* (False Chase), Sangi dots the i's by introducing a third character—a "rootless" shock worker in his prime, a man of uncertain lineage but with superior kolkhoz and newspaper credentials. As events unfold, with the old hunter asserting his nobility and the young apprentice demonstrating his courage, the shock worker is exposed as a cheat and a ruthless predator. Moreover, it turns out that he is a former kolkhoz chairman who had distinguished himself by forcibly settling his people, ruining them in the process, and having at least one of them arrested and executed for insubordination. For the first time, the Long Journey has been attacked directly and unequivocally; heroes and villains have switched places.

Having undermined the dominant formula, Sangi proceeded to reverse the standard images of prerevolutionary Russo-northern cooperation as well. In *Zhenit'ba Kevongov* (The Marriage of the Kevongs), the first Russians to present themselves before the Nivkh are escaped prisoners—hairy monsters who rape, pillage, and murder as only the Americans and Japanese have done before.[98] This first encounter is prophetic: the story that follows describes the slow disintegration of a Nivkh clan after the arrival of Russian and Yakut traders. What rape and murder failed to accomplish is

achieved by money, liquor, and enslavement. Far from bringing light into the lives of the northern peoples, let alone supporting them in their environmentalism, Russian culture has brought nothing but death and corruption. As far as Sangi was concerned, the Long Journey had been a trail of tears. Dersu Uzala had traveled to the future and come back unimpressed.

Notes

1 V. K. Arsen'ev, *Izbrannye proizvedeniia v dvukh tomakh* (Selected Works in Two Volumes) (Moscow, 1986), 1: 41. Cf. A. A. Fadeev, *Poslednii iz Udege* (The Last of the Udege), in *Sobranie sochinenii* (Collected Works), Vol. 2 (Moscow, 1970).

2 "The long journey" was the conventional metaphor for the northern peoples' flight from the past; cf. the titles of A. Koptelov's *Velikoe kochev'e* (The Great Trek), M. Osharov's *Bol'shoi argish* (The Long Trek), I. Gol'dberg's "Bol'shaia nul'ga Barkaulia" (Barkaul's Long Trek) and "Kak Iukhartsa poshel po novym tropam" (How Iukhartsa Set Out on New Paths), and R. Fraerman's "Puteshestvie v nastoiashchee" (Journey into the Present), *Nikichen,* in *Izbrannoe* (Selected Works) (Moscow, 1958).

3 G. Gor, *Nesi menia, reka* (Carry Me, River), in *Bol'shie pikhtovye lesa* (The Big Silver-Fir Forests) (Leningrad, 1968), 186; and I. Kratt, "Kaiur" (The Sled Driver), in *Moia zemlia: Kolymskie rasskazy* (My Land: The Kolyma Stories) (Moscow, 1938), 51.

4 T. Borisov, *Syn orla* (Son of the Eagle) (Khabarovsk, 1939), 156. See also V. Itin, "V chume" (In the Tent), *Sibirskii okhotnik,* No. 3 (1930): 62.

5 I. Kratt, "Ulakhan poslednii" (Ulakhan the Last), in *Moia zemlia,* 31; I. Kratt "Tin'ka," in *Dal'niaia bukhta* (The Faraway Bay) (Leningrad, 1945), 158; Gor, *Nesi menia, reka,* 264.

6 V. G. Bogoraz, *Voskresshee plemia* (The Resurrected Tribe) (Moscow, 1935), 93. Cf. G. Gor, "U bol'shoi reki" (By the Big River), in *Bol'shie pikhtovye lesa,* 26.

7 Bogoraz, *Voskresshee plemia,* 95.

8 R. Fraerman, *Vas'ka-giliak* (Vaska the Giliak), in *Izbrannoe,* 136.

9 Borisov, *Syn orla,* 122; Fraerman, *Vas'ka-giliak,* 163, 180; A. L. Koptelov, *Velikoe kochev'e* (Moscow, 1937), 231; Nikolai Nikolaevich, "Sukonnaia rukavichka" (The Broadcloth Mitten), *Okhotnik i rybak Sibiri,* No. 8 (1929): 46–55; I. Sel'vinskii, *Umka belyi medved'* (Umka the Polar Bear), in *Sobranie sochinenii v shesti tomakh* (Collected Works in Six Volumes) (Moscow, 1973), 4: 49–50; I. Voblov, "Eskimosskaia byl'" (An Eskimo Tale), *Sovetskaia Arktika,* No. 9 (1937): 56–61.

10 Bogoraz, *Voskresshee plemia,* 79, 87.

11 See, for example, Kratt, "Ulakhan poslednii"; and "Moia zemlia," in *Moia*

zemlia; Fraerman, *Nikichen;* Gor, *Nesi menia, reka;* Koptelov, *Velikoe kochev'e;* G. Mok-shanskii, "Tygrena iz stoibishcha Akkani" (Tygrena from the Akkani Camp), *Sovet-skii sever* 3 (1933): 113–15; P. Kuchiiak, "Arbachi," *Sibirskie ogni,* No. 2 (1935): 107–12; Nikolai Nikolaevich, "Sukonnaia rukavichka," *Okhotnik i rybak Sibiri,* No. 8 (1929): 46–55; and V. Petri, "Dun'ka-okhotnitsa" (Dunka the Hunter), *Okhotnik i rybak Sibiri,* No. 10 (1929): 48–51.

12 Voblov, "Eskimosskaia byl'," 61.

13 Kratt, "Ulakhan poslednii," 35.

14 Ibid., 41.

15 See Gor, "U bol'shoi reki"; and *Lanzhero,* 345ff.; Kratt, "Pastukh" (The Rein-deer Herder), *Moia zemlia;* G. F. Kungurov, *Topka* (Irkutsk, 1964); T. Z. Semush-kin, *Chukotka* (Moscow, 1941), 310ff.; Koptelov, *Velikoe kochev'e;* Sel'vinskii, *Umka belyi medved'.*

16 See Gor, "U bol'shoi reki"; "Ivt odnoglazyi" (One-Eyed Ivt); and "Starik Tevka" (Old Man Tevka), in *Nesi menia, reka;* and *Lanzhero.*

17 Sel'vinskii, *Umka belyi medved',* 80. Such imposters include Kratt's Dudiuk, Koptelov's Govorukhin, and Gor's Samovarov.

18 Quoted in Sel'vinskii, *Sobranie sochinenii,* 4: 411. Actually, Sel'vinskii overdid the "all fours" part, and the play was cancelled in 1935 after "a group of Chukchi" complained that it was "slanderous," "insulting," and full of "disgusting details." See *Pravda,* 18 April 1937; and "Vrednaia p'esa iz zhizni luoravetlanov" (A Vile Play about the Life of the Luoravetlan), *Sovetskaia etnografiia,* No. 4 (1937): 153–54.

19 M. Zinger, "Ukunaut," in *Severnye rasskazy* (Northern Stories) (Moscow, 1938); A. I. Mineev, *Ostrov Vrangelia* (Wrangel Island) (Moscow, 1946); Kratt, "Zolotoi-skateli" (The Gold Miners), in *Moia zemlia.* See Katerina Clark, *The Soviet Novel: History as Ritual* (Chicago, 1981), 102–3.

20 I. G. Gol'dberg, "Evseikina pesnia" (Evseika's Song), in *Izbrannye proizvedeniia* (Moscow, 1972).

21 See, in particular, the work of Ivan Kratt, Nikolai Maksimov, S. N. Markov, and Nikolai Zadornov.

22 I will include in this section a number of later works that reproduced the "master plot" formulated in the first postwar decade.

23 See R. Agishev, *Syn taigi* (Son of the Taiga) (Moscow, 1968 [1947]); S. Byto-voi, *Poezd prishel na Tumnin* (The Train Arrived in Tumnin) (Leningrad, 1951); and *Sady u okeana* (Gardens by the Ocean) (Leningrad, 1957).

24 See Iu. Rytkheu, *V doline malen'kikh zaichikov* (In the Valley of Little Rabbits) (Leningrad, 1972); N. E. Shundik, *Bystronogii olen'* (The Fleet-Footed Deer), in *So-branie sochinenii,* Vol. 1 (Moscow, 1983 [1947–51]); and V. N. Azhaev, *Daleko ot Moskvy* (Far from Moscow) (Moscow, 1949). Azhaev's novel is primarily concerned with other matters, but the native Long Journey is an important subplot.

25 Azhaev's Zalkind was one of the last Jewish Bolsheviks.

26 Azhaev, *Daleko ot Moskvy,* 30; see also T. Semushkin, *Alitet ukhodit v gory* (Alitet Leaves for the Mountains) (Moscow, 1974), 40, 47, 49, 127, 143, 144, 152, 159, 161, 168.

27 Semushkin, *Alitet ukhodit v gory,* 122; N. Shundik, *Belyi shaman* (The White Shaman), in *Sobranie sochinenii* (Moscow, 1984), 3: 68, 123. See also Bytovoi, *Poezd prishel na Tumnin,* 25; and *Sady u okeana,* 18; N. Shundik, *Na Severe Dal'nem* (In the Far North) (Moscow and Leningrad, 1952), 9; V. Sangi, *Izgin* (Moscow, 1969), 105–6; and A. Nerkagi, *Severnye povesti* (Northern Tales) (Moscow, 1983), 37.

28 Rytkheu, *V doline malen'kikh zaichikov,* 36; see also Iu. Rytkheu, *Ostrov nadezhdy* (The Island of Hope) (Moscow, 1987), 14; and Iu. Shestalov, *Izbrannoe* (Leningrad, 1976), 190.

29 Iu. Rytkheu, *Povesti* (Stories) (Leningrad, 1972), 228.

30 Rytkheu, *Ostrov nadezhdy,* 14. After the creation of a nature reserve on the island in 1976, most of the settlers were moved back to the mainland.

31 See, for example, Semushkin, *Alitet ukhodit v gory,* 40–49, 104, 118, 143–68, 187; Shundik *Na Severe Dal'nem,* 33, 37; and Rytkheu, *Ostrov nadezhdy,* 27.

32 See, in particular, Shundik, *Na Severe Dal'nem;* see also Semushkin, *Alitet ukhodit v gory;* Shundik, *Bystronogii olen';* G. Khodzher, *Belaia tishina* (White Silence) (Moscow, 1970), 7084; Iu. Rytkheu, *Inei na poroge* (Frost on the Doorstep) (Moscow, 1971), 66ff., 151–58; and *Povesti* 133, 208–10.

33 See Shundik, *Na Severe Dal'nem,* 336–41; and Rytkheu, *Povesti,* 84.

34 Rytkheu, *Povesti,* 13–106.

35 Iu. Shestalov, *Shag cherez tysiacheletiia* (A Step across Millennia) (Moscow, 1974), 19.

36 See Vera S. Dunham, *In Stalin's Time: Middleclass Values in Soviet Fiction* (Durham, 1990); Clark, *Soviet Novel,* 189–209. See also R. Rugin, *Solntse nad snegami* (The Sun over the Snow) (Sverdlovsk, 1986), 35–36.

37 Nerkagi, *Severnye povesti,* 60; see also P. Kile, *Idti vechno* (To Walk Forever) (Novosibirsk, 1972), 24.

38 Iu. I. Shamshurin, *U studenogo moria* (By the Frozen Sea) (Moscow, 1952), 88; Rytkheu, *Ostrov nadezhdy,* 111 et passim.

39 Azhaev, *Daleko ot Moskvy,* 279.

40 Cf. Dunham, *In Stalin's Time,* 22, 59–86, 188–90; and Clark, *Soviet Novel,* 199–204. For examples, see Semushkin, *Alitet ukhodit v gory;* Shundik, *Bystronogii olen';* Azhaev, *Daleko ot Moskvy;* Khodzer, *Belaia tishina;* Rytkheu, *Inei na poroge;* and *V doline malen'kikh zaichikov;* G. Khodzher, *Amur shirokii* (The Wide Amur) (Moscow, 1973); Shundik, *Belyi shaman;* Zhores Troshev, *Bol'shoi Oshar* (Krasnoiarsk, 1987).

41 In socialist realist novels set in ethnic Russia, the spontaneous hero of the 1930s was usually a young man, while the later mature and family-oriented leader could be a woman. The frequent reversal of this sequence in northern texts was

due to the persistence of the noble-savage paradigm: the best "unspoilt" natives were Amazons and wise elders, while the kindly missionary had to be male. See Shundik, *Bystronogii olen'*; Rytkheu, *V doline malen'kikh zaichikov.*

42 Shundik, *Bystronogii olen'*, 61.

43 Khodzher, *Belaia tishina*, 259.

44 See, for example, Khodzher, *Amur shirokii*; Shundik, *Belyi shaman.*

45 Rytkheu, *Ostrov nadezhdy*, 247.

46 Khodzher, *Belaia tishina*, 240.

47 Shundik's *Bystronogii olen'*, in particular, has an almost Dickensian ending with wedding bells ringing all around.

48 See Clark, *Soviet Novel*, 204–9.

49 For an early description of paradise as the heroes' present state, see Azhaev, *Daleko ot Moskvy*, 258–79. See also *Ot Moskvy do taigi odna nochevka: Sbornik* (It Is Only a Two-Day Trip from the Taiga to Moscow) (Moscow, 1961), 108, 137, 463; Rytkheu, *Povesti*, 118–19; Iu. Shestalov, *Sibirskoe uskorenie* (Siberian Acceleration) (Moscow, 1977), 22–31; and *Shag cherez tysiacheletiia*, 7–8.

50 *Ot Moskvy do taigi odna nochevka*, 457.

51 Bytovoi, *Poezd prishel na Tumnin*, 186, 156–65.

52 See, for example, I. Istomin, "Legenda," in *Radost'* (Joy) (Moscow, 1961); *Ot Moskvy do taigi odna nochevka*, 204; or Shestalov, *Shag cherez tysiacheletiia*, 12.

53 *Ot Moskvy do taigi odna nochevka*, 95.

54 See, for example, Shamshurin, *U studenogo moria*; and Iu. I. Shamshurin, *Severnaia shirota* (The Northern Latitudes) (Moscow, 1956); Istomin, *Radost'*; *Ot Moskvy do taigi odna nochevka*; I. Istomin, *Tsevety v snegakh* (Flowers in the Snow) (Moscow, 1966); Rytkheu, *Povesti*; Iu. I. Shamshurin, *Shli dvoe po tundre* (The Two Were Walking in the Tundra) (Moscow, 1972); G. Khodzher, *Pustoe ruzh'e* (The Empty Gun) (Moscow, 1982); A. Val'diu, *Svet v okne* (The Light in the Window); and Rugin, *Solntse nad snegami.*

55 I. Istomin, *Zhivun* (Moscow, 1974).

56 N. D. Kuzakov, *Liubov' shamanki* (The Shaman's Love) (Moscow, 1975), 89.

57 Rytkheu, *Ostrov nadezhdy*, 40.

58 For an early example in mainstream literature set in Russia, see V. Ovechkin, *Raionnye budni* (Rural Routines) (Moscow, 1972). See also Clark, *Soviet Novel*, 213ff.

59 Kuzakov, *Liubov' shamanki*; and Troshev, *Bol'shoi Oshar.*

60 Kuzakov, *Liubov' shamanki*, 163; see also Troshev, *Bol'shoi Oshar*, 108, 100.

61 Troshev, *Bol'shoi Oshar*, 133, 301.

62 Kile, *Idti vechno*, 22.

63 Shestalov, *Shag cherez tysiacheletiia*, 24. See also Iu. Shestalov, *Zemlia Iugoriia* (The Land of Iugoriia) (Moscow, 1985), 16.

64 Iu. Rytkheu, *Vremia taianiia snegov* (The Time of Melting Snows) (Moscow, 1981), 113 (see also pages 84 and 122).

65 Kile, *Idti vechno,* 57.

66 Ibid., 88, 65, 83.

67 Cf. Iu. Shestalov, "Iazycheskaia poema" (A Pagan Poem), in *Izbrannoe;* Rytkheu, *Vremia taianiia snegov;* Khodzher, *Pustoe ruzh'e,* 3–54; and Val'diu, *Svet v okne,* 52.

68 Kile, *Idti vechno,* 154.

69 See Clark, *Soviet Novel,* 228–31, 242.

70 Oleg Kuvaev, *Izbrannoe* (Moscow, 1988), 1: 5.

71 V. Liubovtsev and Iu. Simchenko, *Tundra ne liubit slabykh* (Moscow, 1968). See also Kuvaev, *Izbrannoe,* 1: 157.

72 Kuvaev, *Izbrannoe,* 1: 75. See also Iu. V. Simchenko, *Liudi vysokikh shirot* (The People from the High Latitudes) (Moscow, 1972), 7.

73 V. A. Tugolukov, *Sledopyty verkhom na oleniakh* (Pathfinders on Reindeer) (Moscow, 1969), 5.

74 Liubovtsev and Simchenko, *Tundra ne liubit slabykh,* 65, 67.

75 Tugolukov, *Sledopyty,* 209. See also V. A. Tugolukov, *Idushchie poperek khrebtov* (Crossing Mountain Ranges) (Krasnoiarsk, 1980 [a slightly revised version of *Sledopyty*]); V. A. Tugolukov, *Kto vy, iukagiry?* (Who Are You, the Yukagir?) (Moscow, 1979); and Iu. Simchenko, *Zimniaia doroga* (The Winter Road) (Moscow, 1985). A special case is V. V. Leont'ev, a Magadan-based writer and ethnographer who grew up among the Chukchi; see his *V Chukotskom more* (In the Chukchi Sea) (Magadan, 1961); reprinted as *Okhotniki proliva Beringa* (The Hunters of the Bering Straits) (Magadan, 1969); and *Po zemle drevnikh kerekov* (In the Land of the Ancient Kereks) (Magadan, 1976).

76 Shundik, *Sobranie sochinenii,* 1: 31.

77 G. A. Fedoseev, *Glukhoi, nevedomoi taigoiu* (In the Virgin Taiga) (Krasnoiarsk, 1960), 17, 41; *Tropoiu ispytanii* (The Path of Trials), in *Izbrannye proizvedeniia* (Moscow, 1976), 1: 33, 61–62, 262; and *Poslednii koster* (The Last Campfire), in *Izbrannye proizvedeniia,* 284.

78 Fedoseev, *Tropoiu,* 33, 196; and *Poslednii koster,* 282.

79 See, in particular, G. A. Fedoseev, *Zloi dukh Iambuia* (The Evil Spirit of Iambui), in *Izbrannye proizvedeniia,* 39–45.

80 Fedoseev, *Tropoiu,* 242.

81 Fedoseev, *Poslednii koster.*

82 Fedoseev, *Tropoiu,* 196.

83 Fedoseev, *Glukhoi,* 148.

84 Fedoseev, *Zloi dukh Iambuia,* 250. See also N. Kuzakov, *Taiga—moi dom* (The Taiga—My Home) (Moscow, 1977), esp. 51ff.

85 Fedoseev, *Zloi dukh Iambuia,* 40.

86 Kuzakov, *Taiga—moi dom,* 34, 77–78. See Johanna Nichols, "Stereotyping Interethnic Communication: The Siberian Native in Soviet Literature," in *Between*

Heaven and Hell: The Myth of Siberia in Russian Culture, ed. Galya Diment and Yuri Slezkine (New York, 1993), 204–6.

87 V. Kornakov, "Cheglok," *Sibirskie ogni,* No. 12 (1972): 69–81.

88 R. K. Agishev, *Luna v ushchel'iakh* (The Moon in the Canyons) (Moscow, 1967), 9, 45–56.

89 Shundik, *Belyi shaman,* 522–23.

90 Iu. Rytkheu, *Sovremennye legendy* (Contemporary Legends), 182, 193–94, 212, 215, 218, 269–70. See Adele Barker, "The Divided Self: Yuri Rytkheu and Contemporary Chukchi Literature," in Diment and Slezkine, eds., *Between Heaven and Hell,* 218–26.

91 Rytkheu, *Sovremennye legendy,* 214–15.

92 Ibid., 213.

93 A. Sheludiakov, *Iugana* (Moscow, 1982), 203.

94 Ibid., 264, 126–27, 254.

95 See Nichols, "Stereotyping Interethnic Communication," 206–9.

96 Fedoseev, *Zloi dukh Iambuia,* 40, 52–53; and *Tropoiu,* 199; Kuzakov, *Taiga—moi dom,* 33–34.

97 See V. Sangi, "Izgin," "U istoka" (At the Source), "Pervyi vystrel" (The First Shot), and *Lozhnyi gon,* in *V tsarstve vladyk* (In the Realm of the Masters) (Moscow, 1973). "Pervyi vystrel" and "Izgin" can also be found in *Izgin* (Moscow, 1969).

98 V. Sangi, *Zhenit'ba Kevongov* (Moscow, 1975), 59–60.

Régine Robin

THE PAST AS A DUSTBIN, OR, THE PHANTOMS
OF SOCIALIST REALISM

When I wrote *Le Réalisme socialiste: Une esthétique impossible*,[1] devoted above all to Soviet literature of the 1930s, I could hardly have known that Gorbachev's rule would end not only with the fall of Communist regimes in all the Socialist states but also with the collapse, like a house of cards, of the Soviet Union itself, which then still seemed an indestructible superpower. With the passing of time, it seems worthwhile both to examine the aesthetic environment that was intrinsic to the evolution of this regime and which came to be known as socialist realism and to investigate the remains, the monumental leftovers, the traces of those regimes destined for the new dustbins of History. Well known and often analyzed at length is the issue of how this monumental aesthetic represented a utopian attempt to disguise social tensions, to claim that a socialist society had actually been established and had succeeded in vanquishing the Old World. The New Man responded to this illusion which confounded aspirations with reality. The word "kitsch" has been used to define this aesthetic. I don't agree: kitsch, or bad taste, seems to me more perfectly reflected in the examination of the concept of average taste attempted by two former Soviet artists who became Americans.

The 14 March 1994 issue of *The Nation* included the results of a curious poll conducted in the context of an exhibit of paintings at a museum on lower Broadway in Manhattan. Based on a representative sample of 1001 people throughout the United States, this poll sought to elicit the aesthetic tastes of average Americans with regard to painting. Apart from objective questions on the respondents' social and cultural background, most of the questionnaire concerned their taste. What color did most Americans prefer? Up to 49 percent of the respondents answered "blue," with "green" a close second. Did they prefer contemporary or classical painting? A strong preference for classical art emerged. What did they like to see represented? The available options were lakes, rivers, the sea or ocean, rural landscapes, and "cityscapes." The vast majority chose landscapes with lakes. Did they like landscapes as such or preferably with people? They preferred landscapes with people. Nude or clothed? These people should definitely be

clothed. Should they look grave or untroubled? Untroubled. Should they be working or relaxing? They should be utterly relaxed. What season should this landscape with a lake and a group of people represent? Autumn or summer. A number of questions referred to the ideal size of the picture: not too small but not too big either — the size of a large television screen or of the surface of a washing machine rather than a refrigerator, for example. The poll goes on like this, with more than ninety questions to answer. None of this is particularly striking. This is still the framework of sociology of taste à la Pierre Bourdieu. Less banal was the exhibition that spawned the poll, which had been mounted by two artists, Vitaly Komar and Alexander Melamid, both former Soviet dissidents who had been living in the United States for a number of years.

Based on the results of the poll, they decided to create two pictures: an anti-picture representing what Americans liked the least and, conversely, an ideal picture corresponding to what Americans preferred in their paintings. All of this was accompanied by grandiose ideological pronouncements which left the viewer in the dark about whether these were serious statements or a cynical declaration by two artists who wanted to show that they had not swallowed their own bait. Society has long resorted to polls to discover what the public likes, what people prefer in terms of color, taste, packaging, design, and the organization of messages. No one would find this scandalous. By the same token, politicians have long resorted to polls in order to discover the public's desires, and sometimes they have adjusted their political programs to conform to the wishes of the majority. Everyone considers this to be part of democracy and no one finds it scandalous. Why should art be exempt from majority rule? The artists positioned themselves as executors of the will of the people and intended to find in this populism the root of artistic democracy. Those who complained would inevitably be dismissed as belated modernists who failed to understand that society had changed and that there was no longer any hierarchy in the domain of taste, values, and representation.

The ideal picture resembles those "daubs" that might be found at a flea market or in the Place du Tertre. It is of average size and represents a landscape with a lake, blue and calm, surrounded by green hills, with a light touch of yellow here and there to show that it is the end of summer or the beginning of fall. At the edge of the lake there is a group of people, obviously a family and obviously on vacation. One cannot see them clearly, but they look serene. Nothing is grotesque, nothing is disquieting. The picture

is sleek and smooth, without visible brush strokes, so that the act of painting is not inscribed on the picture. It makes one think of a photograph in a family album. This was, in fact, the preference of the vast majority of respondents to the questionnaire: the more a picture resembles a photograph, the better. We are talking about banality, artistic mediocrity, and, above all, about the conformity of kitsch: a craving for reassurance, a flat, affected, and placid image of happiness, unclouded happiness. The anti-picture, on the other hand, is a very small painting in yellow and orange. It is nonfigurative and features triangles and other geometrical shapes. While the ideal picture is like a very bad Corot, the anti-picture might make one think of Klee. And—it goes without saying—such modernism is totally rejected.

How can one conceive of art as a populist response to average taste, synthesized in conformity to demand? The artificial happiness thus represented depends on renouncing the laws of art, which are not directly subject to oppressive decrees such as the logic of the artistic world, institutional criteria, public tastes, the artist's conscious response in terms of his background, and so on. Anything that suggests anticipation of the imperative of imagination or dream, any conflict within oneself, any dialogue with an imagined interlocutor, any formulation of the unconscious, anything subversive and transgressive in art, any formal innovation (and therefore everything which is hard to comprehend at a glance), any destruction of clichés and stereotypes, anything that strives against kitsch—all this is eliminated. One rarely sees such a collapse of the horizon (in Ernst Bloch's sense) into a well-behaved and self-effacing pragmatism. These are the consumerist and populist implications of democracy, which by the same token are, in the age of polls, its perverse consequences. For, as Jacques Derrida said in a different context, art is not "un programme mais une promesse." What ought to be counterposed to this consumerist kitsch and cultural leveling is the image of utopian heroism, which, far from being affected, is nevertheless unsettling by virtue of its unreality, its erasure of contradictions, and its demand for a New Man at once oriented toward the future and already realized.

In the midst of tremendous failure, the statues, at least those which have not been destroyed, look with empty eyes, no longer able to convey their message. What became of these ruins, these leftovers of a former aesthetic of monumental propaganda for a new society marching toward a "bright" future? Most were destroyed or put on exhibit. In his last film,

Figure 1. Catalogue (*right*) and chart (*opposite page*) of the Szobor Park Muzeum. (Publications of the Statue Park. Budapest XXII., Balatoni út — Szabadkai utca sarok. Publisher: Ákos Réthly. Budapest, Pf. 96/96 1388.)

Ulysses's Gaze, Theo Angelopoulos shows a monumental statue of Lenin being placed on a ship at Constanza for transport on the Danube to a rich German collector. People on the riverbank cross themselves as if they have seen a devil. Lenin, empty-eyed and virtually disassembled, is mere merchandise at this crossroads of History: the triumphant march toward a heroic utopia is obliterated by the ridicule of history. When asked by the authorities if he is carrying any passengers, the captain — who actually has on board the main personage of the film — replies, in view of the disassembled statue, "None."

I arrived at the Szoborpark in Budapest on Friday, 1 September 1995. For 2,000 forints, a limousine from the Gellert, a grand hotel in "art nouveau" style, took me to Statue Park in the twenty-second district of southwestern Budapest, rather far from the center. If I had gone there on my own, I would have had to take a trolley to Kostollany Square, then, at the Hotel Flamenco, a local yellow bus to Erd, a suburban village. Quite an expedi-

Entrance

tion! It was a gray morning with a cloudy sky, heavy clouds but no rain, the weather concording with the strange place I was about to visit. It was completely deserted at opening time—ten o'clock in the morning—with a concièrge at the entrance, an old lady who vigilantly attended the site as some kind of reliquary. As she sold tickets, along with statuettes of Lenin, Marx, and Engels, she listened to Soviet and Hungarian marches of the "ancien régime," as they used to call Communist rule before the events of 1989–90, or to speeches (in Hungarian, of course) by Hungarian leaders (including Rákosi, I believe), her eyes staring into the distance. In the middle of the park an old gardener, watering can in hand, was busy attending to his flowers, as in a cemetery. Flowers were arranged in the form of a Red Star, a replica of the one you could see at the entrance to the Bridge of Chains at Adamt Ter (*ter* means square), right across from Parliament on the other side of the Danube.

One arrives at a parking lot for cars and tour buses. It was practically empty. Across from this parking lot is a neoclassical brick façade in

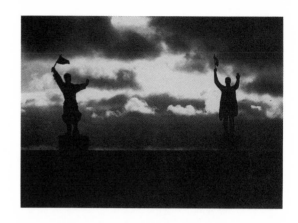

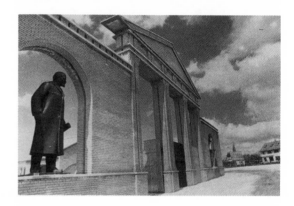

Figure 2. (*right and opposite page*) Postcards of the Statue Park, SzoborPark Muzeum. (Publications of the Statue Park. Budapest XXII., Balatoni út — Szabadkai utca sarok. Publisher: Ákos Réthly. Budapest, Pf. 96/96 1388.)

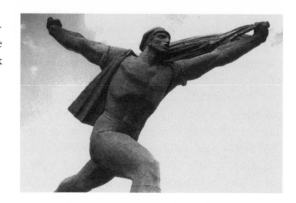

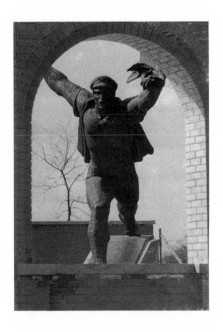

which two enormous niches hold two monumental statues in the heroic style of socialist realism, which was forcefully imposed in the Soviet Union for thirty-four years and became equally mandatory in other Communist countries after World War II. On the left is the bronze statue of Lenin that used to stand on an immense avenue where the May First parades took place. It is a classical statue, four meters high: Lenin with his left arm hanging by his side and his right hand holding a book. It used to stand atop a fifteen-meter pedestal made of concrete and faced with Swedish granite, which further emphasized its monumental character and the solemnity of the site. Needing some repair, it was removed for restoration, not for any political reasons. When the political changes occurred, the statue was at a restoration studio where, not surprisingly, it stayed. The pedestal didn't stand a chance: it had to be disassembled since its symbolic value, even empty, was troubling at the new juncture.

The second niche is occupied by a monumental ensemble representing the inseparable "couple" Marx and Engels. Made of granite and measuring 4m × 2m, it used to stand in front of the Hungarian Communist Party headquarters on the Pest side of Marguerite Bridge. These two monumental statues face visitors about to enter the park, but not the other

statues. This produces a strange, almost surrealistic effect, as if the statues in the garden had been abandoned by the founding fathers of Marxism–Leninism. By virtue of this abandonment, the effective solitude of their exile to a remote place grows even stronger.

There is no entrance between the two niches. Where normally would be found a porch there is a mural with an engraved poem by Gyula Illyés (1902–1983), a famous poet and dramatist who associated himself from adolescence with the Workers' Movement and who distanced himself from Stalinism in the 1950s. The engraved excerpts from this poem denounce tyranny. The entrance to Statue Park is on the side, where the old lady sits at the ticket booth. The park was first conceived by Laszlo Szorenyi, who proposed it in an article in the 5 July 1989 issue of the periodical *Hitel.* Szorenyi suggested a "Lenin Garden," where all the statues of Lenin from parks, squares, and public buildings throughout Hungary could be gathered in one place. Public debate continued through 1990 and 1991, until finally, on 5 December 1991, the National Assembly decreed that the choice of whether to keep statues left from the previous political system should be decided by each district individually. The Assembly then launched a competition for the design of a "statue park"; the winner was architect Akos Eleod of the Vadasz Studio. The park was opened in the fall of 1993, but it was not completely finished. The architect had conceived of a brick wall which was supposed to run all around the park, enclosing and linking all the various statues, commemorative plaques, and monuments in one setting. He had also imagined various features and explanations to guide the visitor instead of the small printed guidebook that one can buy at the entrance and without which one would feel completely lost. An account of the museum's opening appeared in *Le Monde:*

Hungary has symbolically immortalized, not without humor, forty years of its history. On Sunday, June 27 [1993], on the occasion of the celebration of the second anniversary of the departure of Soviet troops, the city government of Budapest, headed by the longtime dissident Gabor Demszky, inaugurated the first open-air museum of statues from a former Socialist state of the Soviet bloc.

In the shade of the monument to the martyrs and under the benevolent gaze of two colossal Red Guards, a group of actors parodied an official ceremony of the 1950s with processions of Young Pioneers and worker-heroes, as well as their speeches, filled with official Communist jargon. They joyously celebrated the birth of this strange new genre of amusement park, which will be open to the public on the first of August.

The park is spread out over four hectares on the outskirts of the city and brings together some forty statues and a dozen commemorative plaques of the former regime. It is also one of the rare places in Hungary where, after the recent ban on using Communist symbols for anything other than "cultural" or "educational" purposes, it is still possible to exhibit Red Flags without fear.

Histoire oblige: the statues of the founding fathers of socialism, Marx, Engels, and Lenin, are installed in niches on either side of the neoclassical pantheon at the entrance to the park. Other relics are divided into three groups: historical events, political figures, and a monument, *To the Liberators,* those of 1945 who came back in 1956 to suppress the Hungarian Revolution. The tour takes one to a flower bed in the shape of the Red Star, which once decorated the entrance to the Bridge of Chains, and then one gets a glimpse of the wall—the last feature of the tour.

The opening of the park was preceded by a lively debate between advocates for the destruction of the statues and advocates for their preservation, not to mention those who suggested that they should be sold—to whom?—to compensate the "victims of communism." "We were trying to avoid both extremes," insisted Míklos Marschall, Budapest's Deputy Mayor for Cultural Affairs, "to avoid establishing a socialist Disneyland that would turn History into a joke, on one hand; and, on the other, to avoid creating something too grave and ostentatious. The solution is typically Hungarian: a compromise with a touch of ironic wit." [2]

In 1994 Tibor Wehner, an art historian, made an attempt to define more precisely what the architect's intention had been:

There is a certain joy in the absence of book burnings. The park was planned with the following idea in mind: one had to make one's way through territory mined with controversies and to arrive at an adequate representation of the statues without any hidden agendas. It was not supposed to be an "amusement park." Absolutely not. It aimed to achieve a critique of the ideology that defined the aesthetic of these statues through the general atmosphere of a park, and via the use of certain elements.[3]

The park is arranged in three big ovals (the central one being the biggest) that converge toward the center, forming an alley with the big Red Star of flowers in the middle. Statues, monuments, and commemorative plaques are placed along the curbs of this alley, at the very end of which, in front of a brick wall, stand two huge statues, each brandishing a Red Flag. But this is a dead end; the alley leads only to a path that borders the park. No explanation is provided to the visitor, but the visitor himself

must want to go to this lost corner which is already almost in the suburb and thus supplies its own motivation.

The very first statue, encountered on the right as one enters the park (#3 in the chart; see Figure 1), has a story of its own. It is of a Soviet soldier, liberator of Budapest in 1945. He stands solemnly, holding in his right hand a flag of liberation, his gun strapped diagonally across his chest. The six-meter statue of bronze seems lost in this spot. It used to be a part of the *Monument of Liberation,* which became *Liberty,* and once stood on top of Gellert Mountain, which dominates the Danube in Budapest. This monument, erected in 1947, included the soldier atop a seven-meter pedestal and, towering over it, a second, 22-meter pedestal topped by a 13.50-meter statue of *Liberty*—a feminine figure holding a palm frond, towering over the city. The monument was decorated with a Red Star and inscribed with tributes to the Soviet Army. Right after the war, rumors about this ensemble started circulating; some suggested that the monument had actually been commissioned before the arrival of Soviet troops and was supposed to honor one of Míklos Horthy's sons who had died fighting on the side of the Germans. At any rate, the sculptor, Srolb, created the monument according to the aesthetic of socialist realism and not in the neoclassical style praised by the Nazis, albeit both aesthetics featured elements of monumentalism. The statue of the soldier was taken down during the events of 1956 and then replaced by an identical figure in 1958. Therefore, the statue in the park is the replica, not the original. The feminine figure was veiled in 1992, then unveiled again as if incarnating, in its rebirth, a new spirit of liberty. However, debates had raged over whether the ensemble should be dismantled and permanently reinstalled in Statue Park or whether the feminine figure holding a palm frond should be preserved and assigned a new identity. The second option was taken.

As for the soldier, it is with his statue that the tour through this new style "dustbin," this "exhibition" or "installation" of the leftovers of History, begins. Then come the monuments dedicated to Soviet–Hungarian friendship—figures holding or shaking hands—and statues in honor of the liberation of Hungary, built by either Young Pioneers or the unions. Likewise, the circular territory to the left of the entrance displays all the monuments glorifying Soviet heroes. From #13 to #20 on the chart, all along the second circle to the right of the floral Red Star, stand the statues of individual heroes. Among these are a small bronze of Lenin which used to stand on "Lenin Korut" (*korut* means boulevard), today called "Erzébet

Korut," and a small bronze of Dimitrov taken from Dimitrov Square (now called "Fovam Ter"), directly in front of the Gellert Hotel at the Bridge of Liberty. Dimitrov's statue had been damaged during the events of 1956 but was later restored, then replaced by a much larger statue of him in 1984. The large and the small statue were brought together in the Park. At the far end of the circle (#16) stands a memorial to the three leaders of the 1920 Commune: Béla Kun, Jenö Landler, and Tibor Szamuely. On the other side of the circle (from #17 to #20) are the statues of the Workers' Movement and Communist Party leaders. There is a monument to Imre Sallai and Sándor Fürst, who were executed by the Fascist regime in Hungary in 1932 after a mock trial. This monument was erected in 1974 to celebrate the centenary of the merging of Buda and Pest into a single city. Later, it was removed during construction of the subway Blue Line and put into storage, where it remained until it was finally erected in Statue Park. It consists of two bronze statues, their hands extended in heroic pathos. Then there are statues of three Communist activists: one was executed by the Nazis (the name on the plaque is Robert Kreutz); the second died in 1956 while defending the Central Committee of the Party against the besiegers (the name on the plaque is Janós Asztalos); the third one, Jozsef Kakamar, was killed in 1956 after he was discovered hiding in the forest of Király—executed, no doubt, for his role in the repressions of the Rákosi regime. On the other side of the floral Red Star (#21 to 23) is a bust (with plaque) of Béla Kun and a two-meter bronze statue of Arpád Szakasits, the Communist activist who was jailed in 1950 and later "rehabilitated."

At the end of this second circle is a work (#24) that is drastically different from everything one has encountered so far. It is a huge monument to Béla Kun in the modernist, avant-garde style, not in the style of socialist realism like the others. In this well-known grouping created by Imre Varga, Béla Kun towers over several infantrymen in action, all of whom seem to soar toward the sky. In the middle of the group (constructed of iron pipes) stands a surrealistic lamppost. A sense of rhythm in this work gives the group an extraordinary presence. Just before the sculpture was dismantled, it was wrapped with aluminum foil and painted red—doubtless to symbolize the Red Terror of the 1920s and to remind us that it once stood at "Vermezo," the bloody field that got its name after the Jacobins were executed there in 1795. The circle is completed by a bronze 2.40 meter-statue of Ferenc Münich, an early activist and cofounder of the Communist Party who participated in the Commune of Béla Kun as a

political commissar. After the latter's fall, Münich fled to the Soviet Union where he joined the Red Army and played an important role in the war in Spain. He returned to Budapest with the Soviet troops after having fought the entire war—including, in particular, the Battle of Stalingrad—in their ranks. In 1945 he became the chief of police, and 1956 he was a crony of Kádár's. He died in 1986, still holding one of his many and diverse positions within the upper echelons of government. His statue, painted red in 1990, then had its legs sawed off before being completely dismantled. Next, we encounter a bronze bust of Ede Chlepko, a Party activist and refugee in the Soviet Union after the defeat of the Commune, as well as a victim of the purges of 1937; a marble plaque commemorating Kalman Turner, an activist who died in 1956 defending the headquarters of the Communist Party; and another marble plaque in memory of Kato Haman, a woman who was a Workers' Movement activist and who died in the 1930s in one of Horthy's prisons.

A marble sculpture in honor of the workers and soldiers of the 1920 Commune opens the third circular section, to the right, of the Park. There are monuments that glorify the proletariat, represented by a jaunty air, outstretched arms, and a worker's cap. At the end is a bronze disk glorifying the Hungarians who fought in the International Brigades in Spain. On the side are engraved the names of Spanish cities known for the heroic resistance of the Republicans, as well as those of the 1,200 Hungarians in the International Brigades. Then come the statues dedicated to the Republic of the Soviets, that is, the insurrectionary government of Béla Kun. On the other side is a plaque that had once been installed where the Hungarian Communist Party was founded in 1919 and another plaque that marked the opening of a clandestine Party printing house in 1922. To the left of the last oval, symmetrically placed vis-à-vis the disk in honor of the International Brigades, is a memorial to the power of the working class. It was created to glorify those who stayed loyal to the Communist regime in 1956 and died defending the values of socialism. A huge ensemble made of stone, it used to stand in front of Party headquarters in Budapest. Finally, there is a memorial to the Buda Regiment, whose 2,500 members, together with Soviet troops, liberated the city.

Two statues remain at the end of the park. On the day I saw them, they stood out clearly against a tragic, heavily clouded sky, brandishing their Red Flag in front of a brick wall. One is a bronze, 4.3-meter statue of Captain Steinmetz, a Party activist who died in 1944 while trying to reach the

Soviet border after returning from a mission in enemy territory. His original memorial was an ensemble consisting of two statues, each with a Red Flag. That monument was destroyed in 1956, however, because Steinmetz, who had joined the Soviet troops, negotiated the surrender of the Nazi army as a Soviet officer and not as a Hungarian. And last comes a statue that is very well known in Hungary, a bronze more than three meters high of Osztapenko. The events of 1956 likewise took their toll on this monument to the Red Army captain who died in service in 1944. He is represented advancing, flag in hand, to demand the surrender of the German troops as they approach Budapest. During the debates of 1989–90, the question of what to do with the bronze Osztapenko arose. People liked the statue because, from where it used to stand on the Budapest–Vienna highway, it had seemed to bid farewell to travelers. It now completes the tour through Statue Park. Behind the two negotiators, there is only a small brick wall.

As I was leaving later that morning, I saw a group of young Americans arrive, cameras slung over their shoulders, looking as if they had just gotten off a flight from Mars.

Soon it will be necessary to make an inventory of all the Communist ruins: the mausoleums, monuments, statues, flags, hymns, medals, badges, emblems, mottoes, slogans, symbols. But can fallen History simply be exhibited or installed artistically? Can fallen History be placed behind glass, transformed into a hologram? (If so, wouldn't this mean a new reading of the opening phrase of Marx's *Communist Manifesto:* "A specter haunts Europe, the specter of communism"?) Shall we bury its symbols? Recycle them? Reuse them? Shall we buy medals sold at the Brandenburg Gate or take home trophies, such as pieces of the Berlin Wall, to put in our gardens? For that matter, in Budapest two big chunks of the Wall tower like statues. I am betting that these symbols will come back to haunt us — in what way, we haven't the slightest idea. Because after all, as much as one might want to turn the past into ruins, garbage, artifacts, relics, to invert the signs and symbols, to parenthesize the past, to invent another, fake past, to create a simulacrum; as much as one might want to museify the past, to parody it, mock it, pastiche it, or criminalize it, to find those responsible for it, to make scapegoats, to destroy statues and put their pieces in museums, to obsess about symbols, digging them up to bury them again, all this fabrication of ruins would be meaningless relative to

the necessary work of mourning and of a critical, nonhysterical rereading of the past.

Le Monument, a book by Elsa Triolet published in 1965, is worth rereading.[4] Triolet recounts the story of a Prague sculptor who, commissioned to make a statue of Stalin in 1956, committed suicide because his work seemed so hideous. He left the money he had received for it to the blind — to those who would never see their town dishonored by this statue. The present brings the new blind, who see the hideousness of neither the dismantled statues nor the new effigies.

In a more recent novel by Julian Barnes, *The Porcupine,* an old dictator — a Honecker type — of an East European country is brought to trial, and the Chief Prosecutor is also an old Communist: in this settling of accounts for those miserable times, no one is innocent. A variety of monuments get dismantled, beginning with the statues of Stalin which are lined up along the shunting yard. Later, his statues get company, joined first by those of Brezhnev and Lenin, then by that of the novel's hero, Stovo Petkanov. *The Porcupine* ends poignantly:

In front of the vacant mausoleum of the First Leader an old woman stood alone. She wore a woollen scarf wrapped round a woollen hat, and both were soaked. In outstretched fists she held a small framed print of V. I. Lenin. Rain bubbled the image, but his indelible face pursued each passer-by. Occasionally, a committed drunk or some chattering thrush of a student would shout across at the old woman, at the thin light veering off the wet glass. But whatever the words, she stood her ground, and she remained silent.[5]

I'm also reminded of Dušan Makavejev's film *Gorilla Bathes at Noon.* It is about a Russian officer after the fall of the Berlin Wall. Unemployed, he roams the streets of Berlin — and explores the ruins. He is trying to sell his uniform when he comes across a statue of Lenin that has been left standing: a grand meditation on the end of an empire and the new fabrication of ruins. "The end of Communism: winter of the souls, December 25, 1991," wrote Danièle Sallenave, who can hardly be accused of nostalgia for the past or that political regime.[6] Is kitsch the only memory we retain of the past and its Symbolic?

To the past placed in a museum without explanation, without the slightest idea why antifascists and heroes of the Spanish civil war should be thus exiled and grouped with those responsible for the repressions that followed

the 1956 Revolution, with Lenin, and with Marx and Engels; without the slightest idea why a clandestine Party printing shop of the 1920s and Béla Kun should be doomed to this park while Admiral Horthy gets a new, quasi-official funeral;[7] to such a disordered past one ought to counterpose, I believe, Jochen Gertz's work that questions memory. Visiting him in his Paris studio two years ago, I had an opportunity to acquaint myself with the work of this artist, which poses unsettling questions in a period dominated by simulacra of the past, by history's museification, and by the transformation of any remains, of any relics, into public property.

Because memory has become a fetish, it has also become the ultimate recourse of those who deny the true work of mourning that a culture must undertake in order to come to terms with its own past: *Memory* as opposed to *History.* It makes one think of the famous *Lieux de Mémoire,* Pierre Nora's encyclopedic undertaking. Nora explains the shifts, the decenterings, that his work brings to bear on History:

But from the moment one refuses to consign the Symbolic to a particular domain in order to also define France itself as a symbolic reality—which, in fact, to deny it any possible definition that could reduce it to any of the assignable realities—from that moment life opens to quite a different history. It is no longer the determinants, but their effects; no longer memorized or even commemorated actions, but the trace of these actions and the play of memory; not the events as such, but their construction in time, the effacement and reemergence of their significations; not the past as it is, but its constant recycling, its use and misuse, its rich implications for successive presents; not tradition, but the fashion in which it is constituted and passed on. *In brief: it is neither resurrection, nor reconstruction, nor even representation, but re-memorization.* Memory is therefore not a reminiscence, but the general economy and administration of the past in the present: a history of France, but to the second degree.[8]

Jochen Gertz takes the work of mourning very seriously, without making any concessions. Born in Germany in 1940, he married an Israeli woman and has lived and worked in Paris since 1966. Of his many projects I will mention only a few salient examples to illustrate my point. In *Le Transsib-Prospekt,* a 1977 project, Gertz took over a compartment of the famous Transsiberian Express on its Moscow–Khabarovsk–Moscow route. During the trip the windows of the compartment not only remained closed, but were also covered with paper or fabric so that nothing outside could be seen. Crossing the European and Asian parts of Siberia, a round-

trip of more than 16,000 kilometers, took sixteen days. Gertz brought along sixteen slates on which to put his feet, one slab of slate each day, so that no trace of his passage would be left in the train compartment. Everything that could have testified to his presence on the train, such as ticket stubs, was burned upon arrival so that when he returned it would no longer be clear that a trip had even taken place.

The disappearance of traces, the fragility of evidence, the tenuous presence of absence. In the context of this aesthetic of absence, one can't help but think of Georges Perec's *A Void,* at the hollow center of which is the tragic disappearance of his mother, who was arrested on 17 January 1943 in Paris and "disappeared" to Auschwitz, deported by train on 11 February. Perec describes a book missing from its place as follows:

To his right is a mahogany stand on which sit 26 books—on which, I should say, 26 books normally ought to sit, but, as always, a book is missing, a book with an inscription, "5," on its flap. Nothing about this stand, though, looks at all abnormal or out of proportion, no hint of a missing publication, no filing card or "ghost," as librarians quaintly call it, no conspicuous gap or blank. And, disturbingly, it's as though nobody knows of such an omission: you had to work your way through it all from start to finish, continually subtracting (with 25 book-flaps carrying inscriptions from "1" to "26," which is to say, 26 – 25 = 1) to find out that any book was missing; it was only by following a long and arduous calculation that you'd know it was "5."[9]

Or elsewhere:

A unit is lacking. An omission, a blank, a void that nobody but him knows about, thinks about, that, flagrantly, nobody wants to know or think about. A missing link. . . . Things may look normal and natural and logical, but a word is but a *faux-naïf* talisman, a structurally unsound platform from which to sound off, as a world of total and horrifying chaos will soon start to show through its sonorous inanity. Things may look normal, things will go on looking normal, but in a day or two, in 7 days, or 31, or 365, all such things will rot. A gap will yawn, achingly, day by day, it will turn into a colossal pit, an abyss without foundation, a gradual invasion of words by margins, blank and insignificant, so that all of us, to a man, will find nothing to say.[10]

In 1986 Jochen Gertz and his wife, Esther Shalev-Gertz, questioned the memorial function of monuments in a work entitled *Mahnmal gegen Faschismus* (Monument against Fascism). This was a column, twelve meters

high and covered with a thin layer of lead on which passers-by could—indeed were encouraged to—inscribe their names or comments. The column was designed to gradually sink into the ground, disappearing on 10 November 1993 and leaving an empty place. Gertz's use of "Mahnmal" instead of "Denkmal" for his antimonuments signifies his rejection of the language of the State, the official memory that selectively commemorates events in national history. "Mahnmal" is an allusion to the negative past, the past that is unfathomable, the memory of which governments repress or pass over in silence. The antimonument could be considered an attempt to face the past by enacting amnesia and repression. Despite seven years of interaction with the monument—literally marked by violent and hostile inscriptions and even gunshots, as well as signatures in support of the project—in the end, with the obliteration of the monument, no traces of that interaction remained.

Another example of Gertz's aesthetic of absence is *Le Monument invisible* (or The Monument against Racism) of Saarbrücken, unveiled on 23 May 1993. It took up the central part of the courtyard of the Castle of Saarbrücken, which is paved with 8,000 cobblestones. Gertz and his team "secretly" removed 2,160 cobblestones and inscribed them with the names of Jewish cemeteries desecrated by the Nazis, then reinstalled them. Since the inscriptions remained invisible under the cobblestones, only about a fourth of which had been marked, it would always be impossible thereafter to know whether one were walking on inscribed or uninscribed cobblestones. Again, this is absence as presence, disappearance, memory turned over on itself. The artist has expounded more than once on the meaning of his project:

A certain number of people of my age—and even those who are younger—have always felt they don't know how to behave facing the past. This is a form of sublime repression. From here comes my idea of repressing the work itself. Since Freud's time we have known that we are haunted by that which is repressed. I want to give the viewer this relation to the past that could also be mine.[11]

As one of his interviewers noted, the gesture of burying memory has the effect of evoking it. Responding to a journalist from *Libération* who asked Gertz why, after all, this was an invisible monument, the artist said:

It is not an aesthetic trick. . . . One can't live with this past, it is an impossible heritage. It is impossible to establish an authentic relationship with absence; it

makes no sense. In the richness of its visual qualities, and precisely because of its visibility, the work is unable to treat absence adequately. This work therefore ought to find a means to be absent in turn. Why? In order to allow us to penetrate our past and talk about it. The work has to sacrifice its presence so that we may approach the kernel of our past. We can't stay in the periphery of our past. We should not become mere accessories of our own history. It is necessary to rediscover responsibility.[12]

Paradoxically, Jochen Gertz relies on an invisibility that renders things visible (for visibility as such is a delusion), on absence that works subliminally to evoke a different kind of memory and presence. It is an active memory, a real work of mourning, that knows how to deal with oblivion. It is also aware that those of us who use the word "memory" most are often those who avoid any destabilization, any erasing that operates within us, any threatened collapse of our universe. They reconstitute themselves out of the singular, from the many, without exposing themselves to the process of chipping away at the past or to the necessary awareness of our culture's fragility. Gertz's project is also about transience in the style of those installations that question "the call of eternity and the market value of the work of art." [13]

At a time of television presence, of real time and obsession with the visible and the direct, Gertz's antimonuments remind us that the Greek epic poets were blind and that today's seers are perhaps those who are marginalized, working in invisibility, in solitude, in the realm of transgression, fragility, oblivion, and outcast memory. In contrast to spectral, holographic, prosthetic, virtual memories that don't distinguish the true from the false, in contrast to the "reality shows" of memory, Gertz's art goes back to the time and space where the density of memory can be rediscovered, where the full force of its uncanniness is not glossed over. In this context, what can be said about the remains of socialist realism?

Ruins, wreckage, debris accumulated in the style of Arman or installed in a Statue Park like Budapest's, museified without explanation—perhaps in their silence they are still able to compose a saga from the hollows of lost promise, of its rapid diversion into tyranny, but a promise that still looms like a dead shadow over the new deviations of societies doomed to nationalisms, fundamentalisms, or a market economy that has gone insane.

—Translated by Julia Trubikhina and Candice Ward

Notes

1 Régine Robin, *Le Réalisme socialiste: Une esthétique impossible* (Paris, 1986)/*Socialist Realism: An Impossible Aesthetic,* trans. Catherine Porter, Foreword by Léon Robel (Stanford, 1992).

2 Yves-Michel Riols, "Hongrie, les statues socialistes au musée," *Le Monde,* 30 June 1993.

3 Tibor Wehner, "Public Statue Cemetery from the Recent Past," in *Szoborpark Muzeum,* a guidebook to Statue Park in Budapest (n.d.).

4 Elsa Triolet, *Le Monument* (Paris, 1965).

5 Julian Barnes, *The Porcupine* (New York, 1992), 138.

6 Danièle Sallenave, *Passages de l'Est: Carnets de voyages 1990–1991* (Paris, 1992), 309.

7 In September 1993 the remains of Admiral Miklós Horthy, Hungary's fascist dictator from 1920 to 1944, were returned to the country, and his image was stamped on a coin. The radical Right called on Hungarians to make this belated funeral "a great manifestation of national continuity."

8 Pierre Nora, "Comment écrire l'histoire de France," in *Les Lieux de Mémoire,* Série *La France* (Paris, 1993), 3: 24.

9 Georges Perec, *A Void,* trans. Gilbert Adair (London, 1994), 12.

10 Ibid., 13, 16.

11 "Jochen Gertz's 'La Place du monument invisible,'" interview by Jacqueline Lichtenstein and Gérard Wajeman, *Art Press* (April 1993): 11.

12 Miriam Rosen, "Gertz, sous les pavés la mémoire," *Libération,* 17 March 1992.

13 Manon Regimbald, "Générique," in *Un siècle éventré: Les Nuits de vitre, la nuit des masques* by Paul Emile Saulnier, Moncton University Art Gallery, 1991, 41. See also Régine Robin, *Le Naufrage du siècle* (Paris, 1995).

INDEX

CONTRIBUTORS

ANTOINE BAUDIN is a researcher in the Department of Architecture of the Federal Polytechnic School in Lausanne, Switzerland. He has published articles on the history of the Russian and Polish avant-garde and on European twentieth-century art. His book, *Le Réalisme socialiste de l'ère Jdanov: Situation des arts plastiques,* is forthcoming.

SVETLANA BOYM is John L. Loeb Associate Professor of Humanities in the Department of Comparative Literature at Harvard. She is the author of two books, *Death in Quotation Marks: The Cultural Myths of the Modern Poet* (1991) and *Common Places: Mythologies of Everyday Life in Russia* (1994), and of a play and screenplay, *The Woman Who Shot Lenin.*

GREG CASTILLO is a doctoral candidate in the Department of Architecture at the University of California–Berkeley. He has published articles on Stalinist architecture and is the coauthor (with Spiro Kostof) of *The City Assembled: The Elements of Urban Form through History* (1992).

KATERINA CLARK is Professor of Comparative Literature and Slavic Literature at Yale. She is the author of *The Soviet Novel: History as Ritual* (1981), *Mikhail Bakhtin* (with Michael Holquist, 1984), and *Petersburg: Crucible of Cultural Revolution* (1995).

EVGENY DOBRENKO, Associate Professor of Russian Literature at Duke, has written many works on the history of Soviet literature. His publications (in Russian) include *Ridding Ourselves of Mirages: Socialist Realism Today* (1990), *Metaphors of Authority: The Literature of the Stalin Era in Historical Context* (1993), and *Red Cavalry by Isaac Babel* (with Galina Belaya and Ivan Esaulov, 1993). *The Making of the State Reader: Social and Aesthetic Contexts of the Reception of Soviet Literature* is forthcoming from Stanford University Press.

BORIS GROYS teaches Russian intellectual history at the Universität Münster, Philosophisches Seminar. His publications include *The Total Art of Stalinism: Avant-Garde, Aesthetic Dictatorship, and Beyond* (1992 [1988]) and (in Russian) *Utopia and Exchange* (1993).

HANS GÜNTHER is Professor of Slavic Literatures at the Universität Bielefeld. He is the author of *Die Verstaatlichung der Literatur: Entstehung und Funktionsweise*

des sozialistisch-realistischen Kanons in der sowjetischen Literatur der 30er Jahre (1984) and *Der sozialistische Übermensch: Maksim Gor'kij und der sowjetische Heldenmythos* (1993), as well as the editor of *The Culture of the Stalin Period* (1990).

JULIA HELL, Associate Professor of German at Duke, is the author of *Post-Fascist Fantasies: Psychoanalysis, History, and the Literature of East Germany* (1997).

LEONID HELLER, Professor of Russian Literature at the University of Lausanne, Switzerland, is the editor of *Le Livre d'or de la science-fiction soviétique* (1983), *Autour de Zamiatine* (1989), and *Amour et érotisme dans la littérature russe du XX^e siècle* (1992). He is also the author of *Beyond the Dogma, a Universe: Soviet Science Fiction* (1985 [1979]), *The Word as a Measure for the World* (in Russian, 1994), and *Histoire de l'utopie en Russie* (with M. Niqueux, 1995).

JOHN HENRIKSEN, who translated four Russian articles in this collection, is a doctoral candidate in Comparative Literature at Harvard.

MIKHAIL IAMPOLSKI is Assistant Professor of Comparative Literature and Russian Studies at New York University, has published on Soviet and international cinema, literature, and theory. His publications (in Russian) include *Teresia's Memory* (1993), *The Visible World: Essays in Early Film Phenomenology* (1993), and *Babel-Babel* (with Alexander Zholkovsky, 1994).

THOMAS LAHUSEN, Associate Professor of Russian Literature at Duke, is the author of *The Concept of the "New Man": Forms of Address and Society in Nineteenth-Century Russia* (1982) and (in Russian) *On Synthetism, Mathematics and Other Matters: Zamiatin's Novel* We (with Edna Andrews and Elena Maksimova, 1994). He is also the editor of *Late Soviet Culture: From Perestroika to Novostroika* (1993) and coeditor (with Véronique Garros and Natalia Korenevskaya) of *Intimacy and Terror: Soviet Diaries of the 1930s* (1995).

GAYLE LEVY recently earned her Ph.D. in Romance Studies at Duke. Her translations of articles in French have appeared in several issues of the *South Atlantic Quarterly*, including "Céline, USA" (Spring 1994).

LILY WIATROWSKI PHILLIPS, a doctoral candidate in the Program in Literature at Duke, is writing a dissertation on "Teenagers and Subversion in 1950s Cold War Culture."

RÉGINE ROBIN is Professor of Sociology and Director of the Centre Interuniversitaire d'Analyse du Discours et de Sociocritique des Textes (CIADEST) at the University of Québec in Montréal. Her publications include *Socialist Realism: An*

Impossible Aesthetic (1992 [1986]), *Le Deuil de l'origine: Une langue en trop, la langue en moins* (1993), *Le Naufrage du siècle* (1995), *Le Cheval blanc de Lenine, ou, L'Histoire autre* (1995 [1979]), and *L'Écriture du hors-lieu: Rencontres culturelles devoyées* (1995).

YURI SLEZKINE is Associate Professor of History at the University of California–Berkeley. He is the coeditor of *Between Heaven and Hell: The Myth of Siberia in Russian Culture* (1993) and the author of *Arctic Mirrors: Russia and the Small Peoples of the North* (1994).

JULIA TRUBIKHINA, who translated three articles in this collection, is a doctoral candidate in the Department of Comparative Literature at New York University. She has published poetry and translations in Russian, French, and U.S. anthologies and journals.

CANDICE WARD is Managing Editor of *South Atlantic Quarterly*.

XUDONG ZHANG is Assistant Professor of Chinese in the Department of East Asian Languages and Cultures at Rutgers University. He is the author of *Chinese Modernism in the Era of Reform: Cultural Fever, Avant-Garde Fiction, and the New Chinese Cinema* (1996).

SERGEI ZIMOVETS is a researcher at the Institute of Philosophy of the Russian Academy of Sciences in Moscow. His research interests include sociopolitical strategies of power and literary representations of communal consciousness, and he has published on the philosophy of postrevolutionary proletarian culture.

Library of Congress Cataloging-in-Publication Data

Socialist realism without shores / edited by Thomas Lahusen and Evgeny Dobrenko.

p. cm. —(Post-contemporary interventions)

Includes index.

ISBN 0-8223-1935-7 (cloth : alk. paper). — ISBN 0-8223-1941-1 (paper : alk. paper)

1. Socialist realism in art. 2. Arts, Modern—20th century—Soviet Union. 3. Arts,
Modern—20th century—Communist countries. I. Lahusen, Thomas.

II. Dobrenko, E. A. (Evgeniĭ Aleksandrovich)

NX556.A1S6 1997

700'.947'0904—dc20 96-43217

 CIP